Mawson's Mission

Mawson's Mission

Launching Women's Intercollegiate Athletics at the University of Kansas

LORA MARLENE MAWSON

UNIVERSITY PRESS OF KANSAS

Published by the University Press of Kansas (Lawrence, Kansas 66045), which was organized by the Kansas Board of Regents and is operated and funded by Emporia State University, Fort Hays State University, Kansas State University, Pittsburg State University, the University of Kansas, and Wichita State University.

Library of Congress Cataloging-in-Publication Data
Names: Mawson, Lora Marlene, author.
Title: Mawson's mission : launching women's intercollegiate athletics at the University of Kansas / Lora Marlene Mawson.
Description: Lawrence : University Press of Kansas, 2020. | Includes bibliographical references and index.
Identifiers: LCCN 2020006556
 ISBN 9780700629749 (cloth)
 ISBN 9780700629756 (epub)
Subjects: LCSH: Mawson, Lora Marlene. | University of Kansas—Sports—History. | Women athletes—Kansas—Lawrence—History. | College sports for women—Kansas—Lawrence—History. | Athletic directors—Kansas—Lawrence—Biography.
Classification: LCC GV691.U542 M38 2020 | DDC 796.04/30978165—dc23
LC record available at https://lccn.loc.gov/2020006556.

British Library Cataloguing-in-Publication Data is available.

Printed in the United States of America

10 9 8 7 6 5 4 3 2 1

The paper used in this publication is acid free and meets the minimum requirements of the American National Standard for Permanence of Paper for Printed Library Materials Z39.48-1992.

In memory of my twin sister . . .
my best half and dearest confidant,
Nora Darlene Mawson Helman
(1940–2015)

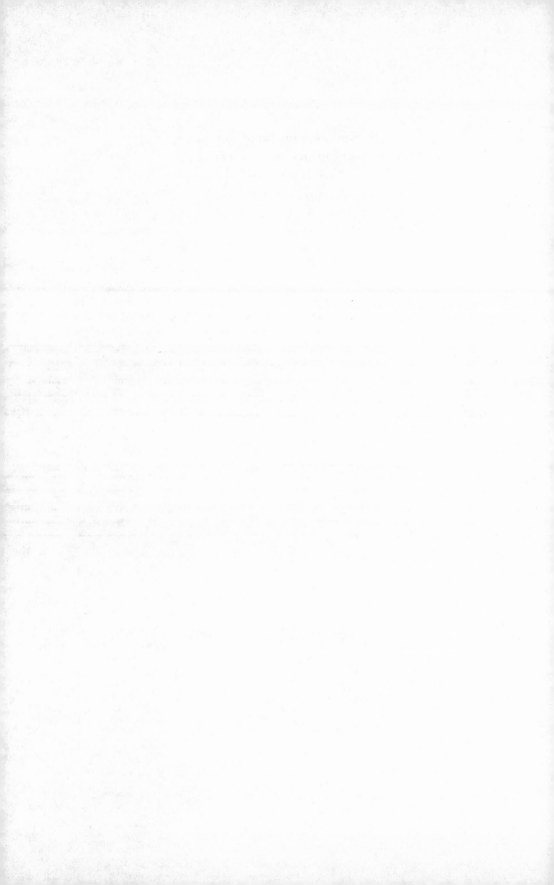

CONTENTS

ABBREVIATIONS

AAHPER American Association for Health, Physical Education, and Recreation

AAHPERD American Association for Health, Physical Education, Recreation, and Dance (formerly AAHPER)

AAU Amateur Athletics Union

ACACW Athletic Conference of American College Women

AIAW Association for Intercollegiate Athletics for Women

AKWIS Association for Kansas Women's Intercollegiate Sports

APEA American Physical Education Association

ARFCW Athletic and Recreation Federation for College Women

CAPECW Central Association for Physical Education for College Women

CIAW Commission on Intercollegiate Athletics for Women

CWA Committee on Women's Athletics

DGWS Division of Girls and Women in Sport

DGWS-OSA Division of Girls and Women in Sport—Officiating Services Area

FIVB Fédération Internationale de Volleyball

GAA Girls Athletics Association

IOC International Olympic Committee

KAHPER Kansas Association for Health, Physical Education, and Recreation

KAHPERD Kansas Association for Health, Physical Education, Recreation, and Dance (formerly KAHPER)

KAIAW Kansas Association of Intercollegiate Athletics for Women (formerly AKWIS)

KARFCW Kansas Athletic and Recreation Federation for College Women

KCAC Kansas Collegiate Athletic Conference

KSU Kansas State University

KU University of Kansas

LPGA Ladies Professional Golf Association

NAAF National Amateur Athletics Federation

NAAF-WD National Amateur Athletics Federation—Women's Division

NAIA National Association of Intercollegiate Athletics

NAPECW National Association of Physical Education for College Women

NAPEHE National Association for Physical Education in Higher
 Education
NASPE National Association for Sport and Physical Education
NASSM North American Society for Sport Management
NASSS North American Society for Sport Sociology
NCAA National Collegiate Athletics Association
ROTC Reserve Officers' Training Corps
USLTA United States Lawn Tennis Association
USOC United States Olympic Committee
USTA United States Tennis Association (formerly USLTA)
USVBA United States Volleyball Association
WAA Women's Athletics Association
WRA Women's Recreation Association
YMCA Young Men's Christian Association

PREFACE

The stories you tell about the early years of KU women's athletics are history. You should write about this for future generations of young women athletes.
—Senior Director of K-Club Candace Dunback

The Women's Intercollegiate Athletics program was established at the University of Kansas (KU) in fall 1968, and it was my good fortune to be the KU faculty member assigned to initiate this program. There was little attention devoted to KU women's athletics during the first decade of its existence, and I have written my account of those early years both from memory and from documented verification of the development of KU women's athletics using university, state, and national sources.

In January 1968 the newly established Commission on Intercollegiate Athletics for Women (CIAW), within the Division of Girls and Women in Sport (DGWS), announced that national sports championships for college women were to begin in 1969–1970. Prior to this announcement, there were no intercollegiate athletics programs for women across the country. Immediately, colleges scrambled to set up women's intercollegiate athletics programs, and KU was among the first to respond to the challenge. I was a newly appointed full-time faculty member in physical education at KU in fall 1968, and I was charged with creating the new program as an extra responsibility.

In this book I tell my story of initiating the KU women's intercollegiate sports program within the context of institutional support, national regulations and guidelines, and the resulting accomplishments of women's athletics teams at KU. The KU Women's Athletics program was initially administered within the Department of Physical Education. With a limited budget and resources borrowed from academics in the first year, I established a six-sport intercollegiate program for KU women, competing in the first season within the state of Kansas. KU women athletes had to deal with inequalities in their practice and competition facilities, athletic attire and equipment, and travel arrangements. The media ignored them for the first six years, but they persevered because their incentive was to

have the opportunity to compete in intercollegiate sports, and their plight was similar to that of women athletes at other institutions. During that first decade, KU women's teams were among the leading schools when they competed in national championships in volleyball, basketball, softball, and gymnastics.

In this book I describe the contributions and achievements of the early women athletes, their coaches at KU, and the women athletics leaders across Kansas and the nation during the dawning and development of women's intercollegiate athletics. My contributions to women's intercollegiate athletics extended beyond KU in leadership positions in state, regional, and national athletics organizations and in academic sport management organizations. I invited KU women athletes and coaches who participated in KU sports during that first decade to share their own memories of KU women's athletics (see the Appendix). This book honors those stalwart pioneers.

The book title stems from the 2011 christening of a new scull boat for the KU crew team that the team named *Mawson's Mission*. I am grateful that the creation of a competitive athletics program for women at KU has resulted in ever-increasing opportunities for many young women over the past five decades. The first decade of KU women's athletics established the foundation for what KU women athletes enjoy today.

CHAPTER ONE

CENTER COURT

Standing on the dynamic Jayhawk icon at the center of the James Naismith basketball court in the storied Allen Fieldhouse on the University of Kansas (KU) campus in Lawrence seemed surreal that winter evening in 2009. Baby Jay, the mascot, had led the line of KU Athletics Department administrators and KU women alumna athletes with me from the northwest tunnel under the stands out into the bright lights of the arena. The alums lined the edge of the arena while I stood at center court. The public-address announcer at the scorer's table identified the occasion and rattled off the contributions and achievements I made during my tenure at KU as I gazed at the crowd and smiled. I reflected on what had brought me to experience that moment. The special occasion was my induction into the Kansas Athletics Hall of Fame.

Immediately I felt gratitude toward the tenacious young women athletes at KU, now retired. They had played several sports with desire and joy in the late 1960s, and they had inspired me to forge on and persevere amid all kinds of adversity. Many of those pioneers now lined the sides of the court for the ceremony. My mind flicked back to a time when those athletes played in Robinson Gym, putting up with stray intramural balls thrown across their court and having to chase balls on minimally mowed outdoor intramural fields, and when I hauled sports equipment along the Robinson hallways in late afternoons to the practice areas.

My family, including my sisters, brothers-in-law, nephews, and nieces stood in the bleachers applauding with the crowd. I had an emotional high reflecting on how proud my father and mother would be of my honor that night, as well as my oldest sister, Mary, who had passed away just two years previously. My dad had instilled in me the conviction that I could achieve anything I set my mind to, resulting in my resoluteness, and my mother was steadfast in her support for me in all my endeavors. My oldest sister had set the standard for all of her younger sisters by being the first college

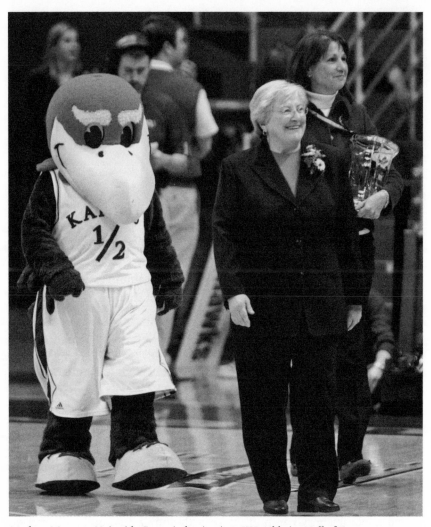

Marlene Mawson, Naismith Court, induction into KU Athletics Hall of Fame, 2009.

graduate in the family and being honored in the Kansas Teachers Hall of Fame. My sisters had always been the most solid source of my support, regardless of my seemingly impossible aspirations, and I knew that my induction into the Kansas Athletics Hall of Fame made them proud.

Standing on this famous basketball floor, I flashed back on the opportunities that brought me to this moment. I thought about my own basketball career in high school, my disappointment that no intercollegiate teams for women existed, my teaching sports skills to high school girls in Kansas City, and my learning of my appointment as a faculty member

at KU so long ago. It did not seem that more than forty years had passed since I coached women's basketball, volleyball, softball, and field hockey at KU because my classes of twenty-year-old student athletes never got older, so I could not have aged either. I felt the anticipation and excitement that ran through me before each sport competition and the joy of the KU teams playing well and winning.

I waved, acknowledging the cheering crowd in the brilliant light, and I was amazed to be recognized with this honor. The basketball game program for that night contained my nickname: "Mother of KU Women's Athletics." It was odd to be called a mother because I had no children of my own, but there were the many athletes who had played ball for me. I loved them all, so it was a true accolade.

Earlier that evening, I had attended an induction dinner in the ballroom of the KU Memorial Union. The windchill that night made it very cold, and after several days of sleet and snow, the streets and sidewalks were frozen. As I arrived on campus for the dinner, the graduate assistant carrying the engraved plaque for me fell on the ice at the doorway, cracking the award.

Even though I knew my sisters had all flown in from both coasts and the Rockies for the event, I was not prepared to see them at the top of the stairs by the ballroom. I had been calm as I flew in from Illinois, settled in at my hotel downtown on the Kansas River, and was escorted to campus on the minibus, but seeing their beaming faces was so unexpectedly thrilling that I reached out to hug each of them and cried tears of joy.

As I entered the ballroom, I was shocked to see more than forty tables of ten seats each—this crowd was there specifically for me because I was the only inductee that night. Former faculty colleagues and student athletes, family, and friends greeted me with wonderful congratulations. It gave me a sensational feeling of appreciation for my work that I had never before felt at KU.

Associate Athletics Director for Women Debbie Van Saun made remarks during dinner, followed by a short video regarding my achievements at KU. As the crowd applauded, I climbed the few steps onto the stage. Athletics Director Lew Perkins conducted the induction ceremony. After accepting the photo plaque that would hang in the Kansas Athletics Hall of Fame and the red wool blanket with the blue "K" and white "Marlene Mawson, Kansas Athletics Hall of Fame" sewn on it, I stepped to the podium. I spoke confidently before the large audience, as I had done many times during my career. First thanking those in the KU Athletics Department, I introduced my family, then acknowledged the late Henry Shenk, who had hired me at

KU; the late Joie Stapleton, who had continually supported my efforts for women student athletes at KU; and most of all, the early women athletes and women's coaches at KU, who had overcome much adversity to make KU women's intercollegiate athletics so successful.

This prestigious award remained astonishing to me because it seemed that during my entire tenure in women's athletics, there was resistance to nearly every one of my seemingly bold initiatives and to my ultimate mission. That mission, to provide young women access to competitive sports, had burned in my mind since I was a teenager entering college, where I sought a degree and a career in teaching and coaching sport teams for girls but found no opportunities for me to play or coach women's intercollegiate sports myself at that time.

Prior to the close of the 1960s, sport in the United States was the domain of men. Women were not considered serious competitors; they were expected to be spectators only. Perhaps they could engage in some recreational pursuits. Little did I realize that early in my professional career, national cultural, social, and political forces were igniting that would offer me an opportunity to realize my ambitious dream—to initiate the kind of competitive intercollegiate athletics program for elite, skilled women athletes I had envisioned as an undergraduate.

During the first decade of my career, I experienced firsthand the trials and tribulations of women "intruding" in the male-dominated arena of sports. Little support came from men in sports careers, or from women who believed competitive sports were unfeminine, or from women who had never engaged in competitive sports. Influence from the US Olympic Development Committee and early state and national athletics organizations provided the initial framework in which women organized intercollegiate sport competitions prior to the legal enforcement of Title IX. It was signed into law in 1972, but federal compliance regulations were not in effect until 1978.

Currently, in the twenty-first century, college women athletes and their fans have scant notion of what their forebears pursued and endured to make collegiate sport opportunities for women possible today. It was always my goal to create opportunities for young women with elite sport skills to engage in intercollegiate competitive sports. Sharing my experiences of the formative years of KU women's athletics now is primarily for enlightening those interested in the history of women's collegiate athletics and the formidable barriers for women athletes fifty years ago because there are few records of the battles of that eventful era. This is my story as I recall those

precious years of the first decade of intercollegiate athletics for women in Kansas.

In 2013 the KU women's crew team purchased two new scull boats. Their coach approached me at a K-Club reception, asking my permission to name one of the new sculls after me. He informed me that the crew athletes named their new boats for women they respected and wanted to emulate. It gave me a jolt of surprise and gratitude when I first saw the bold lettering on the boat: *Mawson's Mission*! What an honor it was for me to be invited to christen that boat at a KU regatta that April. I ceremoniously poured sparkling water over the fragile, gleaming bow. The KU crew had captured the fullness of my career-long passion in the scull's title.

CHAPTER TWO

A HALF CENTURY OF SPORTS FOR
WOMEN IN THE UNITED STATES

The Archie grade school playground in the late 1940s was a grassy field west of the schoolhouse and across the gravel parking lot. A set of six swings hung on chains from steel girders, and a slippery slide sat at the far end of the swings. It was a perfect place to watch the skills of the grade-school boys as a pitched ball was hit and bounded toward an infield player who stepped toward the ball, caught it in his glove, and threw it to first base ahead of the runner for an out. The grade-school girls' softball diamond was on the far side of the boys' diamond, and rather than worn baselines with dust around the bases, it had only grassy paths because it didn't get much use. In fact, the girls' bases weren't even the correct distance apart because the girls didn't want to run so far if they happened to hit a pitch. The boys' game seemed more fun than the girls', and I always wished I could play with them.

It never seemed fair or made sense to me that boys in school were encouraged to play ball, but even though girls were given an occasional chance to play the same games, they were not expected to be skillful or to compete as rigorously as boys did in sports. My perspective might have come from growing up at the end of a long era of restricted sports for girls in all schools across the United States when girls did not play ball competitively. I loved to race outside to play ball from the time I could first successfully throw and catch. If there was any chance for me to leave the girls' game, I took the opportunity to play with the boys on their diamond. The first time I got to bat on the boys' diamond, I got a hit. I was in the second grade and voluntarily filling a position on a team for an elementary-school boys' playground game.

My own early athletic experiences were quite different than what was condoned across the country because I attended a small, rural high school in the heartland. In Missouri, the Cass County High School Athletics Association supported both boys' and girls' basketball teams and other sports from the 1920s through the 1950s. Even though boys' teams had postseason

competitions at the state and regional levels, the Cass County girls' teams understood there were no postseason competitions available to them. We knew that the larger Harrisonville and Pleasant Hill schools did not have girls' teams playing in an interscholastic conference, but their boys' teams did not schedule games with the Archie boys' teams either. None of us questioned the unfairness of it because other Missouri counties did not support girls' interscholastic sport teams.

This dichotomy became clearer to me after I entered college and discovered there were no athletic teams for women in college—only intramural teams—and I realized that college women from larger school districts who had not had experience playing competitive high school basketball had inferior skills compared with those of rural-school girls. We Cass County girls banded together to form college intramural teams and found it easy to win. Even so, because there were only basketball and softball teams for high school girls where I attended school, there was no opportunity to learn a wide variety of sports such as field hockey, soccer, swimming, track and field, tennis, and volleyball and become skilled in these sports until I entered college classes. I enjoyed learning these additional team sports, but I lacked the individual sport skill and finesse of classmates who had participated in private clubs or city recreation programs as high schoolers and those introduced to the additional team sports in high school physical education (PE) classes and intramurals.

When I became a high school girls' PE teacher in the Kansas City, Missouri, schools in the early 1960s, a wide array of sports was included in the school district curriculum and also sponsored by the Girls Athletics Association (GAA) intramural program where I taught. Still, the only interscholastic sports teams the school system sponsored were the occasional citywide Sports Days. My high school teaching assignment included being a sponsor of GAA intramural programs and several high school Sports Day teams, and these experiences assisted me in meeting the challenges of the unfolding decade ahead for girls and women athletes.

US Sports for Women in the Nineteenth and Twentieth Centuries

There were no intercollegiate athletics for women in my youth because sport in the United States before the mid-twentieth century was primarily a masculine domain. Playing ball in any free playtime was considered normal for boys growing up at the turn of the twentieth century, but adolescent girls were socialized not to compete in sports, or they might be labeled

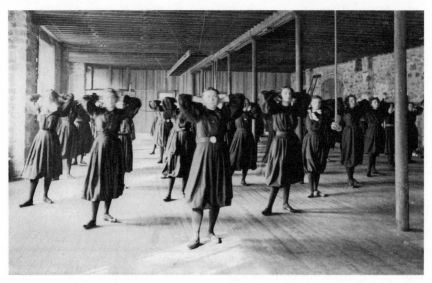

KU women in bloomers for posture exercises in old Snow Hall, 1893.

tomboys. Schoolgirls and college women did not have the same opportunities or encouragement to engage in school sports for more than fifty years into the twentieth century because they were purposely excluded from participating in interscholastic and intercollegiate sports.

As new sports were invented at the turn of the twentieth century, young women liked to try the new games, but they were restrained from vigorous sports competition by the women who planned and led sports in schools discouraging schoolgirls from playing the games between girls' teams in public.

The University of Kansas (KU) first offered college courses in 1866, more than a hundred years before it initiated intercollegiate athletics for women. Not many women attended college in the nineteenth century, but KU admitted women students from the beginning. The only woman in the first graduating class of four at KU was valedictorian in 1873.[1] No athletics were offered for women at KU until 1902, when KU women competed for one season in intercollegiate basketball with James Naismith, the inventor of basketball, as their coach.

In the last decades of the nineteenth century, wealthy American women with household servants often engaged socially in sports that were not too exerting, such as archery, badminton, croquet, golf, or lawn tennis, but they did not play men's rough, competitive sports such as baseball or football. Fashionable apparel of long hoop skirts with voluminous petticoats and tight bodices with corsets prohibited free movement and deep breathing

for women. Physicians believed that strenuous physical effort would dam-age women's childbearing ability and would cause women irreparable emo-tional trauma. When they cautioned against women engaging in extended physical exertion, the physicians whose women patients were wealthy and pampered likely never considered the rigorous activities of pioneer women, who had superior strength and endurance because they were more phys-ically engaged daily. Women from the social elite who had time to partici-pate in sports did not exercise for health and had not developed stamina to cope with physical exertion.[2]

In the nineteenth century, Ivy League universities—separate sister col-leges supported by Harvard, Princeton, Yale, and other elite colleges—were designed to train women to teach, be a nurse, or become a secretary for a businessman. Women students were trained and expected to wear appro-priate and fashionable attire and to demonstrate formal etiquette in society. Many other women of the nineteenth century were settlers on the frontier, busy operating their households, cleaning, cooking, raising children, and often working outdoors gardening and doing farm chores, so there was little or no time for sports. Few pioneer women attended college; that desti-nation was reserved for young men of wealthy families, whereas the young women were expected to marry well and raise a family.

Young college women in the nineteenth century took formal gymnas-tics exercise classes in which they were taught to move their arms, legs, and torsos to develop strength and posture. Lawn sports were restricted to leisure time.[3] Meanwhile, frontier girls played sports with their brothers until they lost the advantage of height and physical strength to compete and then turned their attention to learning household duties because they approached marriage at a young age.

Baseball, football, rowing, and track were all collegiate sports for men prior to the turn of the twentieth century. Intercollegiate rowing competi-tion began in 1852 between Ivy League colleges. Baseball was first played as an intercollegiate sport in 1859 among the Ivy League colleges, and when the game was taught to Southern prisoners in the Civil War by Union boys, it became the popular national sport soon after the war concluded. Football began as an intercollegiate sport in the Ivy League in 1869, and college men began to compete in track and field in 1873 at the Princeton Meet.[4] New sports were invented and developed in the last decade of the nineteenth century, and these sports were eventually taken up by women, although not as competitively as by men. Newly developed sports women played in the 1890s included basketball, bicycling, field hockey, softball, and volleyball.[5]

The 1890s were the peak of a bicycle craze that brought active participation for women, but riding a two-wheeled cycle required straddling the bar between the front and back wheels. Pantaloons, seen being worn by Iroquois women by suffragists in New York, were the solution for women who wanted to ride a bicycle. Amelia Bloomer had created a biweekly newspaper in the mid-nineteenth century called *The Lily*, and she used it as a platform for women's rights and social reform. She was most influential in dress reform: she advocated that women should wear such pantaloons under a short skirt to allow for greater movement, and the publicity her newspaper created caused them to be called "bloomers."[6] The bloomers allowed women to be free of corsets, hoops, bustles, and extra petticoats under their skirts, and with more freedom of movement they could engage successfully in more vigorous sports. A long-sleeved blouse and long skirt with bloomers were the expected apparel for college women engaging in movement exercise classes so that their legs and arms would not be indecently exposed. In 1895, suffragists Elizabeth Cady Stanton and Susan B. Anthony claimed the bicycle would inspire and emancipate women to transform their lives with new freedom and independence.[7] They were right.

Introduction of New Sports

As the Industrial Revolution unfolded in the late nineteenth century, new sports were invented. In 1887 George Hancock, while waiting with friends in a boat clubhouse on Lake Michigan for scores to be telegraphed to Chicago about a Yale versus Harvard football game, fashioned a "soft" ball from a boxing glove, drew an indoor diamond on the wood floor in chalk, broke a broomstick for a bat, and started a new game called "ladies' baseball" or "kitten-ball." The game was later played outdoors with a larger ball, a thicker bat, shorter baselines, and a shallower outfield than those of baseball. It was renamed "softball" in 1926. Softball was associated with women because it was considered a less vigorous sport than baseball.[8]

Late in the nineteenth century, physical conditioning coupled with sports became popular among young men because of the influence of the Young Men's Christian Association (YMCA) colleges opening across the country.[9] Exercising without external motivation was tedious, and the young men enrolled at the YMCAs grew restless in winter without some type of sports competition. Young men turned to their own roughhousing in the gymnasium, and it was important to offer organized exercise programs to prevent unruliness and potential injury. The superintendent of the YMCA at Springfield

College in Massachusetts, Luther H. Gulick, asked his faculty to develop a new ball game to be played indoors by the young men in winter classes.[10]

In December 1891 James Naismith, a Canadian graduate student teaching classes at the Springfield College YMCA, created a new team game for college men that could be played indoors. Because an indoor game would be restricted in space, running could not be a part of the game, and to eliminate roughness, tackling other players could not be included. In formulating the rules to his new game, Naismith thought of the skill required in his boyhood game in which a hand-sized rock was tossed to knock a target rock off a large boulder. The accuracy of the throw was more important than the force of the throw.[11]

The original game Naismith created had thirteen rules typed on two pages and hung on a bulletin board in the YMCA gym. The object of the game was for each team to attempt to score by tossing a soccer ball into a peach basket Naismith had hung at each end of the gym at the height of the balcony floor, exactly ten feet above the gym floor. He used peach baskets because they were large enough to hold a soccer ball and readily available from the school janitor. Two teams of players competed: the team with the ball attempted to score on offense, and the opposing team defended its own goal. The playing floor dimensions for the new game were the same as those of the Springfield College gym, and the rules forbade rough play by calling a foul on any player running into an opponent, with the penalty being his team's loss of the ball. This new game was called *basketball*. Soon, the bottom of the peach basket was cut away, and a backboard was constructed behind the rim of the basket to eliminate the need for someone to retrieve the ball each time it landed in the basket or was shot too vigorously into the balcony. The new game of basketball rapidly became the most popular indoor game for young men as well as for young women in college.[12]

Naismith brought his game to KU in 1898, when President Francis H. Snow (later to be called the chancellor) appointed him as the new university chaplain and PE professor. Naismith, who held doctor of divinity, doctor of philosophy, and doctor of medicine degrees, was promoted to the position of university physician and chair of the Physical Education Department in 1907. With the exception of a leave of absence to serve as a US Army medic and chaplain in the Mexican Border War and World War I in France from 1915 to 1919, Naismith remained a KU faculty member until his retirement in 1937.[13]

Naismith's careerlong presence at KU ensured that the campus would henceforth be recognized as the "cradle" of basketball. The original two

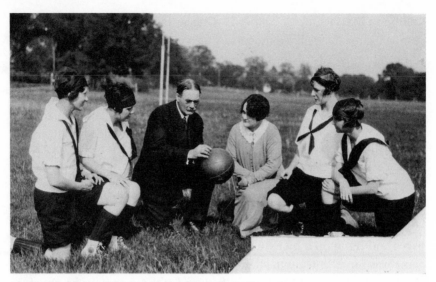

James Naismith coaching the KU women's basketball team, 1902.

pages of basketball rules are now enshrined in a visual vault on the KU campus, the basketball court at KU bears Naismith's name, a statue of Naismith holding a basketball commemorates him outside the Allen Fieldhouse, the street in front of the fieldhouse is named for him, and he was buried in Lawrence's Oak Lawn Cemetery in 1939.

The year after Naismith invented basketball, Senda Berenson at Smith College for Women in nearby Northampton, Massachusetts, contacted him to inquire about his new game because she wanted to teach basketball to college women. After watching the college men play, she determined that the game would be too exerting and physically rough for women, so she adapted the original rules for them by dividing the court into three equal parts—a center court and a court adjacent to each basket—with two players assigned to remain in each one-third of the total court, so that each team had six players. These rules limited the amount of court space on which women could play and avoided crowding on the court, curtailing opportunity for roughness. Her 1893 adaptation of the game included holding the ball for less than five seconds and not touching the ball when another player was holding it. Her rules allowed only one dribble before a player passed the ball or shot a basket.[14] In 1892, the first women's extramural sport competition in higher education was a women's basketball game between Stanford University and the University of California–Berkeley on the Golden Bears campus, which Stanford won, six to five.[15]

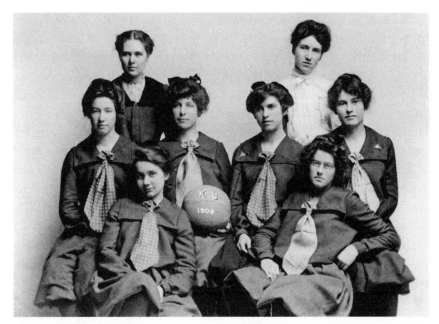

KU women basketball players, 1902.

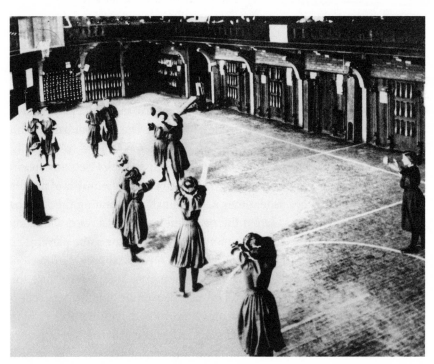

Women playing three-court basketball in old Robinson Gym, 1910.

The change in college women's rules from a three-court basketball game to a two-court game came in 1938. That same year, Amateur Athletics Union (AAU) women's basketball rules provided for one roving player to cross the center line and run the entire length of the floor, so that one player of the six on each team could play both offense and defense. The roving-player rule changed women's basketball from a three-player offense/defense to a four-player strategy. Possession of the ball meant that the team's rover became a fourth offensive player, and she was defended by the opposing rover as a fourth defensive player. Girls' and women's rules for high schools and colleges retained a six-player game, with three players on each end of the court, until 1962, when the Division of Girls and Women in Sport (DGWS) rules also permitted a roving player. In 1964–1965, the AAU and the DGWS agreed on a set of rules for women's basketball with the roving player; even so, in Iowa, the three-on-three-player, two-court girls' high school game remained because of its popularity there. Just seven years later, the DGWS enacted experimental basketball rules for a full-court, five-player game that became the standard rules for girls and women in 1971.[16] As with the men's game, the women's game became very popular in colleges, and basketball became women's primary sport as well during the indoor season.

Soon after Naismith invented basketball, in 1895 Springfield College YMCA graduate William Morgan introduced another new indoor game at the Holyoke YMCA (just fifteen miles north of Springfield College) that he called *mintonette*. For this sport, he strung a tennis net across the center of the gymnasium at six feet, six inches off the floor at the center top, just above the height of the average male player then. He marked a playing area of thirty feet by thirty feet on each side of the net. The original ball was an inflated rubber bladder of a soccer ball, but it was too large to volley easily, so a smaller, leather ball was constructed by the Spaulding Company specifically for this game. Originally, each team distributed any number of players on either side of the net, where they kept the ball from hitting the floor by batting it with their hands across the net to the opponent's court within six touches, with no more than two sequential touches by the same player. The first game was played at a conference for YMCA physical training directors at Springfield College, where the game was renamed *volleyball* because the main purpose of the game was to volley the ball over the net. By 1916, volleyball had become so popular that its rules were refined. Only six players were designated to play on each side of the net. After the ball was served across the net, three opposing players per team were permitted to volley the ball once each before it was required to cross the net. Scoring occurred when the

serving team was successful in batting the ball to the floor inbounds on the opponents' side of the court, but if the serving team allowed the ball to fall to the floor on their own court, they lost the serve and their opportunity to make points, and a "side-out" was called to give the serve to the opposing team.[17]

Women enjoyed volleyball because it was less vigorous than basketball; it required less movement around the court, and no physical contact with players on the opposing team was expected. Volleyball for girls and women was a recreational game played mostly in schools. Three rows of three players on the court were positioned so that more girls could play the game at once. Girls' rules for volleyball allowed two sequential hits per player, so that less-skilled players could gain control of the ball, and three different offensive players were allowed to touch the ball before volleying it to the other side of the net. These rules permitted each team to hit the ball between three to six times before sending it over the net. The early girls' rules disallowed reaching over the net to block opponents' hits. Girls were taught an underhanded serve to provide the greatest control and acceleration of the ball so it would reach the opponents' side of the net, and a player on the serving team could boost a short serve over the net with an assisting hit.

In 1939, the United States Volleyball Association (USVBA) rules were introduced internationally during World War II because soldiers played by these rules in other countries, and the game became popular throughout the world. In 1947, the Fédération Internationale de Volleyball (FIVB) was founded in Paris, and the international FIVB rules were used in the 1964 Olympics for volleyball, allowing only three hits on each side of the net and only one hit per player unless defending a blocked ball at the net. These same rules were adopted by the USVBA. Overhand serves, running spikes, double blocks, and digs were introduced as new volleyball skill techniques. The DGWS rules for college women were slow to follow international rules, but as the skill levels increased and national championships were introduced, the DGWS adopted USVBA rules, too. In 1998, the FIVB rules adopted the rally scoring system, in which either team wins points by hitting the ball to the opponent's floor regardless of which team served. The end score of each set was increased from fifteen to twenty-five points; three of five sets wins the match. The USVBA and National Collegiate Athletics Association (NCAA) now use the rally scoring system for national volleyball championships.[18]

Basketball and volleyball were new indoor sports girls and women enjoyed playing at school and in college without spectators. These sports offered alternatives for young women from dancing and movement exercises for body conditioning and posture. But in the early years, women students

were restricted to exercising and playing sports in a closed gymnasium, wearing long skirts and bloomers, because their faculty mentors considered this appropriate etiquette and adherence to feminine modesty.

In 1901, Constance M. K. Applebee, an avid field hockey coach in England, visited Bryn Mawr College in Pennsylvania and introduced the British sport to American college women. Field hockey caught on as a popular outdoor fall sport for women when college men were playing football. It was played on an outdoor field the same size as a football field, with the offensive team using curved wooden hockey sticks to dribble a smooth, hard, rubber ball the size of a baseball toward the opponent's goal, while the defenders attempted to divert the ball by tackling the dribble with their sticks, retrieving the ball, and changing the direction of the attack. Field hockey goals were scored by striking the ball past the goalkeeper and other defenders into goals seven feet high by twelve feet wide and four feet deep at each end of the field. Field hockey kilts have endured as the appropriate uniform for the sport since its beginning in the United States. Field hockey caught on rapidly in the women's private schools in the Northeast and remains a main sporting event on the East Coast for college women.[19]

Athletics Governance in Twentieth-Century Intercollegiate Sport

At the turn of the twentieth century, intercollegiate athletics were organized and scheduled by men students at each institution. College football became physically rough and rowdy; intercollegiate contests were corrupted by heavy outside betting on the outcome of games; and, too often, players who were not college students were recruited for intercollegiate teams. Violence and injuries occurred on the field when teams resorted to physically damaging tactics to defeat opponents. This prompted President Theodore "Teddy" Roosevelt to call college football coaches, faculty, and representatives from Harvard, Princeton, and Yale to the White House in 1905 to assert that although sports competitions were desirable to build physical toughness, masculinity, and leadership in young men, intercollegiate football would be outlawed across the country unless the associated violence and exploitation were controlled by college administrators. The result was the formation in 1906 of a national athletics governing organization for college men at a New York conference of college administrators; in 1910 it was named the NCAA. It still controls collegiate athletics.[20]

In the early 1900s, as competitive sports for women and interest among the athletically gifted ones increased, women college leaders recognized

the need for an athletic governance organization for women. They watched men's intercollegiate competition become less amateur and more professional and commercialized with outside business influences and rising ticket sales for games. Women educators noted that the AAU women's basketball teams were coached by men, and they believed these women athletes were exploited when their teams had to play in flashy, brief uniforms to attract box-office sales. Women PE faculty in colleges were intent on avoiding the exploitation exposed in intercollegiate men's competitive sports, and they sought to control outside influences. Women's organizations for governing sports competitions for girls and women were established early in the twentieth century, and several of them maintained tight control of women's intramural sports for the next fifty years.[21]

Unlike the 1910 development of a single, national, athletics organization for college men, in which administrators established unifying control collectively among institutions, women educators took the initiative themselves to organize women PE leaders to monitor and control women's athletics. Within the first two decades of the 1900s, four national organizations for women's athletics were established with the intent to control sport programs for women and girls inside educational institutions and to protect young women from outside exploiting influences.

Two of these national women's governing organizations were formed in 1917. Twenty-three student presidents of college women's athletic associations organized the Athletic Conference of American College Women (ACACW) to coordinate college intramural and extramural sports to be affiliated with the PE departments on each campus. Simultaneously, the American Physical Education Association (APEA) appointed its Committee on Women's Athletics (CWA) to establish standardized rules and procedures for conducting women's sports.[22]

Soon, two more organizations to protect women in college athletics were formed. In 1923, the National Amateur Athletics Federation (NAAF) founded its women's division (NAAF-WD) as an alternative to the AAU to represent women athletes for Olympic competition. In 1924 directors of college women's PE programs developed the National Association of Physical Education for College Women (NAPECW) to control women's PE curricula and sports opportunities and enforce the policies of women's sports organizations specifically at the college level. The ACACW and the NAAF were institutional membership organizations, whereas individual women could join the CWA and the NAPECW. Because many of the same women PE directors led these four women's organizations and supported

the overall philosophy of constraining women's competitive sports to avoid exploitation, they reinforced the curtailment of sports opportunities for college women.[23]

Nationwide restrictions on women engaging in competitive sports began in 1926, when the NAAF-WD held its first national conference, at which sixteen resolutions were approved for women's varsity sports competitions to be controlled only by women. They created the slogan "A sport for every girl, and every girl in a sport." The organizational philosophy indoctrinated women to believe that girls and women should "play for play's sake," not for developing or enhancing sports skills of female athletes. The CWA supported this philosophy, creating a dearth of intercollegiate sports competition for women from the 1920s until the late 1960s.[24]

Between 1917 and 1967, when women's intercollegiate sports were restrained in favor of sports opportunities for "all," the number of secondary-school girls and college women participating in intramural sports (as opposed to varsity sports) surged, but few intercollegiate women's sporting events were planned. Secondary-school athletic competitions for girls had been more prevalent in the 1920s when small rural schools supported girls' varsity teams in basketball and track and field, and half of the states had some form of organized interscholastic sports competition for girls.[25] However, in 1925, the National Association of Secondary School Principals had passed a resolution to eliminate girls' varsity sports teams and tournaments, causing twenty-one states to drop statewide girls' sports competitions. States such as Iowa and Oklahoma continued their statewide tournaments for girls' basketball, but secondary-school girls in most states were relegated to participating in intramural sports. The GAA and Women's Athletics Association (WAA) intramural programs were the primary sources of sports engagement for girls and women in educational institutions during the mid-twentieth century.[26]

Intramural Sports, Playdays, and Sports Days for Women

From the 1920s through the 1960s, large intramural programs for women were developed on college campuses, and the local WAA programs became affiliated with the national organization called the Athletic and Recreation Federation for College Women (ARFCW). First known on campuses as the WAA and later as the Women's Recreation Association (WRA), these organizations were governed and administered by women students to provide for their intramural sports competition on the campuses. In secondary

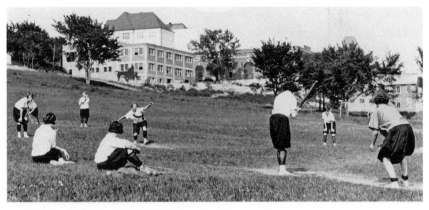

KU Women's softball game played below old Robinson Gym, 1925.

Old Robinson Gymnasium, outside corner from Jayhawk Blvd, 1930s.

schools, similar programs were organized as GAA programs, with female
PE teachers as sponsors.

With the intent of teaching a variety of sport skills and game rules but
downplaying competition, secondary schools and colleges introduced the
"playday" in the 1920s. Intramural sports and occasional extramural play-
days were accepted as appropriate intercollegiate competition for women.
Surveys taken during the 1930s and 1940s revealed that about 80 percent
of colleges sponsored extramural playdays for women athletes. The sur-
veys indicated that participation and competitive status of girls and women

involved in school-sponsored sports changed very little, but there was some interest in allowing skilled athletes to compete at other colleges in club sports competitions. Playdays afforded opportunities for girls and women to engage in sports without the peril of exploitation imminent in intensive competition. Playdays were the primary opportunity for girls and women to compete in sports with players from other schools and colleges.[27]

Playdays were invitational, one-day sporting events in which secondary-school girls in urban schools or college women were invited by nearby host institutions to participate in one or two of several sports offered. Athletes did not arrive as a school team but participated as individuals organized as a team only for that day's sporting events, so that girls or women could be with players from several other schools or colleges. The object was to engage in sport as a social occasion, and often, players had teammates they had never met previously, but team membership lasted only for the day or for the game. Women PE faculty members were assigned as sponsors of the playdays. Usually games were not played to completion or scores recorded because the purpose was "play for play's sake," not winning a competition. The PE faculty planned social gatherings with participants in street attire and sharing refreshments at the conclusion of the playdays to reinforce the philosophy of sports as recreational and social rather than as fierce competition.

After World War II, Sports Days began to replace playdays for college women. Sports Days were scheduled by a majority of colleges from the mid-1940s through the mid-1960s, at which the host institution invited women's intramural sports teams from several institutions to play a given sport on a specific date.[28] Urban high schools followed, changing interscholastic sports competition from playdays to Sports Days. The Sports Day was a step beyond the playday toward skilled sports competition. Usually, only one or two sports were played at a Sports Day, as compared with several sports at playdays. Social refreshments still followed the games, but the more talented and skilled athletes at the participating institutions competed in the Sports Days. Little or no fitness training and not much coaching was included for the girls and women participating in Sports Day teams because the host institution did not announce a Sports Day earlier than a few weeks in advance, and women faculty sponsors appointed to accompany the teams were announced when decisions for the institutions to participate were made. Secondary schools and colleges accepted Sports Day invitations when the date and distance allowed students to travel without missing classes.

Sports Day teams at both the high school and college levels were selected and accompanied by women faculty sponsors expected to chaperone

KU field hockey players, 1925.

KU women in old Robinson Pool, 1950.

but not coach. Women who served as Sports Day sponsors were assigned the extracurricular responsibility as a function of their faculty assignment, without extra pay. Women PE faculty of the 1930s through the early 1960s rarely had competitive sports participation experience themselves, and none had a coaching background. Male coaches were not acceptable for

college women's teams, and men generally were not interested in voluntarily coaching women's Sports Day teams.

Ohio State University undertook an experiment in intercollegiate competition in 1941, when Gladys Palmer invited college women golfers to compete in a national invitational tournament. Other than during a few of the World War II years, the annual golf event continued unchallenged, and in 1967 the Commission on Intercollegiate Athletics for Women (CIAW) sanctioned it as the DGWS National Golf Championship.[29] However, other sports were not acceptable for intercollegiate competition for women until the end of the 1960s.

KU Women Faculty in Physical Education
Before Intercollegiate Sports

KU women PE faculty members were the force behind the highly regarded KU women's PE graduates. Although these early women PE faculty had the academic curriculum as their first obligation, they also contributed to competitive sports for women on campus.

The first KU women faculty appointed to teach "physical culture" courses for women students included (with years at KU): May Clark-Pierce (1893–1898), a Harvard graduate; Cora McCullom-Smith (1898–1903); and Mary Fish (1903–1911). In 1902, KU organized a women's intercollegiate basketball team coached by Naismith. The women's basketball schedule that year included Baker University, Haskell Indian Institute, Ottawa University, the University of Missouri, and Washburn University, but no scores were recorded. This team existed only one year, according to an early *Jayhawker* yearbook.[30]

KU first sponsored intramural and extramural sports for women in 1912, with PE instructor Hazel Pratt (1912–1920) as advisor. The WAA at KU approved a constitution in 1915 to promote women's sports and encourage women to participate in them. Student members of WAA were awarded points for participating in sports or other types of WAA activities, which led to them earning KU sports "letters." In 1920, in support of the 1917 CWA and NAAF proclamation, the Central Sectional Conference of American College Women, in which the KU WAA held membership, announced, "Women may not take part in intercollegiate athletics." In 1923, Margaret Barto, an assistant PE instructor at KU, declared, "Women are not ready for competitive athletics." She later interpreted her remarks as meaning that college women should refrain from "more strenuous sports

such as basketball, football, and volleyball" because they "could not stand the nervous strain that the athlete is obligated to undergo."[31]

Ruth Hoover became the KU faculty advisor for WAA when she was hired as a PE instructor in 1922. She remained WAA/WRA advisor throughout her tenure at KU. A full-time PE faculty member, Hoover had served as the intramural and extramural faculty director for women as an extra assignment for more than forty years when she retired at KU in spring 1966. Although Hoover did not press for intercollegiate sports for women, the women's intramural sport programs on campus at KU thrived under her leadership. More than a thousand women participated in intramural sports annually during her tenure as WRA advisor.[32]

As with other college campuses across the country, the WAA at KU administered annual May Day playdays for high school girls from a number of schools from the 1920s until the late 1940s. The WAA also sponsored the annual KU Quack Club's synchronized swimmers' performance; the KU Circus, featuring acrobatic performers of both genders; and the Jay-Walk Dance, to which women students invited dates. During the 1950s and early 1960s, intercollegiate competition opportunities for KU women advanced to be occasional Sports Days with teams competing in basketball, field hockey, softball, and volleyball.[33]

In the mid-1960s, club sports were initiated by KU women students, similar to the recreational extramural club sports in which KU men participated. That is, when the KU Athletics Department did not offer these sports in the varsity program, but when there was sufficient interest from college students who had honed a particular sport skill in high school, they formed a team, found a volunteer coach, and informally scheduled competition with other colleges with club registration and approval of the KU Student Senate. KU women students fielded teams in basketball, field hockey, softball, and volleyball as club sports during the 1960s and competed against nearby colleges. KU club sports as women's extramurals served as a bridge toward intercollegiate sports, but not until 1969 did KU women have an opportunity to participate in organized intercollegiate sports approved by the university.

Influence of the Olympics on Women's Competitive Sports

The modern Olympics began in 1896. The AAU was formed in 1888 to establish standard rules for amateur sports, encourage sports competition outside of school in the United States, and foster the development of male athletes for the Olympics. The AAU was the US representative to the international

sports federations until after the turn of the twentieth century.[34] After the NCAA was formed in 1910, it nurtured a half-century feud with the AAU, which began over the selection, training, and international representation of amateur athletes for the Olympics. Each organization aspired to control amateur sports in the United States and become the US representative for the Olympic Games, but the NCAA had no jurisdiction over female athletes because it controlled only sports competition for college men.[35]

The first Olympic events opened to women were croquet, equestrian, golf, sailing, and tennis in 1900 at the Paris Games. Later, archery (1904) and ice skating (1908) were allowed because the competitions could be performed in long skirts. Women's swimming was accepted by the International Olympic Committee (IOC) for the 1912 Olympic Games, but the AAU did not sponsor female swimmers because of objections to the exposure of women's bodies. Women leaders within the APEA formed the CWA in 1917 to create standards for women's sports competitions and to protect women athletes from exploitation by controlling and limiting highly skilled sports competition for girls and women in schools.[36] After World War I, Olympic rules were amended, and fifteen American women competed in the 1920 Olympics in five swimming events and won four, firmly establishing swimming as an accepted Olympic event for women.[37]

Two years later, the AAU accepted an invitation for US women to enter an international track meet in Paris. This action resulted in a joint protest in 1923 by the CWA and the newly formed NAAF-WD against the AAU having control over women's amateur sports. The protest led to the 1926 NAAF national conference on women's sports participation, led by Lou Henry Hoover, wife of Secretary of State Herbert Hoover. Leaders at this Washington, DC, conference opposed women's entry into future Olympics, and the CWA joined in publishing resolutions to control sports participation for females as a broad-based amateur program only for all skill levels, including sports competition for girls and women at all educational levels, effectively discouraging women from developing elite sport skills.[38]

Women were first allowed in track-and-field events at the 1928 Olympics, and the AAU sponsored eleven women competitors in the 800-meter race. Five of the US women dropped out of the race, five collapsed on the track during the race, and the one that finished fainted in the locker room after the race.[39] After the 1928 Olympic debacle, the CWA and NAAF-WD insisted to the IOC that women's track and field not be included in the 1932 Olympic Games because women chosen by the AAU were not trained for elite competition, could not compete well, and were being exploited. The

IOC did drop the women's 800-meter race but added the 80-meter hurdles, high jump, and javelin throw for women for the 1932 Olympic Games.[40]

A few elite women athletes trained on their own in spite of the edict against women competing and became Olympic stars. Babe Didrikson, sponsored by a Dallas athletics club, was a young track-and-field athlete who qualified for Olympic events in 1932, and she won gold medals and set records for women in the 80-meter hurdles, high jump, and javelin. Didrikson's commercial popularity following the Olympics caused women PE leaders to be even more concerned about exploitation of girls and women in sport and continued to discourage Olympic sports participation for American women after World War II.[41] Forty years after the IOC initially dropped the 800-meter race, Madeline Manning-Mims was the first American woman to win a gold medal in the women's 800-meter race, at the 1968 Olympics. Wyomia Tyus won golds in the 1964 and 1968 Olympic women's 100-meter race. Both women had the same AAU male track coach at Tennessee A&M University.[42]

Beginning in 1929, the AAU Women's National Basketball Championship began for women's AAU teams sponsored through community recreational leagues. In 1931, Didrikson led her team to win this tournament, and other women who loved the game developed their skill in AAU community basketball leagues coached by men.[43] For years, the AAU National Women's Basketball Championship was held in St. Joseph, Missouri. There were no other national amateur sports championships for women during the first half of the twentieth century, although the AAU offered some regional sports competition for women in areas where specific sports were popular, especially Olympic sports open to women.

Opportunities for women to compete in elite-level amateur sports came mostly in commercially sponsored leagues, not in secondary schools or colleges. Women industrial workers during World War II played on such AAU teams during and after the war, giving highly skilled athletes opportunities to play competitively. The All-American Girls' Baseball League began in 1943 for women aged eighteen to twenty-five to play on teams in midwestern cities, as a "substitute" sport while professional male baseball players were away at war, and it lasted ten years, but support for these teams wavered when televised professional men's sports expanded after the war.[44]

Although the IOC added some individual sports for women to the Olympic Games after 1900, it approved women's team sports only much later. Women's volleyball was introduced in 1964, women's basketball more than a decade later in 1976, and women's field hockey in 1980. Softball became an Olympic sport in 1996, was discontinued after the 2008 Games, and

was reinstated for the 2020 Games.[45] With more women participating in highly skilled sports in school and community recreation competition, the sociocultural stigma for women athletes was easing. The US civil rights and feminist movements in the 1960s also supported the notion that women could compete as successfully as men, given fair regulations and the opportunity to engage.[46]

The fifty-year dark age of restricted intercollegiate sports competition for women would transform into a revolutionary new age during the 1960s. Young women athletes were eager and ready to compete in amateur sports at the elite Olympic level, and women coaches would be trained to support them. It was a fortunate time for me to be a young educator beginning a sports career because women's competitive sports were moving into a bright new world of opportunity.

The National Olympic Development Sport Institutes for Women

Few American women competed in Olympic events during first half of the twentieth century, both because they were not prepared for world-class sports competition and because there was little financial or sociocultural support. Following DGWS national leadership conferences in 1955, 1958, and 1962, the organization changed its principled stance against women's elite sports competition, approved extramural competitive sports participation for high school and college women athletes, and endorsed women's Olympic sports competition as a valuable experience.[47]

With the political push in the early 1960s toward US success in Olympic competition, new opportunities for skilled women in sports came through the US Olympic Committee's (USOC) actions. In 1956–1957, the DGWS was represented on the USOC Women and Sports Working Group for the first time, and the Women's Advisory Board was established within the USOC's Olympic Development Committee. The committee was charged with enhancing women's competition in the Olympics and collaborated with the DGWS to initiate national sports institutes for women PE teachers and coaches in the 1960s.[48] Neither the NCAA nor the AAU were included in planning or conducting these institutes.

The Olympic Development Committee established a major goal with the DGWS of sponsoring these institutes to train participants in Olympic-level coaching strategies along with what to expect from officials and judges of Olympic women's sports. These institutes proved to be the predecessor for the explosion of women's intercollegiate sports competition in the 1970s.[49]

The initiative began in March 1961, when DGWS consultant Rachel Bryant met with the Olympic Development Committee chair to consider the institutes, to be sponsored jointly by the USOC and DGWS between 1963 and 1969. In December 1962, DGWS leaders were informed that the Women's Advisory Board of the USOC had approved in principle a series of institutes for US women PE teachers.[50] With Bryant and three other women leaders, DGWS president Kathryn Ley and DGWS president-elect Phebe Scott formed a steering committee in February 1963 and collaborated with the Olympic Development Committee to plan for five institutes during the 1960s. One member of that committee, Sara Staff Jernigan from Stetson University in Florida, was named chair of the Women's Advisory Board from 1961 to 1969, and she served as director for the five national sports institutes.[51]

For these Olympic institutes, states were asked to send one or two participants for each of two sports and one generalist to interpret and convey the philosophy of the institute at subsequent state workshops. Each state was to select representatives by reviewing the applications of women PE instructors at the high school and college levels and gain their commitment to share the coaching skills they gained. State DGWS leaders notified the national DGWS office of their selected representatives, and institute registration forms were forwarded to these educators. Each participant returned her registration form with a $100 entry fee to the DGWS to cover the expenses of dormitory housing and food. Most representatives paid the fee voluntarily from their personal bank accounts, along with their transportation to the event, because no local organizational funds or educational budgets for such expenses existed.

Universities hosted each institute and offered venues for the workshops on the featured sports, conference rooms for presentations to the representatives, and lodging facilities for 250–300 participants, administrators, and coaches. The instructors of the institutes were the women's US Olympic coaches for the previous Olympics in those sports. Institute participants then became presenters at coaching workshops in their home states. They invited women PE educators from surrounding secondary schools and colleges, and in turn those participants were asked to give workshops at other locations across that state at which they would pass on the coaching instruction. With the committed work of these representatives after completing their institutes, new information about advanced sport skills and coaching strategies spread rapidly across the nation, and interest in women's intercollegiate sport competition was ignited.

The University of Oklahoma hosted the first of these national institutes, in October 1963, focusing on women's gymnastics and track and field.[52] As representatives to the initial institute, most states selected women PE administrators with the greatest seniority in their secondary schools and colleges. These women were in the prime of their educational careers but had never had much opportunity to gain experience playing sports, let alone advanced skills. Their aspirations were those of advanced administrators, but although they might not have been in the best physical condition to participate in a hands-on institute, they returned and conducted productive coaching strategy workshops across their states. However, they also recommended that younger women be selected for these Olympic institutes henceforth.

Michigan State University, in Lansing, hosted the second institute, in February 1965, and featured swimming, diving, rowing, and kayaking.[53] This time, younger representatives were selected to participate, and they came back to their home states eager to offer coaching tips to their colleagues. In subsequent Olympic Games, the US women aquatics athletes gained significantly in competitive placement.

In January 1966, the third institute was held in Salt Lake City, Utah, where the state representatives learned coaching skills for winter sports.[54] Participants learned from US Olympic competitors to coach figure skating at the Hygeia Iceland Skating Rink, and others learned to coach slalom and downhill racing and tobogganing at the Alta, Brighton, and Park City Ski Areas. In later Winter Olympic Games, similar improvements for women skaters, skiers, and sledders were soon realized.

The University of Indiana hosted the fourth institute, in December 1966, focusing on power volleyball and rover basketball.[55] For the first time, women PE educators and coaches learned about coaching volleyball using USVBA rules, along with the skills of overhand serving; spikes initiated from the spiking line; multiple-player blocking; defensive digs, dives, and rolls; and serve-reception placement strategies. I was selected as a Missouri basketball representative to the fourth institute. Between 1938 and 1962, DGWS basketball rules required three players to be either on offense or on defense on one half of the basketball court. AAU rover basketball rules were accepted by DGWS in 1962, dictating the four-player strategy taught at the institute: one player on each team was allowed to cross the center line to follow play to the baskets at both ends. With coaching workshops rapidly spreading new information across the country, college women athletes gained immensely in their volleyball and basketball skills.[56]

The University of Illinois held the fifth institute, in January 1969, the last of the coaching enhancement series. Again I was chosen as a basketball participant, but this time representing Kansas because I had been appointed a faculty member at KU. The advanced basketball coaching institute was planned in anticipation that the five-player rules would be adopted for 1970–1971, affecting the entire game strategy for women's coaches. The rover basketball rules were used for only eight years; then the rule change would require new coaching strategies. Women had demonstrated as rovers that they had sufficient cardiovascular endurance to run the entire basketball court, and by 1971, five-player rules became official for women's basketball, with unlimited dribbling and a thirty-second offensive shot-clock limit to take a shot that would hit the rim, unlike the ten-second requirement in men's rules for the offense to cross the center line from the backcourt but without a thirty-second requirement to shoot. (The men's rules changed to include the thirty-second shot-clock limit in 1985.) Also, at the fifth institute, training for judging gymnastics, officiating basketball, and officiating track and field was included.[57]

Evening keynote speakers at the Olympic institutes focused on the nuances of sociocultural obstacles women who wished to compete in intercollegiate sports faced. The speakers introduced the idea of national intercollegiate sports championships for women and explained the interaction between the AAU, the DGWS, and NCAA regarding philosophies of conducting women's athletics. The speakers included DGWS leaders who cohosted the institutes with the Olympic Development Committee along with committee board members, Olympic coaches, and a nationally renowned woman gynecologist who eschewed the nonsense that engaging in strenuous physical activity during menstrual periods was a threat to the childbearing ability of young women. The speeches were designed to provide participants a vision of what women's intercollegiate athletics could become on a national scale, without the exploitation found in men's athletics. The evening sessions were a mix of information and inspirational pep talks.

Between the fourth and fifth institutes, DGWS leaders were contemplating how to initiate guidelines for women's intercollegiate sports competition that all colleges nationwide would accept as universal regulations. Communication between the DGWS and NCAA leaders had confirmed that the NCAA was not interested in women's intercollegiate sports competition. In 1966, the DGWS appointed the three-person CIAW to formulate qualifications for national women's intercollegiate sports competition and to sanction national championships. The CIAW wrote the guidelines for

governance of these championships, which the DGWS published in 1967. In December 1967 the DGWS announced at a live press conference in Washington, DC, that national championships for college women athletes would begin in 1969 and repeated this news in its professional publication in February 1968. In April 1968, President Scott explained to DGWS members attending the AAHPER National Convention the educational principles the CIAW commissioners used to formulate the guidelines for the national championships.[58] The DGWS announcement prompted the establishment of women's intercollegiate athletics programs in most higher education institutions across the nation beginning in fall 1968.[59]

Historian Joan Hult wrote that Ley and Scott were the most outspoken, assertive, and influential of all leaders in founding women's athletics nationally. Ley was the steady and reliable 1962–1964 DGWS president and the first CIAW chair in 1966. Hult credited the CIAW as being the brainchild of Scott. After serving as 1962–1966 DGWS presidents, Ley and Scott were two of the three original CIAW members who formulated the standards for women's national sports competition.[60]

By the time the fifth Olympic institute was held in 1969, national women's intercollegiate sports championships were already under way, and the CIAW had accepted bids for hosting championships for three more years. The institutes were perhaps most influential in enhancing women's opportunities to compete in intercollegiate sports because the many state workshops returning participants presented caused a dramatic swell of interest and women's coaching ability by the end of the 1960s. DGWS leaders understood that the legion of young women anxiously waiting to compete in intercollegiate sports similar to those their brothers enjoyed would not wait any longer. Still, some older women PE teachers had lingering objections based on their belief there were inherent dangers in offering programs similar to the men's intercollegiate sports governed by the NCAA. Therefore, the DGWS held a conference in June 1969 in Estes Park, Colorado, to guide women PE educators as they formed new intercollegiate sports programs at their institutions.

At the summer conference, women PE educators shared ideas and proposals about how women's intercollegiate sports could be subsidized on campus, within what institutional structure the programs could be administered, how women leaders would deal with recruitment of athletes, and what the eligibility regulations for student athletes and athletic scholarships would be. Veteran women PE educators firmly held the beliefs that exploitation of women athletes should be avoided. Thus, the standards for

women's national intercollegiate sports competition maintained that athletics budgets should be kept to a minimum and without consideration for scholarships, which meant no provisions for recruitment of athletes.[61] Within the subsequent decade, younger women entering the coaching field tested this philosophy as women students began to enjoy many more opportunities to engage in intercollegiate sports.

The 1960s set the stage for dramatic change for college women in sports. National women's and civil rights movements seeking equal rights, the national Olympic institutes, and the DGWS national sports championships led the way for the emergence of women's intercollegiate sports from their restrained past.

SPORT LEADERSHIP EXPERIENCE

The 1960s were opportune for young women to take advantage of the many changing cultural standards in the United States. It was especially an encouraging time for young women interested in initiating competitive sports for girls and women. I was in the right place at the right time, with fortunate educational opportunities and employment to fulfill my ambitions of a career in competitive sport.

Conditions that led to me developing sports skills and playing sports began long before I was born. I grew up in thinly populated Cass County in Missouri along the Kansas state line, where the rural schools fielded girls' sports teams just as they did boys' sports teams as extracurricular activities for students and entertainment for the community. The eight small school districts organized interscholastic competition seasons for two sports, basketball and softball. The communities strongly supported their home teams, and it was prestigious to play on a high school sports team.

The sparse population of these communities was a consequence of the "bloody border strife" between the Missouri Bushwhackers and the Kansas Jayhawkers along the Missouri-Kansas state line before the Civil War, resulting in the four border counties of Missouri south of Kansas City being evacuated to quell the conflict. After the war, land agents appealed to settlers from Northern states to purchase property in the vacated counties. My grandparents were among those from Illinois, Indiana, and Ohio who came to western Missouri after the war and settled in Cass County.

A Missouri Heritage

My grandfather Will Mawson was a first-generation American whose parents both immigrated from Yorkshire, England, settled in central Illinois in 1829 and 1831, married in 1837, and raised a family there. With ten siblings living in their two-room log cabin and an older brother returning home

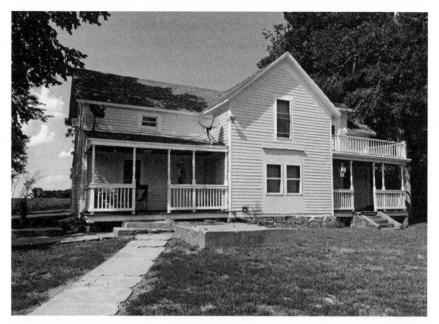

Mawson farmhouse, three miles from Archie, Missouri.

after serving with General Ulysses S. Grant in the Civil War, Will and his closest brother set off in the late 1870s to claim vacated rural property in Missouri along the Kansas border. The farmland became available when US Army Order No. 11 (1859) was nullified. Order No. 11 had required the evacuation of all residents in four counties along the Missouri border because of the "bloody border strife" after Lawrence, Kansas, had been sacked and burned. Many male citizens were killed by William Quantrill, leading a large number of Missouri marauders. When the Missouri-Pacific Railroad came through this part of Missouri in 1880, the town of Archie in was platted on 100 acres in Cass County owned by the family members of my other three grandparents, including the Tillisons, who had moved there in the 1870s from Indiana. Will married the oldest daughter of nine siblings from the Tillison family, Mary Bell, and became a prosperous farmer and cattle rancher in Cass County and neighboring Bates County. With his brother, Will also operated a farmer's grain business in Archie. Although his brother's family moved to Kansas by 1890, Will's four sons remained in Missouri to farm.

My dad, Chester Mawson, was Will's third son. While attending eight grades at the one-room Clay Hill School in a clearing named Dog Holler, he had little opportunity to play organized sports when farm chores, horses,

crops, and livestock were his priorities. His mother had wanted to be a schoolteacher, but in the late nineteenth century women were not certified as teachers. Even though she passed away before I was born, Grandma Mawson instilled the merits of being educated in her children and her oldest grandchildren.

In Cass County there were fewer than a hundred students enrolled annually in the eight school districts from the 1920s through the 1950s. Archie began offering two years of high school courses in 1913 in a town church building, and the districts formed the Cass County High School Athletics Association in 1915, which included both boys' and girls' teams. The eight small towns included Archie, Belton, Creighton, Drexel, Freeman, Garden City, Peculiar, and Raymore. My dad was twenty-eight years old by the time high school was offered in Archie. My mother did complete the two-year high school curriculum offered at the time.

Cass County School Athletics

Archie had a boys' basketball team at the high school as early as 1914–1915 and formed the first girls' basketball team in 1917–1918. The teams practiced and played their home games on an outdoor, gravel court beside the church. By 1917 the high school curriculum had increased to four years. When the town built the new, two-story, eight-room, red-brick Archie High School in 1919, a team of horses was used to grade two outdoor basketball courts. The Archie boys' basketball team won the first tournament it entered in 1923–1924, the first year the school financially supported a team.[1]

In 1929–1930, the first Cass County Basketball Tournament was held, which Archie boys won by defeating Harrisonville, a large school in the county seat. In 1931 Archie constructed a basketball court for the Archie High School teams in a building downtown. Workers laid a wood floor over the concrete foundation of the auditorium, hung a balcony for spectators over bleachers along one side, and built a stage at one end.[2] That same year, the town invited boys' teams from around the area to compete in the first Archie Basketball Tournament. The tournament was open beyond the conference teams to include larger schools such as Butler, Harrisonville, Pleasant Hill, and Raytown. The Archie boys' team won, and the town scheduled the first Archie girls' tournament the following year. From then on, the town alternately scheduled the boys' and girls' tournament games throughout each day of the now combined event.[3]

Mawson twins at home, 1945.

Archie had successful basketball teams and often played in tournament finals during the 1930s. Both the Archie boys' and girls' teams played in the championship games at the 1937–1938 Archie Basketball Tournament. Although the gym normally held 500 spectators, the town set up extra bleachers on the stage and positioned additional folding chairs along the court sidelines. A crowd of more than a thousand fans attended the championship games. Just before the Archie girls' championship game was over, the center iron rods supporting the balcony gave way, and the outer edge of the balcony suddenly crashed to the floor, spilling spectators onto the floor and crushing people sitting under it. My mother was sitting under the balcony with my youngest sister on her lap, and her kneecaps were broken. My oldest sister had been leading cheers along the balcony edge and was thrown to the center of the court below. Three other sisters were saving seats for adults on the stage. Miraculously, nobody was killed, but several were severely injured. The tournament finals were postponed, and later both Archie teams won.[4]

That was the last basketball game played in the downtown building. A new gymnasium with seating for 800 and a large inset stage at the side of the court were added to the Archie High School in 1938.[5] My second-oldest

Mawson twins in shorts, 1948.

sister played in the first Archie basketball game on the new home court, four other older sisters played between 1938 and 1949, and my twin sister and I played between 1954 and 1958. Like our five older sisters, my twin sister and I attended all twelve grades of school in the Archie Consolidated School District. Our senior graduating class had twenty-seven students, only one of whom lived in town. Basketball and softball were the only sports scheduled in the 1950s for interscholastic competition in the conference, and both girls' and boys' teams were included. The combined annual Archie Basketball Tournament has been scheduled on that court for more than ninety years now.

Cass County was an exception in hosting girls' competitive interscholastic sports between 1917 and 1967 because larger schools offered girls no such competitions. This restriction on girls' participation in interscholastic tournaments stemmed from national control of girls' access to sports competition from the beginning of the twentieth century. National women's organizations formed to protect girls and women from physical injury in sports, from commercial exploitation, and from the emotional stress of competition. In Cass County, the one physical education (PE) teacher for each school was male, and he was expected to coach both boys' and girls' teams regardless of the national edict by women PE administrators. I had

no idea that other girls in larger schools did not have the opportunities to develop the sport skills I did.

Athletics Opportunities at School

From the time I was a first grader, basketball intrigued me. Our whole family attended the home games when my older sisters played. The Archie High School girls' basketball players were my idols. My sister and her teammates rode on the same school bus I did every day. As a first grader, I boarded the school bus before the older students, and I saved seats for them. Their uniforms, red satin shorts and white satin blouses with red felt numbers, seemed regal, but the red satin warmup jackets with the word "Archie" stitched across the back and the long-legged warmup pants with zippers at the ankle were especially mesmerizing. Each player purchased white, canvas, high-topped Converse shoes with thick rubber soles and wore them with double white wool socks. As a grade-school kid, I watched

Marlene Mawson in Archie High School women's basketball uniform, 1957.

my older sisters iron their basketball uniforms at home and don them for a game. Courtside, it was fascinating to observe the high school players warming up for the game in two lines for layups, with the unzipped bell-bottomed warmups flapping around their ankles as they jumped for layups, rebounds, and jump shots. By the time we twins were in the fifth grade, our older sisters had all entered college or completed college and were teaching, but I had dreamed throughout my childhood of being a high school basketball player and wearing an Archie uniform.

However, softball was my best high school sport. In the second grade I began playing during recess on the boys' diamond at school because the girls my age were not skilled enough to throw, catch, or hit well and keep the game going. My great-uncle Sherman Tillison whittled a bat from a branch of balsam wood for me

Mawson barn, where Marlene hit fungos for practice.

when I was eight years old, making it short and light enough that I could handle it. Then, for a fourth-grade birthday gift, an older sister gave us twins a brand-new, official softball. So, as an elementary school farmgirl, after I had done my chores, I would hit fungos high against the outside barn wall and then try to catch the rebounds before they hit the ground. In good outdoor weather, I practiced hitting and catching repeatedly until darkness came. Inside in winter, in the dusk of evening after finishing my outdoor chores, I bounced a tennis ball left over from an older sister's college tennis class against the living room wall, throwing it right-handed to bounce up from the floor to the wall, catching it left-handed, developing my hand-to-eye, throwing-catching coordination. Outside again in spring, compacted coal dust from the winter's depleted coal pile created a smooth surface atop clay dirt, perfect for retrieving bouncing balls thrown against the side of our one-car garage. In seventh and eighth grades, I played softball before school and at noon recess with the boys because the girls my age didn't care to play competitively. By the time I tried out for the softball team in my first year of high school, my coach assigned me to third base because I was the only high school girl with an arm strong enough to throw the ball across the diamond without it bouncing in the dirt. In my first softball

tournament at Drexel, I hit a grand slam homerun, and every game thereafter, I started at third base on the Archie High School varsity softball team.

It was tougher for me to learn basketball skills because we did not have a basketball or hoop at home, and I could only practice dribbling or shooting in gym class or at noon recess whenever I could catch a rebound from the boys, who used several balls to shoot baskets in the gym. However, I had the opportunity to make the high school girls' basketball team without much dribbling or shooting skill because girls' games were played on two half courts, with three players on offense and three on defense at each end of the full court. Girls' rules also prohibited more than two dribbles on either offense or defense, and touching the ball when an opponent held it was a foul. I tried out for the team as a defensive guard, and with my speed and quick reaction time, I made the seventh- and eighth-grade basketball teams and was able to practice more at school. In my first year of high school, I made the Archie girls' basketball team, but I was still playing guard because I had not yet developed a controlled dribble or accurate shooting skills. Those first two years of high school basketball brought more practice time and, coupled with more playing experience, helped hone my dribbling and shooting. As a junior in high school, although starting as a guard, I was also a substitute offensive forward. In my senior year, I started most games as an outside shooting forward.

Physical conditioning was not a component of high school sports practice in the 1950s, but because I grew up on a farm and did barn chores, I was in pretty good shape. My twin sister and I were the youngest of seven girls in our family, and we all did farm chores. Our dad farmed 280 acres and owned the Archie Farmer's Grain Elevator with his brother, so he was either in the field or at the elevator for most of the planting, cultivating, and harvesting times of the year. Our family had a large vegetable garden each summer, which meant that we each spent long days in physical effort. Farm chores for the girls also included haying the Hereford beef cattle, milking the Jersey cow by hand, feeding and watering the Jersey cow's calf for butchering in the fall, filling gunny sacks with corn from the corn shed and hauling it to feed the Yorkshire hogs, turning on and off the windmill for the livestock water tank, cranking the corn-sheller, feeding and watering the chickens, and gathering eggs. Inevitably, I would run late from the morning milking, gulp down breakfast cereal at the kitchen table, change into school clothes, and then sprint over the hill on the half-mile gravel lane to catch the school bus at the highway. My workouts consisted of lifting hay

bales to throw into the hay mow morning and evening and wind-sprinting to the bus every morning.

Leadership on the Farm and at School

In early April of my junior year in high school, after a day of plowing around tree stumps, my dad suddenly suffered a cerebral hemorrhage early the next morning. He passed away two days later in the hospital. It was devastating for a fifteen-year-old because I adored my dad and had followed and helped him in every outdoor activity on the farm. My twin sister, Darlene, and I were left at home with our mother because our older sisters, four of whom were married, were living in other states. After Dad's death, I took over family responsibilities for most of the outdoor farm chores because I had developed the expertise required, and Mother supported this. By the time I turned sixteen that summer, I had passed my driver's test and became the primary driver of the family car. Mother had never driven a car, and Darlene preferred to ride if I drove, even though she, too, had a driver's license. For our last two years of high school, we twins continued to ride the school bus, but I drove us to school for ballgames in the evenings and was the family chauffer, driving us all into town for groceries, errands, and church. Throughout my junior and senior years of high school, I developed a solid sense of confidence that I could do anything I set my mind to, as Dad had often told me.

In my senior year, I was elected student council president and named captain of the Archie girls' basketball team. At the end of my senior year, I received the Archie High School Female Athlete of the Year award. This thrill was the culmination of my success at interscholastic sports. College was my next goal. Dad had always told all of us girls that he wanted to send us to college to earn a degree because it was something nobody could ever take away from us. A very wise man, Dad believed a college degree was a better investment than leaving us money. In the 1940s and 1950s, women had only the basic choices of teaching, nursing, or becoming a secretary. Six of us Mawson sisters earned a bachelor's degree in education from Central Missouri State College (CMSC, which became Central Missouri State University [CMSU] in 1972 and is now the University of Central Missouri), and our middle sister earned a nursing degree from the University of Kansas (KU). The youngest three of us went on to earn master's degrees at the University of Colorado, but I was the only one who continued further in higher education, earning a doctoral degree at the University of Oregon.

In my first year of high school, when I had noted at the Archie Basketball Tournament that the Raytown High School girls' basketball team had a woman coach, I knew immediately that was what I wanted to do after college. All of our small county schools had male coaches for both the boys' and the girls' teams, so I knew I would need to be at a larger school. I looked forward to teaching PE and coaching a girls' basketball team as my career.

College Extramural Sports

When I entered college at CMSC in Warrensburg, it was a disappointment to learn there were no academic sports-coaching programs for women, not at that institution or at any other US college. PE was the closest academic major to coaching sports, so I chose to pursue that. Every high school sports coach I knew was also a PE teacher. An academic minor was also required for the degree program. I chose English as a second teaching field because the required curriculum was primarily literature, and I loved to read. English grammar was easy for me in high school. As a college PE major, I found myriad other sports to play beyond basketball and softball, and I loved learning the skills, game strategies, and teaching methods for every sport.

Not only was there no coaching program at the college level but also there were no intercollegiate sports teams for women. However, there were occasional Sports Days for women at a few host colleges in a few sports. I tried out for every basketball, softball, and volleyball Sports Day team at CMSC, and I played on every team scheduled for these three sports during my college years. CMSC sent Sports Day teams to Southwest Missouri State College (SMSC), Northwest Missouri State College (NMSC), and the University of Missouri–Columbia. CMSC also hosted several Sports Days for other Missouri colleges during my four years there. Uniforms for basketball and volleyball games at CMSC were the same as the required PE uniforms: white shorts, white shirts, white socks, and white rubber-soled shoes. Red pinnies with black numbers identified our school colors on the courts. Softball uniforms at Sports Days were blue jeans, white sweatshirts, white socks, and white canvas shoes. However, pinnies with numbers were deemed unnecessary for softball. Players were expected to have their own softball gloves, although the women's intramural program provided bats and balls. Likewise, basketballs and volleyballs for Sports Days were financed through the women's recreation equipment budget.

During the summers between my college years, I played shortstop, catcher, and sometimes pitcher for Archie in the Women's Cass County

Summer League. Our coach was the Archie High School basketball and softball coach, so he knew the players well, and we won most softball games against nearby town teams. Games were scheduled in the cool of the evening, before I worked an eight-hour graveyard shift in the Solo Cup factory in Grandview, Missouri, as an inspector and packer of paper cups. Solo hired college students in summers for a special night shift because more paper cups were in demand then. During our summers between college years, my twin sister and I carpooled with a cousin the seventy miles round trip from the farm to work every weeknight, and then we slept during the heat of the day in our upstairs bedroom in the family farmhouse without air-conditioning. We twins did this shiftwork to earn "spending money" beyond the college tuition and housing our mother paid each semester for us at CMSC. She earned enough by sharecropping the acreage on our farm to cover the major college costs for us. The factory experience instilled in me the value of earning a college degree to become a professional and surpass the repetitive hourly work and wage of a shift worker. We spent our summer wages on school clothes, books, academic fees for course materials and labs, social activities, and other incidentals. Because my twin sister and I were college dormitory roommates, we shared most expenses equally.

CMSC sponsored an expansive Women's Recreation Association (WRA) collegiate intramural program affiliated with the Athletic and Recreation Federation for College Women (ARFCW). More than two dozen women's intramural teams competed in team and individual sports at CMSC, and the team members included sorority women, PE majors, and women in PE courses encouraged to participate. As a first-year student, I was invited by PE majors with whom I had played sports in high school to play on the Little Mules basketball, softball, and volleyball teams (the CMSC mascot was a mule). The Little Mules wore home-sewn blue pinnies with white lettering and numbers. Each intramural team had a team captain as a contact person but no coach. The Little Mules teams were made up mostly of PE majors who had played competitive sports in high school, and several of us were from Cass County. Our teams were dominant in the collegiate intramural program and won tournaments in several sports at CMSC.

During my college years, I studied sports rules in officiating courses. Our course instructors assigned us to referee college intramural games. I trained to become a Division of Girls and Women in Sport—Officiating Services Area (DGWS-OSA) rated sports official. The initial DGWS-OSA rating was called a *local rating,* for officiating intramurals. Then one earned a *regional rating* to officiate at high school Sports Days. Finally, with sufficient

skill and experience, one could achieve a *national rating,* which meant eligibility for officiating at college Sports Days. For the latter, I had to pass a national test, including a closed-book, written examination on the rules, and officiate a game in front of a national rating board of three women who judged my level of expertise. By the time I graduated, I was nationally rated in basketball and volleyball and served as an official at Sports Days. Becoming a nationally rated sports official was a prestigious achievement, although there was no pay for officiating prior to the late 1960s.

By the late 1960s, being nationally rated also meant one could be appointed an official for intercollegiate sports competitions. Host institutions for Sports Days were not expected to pay the officials, but nationally rated officials were honored to be selected. We were required to retake ratings exams every three years to renew our rating status. By the end of the 1960s, some officials were paid if they travelled to the competitions from outside the immediate area. By the 1970s, college athletic budgets for women began to provide compensation for nationally rated officials. Even then, they paid officials as little as five dollars per game, but by the mid-1970s most raised the pay to include the officials' travel expenses.

CMSC sponsored a synchronized swimming club from the 1930s through the 1960s, called the Dolphins. This team of women students swam in unison to music in choreographed patterns in solos, duets, and group numbers, using various swim strokes to simulate dancing in the water. The Dolphins performed an annual synchronized swim show each spring, demonstrating their expertise in underwater maneuvers and unity of movement. I had never been in water deep enough to swim in before I went to college, so I started learning to swim in a beginner's class and worked my way up through the Red Cross Water Safety Instructor rating. Although I was not a Dolphin member, in my senior year I was asked to serve as the Dolphin Synchronized Swim Show ticket manager for the annual show. This task required organizational management and marketing along with accountability for funds commensurate with tickets distributed and sold. This experience complemented similar business skills and responsibilities that served me when I began teaching.

The CMSC Physical Education Majors (PEM) Club was a campus organization for upper-class women who had earned at least a 3.0 grade-point average (GPA) in their PE major courses. The club elected officers, and the membership planned professional lectures, fund-raisers, and social meetings throughout the school year. Seniors with good standing in the PEM Club were subsidized for transportation and housing at the national

American Association for Health, Physical Education, and Recreation (AAHPER) convention each spring. Demonstrating leadership characteristics to my peers, I was elected PEM Club treasurer as a junior and PEM Club president as a senior. In my senior year, I was thrilled to attend my first AAHPER convention in Cincinnati, Ohio. It was the first time I had traveled east beyond Illinois. The PE major program for women at CMSC was affiliated with the national honorary sorority for women PE teachers, Delta Psi Kappa. As a junior, I was inducted into this sorority for upper-class women who had earned a GPA of 3.5 or higher in their PE major courses and who were involved in extracurricular sports and other campus activities. Participating in these several sport-oriented organizations gave me the opportunity to gain experience and recognition in more leadership positions during my college years.

As a college junior, I enrolled in the required PE course on interscholastic sports administration. This course oriented women PE teachers in how to plan, organize, direct, and evaluate a large athletic event, and this experience made a significant contribution toward the events I conducted later in my professional career. The specific focus of this class was to prepare for a high school Sports Day sponsored by CMSC. Teams from twelve nearby high schools participated in the Sports Day our class planned and executed. Class members selected leaders and subcommittees to plan tournament functions such as school invitations, game schedules, game official appointment, equipment setup, player registration, locker room assignments, first-aid stations, lunches, participant awards, and refreshments at the conclusion of the event. Our 1960 Sports Day included swimming, tennis, and volleyball, and high schools in the surrounding area were invited to enter girls' teams in one or more sports. I was responsible for planning the volleyball competition by drawing the consolation tournament bracket on a large cardboard poster, entering teams into bracket berths with their match times, and appointing officials for the matches. Every class member was expected to contribute to other tournament committees, too.

Teaching High School PE

After graduation from CMSC in spring 1962, I accepted a position as a girls' PE teacher at Van Horn High School in the Kansas City, Missouri, School District that fall. There were only two open positions for girls' PE instructors in the district that year, but it was no coincidence that I was hired for this one because I had been successful as a student teacher at Van

Horn during my senior year in college. My cooperating teacher for student teaching was University of Kansas alumna Ellen "Jake" Welch, an eight-year veteran teacher and a phenomenal athlete in a wide range of sports.

Van Horn High School was among the largest of the ten high schools in the district, with about 2,500 students enrolled in eighth through twelfth grades, but the building was supposed to hold only 1,800. Even so, it was the newest high school building in the school district. It was built in 1955 on the home site of the Civil War–era Kansas City mayor and newspaper publisher, Robert T. Van Horn, and was within the city limits on the east side of Independence, Missouri, along Truman Road.

With the first baby boomers coming of high school age by the early 1960s, classes were large, with sixty to seventy students per class hour for all six PE teachers. I was glad to be one of the three women PE teachers at Van Horn. Along with the men teachers, we all taught in one gymnasium the size of a regulation basketball floor with folding bleachers. A hydraulic folding door divided the court in half, allowing the girls' and boys' classes to be separate. Shortened badminton, basketball, and volleyball court lines were painted across the floor on each side of the folding door. The school building had a natatorium and an interior rifle range constructed for the Reserve Officers' Training Corps (ROTC) but never used for that purpose, so its floor was covered with mats and used for gymnastics. Outside was a football practice field for boys' PE classes and a fenced, unmarked, mowed grass field for girls' PE classes. The playing areas in addition to the gym allowed four classes to be scheduled each hour for the six hours of class time per day, and each teacher also had one planning hour a day.

During my six years as a PE teacher in that school district, I took on various leadership responsibilities. In 1962–1963, my first year of teaching, a new junior high school was constructed near Van Horn High School because of the overcrowding. In my second year of teaching, as the most recently hired Van Horn PE teacher, I was transferred with the eighth- and ninth-grade classes to the new Nowlin Junior High School. Its students would begin attending Van Horn High School at the tenth-grade level. At Nowlin, I was named chair of both girls' and boys' PE. Two other women and three men taught PE as well, a requirement for all eighth- and ninth-grade students. I taught the same schedule of five PE classes per day as the other five PE teachers. In addition to my regular class load, I scheduled all of the PE classes. Also, I served as the Nowlin basketball and volleyball coach for the Saturday Sports Days hosted for junior high girls in Kansas City.

As department chair, I also directed the schoolwide spring gym show for Nowlin, a "public relations" demonstration for parents and the community. I did not receive additional salary for these types of extracurricular leadership assignments; they were just expected of women PE teachers then. This one entailed organizing demonstrations for both the girls' and boys' classes to perform, such as ball-control routines; folk, modern, and square dancing; gymnastics and tumbling; precision marching; and synchronized conditioning exercise routines. The girls' PE teachers selected two performances, and the boys' PE teachers each agreed to participate in one type of demonstration, for a total of nine demonstrations. Each presentation was to last about four minutes, or the length of a recorded song, because most demonstrations were performed to music.

As chair, I coordinated with the other five teachers for each PE class to have rehearsal time for these performances. It required detailed organizing of the junior high students to enter, perform, and exit the school gym sequentially so that there would be no unexpected break in the show and no commotion from the hallways where they waited in lines for their cues. It also required us to assign and monitor designated areas in the downstairs hallways for the large number of students to wait. It was imperative that the PE instructors act as a team to keep the students streaming on and off the gym floor promptly. Many parents and community members would fill the bleachers in the school gym to watch these demonstrations.

One of the Van Horn High School women PE teachers resigned at the end of the 1963–1964 school year, so I had the opportunity in my third year of teaching to go back there. The following summer my mentor, Ellen Welch, also resigned to spend more time with her family after serving as the girls' PE department chair there for ten years. I was appointed as her replacement because I had seniority over the other new women PE teachers at Van Horn. For the next three years, I served in that position while still teaching full time. My responsibilities as chair required that I plan for the Kansas City, Missouri, School District PE curriculum to be offered at Van Horn within the six grading periods of the year, so I planned the teaching assignments and teaching stations for all the PE teachers at the high school. In 1966, the school district conducted a ten-year curriculum accreditation review that required written reports from every department chair, too. Every PE teacher taught all PE activities to students enrolled in her classes because no teacher specialized in teaching specific sports. Those included team sports in season such as field hockey, volleyball, basketball, and softball as well as individual sports such as archery, badminton,

bowling, gymnastics, tennis, and track and field. Folk, jazz, modern, and social dance were also included in their curriculum. Swimming was taught by each instructor one day a week all year long because the natatorium was one of the four teaching stations in the school.

Extracurricular Sports Assignments

One of my extracurricular leadership assignments was sponsoring the synchronized swim club, the Van Horn Mermaids. Again, I was not paid for this assignment, and it required weekly two-hour practices after school. The Mermaids Club selected student members skilled in synchronized swimming through annual tryouts and then held traditional initiation ceremonies for pledges to declare loyalty to academic excellence and allegiance to the swim club. It was an honor for girls to be skilled enough to become Mermaids because the club membership numbered only 20–25 out of the more than 450 girls enrolled in PE classes. The Mermaid Club's Synchronized Swim Show for the public was scheduled annually in spring, with tickets sold for at least three evening performances in the school natatorium. Announcements were posted for Mermaid Club tryouts each fall semester, and any high school girl in tenth to twelfth grades was eligible. Although new members had to be able to perform basic synchronized swimming skills, the upper-class girls in the Mermaids Club taught the first-year members advanced synchronized swimming skills. Juniors and seniors were expected to choreograph a show number each year, with juniors directing a group number and seniors not only choreographing group numbers but also swimming a solo for the show. Each year the members selected a show theme and the music for each synchronized number. I supervised each weekly practice, designed the practices so that each swimmer gained enough skill to be included in the show, directed show rehearsals, and choreographed the finale show number involving all club members. Preparing for this show each year meant not only planning the performances but also working with the club members for promotion of the show, ticket sales, printing the programs, costumes, sound system, underwater lighting, natatorium lighting with spotlight, and seating. Poolside bleachers filled for each of the three shows. My experience with the CMSC synchronized swim club shows provided me special insights for this responsibility, and sponsoring the Mermaid Club prepared me for greater organizational tasks to come.

In addition to coaching team sports at high school Sports Days, I also directed two semiannual high school Girls' Gym Shows. Beyond organizing

student performances with the other PE teachers as director of the gym shows at my own junior high and high school, I was appointed by the city PE director, Dorothy Canham, as director of the citywide Girls' Gym Show held in spring 1968 near Swope Park at the Kansas City Southeast Fieldhouse, the largest high school arena in the city at the time. My responsibilities entailed planning, coordinating, and supervising a different performance by each of the ten high schools and seven junior high schools in the city. I contacted the girls' PE department chair at each school to determine the activity the school's students might be willing to perform. This resulted in a combined program of seventeen groups of girls demonstrating various sport skills; ballroom, jazz, modern, and square dance; gymnastics; and calisthenics and rhythmic exercises. We planned the recorded music that accompanied each school's performance, and I used a tape recorder to put the songs in sequence to play over the fieldhouse public-address system. I frequented the schools throughout the spring semester to review rehearsals of the performances, and I mapped with the various teachers where their students would assemble in the fieldhouse prior to performing and coordinated the order in which they would enter and exit the floor according to the program.

Organizing and timing the performances for more than 400 participating students backstage required intricate planning and precision. The student performers quietly waited while their teachers monitored them in the hallways before entering the gym promptly for their performances. No rehearsal of the entire program was possible, so it was necessary for all the schools to have their presentations polished and their teachers in command of their students.

The seventeen schools announced the Girls' Gym Show to all their students and promoted the free event to the communities, and a large audience turned out. On the night of the 1968 Girls' Gym Show, the fieldhouse was filled with families and friends of the students, and the event went off without a hitch. I served as the mistress of ceremonies to introduce school district dignitaries and to introduce each school's performance and the teacher in charge. The spectators roared their appreciation during the gym show performances, and I received appreciative accolades afterward. The production demonstrated the excellence of PE instruction and the diversity of students in the schools. It was the last Girls' Gym Show event of its kind in the Kansas City, Missouri, School District because opportunities for girls and women in competitive sports were expanding with a nationwide

movement that would replace these noncompetitive activities for girls. This Girls' Gym Show event was my most extensive attempt at organizing and directing a large production, and it was a great opportunity to demonstrate my leadership ability in a sporting environment.

Leisure Time Sports Involvement

During the evenings of my six years of high school teaching, I played competitive sports in Kansas City. Joining my teaching colleague Jake Welch, I competed in the United States Volleyball Association (USVBA), travelling with the Kansas City Parks and Recreation Women's USVBA team to weekend tournaments in the Missouri-Oklahoma League. As an athlete, I picked up new volleyball skills and learned the strategies of power volleyball. Our volunteer male coach was a USVBA player who gained his volleyball experience while in the military, so our practices were well organized, disciplined, and demanding. Travel to USVBA tournaments in Oklahoma required leaving before dawn on a Saturday morning and returning very late, often into the early Sunday morning hours. The Kansas City USVBA team members volunteered to drive their own vehicles, and other players chipped in for gas. All players paid for their own meals on trips. All-day tournament play was scheduled as a round robin, and team wins/losses determined the winners of each tournament. Team members were engaged as officials for other teams when scheduled for a bye.

In addition to volleyball teams from Kansas City Parks and Recreation, one extramural college women's team from SMSC, coached by Mary Jo Wynn, participated in this league before opportunities existed in intercollegiate competition. Coach Wynn had made acquaintance with Russ Cooper, a national leader in USVBA volleyball from Tulsa who formed the league, and he augmented her coaching background for teaching the power volleyball skills to her college students. I had competed against her teams as a CMSC student and knew her from college Sports Days. But the teams she coached in the Missouri-Oklahoma League were more skilled because of their exposure and experience in the league.

This USVBA experience enabled the SMSC team to enter and win several matches as the only regional team from surrounding states in the first DGWS National Volleyball Championship in 1969. Also, my experience traveling with the Kansas City USVBA team helped me as a coach later in my career to comprehend the planning required in undertaking

intercollegiate athletics trips, and my acquaintance with Coach Wynn established a future connection for these sports competitions and for athletics organizational leadership, too.

The Kansas City Dons Amateur Athletics Union (AAU) women's basketball team invited me to join during the last two winters I taught PE in Kansas City. Jake Welch, previously an All-American player for the Dons, recommended me because she knew my skills from the time we played on the same basketball team in the Kansas City Women's Recreation League. The Kansas City Dons were a nationally prominent team that originated in the 1950s. In 1954, the Dons defeated Hanes Hosiery in the AAU Women's National Basketball Championship semifinals, breaking a 102-win streak by Hanes.[6] The Dons dominated AAU women's basketball in the central region for more than a decade, continually qualifying into the mid-1960s for the AAU Women's National Basketball Championships held in St. Joseph, Missouri. When I was on the team, we practiced and played on our "home court" at the Wyandotte Recreation Center in Kansas City, Kansas. A former Dons player, "Sis" McDaniel, served as our coach. The team also competed at other recreation centers in the Greater Kansas City AAU Women's Basketball League. The Dons issued pullover uniforms with numbers, and because my high school basketball uniform was no. 12, I chose that number each time I played on a team. During the few years I played for the Dons during the 1960s, the team did not compete beyond the Kansas City limits, but playing AAU basketball there stood me in good stead later when I coached intercollegiate basketball.

Women's AAU and DGWS basketball leaders agreed to adopt a new rule for a "roving player" in 1962, when the court was still divided at the center line with three players each on offense and defense playing half court only. Under this rule, one of the six players on each team was allowed to cross the center line at any time and could play both offense and defense.[7] Running the full court meant the rover needed to be in better cardiovascular condition than players who remained on one end or the other. It was advantageous to have an outside player be the rover rather than the taller center because movement would be primarily across the center line, and the taller players would be freed up to either protect or attack the goals at the ends from underneath. Thus, being a short and quick player with experience as both outside shooting forward and guard, I was often designated the rover for my team.

The Kansas City Goodtimers Bowling League during the 1960s was made up of women elementary school teachers along with PE teachers of

grades K–12. These women competed with ten teams of five bowlers each at the Ranchmart Lanes at Ninety-Fifth Street and Mission in Leawood, Kansas, once a week on Thursday evenings throughout the school year. My team had one elementary school teacher, two elementary school PE teachers, and one junior high PE teacher in addition to myself as a high school PE teacher. I had a 175 bowling average in my best season, but our team never won first place. However, we did come in second more than once. I played in this bowling league all six years I taught in Kansas City, Missouri, and I served as league president my last year there in 1967–1968. In that role I gained recognition as a leader when selected by my professional peers to run a sports group in a different venue than at school.

Although softball was always a favorite sport of mine, I was unable to continue playing after taking a teaching position in Kansas City because I enrolled in graduate school at the University of Colorado–Boulder (CU) each summer. Pursuing an MS degree was important in earning a raise on my school district's teacher pay scale. Each six course hours on a graduate transcript constituted a 200 dollar raise over the previous year's salary. After earning the MS, one would receive a raise of 500 dollars. During the four summers between 1963 and 1966, I took graduate PE courses at CU and earned my MS degree in 1966. In the only two free summers of my career, I camped throughout the western states in 1967 and drove through the East Coast states in 1968 on my vacations.

Experience as a National Olympic Institute Participant

The fourth national Olympic institute for girls' and women's sports was held in 1966 at the University of Indiana, featuring basketball and volleyball. In my fourth year of teaching I applied to be a basketball coaching participant at this Olympic institute, and I was selected as one of the two basketball representatives from Missouri. The other Missouri basketball coaching representative was a PE instructor at the University of Missouri–Columbia.

As of January 1966, I had not been on a college campus outside of Missouri other than that of CU, and the Big Ten athletics facilities at the University of Indiana seemed enormous to me. There were gymnasia for women separate from the men's PE gym and the athletics facilities in the fieldhouse, and the number of campus classroom buildings far exceeded those on the smaller campuses of the state colleges in Missouri where I had competed in Sports Days. But the DGWS women at the institute and the presentations and workshops seemed similar to those at national AAHPER

Marlene Mawson (no. 12, first row, fourth from the left) at Fourth Olympic National Institute for Women's Sports, 1966.

conventions I had attended. One main difference was that I attended convention sessions in street clothes, but at the Olympic institutes we wore athletic clothing so we were prepared to participate actively on basketball courts at a moment's notice. My self-confidence as a Kansas City AAU basketball player and USVBA volleyball player made me comfortable in these surroundings.

Olympic institute participants were housed in university women's dormitories or in guestrooms of the student union during academic breaks on campuses. The coaching sessions were held in campus fieldhouses and gymnasia nearby. Previous Olympic coaches of each sport conducted the daily skill and strategy sessions in the various sports venues, and each aspect of coaching was proportioned within the time available. A schedule for specific coaching content was distributed prior to the weeklong institute, along with directions to locations and meals. Written materials accompanied each session for the participants to present the coaching instruction to other women PE teachers after returning to their states.

During the fourth Olympic institute, US Olympic basketball coaches taught us coaching strategies for four-player roving-player basketball. At the end of the week, the volleyball coaching participants gave a special exhibition game of power volleyball to introduce the new skills and strategies to all coaching participants, so even those attending the institute as basketball participants learned that the skills for volleyball would be changing drastically. Likewise, a basketball scrimmage demonstrated Olympic coaching skills to those at the institute for volleyball.

Evening keynote speakers at the Olympic institutes focused on the nuances of cultural and social obstacles facing women wishing to compete in intercollegiate sports. The speakers were DGWS leaders, such as Presidents Katherine Ley and Phebe Scott (future founders of the Commission on Intercollegiate Athletics for Women), who had arranged to cohost the institutes with the Olympic Development Committee. From the presentations by these DGWS leaders, along with Olympic committee board members and Olympic coaches, participants also learned about the goals of national women leaders striving to organize intercollegiate sports competitions for women. The speakers introduced the idea of national championships for women and explained the differences in philosophy between the National Collegiate Athletics Association (NCAA) and the DGWS about conducting women's athletics. Nationally renowned gynecologist Evelyn Gendell, MD, was an unforgettable speaker who eschewed the nonsense of engaging in strenuous physical activity during menstrual periods as a threat to the childbearing ability of young women.

President Scott was one of the most memorable speakers at the Olympic institutes. Her Scottish and Boston accent required careful listening, but her passion about providing young women with high-level sport skills an opportunity to compete was unsurpassed. In addition to her presentations at several DGWS conferences, she spoke at all five Olympic institutes, so I heard her again when she addressed the fifth Olympic institute. Even though her exact words might have escaped me, her ideas stayed with me, but I did not know then how closely I would be following her academic footsteps at Illinois State University later in my career.

The evening speeches at the institutes provided participants a vision of what women's intercollegiate athletics could become on a national scale without compromising the integrity of women's programs with the types of exploitation found in men's athletics. The evening sessions were a mix of information and inspirational talks. State representatives at the institutes wore athletic clothes during the day, but, according to decorum of the 1960s, they changed into skirts, hose, and heels for the evening sessions. At least hats and gloves were bygones in women's fashion by then.

After I returned from the fourth Olympic institute, I conducted several basketball coaching workshops at Van Horn High School for women PE teachers in surrounding schools, as was expected of all institute participants. In addition, I drove to other Missouri colleges to present these workshops. I copied and handed out materials I had collected at the institute for further distribution by local participants. Leading these basketball coaching

workshops further enhanced my expertise and visibility as a national and state leader in women's sports from the perspective of many women PE teachers in the area. It was evident at the Olympic institute that a movement for women's intercollegiate sport competition was taking hold across the country.

Just two years later, I faced a decision that would be a milestone in my career and a change in my lifestyle. After teaching in Kansas City for six years, I was appointed to a faculty position in PE at KU in fall 1968, where I was also asked to initiate a new intercollegiate sports program for women. I had a strong experiential background in directing sporting activities, and I was eager to develop sports competition for college women. In my first year at KU, I was chosen to attend the fifth Olympic institute in January 1969 for basketball coaching, and this time, I was a Kansas representative.

The fifth Olympic institute was held for advanced basketball coaching and for officiating basketball, gymnastics, and track and field. Women's Athletics Director Judy Akers, also the Kansas State University (KSU) women's basketball coach, was the other Kansas representative. The reason two consecutive institutes featured women's basketball (the second one "advanced") was because the fourth institute used a four-player strategy for coaching six-player basketball with a roving player, whereas the fifth institute taught strategies for a five-player rule, allowing all players to use the entire length of the court. The five-player rule was experimental between 1969 and 1971, and in February 1971 the DGWS approved this rule for college women.[8] It was essential for institute participants to learn the coaching techniques in a rapidly changing sport. The comradery with these Olympic institute participants from all over the country allowed young women like me to forge face-to-face professional and social networks for the future national development of women's athletics.

When I returned from each of the final two Olympic institutes, I scheduled basketball coaching workshops at the places I had previously worked and at other schools and colleges where I had contacts. I was also invited to conduct a coaching workshop for women PE professionals in the area. These workshops were held on Saturdays and required planning for lunch between presentations. The PE teachers participating were expected to be attired in athletic clothing so that they could practice the new coaching skills. Those attending were very interested in learning about basketball coaching, and in addition to leading them through the coaching skills I had learned at the institute, I provided them copies of the handouts I

collected there. Leading several coaching workshops after the fourth Olympic institute in 1966 provided me the confidence necessary to present other national events later in my career. By the time I was presenting coaching workshops after the fifth Olympic Institute in 1969, I was also preparing a bid to host the first DGWS National Volleyball Championship, and my past athletic organizing experiences were essential to the success of future events I directed.

In the first six years of my career, I experienced sports leadership opportunities that built my credentials for directing a university women's athletics program and for coaching sports teams at that level. When I was a high school senior I had dreamed of coaching as a career, but little did I know then that not only would I become coach of a women's basketball team but also I would be building a college sports program for women. It seemed nearly impossible when I entered college and hoped that someday there would be women's intercollegiate sports teams just like the varsity teams for men. In 1968, the horizon for women's sports was visible, and I was prepared and eager to be a significant part of that development.

FORMATION OF WOMEN'S
INTERCOLLEGIATE SPORTS AT KU

The robust, shrill steam whistle sounds across the hill on the University of Kansas (KU) campus every weekday precisely on the half hour, notifying all students and professors that class sessions have concluded. During the late 1960s, the end of the last afternoon class also signaled when KU women athletes would soon enter Robinson Gym, excitedly joining their teammates in the women's physical education (PE) locker room to don workout apparel they bought on their own for intercollegiate sports practices.

In fall semester 1968 I initiated a new mission: an intercollegiate sports program for KU women. As a newly appointed full-time faculty member in PE, I was also the new director of KU Women's Intercollegiate Sports.

Henry Shenk chaired the KU Physical Education Department in 1968. He had been department chair since 1941, and in the 1967–1968 academic year he supervised a PE faculty of twelve men and women in Robinson Gym. KU offered two undergraduate academic programs in PE in 1968, the men's and women's programs, along with a graduate program in PE for a master's degree. In addition, the Physical Education Department administered the intramural programs for men and women then. Joie Stapleton had been a faculty member in that department since 1939. Shenk considered her his indispensable authority on women's PE, and he designated her director of women's PE in 1954. Her responsibilities included monitoring both the undergraduate academic PE curriculum for women and their intramural programs. In the late 1960s, Shenk served in a leadership position at the national level on the American Association for Health, Physical Education, and Recreation (AAHPER) Board of Directors. Stapleton was also a member of AAHPER and the Division of Girls and Women in Sport (DGWS), and she had served as Central District president for AAHPER recently, so both were well informed about current issues in the profession.

Front catwalk of Robinson Gym, 1968.

DGWS Initiatives for Women's Intercollegiate Sports

The DGWS leaders took formal steps during the 1960s to initiate women's intercollegiate athletics at the national level. The positive results from the first of five planned Olympic Institutes for Girls' and Women's Sports during the 1960s caused the DGWS to see the rising engagement and envision a future groundswell of interest in women's intercollegiate sports. At the January 1964 National Collegiate Athletics Association (NCAA) Convention, DGWS representatives were invited to inform the NCAA of their plans for offering national championships for women and conveyed that women would assume leadership of women's sports competition but welcomed the men's assistance. Subsequently, in April 1964, in order to emphasize that the NCAA would not be involved in women's athletics, the NCAA Executive Committee edited its governing document, limiting participation in the NCAA to males only.[1]

Following the 1965 DGWS Study Conference on Competition, the DGWS inquired again about the NCAA's interest in including women's athletics as a part of its national organization. In March 1966, Assistant to the Executive Director Charles Neinas responded in a letter to then DGWS chair Katherine Ley that the NCAA limited its competition to male student

athletes and disallowed women from participating in national collegiate championship events but that an organization offering national championships for women would not be in conflict with the NCAA.[2]

Understanding clearly that the NCAA had no intention of offering athletic competition for women and realizing that women had the backing of the US Olympic Development Committee, the DGWS began planning to govern national intercollegiate championships itself for women. The DGWS immediately formed the Commission on Intercollegiate Athletics for Women (CIAW) in March 1966 to provide a framework for national sport championships for college women.

The DGWS president from 1966 to 1968, Frances McGill, appointed the first three commissioners: Phebe Scott from Illinois State University, Kathryn Ley from the State University of New York–Cortland, and Maria Sexton from Wooster College of Ohio.[3] These women drafted the policies and regulations for the first DGWS national championships, selected the championship sports, designed the bidding process for national championship locations, and selected the sites for the initial championship events. Thereafter, one commissioner was replaced annually. Scott had inspired this CIAW structure, and the new commissioners met for the first time in June 1966 for planning and development.[4] The three-person commission selected five sports for which the DGWS would sponsor annual tournaments during the first three years of national women's intercollegiate sports competition.

In August 1966, the DGWS informed the NCAA and the National Association of Intercollegiate Athletics (NAIA) of the existence of the CIAW and of its purpose to organize national intercollegiate championships for women. Despite previous correspondence, in December 1966 the NCAA's Neinas inquired of Executive Director Ross Merrick of the AAHPER if the DGWS intended to offer national championships for women because there appeared to be renewed interest within the NCAA in providing sports competitions for women.[5]

In January 1967, CIAW chair Ley informed the NCAA that the DGWS would announce national championships for women in January 1968. In May 1967, the NCAA Executive Council voted to study the feasibility of governing women's intercollegiate athletics, and in late July 1967 Executive Director Walter Byers of the NCAA notified Ley that she and Vice Chair Betty McCue of the DGWS had been named with seven men to an NCAA Committee on Intercollegiate Competition for Women.[6]

Ley replied to Byers in early August 1967 indicating her surprise at the establishment of the committee because the NCAA had previously informed the DGWS in written correspondence that it would not interfere with national championships for women. Ley reminded Byers that the CIAW planned to accept bids for national championships in January 1968. Byers replied in mid-August that he did not know who had informed the DGWS that the NCAA was not interested in women's competition, but this committee was only for study.[7]

Then in October 1967, after the NCAA Executive Council had met, Byers wrote Ley again, stating that traditionally intercollegiate competition had been governed by institutional organizations, not by a national professional organization of individual membership such as the DGWS. Byers indicated that the NCAA was not attempting to supervise women's athletics but merely provide guidance because there was no clear determination as to the appropriate organization to offer national championships for women.[8] It was an early indication that the NCAA leaders were indeed interested in controlling women's national sport championships.

Despite the conflicting information from the NCAA, the CIAW, under the direction of the DGWS Executive Board, continued to develop directives for offering national women's intercollegiate championships. The board approved the thirty-five-page *Procedures for Intercollegiate Athletic Events*, written by the CIAW commissioners. The content included procedures for sanctioning national sports competitions, bidding to host national championships, and planning and holding those championships. The DGWS national championship directors used these procedures for the first four years of the women's intercollegiate tournaments.[9]

DGWS Announces National Championships for Women

In December 1967, the CIAW's Ley held a press conference to announce the first DGWS national championships, with the commission as the official governing body. In February 1968 the *Journal of Health, Physical Education, and Recreation* printed the announcement that the championships would be held for five women's sports during the 1969–1970 academic year.[10] The first DGWS/CIAW championships for gymnastics and for track and field were scheduled for fall 1969 and for badminton, swimming, and volleyball in spring 1970. Colleges and universities across the country immediately initiated women's intercollegiate sports programs.

However, national competition in women's sports was under way even before the CIAW announced the DGWS national championships. Golf, using Ladies Professional Golf Association (LPGA) rules, was an acknowledged DGWS national invitational tournament as a continuation of an annual event Ohio State University had sponsored since 1941, but the CIAW officially sanctioned the sport for its national championships in 1966.[11] DGWS national basketball invitational tournaments were held at West Chester State University in Pennsylvania in 1969, at Northeastern University in Boston in 1970, and at Western Carolina University (WCU) in North Carolina in 1971, but the CIAW had not sanctioned them as national championships because the two years of experimental five-player women's basketball from 1969 to 1971 caused the rules to be tentative. A national basketball championship was therefore delayed until the DGWS officially approved the five-player rules for women's basketball in 1972.[12] Thus, during the first three years the DGWS held national championships (1969–1972), the CIAW actually sanctioned seven sports before the AIAW was formed.

Most women's PE teachers at colleges and universities realized that real change in intercollegiate sports would commence when the institutions contended for national championships in the 1969–1970 season, and they wanted their own institution to gain a national reputation in women's sports because it could affect the interest of highly skilled women in seeking a PE teaching degree. Collegiate PE administrators across the country focused on selecting a faculty member to lead new intercollegiate sports programs for women as well as identifying other women faculty with coaching skills.

KU Plans for Women's Intercollegiate Sports

At KU in the mid-1960s the Physical Education Department had only two tenured women faculty members; one of them retired in 1962, and the courses she taught were covered by graduate teaching assistants. The other, appointed the head of the women's academic PE curriculum, planned to retire in the early 1970s. A third full-time female faculty member had been hired in 1961 as a dance specialist, but she had no background in competitive sports. It was necessary to find new women faculty qualified to lead the women's intercollegiate athletics initiative for the university.

Shenk and Stapleton conferred during the 1967–1968 academic year about the rising interest in national intercollegiate championships for

women, an issue paramount among DGWS members and becoming so for the AAHPER Board of Directors. When *Journal of Health, Physical Education, and Recreation* announced the championships to all members of AAHPER in spring 1968, these two administrators immediately agreed to initiate a women's intercollegiate sports program at KU. They knew from communications through their respective national organizations that the NCAA would not be cooperating with the DGWS in organizing the new championships, so it would be inconsequential to the KU Athletics Department if the Physical Education Department provided the home for the new initiative. It seemed appropriate for the new program to originate in the Physical Education Department because, as at most other colleges and universities across the country, it would be an extension of the women's intramural/extramural sports already offered through the Women's Recreation Association (WRA) on campus.

Upon receiving the approval and support of the KU chancellor and the dean of the School of Education, under which the Physical Education Department was administered, Shenk requested three new full-time faculty positions in PE beginning in fall 1968 to replace retiree Ruth Hoover. Hoover had taught the courses required of women undergraduate PE majors, and she had been the faculty sponsor of the Women's Athletics Association (WAA; renamed the WRA) for forty years, beginning in 1922.[13] One of these three new positions would be assigned the additional responsibility of directing the women's intercollegiate sports program at KU. Shenk expected that more than one person would be needed for the additional responsibility of coaching the several sports teams and that these coaches should be young women PE professionals.

KU announced these new positions in spring 1968, advertising for an experienced PE teacher with a minimum of a master's degree to teach academic PE courses. No applications from men were considered. Competencies for covering the health and PE courses Hoover taught were needed as well as for sponsorship of the intramurals and extramurals. Additional expertise was required in sports strategy, sports skills, and PE activity courses for women students. Leadership experience was desired for developing the intercollegiate women's sports program.

Because I was comfortable teaching secondary school PE in the Kansas City, Missouri, public schools and serving as the Physical Education Department chair at Van Horn High School, I was not seeking a position in higher education. I had earned my MS in PE during summers at the University of Colorado (CU) in my fourth year as a Kansas City teacher,

Marlene Mawson receives her master's degree at the University of Colorado, 1966.

and I was considered a master PE teacher. I was confident in my teaching position and not even aware at first that KU had an open position in PE.

In spring 1968, I was the cooperating teacher for a student teacher from KU, Gretchen Hausman. She told her university supervisor, Stapleton, that I should be considered for one of the newly established PE instructor positions. She understood there would be an additional assignment to establish a women's intercollegiate athletics program in fall 1968, and she knew of my leadership background in sports. She had been a skilled athlete at KU, participating in several Sports Day events and on KU club teams, and she yearned for competitive intercollegiate opportunities, but she missed that privilege by just one year, graduating in spring 1968. She knew from her daily contact with me at Van Horn High School just how passionate I was about sports opportunities for girls and women and how my academic and experiential credentials in multiple sports fit the position available at KU.

Over the previous six years, I had never considered seeking a position in higher education or even being qualified to be a university faculty member. I was anticipating continuing to teach high school in the Kansas City, Missouri, School District. When Stapleton came to Van Horn to supervise her student teacher that spring, she met and interacted with me on those occasions. After conversations with Stapleton, who informed me about the academic PE positions open at KU, of course I was interested. She consulted

with the director of PE for the Kansas City School District, Dorothy Canham, and arranged for me to drive to Lawrence for an interview with Shenk at the end of spring semester 1968.

Shenk came across to me as a wise, easygoing, and compassionate man who cared deeply about his faculty and the professional reputation of the academic PE program at KU. He inquired during the interview about my academic and experiential credentials, and he explained the expectations of the position and discussed the salary with me. I left the interview seriously weighing the positives and negatives of leaving my secure high school teaching position for a college teaching career.

The assignment for the new position would be to teach a full load of PE activities courses, twelve semester hours, meaning twenty-four class hours per week. My high school class load was five days of five hours of classes a week, so the college teaching hours seemed similar. Shenk explained that KU was anticipating offering intercollegiate sports for women in the coming year, and the position would include an additional assignment of extracurricular responsibilities in women's sports. Little did I realize that far more hours than expected in high school extracurricular assignments would be required to fulfill KU's academic demands on my time, not to mention developing a new women's intercollegiate sport program.

The salary for the KU position was $7,000 for a nine-month contract of teaching fall and spring semesters. That was $200 less than I would make at Van Horn High School. I would be paying for rental housing alone because my twin sister, Darlene, would remain in Independence, where we had lived together for the previous six years and shared expenses. As with my high school teaching contract, my salary would be spread over twelve months even though it paid for only nine months of work. With federal and state taxes, health insurance, and other deductions from the monthly salary, my take-home pay per month was about $390, and renting a one-bedroom apartment including utilities in Lawrence was about $150 per month in 1968. That left $240 a month for food, clothes, car insurance, gas, incidentals, and savings for graduate school.

A major drawback of this college position was that for the first twenty-eight years of my life, I had lived with my twin sister while attending school from grades one to twelve together, rooming together in college, and renting housing together for six more years. If I took this offer, each of us would need to subsist on our own. We were emotionally close as twin siblings, so taking this position would be a gut-wrenching separation and a major life change for both of us.

Yet the possibility of becoming a college PE instructor was exciting because it offered new, seemingly limitless, challenges in my career. I had an affinity for KU because one of my older sisters had earned a nursing degree there. When I was ten years old, attending my sister's graduation on the KU campus and watching her march down the hill to receive her diploma was quite impressive. Also, my oldest sister had asked Darlene and I as teenagers to babysit her two children while she was an administrator at the two-week annual summer Kansas Girls State at KU, and I had a lofty perception of the university. My student teaching mentor at Van Horn was a KU alum, and my KU student teacher was very well prepared to teach, so I was impressed with the PE graduates from there. I had several ties to KU, and it seemed a familiar and welcoming place for my next career step.

At my KU interview, I was told this new position was a tenure-line appointment, meaning it carried the minimum requirement of earning a doctorate to become a tenured professor there. In the 1960s, pursuing a degree at the same institution that employed you was discouraged to avoid presenting a narrow view of the academic field to students. My graduate study thus far consisted of an MS in PE from CU, so this meant much more graduate study. My evaluation for tenure at KU would be in five years, so it would be imperative for me to earn the doctorate during those first years I was teaching at KU. A PhD at any institution meant at least another sixty semester hours of graduate coursework, the equivalent of two years of advanced study, and at nine semester hours per summer, it would take too long for me to meet the tenure review deadline by taking course only in the summer. A PhD also required a yearlong campus residency, and I was not sure I had saved sufficient funds to be unemployed for a year during that graduate residency. It would have been possible to apply for a graduate teaching position during the residency year, which allowed for only half-time coursework over two residency years, but there would not be enough time before my tenure review to enroll only half time during a year toward a doctoral degree. These were heavy decisions to make regarding this potential position.

In early summer 1968, I received KU's formal letter offering me a faculty appointment in PE. The opportunity to be a university faculty member was a major promotion for my future career, even with the expectation of having to pursue another degree, and I decided with my twin sister's encouragement to accept the position. I was twenty-seven years old when I signed the faculty tenure-line appointment contract with KU, and I turned twenty-eight before I moved there.

My experiences, decisions, and plans surrounding my career change from high school to college teaching were unique enough that I still recall many details of them. Determination and perseverance were essential for success, but I had amassed much self-confidence in my youth. Accepting the faculty PE position set my destiny on course toward initiating a viable intercollegiate athletics program for KU women. This career decision marked a substantial milestone in my journey toward providing opportunities for young college women to engage in competitive sports.

The PE Rookies

Three new women faculty, all under age thirty, were appointed as PE instructors in fall 1968: Anise Catlett, Delores Copeland, and me. Claire McElroy, from Wichita, was appointed that fall as a graduate teaching assistant while she pursued a master's degree to teach aquatics. She was the only female graduate assistant appointed. We three instructors, each holding an MS degree, were appointed in tenure-track positions and assigned to teach a full load of PE activity courses for women with possibly one or two classroom courses to fulfill our twelve-semester-hour teaching requirement, whereas graduate teaching assistants were assigned a six-semester-hour teaching load. For instructors, that meant a teaching schedule of a two-semester-hour classroom course, such as officiating sports, plus four or five one-semester-hour activity class sessions each day, and those classes met two full clock hours per week for one semester hour of college course credit. We had little time during the day for anything other than teaching classes. Then women's intercollegiate sports practices began at the end of the class day.

Stapleton assigned Copeland, with her three previous years of experience teaching at Kansas State Teacher's College at Pittsburg (now Pittsburg State University), to direct the WRA program at KU, a long-established and large program for women's sports at the time. The WRA sponsored all women's intramural and extramural sports and followed Athletic and Recreation Federation for College Women (ARFCW) regulations. More than a thousand KU women students participated in the WRA intramural program in the 1960s.[14]

As her extracurricular assignment, Catlett was named sponsor of the men's athletics cheerleaders because she had experience with dance, gymnastics, and as a cheerleader in her undergraduate years at West Virginia University. McElroy had aquatic and synchronized swimming experience,

Marlene Mawson, KU faculty member, 1968.

so she was assigned to sponsor the synchronized swim group called the KU Quack Club, founded by Hoover.

Developing and directing the new KU women's intercollegiate sports program was the extracurricular assignment Stapleton gave me that first semester. This new initiative was separate from the WRA program. There was no role model or mentor for initiating such a program for women anywhere in the country, so I would need to develop KU women's inter-collegiate competition on my own, but I was highly motivated. My per-spective on such a program for women was based on my previous sports

experiences, and this provided me the creativity and vision to initiate this new program. Planning and directing this athletics program were my responsibilities alone, but I was able to convince the other young women faculty to become volunteer coaches for it. These extra, unsalaried assignments were above and beyond our teaching responsibilities. The four of us became the driving force behind the new KU program in our first year and its first year.

KU Women's Athletics Administered in the Department of Physical Education

Initiating the KU women's intercollegiate athletics program in an academic department was unique for the 1960s. Earlier in the century, KU men's sports had been administered along with the Physical Education Department as one unit, and most of its PE instructors were also men's coaches. But the two programs had been separated after World War II, when financial requirements for competitive athletics extended beyond academic budgetary provisions.

The academic PE programs were the foremost mission of PE faculty throughout the twentieth century. KU sports in the 1960s were administered separately from academics. Students majoring in men's or women's PE were prepared to teach it in elementary and secondary schools in Kansas with state and national curricular guidelines, but unlike men's preparatory courses, the PE program for women did not include courses in coaching sports. Athletics and the academic PE program had their own administrators, and no full-time faculty in PE held part-time coaching assignments as part of their appointments. However, in the late 1960s two exceptions were the part-time men's coaching positions held by male PE faculty members in addition to their full-time teaching appointments. Bob Lockwood coached men's gymnastics and wrestling, and Dick Reamon coached men's swimming.

PE activity classes at KU in the late 1960s were elective for the students. They were offered as sports skill courses and physical development courses for men and women separately. Only female instructors taught these classes for women, and male instructors taught men students. Likewise, female faculty taught all of the courses required only for women PE majors, and male faculty taught the courses required only for men PE majors. Only the general courses required of both women and men PE majors, such as adapted PE, elementary school PE, exercise physiology, kinesiology, and PE

administration were offered as coed classes. Male instructors taught most of those coed required courses because there were more tenured men faculty in the PE Department.

Responsibilities as KU Women's Intercollegiate Sports Director

Planning sports competition schedules, selecting coaches, organizing policies and procedures for coaches and athletes, coordinating practice schedules, budgeting, and directing the new KU women's intercollegiate sports program were my responsibilities, without much guidance or intervention from anyone else. I was on my own because there was no precedent for creating a women's athletics program with a meager budget.

My initial action was to contact each of the PE Departments in surrounding colleges and universities to ask if they were planning to form women's intercollegiate sports teams, and if so, in what sports. Basketball, field hockey, gymnastics, softball, swimming, and volleyball were the sports initially supported for intercollegiate competition in Kansas because other geographically close higher-education institutions were also fielding teams in these sports at the time. Gymnastics, swimming, and volleyball were three of the five sports in which national championships would be offered within a year. Extramural KU clubs were already established in all six sports, and facilities were available in the Robinson Gym complex of courts, fields, and a pool for them, although most of these facilities were marginally acceptable for intercollegiate sports competition.

The six women's sport teams each needed a knowledgeable and experienced female coach. Having had experience as an all-around athlete and a Sports Day coach in basketball, field hockey, softball, and volleyball and as an official for high school Sports Days, and having instruction in basketball coaching at the fourth national Olympic institute, I was prepared to coach any of the four team sports. I began as a co-coach and an official in basketball and field hockey with Copeland in 1968–1969, but I coached softball and volleyball by myself. Catlett coached women's gymnastics, and McElroy coached swimming in addition to serving as sponsor of the KU Quack Club. Because the women's and men's teams shared the same facilities, Catlett and McElroy scheduled practices and competition in cooperation with men's gymnastics and swimming coaches Lockwood and Reamon.

Copeland resigned her academic position at KU after one year, and I became head coach of all four women's team sports during my second year at KU. Catlett continued as the women's gymnastics coach, and McElroy

continued as the women's swimming coach through the 1969–1971 academic years. Tennis was added to statewide sports for women in the 1969–1970 academic year, and Suzi Cammon, a PE graduate teaching assistant, volunteered to coach the first KU women's tennis team.

In spring 1969, I submitted a bid to host the DGWS National Volleyball Championship sometime at KU, and the CIAW selected KU to host the second championship, in February 1971 with me as director. After attending the first championship in Long Beach, California, I realized I would need help coaching KU women's sports in the 1970–1971 academic year because of my additional responsibilities as the next national volleyball championship director. In my third year at KU, I still carried a full load of courses and remained director of KU Women's Athletics. I did not coach softball or volleyball that year, but I remained head coach of women's basketball and field hockey, and I also coached tennis in spring 1971. Linda Dollar was hired in 1970–1971 as a graduate teaching assistant to carry a half load of PE courses and to coach softball and volleyball while I directed the DGWS National Volleyball Championship.

During the fourth year of KU women's intercollegiate sports, I was off campus completing my doctoral residency, and Ann Laptad filled my position as a full-time PE faculty member and interim director of women's intercollegiate sports in 1971–1972. She coached cross-country, track and field, and volleyball. She appointed graduate teaching assistants Debbie Artman as head women's basketball coach and Veronica Hammersmith as head women's softball coach. Laptad also served as head field hockey coach, with Hammersmith as her assistant coach, and head tennis coach, with Artman as her assistant coach. Catlett remained the women's gymnastics coach, and McElroy continued as the women's swimming coach for that year.

In the fifth year for KU women's intercollegiate sports, I was back on campus as a full-time PE instructor, but Sharon Drysdale had accepted a half-time PE faculty appointment and half-time women's athletics appointment, and her new position replaced me as director of KU women's intercollegiate sports. At that point, I had no continuing leadership authority for the athletics program, but Drysdale did appoint me the KU volleyball coach for the next two years. For the 1972–1973 season, Drysdale was head coach for basketball, field hockey, and softball. McElroy continued as swimming coach, but Catlett resigned to accompany her husband, Gale, to his new head basketball coaching position in Cincinnati, Ohio. Drysdale appointed three women graduate teaching assistants in PE as coaches for

the 1972–1973 season: Marian Washington for cross-country and track and field, Pat Ruhl for gymnastics, and Sally Wulbrecht for tennis.

For the sixth year of the KU women's intercollegiate sports program, Drysdale continued as director and remained the 1973–1974 coach for field hockey and softball, but she appointed Washington, who also continued to coach cross-country and track and field, the new women's basketball coach. McElroy continued as swimming coach, and I continued as volleyball coach. Nancy Boozer was named the first KU women's golf coach in 1973–1974, Judy Jones became the gymnastics coach, and Wulbrecht stayed on as tennis coach.[15] That was the last year I was directly involved with KU Women's Athletics, even though I continued to be involved in women's intercollegiate athletics in state, regional, and national leadership roles.

Funding for KU Women's Intercollegiate Sports

The new women's intercollegiate sports program was constrained by the resources immediately available. The PE Department had arranged for the new program to use sports equipment and support personnel budgeted within PE and student recreation. The allotted proportion of funding for women's athletics was minimal.

The first operating budget for KU women's intercollegiate sports was a total of $2,000 for six sports, to cover one set of uniforms shared between all four team sports, Association for Kansas Women's Intercollegiate Sports (AKWIS) membership dues, tournament entry fees, and travel mileage for coaches' and students' vehicles. In those first few years, game and meet officials were not paid, but they were highly qualified as DGWS nationally rated officials. The student athletes paid all of their other expenses, such as athletic tape, shoes, and other personal sporting equipment as well as their meals. Over four successive years, a $400 increase in the PE Department budget was allocated for women's intercollegiate athletics, but none of it was for coaching salaries.

In 1972–1973 the budget doubled over that of the previous year to approximately $6,400, and in 1973–1974 it doubled again, so that the KU women's intercollegiate sports operating budget was $9,367 by the sixth year. The new half-time athletics director's salary was separate from this operating budget. By then, cross-country, golf, tennis, and track and field had been added to the original six sports in the program, so the additional funding was not used as much for increases per sport but for the additional sports and their competition travel. In comparison, after Title IX,

after almost forty years the KU women's athletics budget increased to $3.2 million by 2006.[16] The 2018–2019 budget for women's athletics at KU was reported to be $17.4 million.[17]

Early funding for women's intercollegiate athletics in most Kansas higher education institutions was administered through the campus PE Department for academic programs, according to a 1970 survey conducted by the AKWIS. This was the same funding structure for administering intramural programs on most campuses in Kansas. Generally the women's athletics director submitted budgets for women's athletics, and the department chair approved them. Women's sports did not garner much in the way of revenues in the early years because there were no admission costs for the few spectators at women's events, and no financial donors were solicited. Men's athletics at most Kansas institutions were funded through gate receipts from their events and from supporters' donations, but those revenues were not available for women's athletics.[18]

KU Physical Education Facilities

The PE faculty members were housed in the "new" Robinson Gym, constructed in 1966 on Sunnyside Avenue east across Naismith Boulevard from Allen Fieldhouse. The new Robinson Gym had only been open two years when the KU women's intercollegiate athletics program began. The original Robinson Gym, on the hill, was demolished in 1967. Built in 1907, it had stood for sixty years on Jayhawk Boulevard where Wescoe Hall is now.

The new women's sports program operated in Robinson Gym around the schedules of academic courses and two intramural programs. Phase I of the new Robinson gym, in 1966, represented approximately half of the square footage added during Phase II, in 1988—providing four more basketball courts in a large gymnasium as well as handball and racquetball courts, a weight room, exercise physiology and biomechanics laboratories, an additional twenty-five-meter six-lane racing pool, and a new department chair's office suite. The early KU women's intercollegiate coaches' offices were the same as the coaches' faculty offices in the limited space of Robinson Phase I. By the time Robinson Phase II was completed, KU Women's Athletics had long been absorbed by KU Athletics and was in Allen Fieldhouse.

Faculty offices in Robinson Gym were on the lower level in the 1960s and 1970s, with six men PE teachers' offices on the east side of the main hallway entrance and four women PE teachers' offices with a women's

faculty locker room on the other side of the hallway entrance. Because the coaches for women's intercollegiate sports were all PE faculty members, the women's coaches' offices were also their faculty offices.

Four classrooms, each built for twenty-five to thirty students, were located on the lower level, and one large classroom for seventy students was upstairs during Robinson Phase I. Two wooden-floor studios downstairs had weight-bearing pillars in the center of the floor. Beyond the downstairs locker rooms and equipment rooms for men and for women was the original twenty-five-foot, six-lane pool and diving well, with adjacent swimmers' dressing rooms and two adjoining faculty offices for the swimming instructors, who were also the swimming coaches.

The hallway on the upper floor of Robinson Gym led to the main office for men's intramural sports, the adapted PE and motor learning laboratory and faculty office, the gymnastics room, and the dance studio and dance faculty office. Two gymnasia divided by a permanent wall were positioned side by side at the west end of the hall on the upper level of Robinson Gym. Each had one regulation basketball court running the length of the floor and two shortened basketball courts marked across them. On top of the basketball cross-court lines were three courts marked for volleyball, overlaid with four courts painted for badminton. The cross-court markings enhanced the two gymnasia for teaching PE activity courses for large classes and accommodated many intramural participants, but the double courts could be distracting during women's varsity competition.

These gymnasia were scheduled continually for PE activity courses during daytime hours and for men's and women's intramurals in late afternoons and evenings. The only place on campus available for KU women's basketball and volleyball practice and varsity competition was one of the two cross-courts in the north gym of Robinson. The women's intercollegiate practices and games could be scheduled only on one cross-court in a two-hour block of time in the late afternoon and again in the evening. This was also the time allotted for women's intramurals, playing side by side on an adjacent court. Often, the varsity women athletes had errant balls bouncing across their practice and competition court from the intramural games. The noise level from excited competition on the adjoining court at times made hearing any coaching remarks difficult.

In the 1960s and 1970s, the two gymnasia in Robinson were the only indoor sports courts on campus other than the intercollegiate basketball court in Allen Fieldhouse. Games moved from Hoch Auditorium to the court in Allen Fieldhouse after it opened in 1955. The basketball floor in

Allen was assembled each season and centered on top of a dirt surface inside the fieldhouse. Permanent spectator seating surrounded the floor at the balcony level, and portable folding bleachers were positioned around the court at ground level for home games. The Allen Fieldhouse court was designated for men's basketball only, but the men's indoor track team practiced and competed around the outside of the basketball court on chalk-lined dirt lanes. Other men's intercollegiate sports teams practiced in Allen Fieldhouse during inclement weather at times other than basketball season. Allen Fieldhouse was locked to all on campus other than men's athletics until 1973.

Field hockey and softball teams used the grassy academic and intramural fields east of Robinson Gym for practice and competition in the early years. Women's intercollegiate gymnastics shared time with gymnastics classes and the KU men's gymnastics team in the Robinson gymnastics room for practice, and they competed in the Robinson south gym when it was set up for gymnastics meets. The Robinson natatorium was the only swimming pool on campus, so for practice and meets, the KU women's swim team scheduled the pool during late afternoon and sometimes early morning, alternately with the KU men's swim team, because swim courses were scheduled in the pool during the daytime hours.

Locker rooms for women's athletics were the same ones in Robinson Gym the women in PE activity classes used. Because most women's sports team members were also PE majors, these athletes used their same locker for classes as for practices and competitions. The military-gray steel, enameled lockers were set in rows of twenty, with a permanent bench centered in each aisle. In the five-stack units, each locker was a twelve-inch square tube, only thirty inches deep. Beside each stack of five small lockers was a "street locker," also twelve inches wide and thirty inches deep but sixty inches high, so that street clothes could be hung inside. Students brought their own combination locks to secure their athletic gear and belongings.

Halftime for women's basketball or time between sets in volleyball was insufficient for teams to return to the locker room, so coaching huddles were conducted on the sidelines of the playing floor rather than in the locker room during the early years. Visiting women's teams were assigned lockers in the far end of the same locker room used by KU women's PE classes because there were no other women's locker rooms on campus. However, when the visiting coach requested it, visiting teams were given a key to a Robinson Gym classroom for pregame pep talks and coaching strategy sessions.

Support Personnel for Early KU Women's Intercollegiate Sports

Officials for games and meets in the first year of KU women's intercollegiate sports were women PE faculty volunteers and graduate student women athletes who had earned a DGWS official's rating at a state or national level in the sport. Similar to coaches, officials received no compensation. Occasionally an official traveled with the team, usually as an additional driver of a team vehicle to off-campus tournaments. However, other than in tournaments, the home team provided qualified volunteer officials for women's games and meets. By the second year of women's intercollegiate sports in Kansas, game/meet officials were paid three dollars per game or match, and in the third year, the officials' pay increased to five dollars. Table officials for scoring and timing were not paid, and the host school provided these volunteer officials. Later, DGWS-rated officials were paid mileage from the women's athletics budget and drove separately from the team to away events if they were not directly affiliated with the university hosting the event. However, most officials traveled with the team back then.

Athletic trainers were not used for women's intercollegiate sports in the initial years, mainly because there was an intern program only for male athletic trainers at KU, assigned by men's athletics to gain experience with men's teams. Women athletes who needed ankles taped did it themselves. First-aid kits were available in the equipment room but were seldom used. Health exams for athletes were conducted by each player's family physician, who gave written approval to play sports. These reports were presented to the coach and kept on file during the academic year. The on-campus Watkins Student Hospital was contacted in the case of an emergency athletic injury.

In the early 1970s, women interning as athletic trainers began to provide injury-prevention tactics and treat women athletes. Jackie King, a physical therapist, was appointed as a KU adjunct PE faculty member in 1971 and voluntarily assisted in treating the injuries of women athletes. A graduate intern in athletic training in 1973–1974, Irene Maley, was the first volunteer athletic trainer for KU women athletes, and she converted the women PE majors' lounge in the women's locker room into a rudimentary athletic training room. Taping and treating athletes' injuries were done there. Cynthia "Sam" Booth was a PE graduate student interning in athletic training. She was appointed athletic trainer for KU women athletes in the late 1970s, when more funding was available. Over several years, she converted a former exercise physiology lab in Allen Fieldhouse into the KU

women's athletic training center, with multiple training tables, diagnostic and modality instruments, electrotherapy, and thermotherapy.

There was no equipment manager for women's intercollegiate sports during the first four years, when the program was administered within the PE Department. Because the women's intercollegiate athletes borrowed their sports equipment from the women's instructional and intramural programs, the women's locker-room and sports-equipment attendant, Frances Wales, issued equipment to the sports teams as requested by coaches. She also voluntarily assisted in securing, laundering, and issuing to players the one set of intercollegiate uniforms used for all varsity team competitions.

Initial Uniforms and Equipment for KU Women's Athletics

At the beginning of the KU women's athletics program, the stringent budget provided for purchasing only one set of twelve competition uniforms. In the 1960s, there were two major manufacturing companies offering women's sports uniforms, Broderick and E. R. Moore. E. R. Moore's main line for women at that time was a one-piece cotton uniform worn in PE classes. Broderick offered a new line of women's two-piece uniforms made of nylon and polyester—a thick, stretchy texture that wore well and could be laundered commercially. Because the KU school colors were Columbia Blue and Harvard Red, and men athletes at KU wore blue, the KU women's uniforms were also blue. Among an assortment of colors, Broderick offered only one shade of blue—a light, sky blue that could be trimmed in other school colors.

With limited choices in the 1968–1969 academic year, I ordered elastic-waisted, light-blue shorts and collarless, sleeveless, pullover shirts from Broderick for the KU women's sport teams. These uniforms were trimmed with matching red and white piping on the shirts and shorts and had red numerals trimmed in white on the fronts and backs of the shirts. I ordered a dozen uniforms in small, medium, large, and extra large—half of them were medium, but only one was extra large. In the second year, I purchased matching light-blue jackets with the word KANSAS in red with white trim sewn on the backs. Small Jayhawk emblems I purchased at the KU bookstore were hand sewn on the front-left shoulders of the jackets. In the 1970–1971 academic year, I ordered a dozen matching long-legged warm-up pants in the same sizes.

The KU women's basketball, softball, and volleyball teams wore these uniforms for the first four years of intercollegiate competition. Often, because of seasons with overlapping schedules, basketball players had to wait

for the volleyball match to end to have the uniforms laundered for them to wear the following day, or vice versa. The softball schedule did not overlap, so the uniforms were available for that. Field hockey uniforms were pleated wool tunics in dark blue and red plaid left from previous KU club field hockey teams. The players wore these tunics over collared shirts they supplied themselves. In late-season cold weather, players also supplied their own dark-colored cotton leggings (sweatpants) and long-sleeved sweatshirts, which they wore with the tunics.

For the 1972–1973 season, volleyball team members each purchased their own red, cotton, long-sleeved turtlenecks to wear with their light-blue shorts as an alternative to the sleeveless, polyester shirts because long-sleeved shirts were more customary for volleyball players then. They ironed white numbers onto the shirts in compliance with volleyball rules and wore these red shirts with the light-blue shorts for the following season as well. After the more lucrative Kansas regents' funding allocations became available in 1974, the program purchased new uniforms for each of the KU women's sports teams.

Prior to 1974, the PE Department lent the women's intercollegiate teams its sports equipment. The PE Department issued new basketballs, softballs, and volleyballs it had purchased for AKWIS and Kansas Association of Intercollegiate Athletics for Women (KAIAW) games to the KU women's athletics teams for their games and matches. When the balls became worn, they were used for practice, PE classes, and intramurals. The PE Department also lent the basketball and volleyball nets and softball bases, bats, and catchers' masks to the teams. The women gymnasts shared floor mats and vaulting horses with the KU men's gymnastics team, and they used the ancient women's gymnastics balance beam and uneven bars purchased for PE classes. The PE Department and intramurals teams provided field hockey sticks, shin guards, and balls. Because both the field hockey team and the PE classes used the same playing field, they used the field hockey goals built for KU club field hockey.

Women basketball and volleyball players bought their own shoes, socks, and kneepads. Field hockey players only needed their own outdoor attire with shoes and socks for practice because they wore PE Department shin guards and tunics for competition. Gymnasts and swimmers purchased their own leotards and swimsuits for practice, but after the initial year their coaches ordered them uniforms. Softball players bought their own gloves, shoes, and socks.

There were no personnel available for grounds preparation in the beginning years of KU women's outdoor varsity sports. The coaches marked the playing fields with a chalk-lining wheel prior to home events for the field hockey sidelines and end lines, twenty-five-yard lines, fifty-yard line, and goal circles. The coach and volunteer players carried softball bases to the field and measured for accurate distances between goal lines or bases before marking the batter box and foul lines. The volleyball coaches were responsible for setting up volleyball standards and stringing volleyball nets at the correct height over the courts where varsity practices and matches were held, too. Often, the basketball goals were in an inappropriate position over the varsity court for volleyball practices and games and had to be raised or lowered slowly according to the sport being played, but fortunately they operated on a hydraulic system, albeit slowly. The women's gymnastics coach could use the men's gymnastics mats and vaulting horse, but she often had to move men's gymnastics equipment to use the uneven bars and balance beam for practices. Usually, student athletes in the respective sports helped the coaches set up these indoor and outdoor practice and competition venues.

Recruitment of Early Women Athletes at KU

KU used campus announcements to recruit women athletes during the first years of the women's intercollegiate athletics program. Recruiting women athletes beyond the students already enrolled at KU was not possible in the 1960s, not only because of insufficient funds for scholarships and recruitment travel but also because the CIAW regulations prohibited it, primarily because women in the PE profession at the time considered it exploitation of student athletes as exemplified nationally in men's collegiate sports. The original AKWIS organization, for in-state women's intercollegiate sports, specified that no athletic scholarships be offered to women and that all women athletes be enrolled as full-time students at the institution they represented. Some private Kansas institutions offered need-based academic "grants in aid" to student athletes, but those students were ostensibly offered the grant for reasons other than for their athletic abilities. Prohibition of athletics scholarships for women continued until the AIAW began to allow it in 1973–1974.[19] In 1976, KU reportedly awarded one scholarship per sport as a grant in aid valued at $15,000, which included tuition and textbook loans or purchases.[20]

Recruitment of women athletes in 1968–1969 was done the old-fashioned way because social media did not exist then. In late August 1968, shortly after classes began, the first notice for field hockey tryouts was typed and tacked to the bulletin board outside the women's locker room in Robinson Gym, and a notice was published in the *Daily Kansan* campus newspaper. Subsequently, for each women's intercollegiate team tryout, a notice appeared on the women's locker-room bulletin board, and a short announcement appeared in the *Daily Kansan*. Women's PE instructors also announced the tryouts for each sport in classes, noted if there were skilled women athletes in those classes, and encouraged them to try out for the teams.

The Robinson Gym bulletin board outside the women's locker room also served as the primary source of information regarding practice and game schedules and travel arrangements for away games. Opportunities for competition were limited in the first year because of the lack of availability of competing teams and the long distances to travel. However, at least five Kansas higher-education institutions fielded intercollegiate athletics teams for women in the inaugural year, 1968–1969.

Early Road Trip Arrangements for KU Women Athletes

In the early years of women's intercollegiate sports, KU women athletes did not have access to the university's vehicle fleet for transportation to off-campus competitions. University-owned cars and vans were available to KU administrators and occasionally to department chairs for professional functions, but these vehicles generally were not available to untenured faculty or coaches. Therefore, coaches and student athletes used their own vehicles to drive their teams to away events during the first two years of the women's intercollegiate sports program.

For team sports, which required multiple vehicles, upper-class-women athletes would volunteer to drive their cars along with the coaches. Cars in the late 1960s and early 1970s had bench seats in the front and back, and each car could hold about six people, so two or sometimes three cars accommodated a traveling team. Neither center consoles nor bucket seats were built into new cars until the early 1980s. Seatbelts were first included in new cars beginning in 1968 but seldom used because the state of Kansas did not mandate it until 1986.[21] During the first three years of the KU women's athletics program, each driver who transported team members in her own car submitted a receipt to the PE Department for gas and was

compensated five cents per mile from the women's athletics budget. Later, KU women coaches were allowed to drive university vehicles and charge the expense to the PE Department budget.

The head coach always drove the lead car when more than one car was required for the trip, and I drove my car to every away game in basketball, field hockey, softball, and volleyball. For basketball, field hockey, and softball in the first year, Copeland drove the second car, and for the subsequent two years, Sandy Hick, a doctoral student, usually drove the second car because she was a rated official for KU. Student athlete Joan Lundstrom (later Wells) also volunteered to drive her car when the volleyball team traveled. Lundstrom always said she could tell when I was telling my passengers an involved story because I slowed my car down below the speed limit. (There was no cruise control then!) I always kept the second car in my rearview mirror and got plenty of experience gauging distances and driving time and following directions in college towns during those years of driving teams to events.

During the years I coached for KU and drove student athletes to away games and matches, there were only a couple of problems or accidents, as I recall. In one instance, a leased vehicle needed a water hose replacement near St. Louis on the way to the 1971 DGWS National Volleyball Championship. Two years later, on the return trip from the 1973 AIAW Regional Volleyball Championship in Minneapolis, I was driving with five players in the car and hit black ice just north of Ames, Iowa. The car spun and slid backward off the edge of the interstate highway, but it stopped when the wheels hit the grassy area of the shoulder. We drove in inclement weather numerous times, but we were cautious and listened to the highway reports. We ensured that the vehicles we used for team travel were covered by private auto insurance. In those early years, it did not occur to anyone that people might file lawsuits over accidents involving students driven in private vehicles, so it was fortunate there were no serious incidents.

Team meals on road trips in the first year of the women's intercollegiate sports program were the responsibility of each player, and often they were asked to bring along a sack lunch if we were away during a mealtime. When travel spanned more than one mealtime, we would plan to stop at an economical restaurant where players could purchase their own food. In subsequent years, prior to the Kansas regents' budgetary supplements in 1974, occasionally the coach chose affordable restaurants on away trips and covered meals for players, designating a limit on the amount each player could spend, usually less than three dollars per meal. If a player wanted a

more expensive meal, she paid the difference. The coach paid the restaurant bill and submitted a receipt to the PE Department for compensation.

Only on rare occasions during the first three years of intercollegiate competition did the KU women's teams make an overnight trip to another Kansas college or university. The exceptions included a doubleheader at Fort Hays State University, a competition with at least one other institution in the west end of the state, and a two-day postseason tournament more than a two-hour drive away. When lodging reservations were required, the players shared rooms at a mid-priced motel recommended by the host school. Four players were assigned to a room with two double beds and sometimes requested a rollaway bed when there was an odd number of players. The players considered an overnight trip an exceptional experience, and the team bonded even more. Often, the budget dictated that the coach have one or two students sharing her room rather than having a private room. If there were two coaches or a coach and an official on the trip, they shared a room. The coach arranged for the lodging and paid the motel bill, then presented a receipt to the PE Department for compensation.

With the meager funding for initiating KU women's intercollegiate athletics in the first five years, budgeting creativity was required to meet the expenses of operating this new program. With the PE Department lending resources and equipment in those fledgling years, the women's competitive athletics program survived and thrived. The willingness of women athletes to endure hardships because of lack of funding, their personal contributions, and the dedication of volunteer coaches and officials who wanted young women to have the chance to compete in sports also sustained the program.

Extended Funding for a National Tournament

Travel to a national tournament seemed far beyond the possibilities for a KU women's team in the early years of their intercollegiate athletics, but the KU women's volleyball team won the state championship and earned a berth in the second DGWS National Volleyball Championship, hosted by KU in February 1971. Because several of the same women athletes also played on the KU women's basketball team, they had tasted the excitement and challenge of playing in a national tournament, and they were eager to play in another one. That opportunity came just a month later, when the KU women's basketball team won the state championship in March 1971 and was invited to the third DGWS National Basketball Tournament at

West Carolina University (WCU) in Cullowhee, North Carolina. The team was thrilled, and as their coach I wanted to find a way to get them there, too. The CIAW had not yet sanctioned a national championship for women's basketball, so this was the only intercollegiate championship tournament in basketball then. KU was the official Kansas representative, even though Kansas State University (KSU) was also invited as a lower seed on the basis of its tournament entry the year before.

The total women's athletics budget for 1970–1971 was $2,800, and all of it had been committed for the seven sports that year. Traveling to North Carolina required transportation, lodging, and food for a week, and we had to be creative in finding resources for each. The basketball team sought funding from the KU Student Senate and was promised enough to purchase food during the tournament week. They planned picnics and purchased groceries for the road trip. Also, meal tickets were available at the WCU dormitory where they would stay.

The university vehicles certainly were not available for out-of-state team travel. There were no rental car agencies in Lawrence in 1971. Joie Stapleton contacted Dean of Women Emily Taylor, who found sufficient funds in the KU Endowment for the team to lease two station wagons from the local Ford dealership, and Henry Shenk authorized the PE Department to use its travel funds to refund our gas expenses. In the 1970s, few four-lane interstate highways existed, so we faced a forty-hour road trip on two-lane highways through many small towns in Missouri, Illinois, Kentucky, Tennessee, and North Carolina.

We had no funds for staying overnight at a motel along the way, so the women athletes supplied air mattresses and sleeping bags to lay in the back of the station wagons, and nine players and three drivers rotated sleeping there or sitting in the front seat while both cars rolled from Lawrence to Cullowhee with only picnic and restroom stops. Paige Carney was the only senior on the team above the age of twenty-one and thus eligible per Ford's lease to drive one of the two station wagons, so I invited senior volleyball captain Joan Lundstrom, then student teaching at Lawrence High School, to be a third driver and serve as team manager. The three of us rotated as drivers among the two station wagons the whole way there and back.

At WCU during the tournament, the team slept in a women's dormitory second-floor lounge, borrowing mattresses, sheets, blankets, and pillows from WCU students who had gone home for spring break. Fortunately, as head coach, I had a dorm room down the hall from the lounge, with a real bed. The team ate meals in the dormitory cafeteria with meal tickets that

1970–1971 KU basketball team with Coach Marlene Mawson.

cost two dollars a day. In many ways, the experience was reminiscent of the many road trips I took with my US Volleyball Association Kansas City team to tournaments in Oklahoma, but those teams never spent the whole night on the road.

That same week, the KU men's basketball team was playing in the NCAA Final Four in Houston. The male athletes were flown there, stayed in a hotel, and had bus transportation throughout the city and to their games. The difference in accommodations did not seem to matter to the KU women's basketball players because they were just excited to be competing in a national tournament. Our trip to North Carolina was unique and memorable. None of the players or I will ever forget the persistence and fortitude it took to participate in that championship. Although the women lost their first game in double overtime, they continued to compete in the consolation bracket and won all of those games except the final one. It was a fulfilling demonstration of what those pioneer KU women athletes were willing to endure to have the opportunity to play in a national competition.

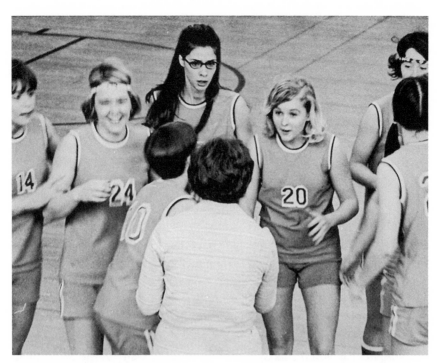

1970–1971 KU basketball team huddles with Coach Marlene Mawson at the DGWS National Basketball Championship.

The tenacity and athleticism of the first women's intercollegiate teams at KU enabled them to achieve state and national recognition and established a firm foundation for KU Women's Athletics. Those first three years were but a spark of the achievements yet to come. National developments would soon enhance the opportunities for women competing in sports. In the 1970s, college women athletes would benefit from the DGWS forming a national governing body and initiating additional national sports championships, along with the passage Title IX promising equal opportunity for women in educational institutions and forcing better conditions for women athletes. Dramatically increased funding for women's intercollegiate athletics amplified the effect of these significant developments. Although KU kept few records of scores and individual achievements in women's intercollegiate sports during the 1970s, and the media seldom acknowledged women athletes, the growth of women's varsity sports and inclusion of women coaches and administrators throughout that decade can be traced. The best was yet to come!

THE FIRST DECADE
OF KU WOMEN'S
INTERCOLLEGIATE SPORTS

Professional apparel appropriate for women faculty at the University of Kansas (KU) in the late 1960s and early 1970s included knee-length skirts, panty hose, and heels. At the time, free parking was in the graveled lot south of the Robinson Gym tennis courts, now a large, hard-surface, restricted parking area across from Allen Fieldhouse. Each morning when I arrived for work, I walked in heels along the sidewalk that wound from the parking lot around Robinson Gym to the front door on Sunnyside Avenue. Striding across the concrete catwalk to enter the front door of Robinson Gym and descending stairs to the lower floor brought me to my faculty office in the women's physical education (PE) office suite.

This office was my campus sanctuary, where I planned and organized the new KU women's intercollegiate sports program. Of course, there were all kinds of priorities and interruptions throughout the day, from preparing to teach classes, changing into sports attire to teach PE activity classes, changing back into street attire for classroom and office hours, advising students, responding to phone calls and memos, and preparing for and attending academic meetings. In the late afternoons and into the evenings, sports practices were held. Normally in those beginning years, I retrieved my car at the end of my workday in the dark parking lot, long after the sun had set, in freezing cold winters and in mild autumns and springs.

I was excited to be the new faculty member selected to direct the KU women's intercollegiate sports program. My mind began to sort the initiatives needed immediately and to consider the means of completing them. I had no idea then of the extent to which women's athletics would develop. If I could have foreseen the dynamic growth of women's athletics, it might have seemed an overwhelming position. But I was a young career professional, eager to find ways to make things happen and to imagine possibilities without considering failure, but only alternate routes to the goal. My

confidence had been developed during my high school teaching years with encouragement from colleagues, and there was support from colleagues in higher education, too.

I had assistance on the KU campus and among my colleagues statewide. My campus mentor, Joie Stapleton, the head of women's PE, provided encouragement and guidance, and she reinforced my leadership authority as KU Women's Athletics director. Women PE teachers named women's athletics directors at other Kansas institutions became my collaborators in formulating guidelines for women's intercollegiate sports, and I soon found that my insistence on establishing uniform standards in Kansas women's athletics positioned me as a leader beyond the KU campus.

Although my agenda involved many tasks each day, the work was so rewarding that the hours slipped away. My only regret was that I did not seem to have sufficient hours in the day for the highest quality in each of my major responsibilities: preparing to teach and teaching, participating in departmental academic governance, preparing to coach and coaching, organizing and directing the new KU women's sports program, contributing to the newly formed state governing organization for women's intercollegiate athletics, and earning my doctoral degree. But my passion was always providing women the joy of competing in sports.

In fall semester 1968, I scheduled games and meets with nearby colleges via phone calls, conferring with other women's athletics directors to confirm home and away events. No state organization had yet been formed for establishing standards for women's intercollegiate sports or scheduling games between institutions. Competition in that first year was not extensive because few colleges had formed varsity teams by then, times other college teams could compete were limited, and the travel distance could be prohibitive. But KU did schedule intercollegiate competition in all six women's sports in the first year.

The Commission on Intercollegiate Athletics for Women (CIAW) called for bids to host Division of Girls and Women in Sport (DGWS) National Championships in fall 1968 for gymnastics and track and field. CIAW accepted bids for badminton, swimming, and volleyball in spring 1969, only a few months after I arrived at KU. Minimum requirements of institutional administration support, a tournament director with experience, adequate practice and competition facilities, team accommodations, transportation availability, qualified sports officials, personnel assistance, and prospects of ticket revenues were among the principal specifications that colleges and universities submitting bids had to document.

Stapleton insisted that KU submit a bid to host a national championship. She suggested I bid for the badminton championship because there were eight badminton courts painted over the basketball and volleyball courts in two gymnasia in Robinson Gym. However, there were also six volleyball courts marked with painted lines in those two gyms, and I thought volleyball would draw more spectators than badminton. She agreed and told me I should gather the necessary documentation and submit a bid to host the DGWS National Volleyball Championship. The bid to host was due within a couple of weeks of our conversation, and I submitted it on March 28, 1969. Before the end of spring semester 1969, the CIAW notified me that Long Beach State University was selected to host the first DGWS National Volleyball Championship in 1970; however, I was encouraged to resubmit our bid to host the second championship, and I submitted a second bid on May 7, 1969. On August 3, 1969, the CIAW notified me that KU was selected to host the second DGWS National Volleyball Championship in February 1971, and that was only eighteen months away.[1] I was thrilled to win the bid but scared to think of the time and effort it would require to prepare for the event. Meanwhile, other enterprises for women's athletics were ramping up in Kansas.

In April 1969, women's athletics directors from across Kansas held a scheduling meeting to generate more intercollegiate events per sport during the 1969–1970 academic year. It would take even more intensive meetings of these directors and coaches to compose a governing document that included the regulations for women's intercollegiate sports competition among Kansas institutions. Initially, the Association for Kansas Women's Intercollegiate Sports (AKWIS) constitution and bylaws governed women's intercollegiate competition. AKWIS continued to be the nucleus for KU women's intercollegiate sports for the first decade of competition.[2]

The formation of KU women's teams and sports seasons remains indelible in my memory, but after fifty years, for specific athletics records, I reviewed the results of each sport's season from the late 1960s through the 1970s published in *AKWIS Newsletters* (1969–1973) and the Kansas Association of Intercollegiate Athletics for Women's *KAIAW Communications* (1973–1981), now held in the Kansas Historical Society Archives in Topeka.[3] These documents reveal that not all competition results were shared with AKWIS member institutions by the early coaches, and generally, individual athletes' achievements were not recorded prior to 1980. Still, the records of women's teams reported during that first decade are worthy of noting.

Early Sports Seasons in AKWIS

At first, sports seasons were loosely defined because competition schedules extended from the beginning of classes in the fall semester until weather and available competition generated a move on to another sport's season. AKWIS approved designated season dates beginning in fall 1971.[4]

Early Women's Field Hockey at KU

KU recruited its first women's intercollegiate team, for field hockey, in September 1968. Mostly, the women who tried out were PE majors who had played field hockey in high school in the larger cities of Kansas. A few prospective field hockey players had high school experience from eastern cities, where field hockey clubs were more prominent, and some had played KU club field hockey.

KU played field hockey on the far-east field from Robinson Gym, where the computer services facility was later constructed. The field had an east-west orientation with a slight uphill grade to the east, making the west goal more of an asset for scoring, so the team always chose to defend the west goal in the first half. Campus maintenance workers built goal cages using the standard specifications. The goals were portable rather than permanent, although they were too heavy to be moved without maintenance assistance. Each of the four goalposts per goal was constructed of two-inch steel-pipe posts, with baseball fencing wire stretched between them and the horizontal bar because the goals also served as softball backstops for classes and intramurals in the spring semesters. The grassy field was uneven: clumps of grass and paths made by students cutting across the field to classes made dribbling a field hockey ball precarious. The coach had to use the marker wheel to chalk the boundary lines, yard-marker lines, and striking circles on the field each week, and she laid down clean markings for intercollegiate competitions. Even though the varsity team practiced in warm late afternoons in the early fall semester, the field hockey season was relatively brief because few other colleges in Kansas supported field hockey and the late-semester weather prohibited a longer season.

Early Women's Volleyball at KU

In October 1968, when the temperatures became cooler, KU announced women's volleyball team tryouts. More women were interested in it than in field hockey because most high school PE and intramural programs in

Kansas included volleyball. Several upper-class-women students had played volleyball at Sports Day events in previous years, and others were recruited from volleyball classes. The team practiced in the north gym of Robinson, where nets were strung on portable volleyball standards. The net height varied somewhat across the court, and it was not possible to tighten the bottoms of the nets with the minimal equipment the intramural teams shared with the varsity team. The KU team played other colleges and universities throughout the state between November and February. KU hosted and won the first Kansas intercollegiate volleyball tournament in February 1969. KU also won the second state volleyball tournament in December 1970 and hosted and competed in the second DGWS National Volleyball Championship in February 1971.

Early Women's Basketball at KU

KU announced women's basketball tryouts in November 1968, and the season was scheduled between mid-December and early March. Women trying out who had played high school intramural basketball and participated in Sports Days or KU club teams competed most successfully for a position on the varsity team. A few women students other than PE majors had played high school basketball in Iowa, and these women exhibited exceptional basketball skills either as defensive or offensive players. Iowa high schools held highly contested girls' state championships, but there, game rules permitted use of only half the court by each player, and Kansas women athletes played the new experimental five-player, full-court rules.

The women's basketball competition schedule overlapped the volleyball schedule in the first two years of competition, and several of the women PE students were chosen for both teams. Thus, volleyball practices were held from 4:00–6:00 p.m., and basketball practices were held from 7:00–9:00 p.m. in Robinson Gym. At the start of the winter months, after an afternoon volleyball practice a majority of the women athletes took a short break for supper in their on-campus dormitory dining hall and then returned to Robinson Gym to practice basketball for the rest of the evening. During the overlapping competition seasons, volleyball matches were typically scheduled as quadrangles on Saturdays, whereas basketball games generally were held on Thursdays and Fridays so that the players and coaches were able to accommodate both schedules. All KU women's varsity basketball and volleyball home games and matches were played on the east court in the north gymnasium in Robinson, and the few spectators sat in folding chairs along

KU women's basketball starting five in blue uniforms with Coach Marlene Mawson, 1968–1969.

the sidelines. Often a women's intramural game was scheduled on the west court simultaneously with the women's varsity team on the east court, but the team continued with practice or an intercollegiate game because it was the only space available at the time.

Early Women's Gymnastics at KU
KU women's intercollegiate gymnastics competition began in the second semester of the 1969–1970 season, although a couple of invitational meets were held in the previous season. Gymnastics instructor Anise Catlett recruited gifted women for the tryouts from her gymnastics classes and some who had honed gymnastics skills in private clubs outside of school. The varsity team practiced in the Robinson gymnastics room after the men's team had completed practice. The women used the same vaulting horse and mats, along with an old balance beam and uneven bars that gymnastics classes in the PE academic program used. Only a few Kansas institutions fielded gymnastics teams in the early 1970s, and meets were usually invitational for surrounding institutions.

Early Women's Softball at KU
Women's varsity softball began at KU in late March 1969, and interest in tryouts came mostly from KU students who had played summer softball in

city leagues. Again, talent was strong and included several of the same PE majors who had made the volleyball and basketball teams. Softball practices were held on the intramural field directly east of Robinson Gym when weather permitted. (Since then, new Robinson tennis courts have been built in the middle of the east Robinson field where the softball diamond was earlier.) A permanent trisection backstop was constructed for home plate at the southeast corner of the Robinson softball field for intramural games. A tractor mowed the grassy field once or twice during warm months. The field sloped downward from home plate in the southeast corner toward the outfield to Sunnyside Avenue, so that when hits went beyond the center fielder or right fielder, the ball kept bounding to the earthen berm that held the sidewalk against the street. Even though there was some grass on the infield, grass surrounding the batting area was worn away from excessive use as a men's intramural softball field; similarly, baselines were relatively free of grass, but the outfield had many clumps of mowed grass. The clay-like surface on the denuded area around the batter's box at home plate was trampled down too hard to rake or for batters to "dig in." The women's softball coach measured the baselines for correct softball base distances and marked foul lines and batting boxes with a chalk-lining cart before home ballgames. The coach and players borrowed balls, bases, bats, and a pitching rubber from the academic PE equipment room and carried them to the field for each practice. During varsity games, the KU team and the visiting team sat on locker-room benches carried outside and placed along each infield foul line because there were no dugouts at the rudimentary softball field.

By the second season, KU women's softball practice and competition were scheduled on Lawrence Parks and Recreation fields. The softball diamond at Broken Arrow Park was scheduled beginning in the 1969–1970 season for competition, and other city parks with ballfields were also used for practices and games. When the Holcomb Complex was completed in 1974 by Lawrence Parks and Recreation, KU women's softball was scheduled there. The softball season did not overlap with the other team sports seasons because the basketball season concluded in mid-March. The end of spring break on campus was the time for softball tryouts, but the softball schedule for practices and competition depended on weather conditions. The softball season concluded in early May, near the end of the spring semester, and in the earliest years the final season conference standings indicated the winner. A postseason softball tournament was deemed unnecessary in 1969 because few teams competed. In the second year of women's

intercollegiate sports in Kansas, more institutions fielded softball teams, and a postseason tournament was held.

Early Women's Swimming at KU

The first KU women's intercollegiate swim team competed in the 1968–1969 season. In 1968, the Robinson Gym natatorium was the only swimming facility on the KU campus and the only indoor competitive swimming facility in Lawrence. The six-lane natatorium had twenty-five-yard competition lanes, a diving well with one-meter and three-meter diving boards, and adjacent women's and men's locker rooms. Permanent seating was at the starting end of the competition lanes. The KU women scheduled practices and competition around academic swim courses and men's varsity swim practices and competition as well as the KU Quack Club synchronized swim practice and show times. Several women swimmers were also members of the KU Quack Club.

When women's intercollegiate sports began in Kansas in 1968, only KU and Kansas State University (KSU) sponsored swim teams. KU students tried out in fall 1968 for the women's varsity swim team, and they began swim competition in spring semester 1969. The KU swim coach was initially responsible for contacting swim coaches at other institutions to establish a competition schedule, but in the later 1970s, swim meet schedules were set annually by all coaches at participating schools. Kansas State Teachers College–Emporia (KSTC; now Emporia State University), KSU, and Wichita State University (WSU) competed with KU in swimming by the third year of women's intercollegiate athletics in Kansas. But because of the lack of aquatic programs at the smaller colleges, swimming was not a dominant intercollegiate sport in Kansas until the Big Eight schools began to schedule intercollegiate competition in the late 1970s. Few meet records of individual achievements from those early years are available.

Early Women's Tennis at KU

The Robinson Gym tennis courts, south of the gymnasium and along the north edge of the parking lot in 1968, hosted PE class instruction, intramural matches, and club competition on campus. There were eight hard-surface, regulation, outdoor tennis courts. On either side of a walkway that split the tennis courts, two tennis courts were enclosed side by side, and two additional courts were situated identically at mutual end lines of the courts inside an exterior fence. A blacktopped sidewalk ran between the two sectioned areas for tennis from the parking lot to the Robinson Gym

west entry doors. Each set of four courts was surrounded by fences, and gates permitted entrance to the interior and between the two enclosed court areas. The KU women's tennis coach scheduled practices and competition among the other users. Kansas women's intercollegiate tennis began in fall 1969, but some spring tennis competition was also scheduled during the 1970s. Although KU at first competed with five other Kansas teams in women's invitational tennis tournaments, win-loss records for the early years are unavailable. In 1970–1971, AKWIS sanctioned tennis for the first time, and six Kansas institutions competed. The following year three more institutions started tennis teams, but one dropped out, resulting in eight teams for the next few years. In the years 1970–1974, the KU varsity team consisted mostly of women who had competed in summer club tennis. Coaching was minimal, with the primary contribution of the tennis coach scheduling and supervising practices on the Robinson Gym tennis courts, selecting competitors for the tennis matches and tournaments, and arranging travel and driving the tennis team to away games.

Early Women's Track and Field at KU

When the DGWS instituted national championships in 1969–1970, the CIAW sanctioned track and field as an eligible sport. As with other women's intercollegiate sports, KU announced track and field tryouts for 1971–1972. In these beginning years, the few women's events in track and field were scheduled simultaneously within the KU men's track-and-field meets. Few other Kansas institutions competed in women's track and field, so AKWIS did not sanction state competition in the sport until later, and early KU women track-and-field athletes competed with individual times and distances for qualification in regional postseason events. KU first sent an athlete to a national intercollegiate track-and-field competition during the 1971–1972 season, when Interim Women's Athletics Director Ann Laptad sponsored a discus thrower to enter.

Marian Washington coached women's cross-country in 1972–1973, and in 1973–1974, she was appointed KU track-and-field coach for one year, but afterward she coached only KU women's basketball.[5] KAIAW did not sanction track and field as a women's intercollegiate sport until 1974. WSU hosted the Association for Intercollegiate Athletics for Women (AIAW) Region 6 championship in track and field in 1974. After 1974, the KU women's varsity team practiced in Allen Fieldhouse for the indoor season events and on the track at Memorial Stadium for the outdoor competition.

Early Women's Golf at KU

Marilyn Smith, a KU golfer, won the National Collegiate Women's Invitational Golf Championship in 1949, hosted by Ohio State University annually before the DGWS sanctioned golf for national tournaments. She was one of the thirteen founders of the Ladies Professional Golf Association (LPGA), and she was the first woman inducted into the KU Athletics Hall of Fame.[6] Nancy Boozer, a 1951 KU graduate, was a success in the LPGA with Smith.[7] Joie Stapleton had regarded Boozer as a leader in the KU Women's Recreation Association (WRA) as an undergraduate PE major and recommended her twenty years later as a volunteer women's golf coach at KU. In the 1970s, Boozer still lived in Lawrence and was an avid LPGA competitor.

In 1972, Boozer was appointed the first KU women's intercollegiate golf coach. KU women's golf was quite successful in the early years, even though the team played only in invitational tournaments because golf was not a KAIAW-sanctioned sport and few other institutions in Kansas sponsored a golf team. With two of Boozer's daughters on the KU team for seven years during the 1970s, the women's team competed well in regional and national tournaments all through the decade.

In the early years of women's intercollegiate sports, most team members were PE majors. They were likely to be either team sport players or individual sport athletes, but seldom were they interested in participating in both team and individual sports. Many women athletes in early intercollegiate athletics tried out for more than one sport and were chosen for more than one team, and some were starters on as many as three or four teams in the same year and for as many as four years. As sports skills improved over the years and the sports preseasons and seasons were extended and overlapped, athletes gravitated toward focusing on one sport year-round.

In July 1974, the KU women's intercollegiate athletics program was moved from the Physical Education Department to KU Athletics. After recruitment of scholarship athletes was allowed for women's sports as of fall 1974, highly skilled athletes chose to attend colleges and universities that had successful programs. In that same year, KU women's intercollegiate sport coaches began to be paid salaries; thus, they had more time to recruit athletes, prepare for practice, and study coaching strategies. However, during the 1970s all KU women's coaches were contracted only part time,

KU women's field hockey scoring on outside field of Robinson Gym, 1970.

and not until the 1980s were head coaches for women's teams offered full-time, salaried positions.

Early Results of KU Women's Intercollegiate Competition

The *AKWIS Newsletter* reported results of Kansas women's intercollegiate competition for all participating institutions between 1969 and 1973, and the *KAIAW Communications* followed suit with quarterly issues from fall 1973 through 1980. The women's athletics directors of the AKWIS member schools met each spring to coordinate mutually convenient competition schedules. When the AKWIS was renamed the KAIAW during the 1972–1973 season and added more sports, the head coaches became more involved scheduling games and meets for the upcoming seasons.

Competition results were reported to an elected AKWIS scheduling officer for each sport, tabulated for the monthly newsletter, and mailed to the women's athletics directors. When *KAIAW Communications* was initiated in October 1973, competition results were reported to the editor and published there. Because of lost or unreported scores, some early competition results are unavailable. I have included early KU team results for national championships in basketball, gymnastics, golf, softball, and volleyball competition in Chapter 6 of this book.

Beginning in 1972–1973, the AIAW held regional championships for teams to qualify for national championships in all sports. In 1974, the AIAW created three divisions for competition according to member institution enrollment size and scholarship numbers. The larger schools, which

Opponent tackles KU women's field hockey dribbler, 1972.

could recruit more highly skilled players, competed separately from the smaller schools. In-state divisions were similar to those of regional and national ones. KU played in state and AIAW Region 6 championships in basketball, softball, and volleyball to qualify for national championships during the last half of the 1970s.

The KU women's teams were relatively successful during the 1970s, as documented in existing records. However, in many cases, the KAIAW postseason records are all that remain in some sports. The larger Kansas institutions consistently fielded teams in all KAIAW-sanctioned sports for women, but several Kansas colleges participated in only a few sports. The evolution of Kansas women's intercollegiate sports competition was evident as the 1970s progressed toward the 1980s because the designated sports seasons changed, the number of colleges participating increased, and the coaching expertise improved as competition grew more intense.

Early Women's Field Hockey Results

KU played field hockey against a few area teams in fall 1968, with Delores Copeland coaching. As her co-coach, I officiated for practice and games. Central Missouri State University (CMSU; now the University of Central Missouri), KSTC–Emporia (now Emporia State University), KSU, and Washburn University scheduled games with KU, and the Kansas City Field Hockey Club played an exhibition game against KU, but results were not recorded.

After the AKWIS began in spring 1969 to schedule games for the following academic year, the competition included home and away games versus KSTC–Emporia, KSU, Washburn University, and WSU. Because the conference included only these teams, instead of holding a state tournament the AKWIS determined the state champion based on final conference standings.

Copeland resigned after the first season, and as the only KU faculty member with field hockey experience, I coached the team for the next two fall seasons. KU won the AKWIS conference championship in fall 1969, defeating both KSTC–Emporia and WSU. KSTC–Emporia, which placed second by defeating WSU, was a highly competitive team coached by Mary Estes. It defeated KU in 1970; KSU was third, WSU fourth, and Washburn University last. No results records were kept other than the AKWIS State Championship winner.[8]

For the fall 1971 season, Laptad was head coach with Veronica Hammersmith, a graduate teaching assistant in PE, as her assistant. At the end of that season KSTC–Emporia, KSU, and WSU were in a three-way tie for the AKWIS State Championship. KU was in fourth place, Washburn University fifth, and Benedictine College last. No playoff was held because the late-November weather was not conducive to outdoor play.[9]

In the fall 1972 season, Sharon Drysdale became the head coach. KU regained the field hockey conference championship; KSTC–Emporia and KSU tied for second, WSU was fourth and Washburn University was fifth. Coach Drysdale continued to lead the team in fall 1973, when the team tied with KSTC–Emporia at the state tournament for first place in the KAIAW conference; however, the tie was broken using the rule of most goals scored during the season, minus goals scored against the team. KU's 12–1 goal record, when compared with KSTC–Emporia's 4–2 goal record, meant that KU won, KSTC–Emporia came in second, and WSU placed third. Also in fall 1973, KU participated in a US Field Hockey Association (USFHA) club tournament in St. Louis, where the opponents were Central Missouri State

University, the Kansas City club team, the St. Louis A & B clubs, Southwest Missouri State University (SMSU; now Missouri State), and the University of Missouri. KU won two games 1–0 and tied Missouri 0–0. KU's Mary Visser was named the A-Team center forward for that tournament.

When the KU women's athletics program was moved from the Physical Education Department to KU Athletics in 1974, graduate teaching assistants became the field hockey coaches. For the two fall seasons of 1974 and 1975, Jane Markert coached the team, and in fall 1976 and 1977, Dianna Beebe coached it. No win-loss records for those years were reported in KAIAW documents. The KAIAW no longer sanctioned field hockey after the 1977 season.

Early Women's Volleyball Results

Women's intercollegiate volleyball began as a late-fall-semester sport in Kansas, and later with out-of-state competition following the conference season, this sport spilled over into the spring semester during its early years. In the 1968–1969 season, KU played several other teams within a ninety-mile range, including KSTC–Emporia, KSU, Mount St. Scholastica College (in Atchison), and Washburn University. KU hosted the first state volleyball championship in February 1969 and won, defeating KSTC–Emporia in the finals.[10] The KU players purchased a small trophy commemorating that championship and presented it to me, and I've kept it as a special memento.

KU retained the AKWIS/KAIAW volleyball crown for the next six years. KU had a nationally recognized team from 1970 to 1974, when it earned a berth in the second through the fifth DGWS National Volleyball Championship. I detail the championship results in Chapter 6.

When the AKWIS sanctioned volleyball competition in 1968 to begin in fall 1969, member colleges and universities agreed to two competition divisions to mitigate the driving distances across Kansas. Often, the women's athletic directors scheduled quadrangular competition so that four colleges could compete at the same location, saving driving time and travel expense for away matches. The AKWIS State Volleyball Championships were held in December 1969, and KU defeated KSTC–Emporia in the finals.[11]

For the 1970–1971 season, the AKWIS East Kansas Division quadrangle match record for KU was 3–1, and in December 1970, KU hosted and won the AKWIS State Volleyball Championships with a 3–0 match record. KSTC–Emporia placed second, McPherson College third, and Marymount College fourth. Under Coach Linda Dollar, KU players Paige Carney, Joan

Lundstrom, and Stephanie Norris were named three of the six all-stars at the tournament. Mary Visser and Julia Yeater, playing for KSTC–Emporia, were two of the other all-star players, and each of them later earned a degree at KU. As the state champion in December 1970, the KU volleyball team qualified, along with KSTC–Emporia, for the second DGWS National Volleyball Championship, which KU hosted in February 1971.[12]

KU's 1971–1972 volleyball team was undefeated in AKWIS matches, with a 13–0 season record. The team had several veteran players, and they drilled the rookies in skill development and team strategies. Coached by Laptad, the team won the AKWIS State Volleyball Championships in December 1971 and qualified for the third DGWS National Volleyball Championship, held in Miami, Florida, in February 1972.[13]

In 1972–1973, for the first time, the AIAW National Volleyball Championship required teams to qualify by competing at the regional level. The seven state champions and runners-up in AIAW Region 6 faced each other in a regional tournament, and the regional champion and runner-up qualified for the national championship, hosted by the University of Minnesota in January 1973. The KU team dominated in-state competition with a cadre of experienced juniors and seniors, again defeating all opponents and winning the KAIAW state championship, hosted by KU. Fort Hays State College finished second, Washburn University third, and KSU fourth. Fort Hays State College did not win enough matches in the regional pool play to compete in the AIAW Region 6 championship finals. KU won every match until the regional championship finals. KU won the first game of that match, but when the lights went out during the second game, and play resumed thirty minutes afterward, SMSU won the last two games. Both finals teams were eligible for the fourth AIAW National Volleyball Championship in Provo, Utah.[14]

In 1973–1974, KU seniors who had developed into elite athletes over the previous three years led the volleyball team, and, as their coach, I was confident they would have a great season. The veteran team members shared their expertise generously. As reported in *KAIAW Communications*, in September 1973 the team conducted a Kansas High School Athletics Association volleyball skills and game strategies workshop for five Shawnee Mission high schools, and in early November the team hosted the United States Volleyball Association (USVBA) Region 8 invitational tournament for five state teams.[15]

In fall 1973, KU scheduled sixteen KAIAW matches, played eight additional matches outside the conference, and competed in two KAIAW

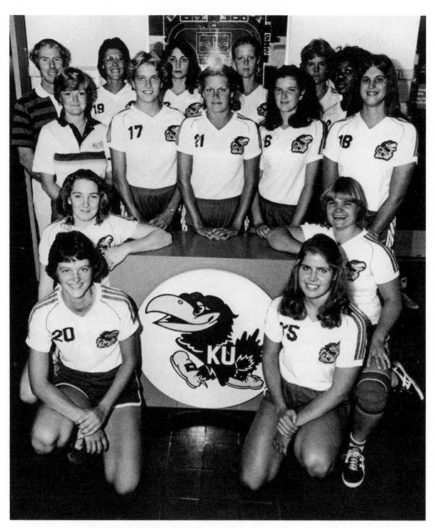

KU women's volleyball team with Coach Bob Lockwood, 1979.

tournaments before winning the KAIAW state championship in November. KU was undefeated during the regular season, winning all its matches in two of three games. The team won the AIAW Region 6 Volleyball Championship and earned a berth among the twenty-four teams playing in the AIAW National Volleyball Championship at Wooster College in Ohio from December 12 to 15.[16] I highlight the details of all four national championships in Chapter 6.

To wit, the KU varsity team's initial year launched six sequential state championships. Also during those six years, KU won and was runner-up

in the first two regional championships, respectively, and earned entry into four of the first five DGWS National Volleyball Championship. KU had a consistently winning volleyball team for more than half of the first decade of women's intercollegiate sports.

Jack Isgur coached KU women's volleyball in the fall seasons of 1974 and 1975, Bob Stanclift coached for the fall seasons of 1976–1978, and Bob Lockwood coached in the fall seasons of 1979–1984. Women's intercollegiate athletics moved from the AIAW to the National Collegiate Athletics Association (NCAA) in 1981–1982. The intensity of recruiting skilled athletes and the salaried coaching positions at competitive institutions changed women's intercollegiate volleyball. None of the KU volleyball teams after 1974 won the KAIAW state championship or Big Eight tournaments; therefore, none qualified for the AIAW Region 6 Volleyball Championship or the DGWS National Volleyball Championship again.

Early Women's Basketball Results

The 1968–1969 KU women's basketball team was invited to play nine games against area opponents. Central Missouri State University (CMSU) was the first opponent, and KU won by twelve points. A five-team elimination tournament in Emporia with Kansas State College of Pittsburg (KSC–Pittsburg; now Pittsburg State University), KSTC–Emporia, KSU, KU, and Southwestern College (in Winfield, Kansas) resulted in KU defeating KSC–Pittsburg and Southwestern College but losing by sixteen points to KSU. KU hosted a double-game weekend with KSTC–Emporia and KSU, defeating KSTC–Emporia but losing to KSU again, this time by only nine points. KSC–Pittsburg hosted a two-game weekend at the end of the season and included Cottey College from Nevada, Missouri. KU lost to KSC–Pittsburg there but beat Cottey College, resulting in a 5–4 season record.[17] By the end of spring 1969, the AKWIS had formed, scheduling games for all of its member colleges.

The 1969–1970 season was my second as the women's basketball coach. The team mostly played against teams in northeastern Kansas, but the first game was against an out-of-state college, CMSU. Although KU had beaten them the year before, this time we lost by eleven points. CMSU's new coach was Millie Barnes, one of the US Olympic institute instructors in basketball. KU won its next three games against Haskell Indian Junior College (now Haskell Indian Nations University), Mt. St. Scholastica, and McPherson College, avenging the loss to McPherson College the previous year. KU lost to KSU in Manhattan, this time by thirty-two points, but defeated Fort

KU women's basketball team with Coach Marlene Mawson, 1969–1970.

Hays State College, Mt. St. Scholastica, and Washburn University. When KU played KSU a second time, in Lawrence, we lost by only five points. Judy Akers was the KSU coach who attended the fifth national institute for basketball with me. We were friends and avid enthusiasts for women's intercollegiate sports, and we were also fierce but respectful competitors. In a final state competition, KU defeated WSU but lost to McPherson, ending with a record of 7–4.[18]

In the 1970–1971 season, KU began with a January loss to CMSU again, this time by only eight points. More than half of the KU team were first-year students, and I continued as the coach for the third year. After a win over Mt. St. Scholastica, KU lost to KSU by nineteen points in Manhattan, and after a win over Washburn University, KU lost again to KSU in Lawrence, this time by only six points. After winning a second game against Washburn University, KU took a weekend trip to western Kansas, where we lost to both Fort Hays State College and McPherson College. At home the first week of March, KU lost to McPherson College on a Friday evening but defeated KSU that Sunday afternoon by eight points. It was the first time in three years the KU team had defeated KSU. In the AKWIS State Basketball Championships held at KSTC–Emporia March 13–15, 1971, KU once more defeated KSU, on an unforgettable second-floor, wooden court that had buckled in strategic places from standing water because of a long-leaking roof, to win the tournament. McPherson College took third. This qualified

KU for a berth in the sixteen-team third DGWS National Basketball Championship in Cullowhee, North Carolina, in March 1971.[19] KSU had participated in the second DGWS National Basketball Championship the year before and was invited again based on its 1970–1971 season record. Details of the KU national tournament games are in Chapter 6.

Even though the 1970–1971 KU win-loss record of 7–8 could be viewed as a losing season, I must make a clarification about the team's achievements: KU Athletics records do not include the AKWIS State Basketball Championship game results. With KU's wins in the first round, versus McPherson College in the semifinals, and against KSU in the final, the more accurate record is 10–8, not 7–8 as shown in the *KU Women's Basketball Media Guide*.[20] The 1970–1971 first-year-student-dominated women's team had matured within one year into a national contender, with great promise for the future. I did not foresee it at the time, but it would be my last opportunity to coach intercollegiate women's basketball.

Beginning in 1971–1972, the AKWIS had eleven member institutions competing in women's basketball, so the teams were divided into the East and West Kansas Divisions for season competition and qualification for the state championship. Debbie Artman, a graduate teaching assistant in PE, was named KU women's basketball coach for that year. KU competed with Benedictine College, Haskell Indian Junior College, KSU, Washburn University, and WSU.[21] Fort Hays State College, Kansas Wesleyan College, McPherson College, Sterling College, and Tabor College made up the West Kansas Division.[22] KU won both home and away games against Benedictine College and Washburn University; split wins with Fort Hays State College, KSU, and WSU; and lost games to non-Kansas schools CMSU and the University of Oklahoma, ending with a 9–8 season record.[23]

In 1972 KU hosted the AKWIS State Basketball Championships in Allen Fieldhouse on March 4–6, in which the KU women's team was allowed to play intercollegiate basketball for the first time. The KU men's basketball team was playing in the Big Eight postseason tournament in Oklahoma on those same dates. At the AKWIS State Basketball Championship, KU defeated KSTC–Emporia but lost to Fort Hays State College and McPherson College by four points each. KSU defeated Fort Hays State College in the finals. McPherson College defeated KU for third place, leaving KU in fourth.[24] KU ended the 1971–1972 season with a 14–2 record.

In 1972–1973 season, the AKWIS was renamed the KAIAW to be consistent with the national AIAW organization. KAIAW now had twelve member institutions competing in women's basketball and created three Kansas

KU women's basketball team with Coach Marian Washington, 1973–1974.

conferences according to school size: Conference I, composed of Fort Hays State University, KSU, KU, and WSU; Conference II, made up of Benedictine College, Haskell Indian Junior College, Southwestern College, and Washburn University; and Conference III, comprising Bethany College, Kansas Wesleyan College, McPherson College, and Tabor College.[25]

Coach Drysdale was appointed the new director of KU Women's Athletics for 1972–1973, and she took the position as women's basketball coach, too. KU recorded the results of only three basketball games with other Kansas institutions for 1972–1973, and KU won all three, defeating KSU twice and Washburn University once.[26] KSU won the KAIAW State Basketball Championships in March 1973. Fort Hays State College finished second, McPherson College third, and Benedictine College fourth. KU Athletics did document Coach Drysdale's season record of 9–8.[27]

Coach Washington, a KU graduate teaching assistant in PE, was appointed for 1973–1974 as the fourth women's varsity basketball coach. In 1974, the team was scheduled for both practice and competition in Allen Fieldhouse.[28] For the 1973–1974 season, the KAIAW welcomed new members Marymount College and Sterling College in basketball and reorganized the two conferences again, this time forming Conference II with the same seven small colleges competing in the men's NAIA Kansas College Athletic

Conference. The KAIAW assigned the other seven member institutions to Conference I: Benedictine College, Fort Hays State College, Haskell Indian Junior College, KSU, KU, Washburn University, and WSU.[29]

KU played its first six games in 1973–1974 against non-Kansas teams. KU defeated Rogers State of Claremore, Oklahoma, and the University of Missouri but lost to CMSC AND SMSU in two games each, both home and away. In KAIAW competition, KU won home and away conference games versus Benedictine College, Haskell Indian Junior College, Washburn University, and WSU; split wins with KSU; and lost both home and away games to Fort Hays State College. During Coach Washington's first year as head basketball coach, KU had an 11–8 season record.[30] At the 1974 KAIAW State Basketball Championships at Bethany College in Lindsborg, Kansas, KSU won for the third consecutive year, Fort Hays State College was second, and Tabor College defeated Bethany College for third.[31]

The 1974–1975 women's basketball records are not complete, but KU Athletics documents show the team had a 7–11 win-loss record.[32] KSU was our dominant opponent in the early years: it won seven consecutive KAIAW State Basketball Championships (1972–1979) and hosted the 1974 AIAW National Basketball Championship in Manhattan, Kansas. Coach Akers served as the national tournament director, and I was the coordinator for the tournament game officials.[33]

On March 6–8, 1975, KU hosted the AIAW Region 6 Basketball Championship in Allen Fieldhouse, and I served as the regional tournament director. As KAIAW state champion, KSU represented Kansas among the seven states in AIAW Region 6, but as the host institution, KU also played in the regional tournament, seeded eighth. KU played top-seeded William Penn College from Iowa in the first round of the single-elimination tournament and lost.[34]

The following year, 1975–1976, KU had a win-loss record of 13–14, playing twenty-one games against out-of-state opponents and only six games versus KAIAW teams. In the 1976–1977 basketball season, KU also played twenty-one games against out-of-state teams, ending the season with an 11–15 record.[35] KSU was the 1977 KAIAW representative to the AIAW Region 6 Basketball Championships, as it had been from 1972 to 1977.[36] In the 1977–1978 season, all AIAW member institutions were required to declare whether they would compete in either the AIAW large- or small-college division. The Big Eight Conference institutions all chose the large division and began scheduling a Big Eight tournament that year.[37] For the two previous years, Big Eight teams had competed in at least two or three

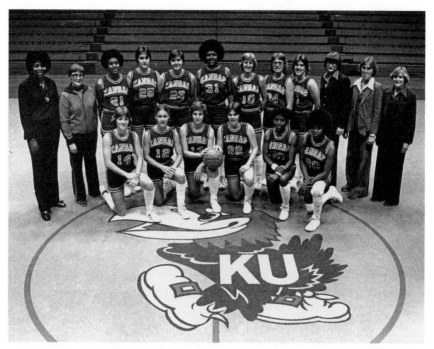

KU women's basketball team, 1977–1978.

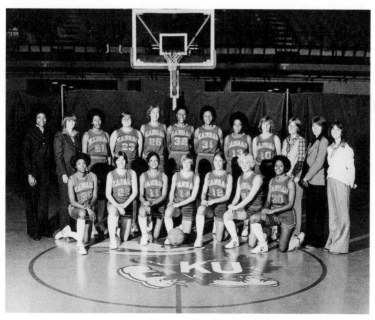

KU women's basketball team, 1978–1979.

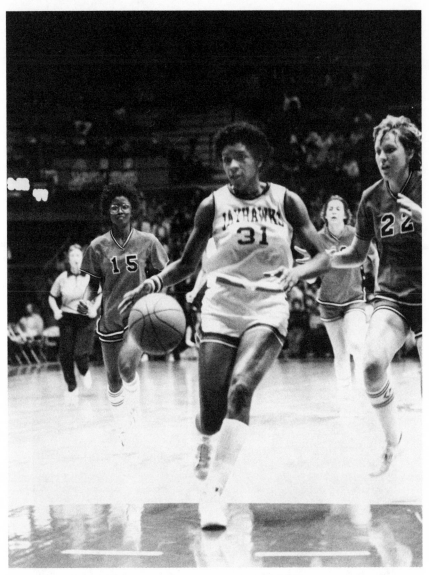

KU women's basketball player No. 31 Lynette Woodward dribbling.

games on Big Eight campuses. In 1978, KU had a 3–3 tournament record versus Big Eight teams.[38]

From 1977–1981, renowned KU player Lynette Woodard set KU records in scoring, rebounding, steals, and minutes played that still stand, and the team dominated opponents at the state and regional levels. She played for four years with talented teammates Adrian Mitchell and Cheryl Burnett and

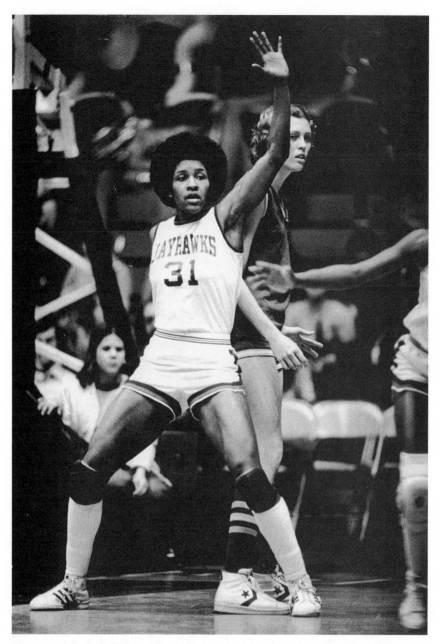

KU women's basketball player No. 31 Lynette Woodward in action.

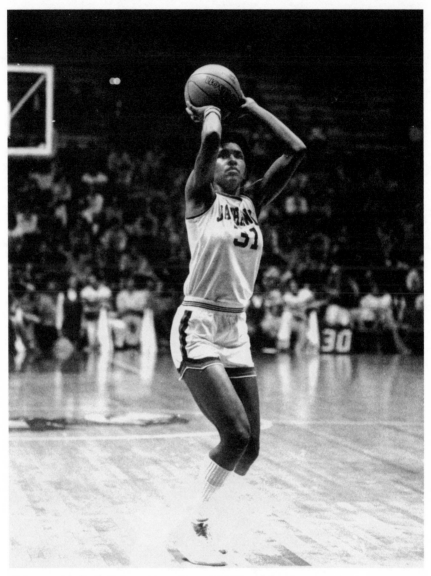

KU women's basketball player No. 31 Lynette Woodward shooting.

for two years with Shebra Legrant. Both Woodard and Mitchell have been honored in the KU Athletics Hall of Fame and had their KU jerseys retired and hung in Allen Fieldhouse. KU was Big Eight Conference runner-up in 1978 and won three Big Eight Conference championships (1979–1981).[39] This earned the team national berths, and in 1978, KU played in the Women's National Invitational Tournament. From 1979 through 1981, KU won

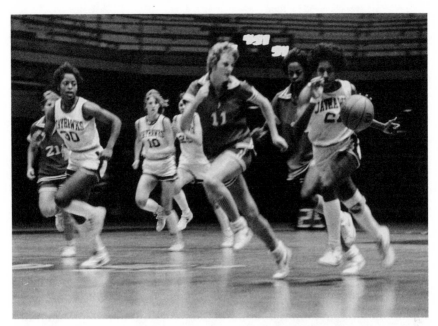

Adrian Mitchell (No. 21) dribbling down court with Cheryl Burnett (No. 10).

the AIAW Region 6 Championship all three years and played in the AIAW National Basketball Championship the last three years that championship was held.[40]

In 1981–1982, when the NCAA took over women's collegiate athletics, the KAIAW/AIAW ceased to exist, and KU scheduled basketball games each season within the Big Eight Conference and with other Division I teams. Washington continued as KU women's basketball coach for thirty years, from 1973–2004.

Early Women's Gymnastics Results

The AKWIS women's gymnastics season was in spring. Beginning in 1969, Coach Catlett scheduled the KU gymnastics meets with nearby institutions for the first three seasons, 1969–1971. Gymnastics instructors from the member colleges judged the events at the meets. In February 1971, KU women gymnasts were invited to a meet at Grand View College in Des Moines, Iowa; individual entries were based on previous meet scores. In spring 1971, the AKWIS State Gymnastics Championships quadrangular meet resulted in KSTC–Emporia winning over KSU, with KU third and Washburn University fourth. In March 1971, four KU gymnasts earned berths at the DGWS National Gymnastics Championship

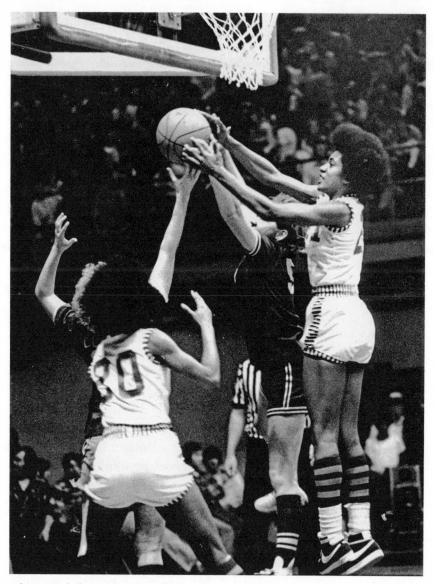
Adrian Mitchell (No. 21) rebounding.

at the Pennsylvania State University based on state and/or regional meet scores. Although none of them placed in the national gymnastics meet, they became oriented to national-level competition.[41]

Coach Laptad, the interim KU Women's Athletics director for 1971–1972, appointed Patricia Ruhl, a graduate teaching assistant in PE, the women's gymnastics coach for that season. The spring 1972 season culminated in

the AKWIS State Championships, in which KSTC–Emporia defeated KSU, with KU third and Washburn University fourth. WSU competed but had the lowest score. KU won third at the regional gymnastics meet in March 1972 and accumulated enough points for fourteenth place at the 1972 DGWS National Gymnastics Championship at Grand View College.[42]

The KU team did not fare very well during the 1973 and 1974 spring seasons. Judy Jones, a graduate teaching assistant in PE, served for those two years as the third women's gymnastics coach. Benedictine College won the KAIAW State Gymnastics Championship in 1973; KSTC–Emporia was second, KSU third, and KU fourth, with Washburn University and WSU not placing.[43] In the 1974 season, KU continued to rank behind the same institutions. At the KAIAW State Gymnastics Championships in March 1974, KSTC–Emporia won, KSU placed second, KU third, Washburn University fourth, and WSU did not place. Gymnasts with qualifying scores on balance beam, floor exercise, uneven parallel bars, and vault earned entry to the first AIAW Region 6 Gymnastics Championships, held at SMSU. Among the sixteen teams there, Washburn University placed tenth, KU twelfth, and KSU fourteenth.[44]

When KU women's intercollegiate sports came under the administration of KU Athletics in summer 1974, Ken Snow was named coach for the 1975 KU women's gymnastics team. WSU won the 1975 KAIAW State Gymnastics Championship; KU took second, Washburn University third, and KSU fourth.[45] Although the KU team continued from 1975 to 1980 with Snow as coach, women's gymnastics were eliminated as a KU intercollegiate sport in 1981–1982, when the NCAA took over the AIAW National Gymnastics Championship.[46] No results of KU women's gymnastics competitions were recorded for the late 1970s.

Early Women's Softball Results

KU women's intercollegiate softball games were first scheduled for the 1968–1969 academic year, and I was the coach the first two years. The KU team was composed primarily of PE majors who had played summer softball and on KU Sports Day softball teams. Colleges and universities scheduled most varsity games independently, and none archived the results. For the spring 1970 season, AKWIS member institutions formulated a round-robin schedule, and the final standings of season games determined the state softball champion. By the end of the 1970 season, KSU had tied with KSTC–Emporia for first place, and KU placed third. Other AKWIS members that competed were Washburn University and WSU.[47] Linda Dollar, a

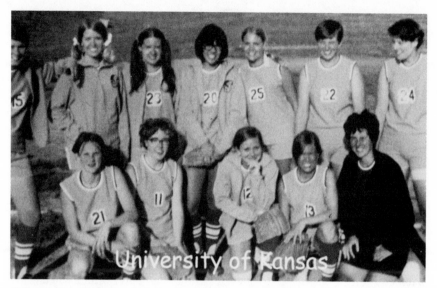

KU women's softball team with Coach Veronica Hammersmith, 1972.

KU graduate teaching assistant, was the softball coach in spring 1971. No KU women's softball game scores were recorded. KSTC–Emporia was the AKWIS state softball champion, with KSU second and KU third. Spring 1971 was the third year of the College World Series, hosted in Omaha, Nebraska; KSTC–Emporia played in the series and took fifth place.[48]

For the 1971–1972 season, with Coach Laptad serving as interim KU Women's Athletics director, the KAIAW split its member institutions into East and West Kansas Divisions. Laptad appointed Veronica Hammersmith, a graduate teaching assistant, the women's softball coach for spring 1972. KU was in the East Kansas Division with Benedictine College, Haskell Indian Junior College, KSTC–Emporia, KSU, and Washburn University. The West Kansas Division included Fort Hays State College, Kansas Wesleyan College, Marymount College, McPherson College, and WSU. KSTC–Emporia won the East Kansas Division with a 4–0 record, KSU and Washburn tied with 3–2 season records, and KU finished fourth with a 2–2 record. Because Fort Hays State College won the West Kansas Division with a 4–0 record, KAIAW held a playoff between the two division winners, and KSTC–Emporia won the state championship title over Fort Hays State College.[49] KSTC–Emporia earned a berth in the 1972 College World Series in Omaha for a second year. Thus, KSTC–Emporia won the first three AKWIS State Softball Championships (1970–1972), but KU won the KAIAW State Softball Championship from 1973 through the end of the decade.[50] By

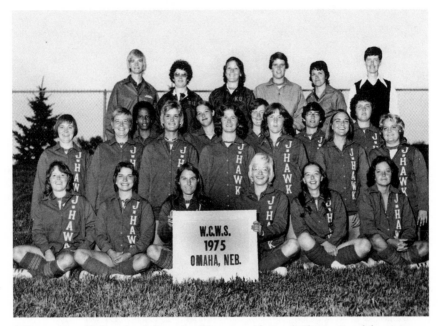

KU women's softball national championship team with Coach Sharon Drysdale, 1975.

mid-decade, AIAW Region 6 Softball Championships were the qualifiers for playing in the national championship.

Coach Drysdale became the KU softball coach in 1972–1973, when she was also the KU Women's Athletics director. As a result of her softball coaching expertise and the talented athletes, KU won the 1973 KAIAW State Softball Championships, with WSU as runner-up. In postseason games between the East and West Kansas Divisions, KU defeated WSU 11–1 and KSTC–Hays 10–6. As the KAIAW champion, KU went to the College World Series in Omaha for the first time in 1973. KU had a 2–2 record in that College World Series.[51]

In the 1974 softball season, KU reported an 11–5 record, playing eight games against out-of-state opponents J. F. Kennedy College (in Omaha, Nebraska), SMSU, and Northwest Missouri State University (NMSU), and all five season losses were to those teams. KU won all of its softball games against in-state rivals, defeating Haskell Junior College 14–4, KSTC–Emporia 6–0, KSTC–Hays 25–3, KSU 6–0, Washburn University 7–2, and WSU 7–6. Winning the KAIAW State Softball Championships again in 1974 allowed the KU women's softball team to return to the College World Series in Omaha behind their All-American pitcher, Penny Paulson. KU placed fourth in that tournament.[52]

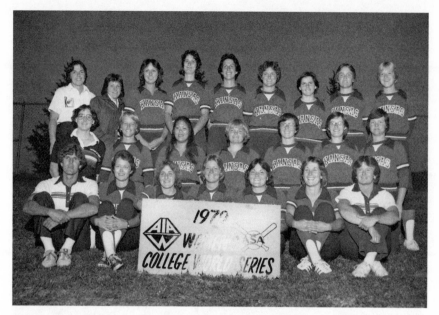

KU women's softball national championship team with Coach Bob Stanclift, 1979.

The KU softball team qualified for the ASA College World Series at the national level for five consecutive years (1973–1977), and then, missing only 1978, the team competed in the College World Series in 1979.[53] Coach Drysdale, who served from 1973 to 1976, was the catalyst for the softball team's continued success, and when she departed KU, Bob Stanclift, who served as coach from 1977 to 1987, continued her winning tradition.[54] I did not find any game results for KU softball in KAIAW records for the late 1970s. I have included more information in Chapter 6 about the KU softball national championship teams during the 1970s.

Early Women's Tennis Results

KU sponsored a women's varsity tennis team for the first time in fall 1969, and a graduate teaching assistant, Suzi Cammon, coached in 1969 and 1970. The AKWIS tennis season was limited to four weeks, from September 15 to October 15, but KU tennis players also competed against out-of-state teams during the spring semester. In the beginning, only six AKWIS member institutions fielded tennis teams: Kansas Wesleyan College, KU, Marymount College, McPherson College, Mt. St. Scholastica, and WSU.[55] I coached KU women's tennis in spring 1971 because some senior women wanted to compete throughout their last year of college, and spring

intercollegiate matches were available with teams outside of Kansas. No tennis match scores were recorded for these first years.

During the 1971–1972 academic year, Coach Laptad served as head tennis coach, and she appointed Artman, a graduate teaching assistant, the assistant coach. Artman conducted practices and accompanied Laptad to matches. Additional colleges competing with that year included Benedictine College, Haskell Indian Junior College, KSU, and Southwestern College. The KU team had a 5–2 match record for the fall 1972 season.[56]

For the 1973 season, Coach Drysdale appointed Sally Wulbrecht, a graduate teaching assistant in PE, tennis coach. The October 1973 *KAIAW Communications* reported that Fort Hays State College had twelve match wins, KSU and KU tied with eleven matches each, and McPherson College followed with two match wins. Only Fort Hays State College, KSU, KU, and McPherson College participated in the KAIAW State Tennis Championships in Salina, Kansas that year, where Fort Hays State College won both the singles and doubles matches, and KSU tied with KU for second in both singles and doubles.[57]

John Sample coached KU women's tennis in fall 1974. The team consisted of six first-year students. They competed at the United States Lawn Tennis Association (USLTA) regional tournament in Columbia, Missouri, and four KU players qualified for the AIAW National Tennis Championship in Kalamazoo, Michigan.[58] Tom Kivisto followed as KU women's tennis coach for 1976–1979. KU women's tennis team records for the remainder of the 1970s were not preserved.[59]

Early Women's Swimming Results

The KU women's intercollegiate swim team began in 1968–1969, and as with the other new teams, competed at the invitation of other colleges. Claire McElroy, a PE graduate teaching assistant, was the first KU women's varsity swim coach. Only KSU and KU sponsored swimming teams for the first three years, but in April 1971, AKWIS designated the swimming season as September 1 to November 30, and KU scheduled swim meets with KSTC–Emporia, KSU, and WSU for the fall 1972 and 1973 seasons.[60] In 1974, the KAIAW extended the swim season from October 1 to March 1, even though there was no state championship meet. That year KU defeated six of seven opponents. KU beat the University of Arkansas, Cottey College and Stephens College in Missouri, Iowa State University, the University of Oklahoma, and Kearney State College in Nebraska (now the University of Nebraska–Kearney) but lost to KSU.[61]

McElroy continued as the KU women's swim coach until the 1975–1976 season. I have not located swim team records for the later years of the 1970s. Gary Kempf coached KU women's swimming from 1976–2000.[62]

Early Women's Track-and-Field Results

The KU women's track-and-field team was initiated in 1971–1972, when Coach Laptad volunteered as its first coach. A sophomore transfer student and Olympic-caliber athlete from Oregon State University, Mary Jacobson, had followed Laptad to Kansas. AKWIS had not sanctioned track and field, and other Kansas institutions did not offer it in 1972, so KU did not recruit more athletes to compete that year. An Olympic shot-put and discus athlete, Jacobson practiced and competed in field events outside of KU Women's Athletics and entered the 1972 Olympic Trials in the shot put. She also entered the 1973 and 1974 AIAW National Track and Field Championship representing KU in the shot put.

Coach Washington volunteered to coach the KU women's cross-country team in in 1972–1973, when she was a graduate teaching assistant, and then she coached the women's track-and-field team in 1973–1974, also her first year as the KU women's basketball coach. In 1974 the KAIAW sanctioned track and field and held a state track-and-field meet in March. Likely because of a lack of entries, KU scored only seventeen points in comparison with KSU, which won with a score of eighty-eight.[63]

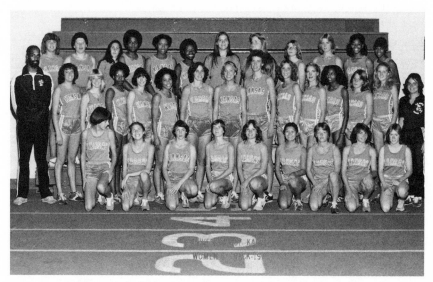

KU women's track-and-field team with Coach Teri Anderson, 1979.

Records for track and field during the 1970s were not preserved in KAIAW documents. After the KU women's intercollegiate sports program was moved from the PE Department into KU Athletics in 1974, the women's track team had different coaches for each of the next three years: Lorraine Davis (1975), Gary Pepin (1976), and Tom Lionvale (1977). In May 1976, WSU hosted the first AIAW Region 6 Track and Field Championship.[64] Teri Anderson served from 1977 to 1979 as the KU women's cross-country coach and from 1978 to 1980 as KU women's track-and-field coach before the NCAA took over AIAW women's athletics in 1981–1982.[65]

Early Women's Golf Results

The first KU intercollegiate women's golf team began in spring 1972. Two athletes constituted the team: Coach Nancy Boozer's oldest daughter, Barb, a junior, and Patty Morrison, a first-year student. Both had been successful LPGA club golfers in Kansas. Barb Boozer had entered the first AIAW National Golf Championship in 1972 in Las Cruces, New Mexico, as a first-year student and also played in the 1973 AIAW National Golf Championship at Mount Holyoke College, Massachusetts, even though KU did not have an official women's golf team yet. The young Boozer and Morrison represented KU in the AIAW National Golf Championship at San Diego State University in June 1974.[66]

Nancy Boozer's middle daughter, Beth, was also an outstanding golfer who played for KU (1974–1978). Barb and Beth Boozer played together on the KU golf team in spring 1975. KU hosted an invitational golf tournament at Alvamar Golf Club in Lawrence in 1975. The team took second at the fourteen-team AIAW Region 6 Golf Championships at Iowa State University in September 1975, where Beth Boozer was the medalist. She also played in the 1975 AIAW National Golf Championship in Tucson, Arizona, with her sister Barb, Morrison, and Kathy Webb.[67]

The KU team, with Beth Boozer as its lead golfer, played in the AIAW National Golf Championship in 1976 at Michigan State University in East Lansing. In October 1976, KU hosted the AIAW Region 6 Golf Championship at Alvamar Golf Club, but because the KU golf team came in third in the AIAW Region 6 Championships, the team did not qualify for the 1977 AIAW National Golf Championship. Instead, its members entered the Hawaii Invitational Golf Tournament in Kuilima (now Turtle Bay), where Beth Boozer finished in the top twenty golfers.[68] The KU team participated in the 1978 AIAW National Golf Championship in Orlando, Florida, but I have not located individual results.

When Coach Nancy Boozer's oldest two daughters had completed their athletic eligibility and graduated from KU and her youngest daughter, Beverly, chose a golf scholarship at University of California–Los Angeles (UCLA), the coach resigned, and Bill Schroeder became the KU women's golf coach in 1978.[69] Beverly Boozer returned to KU to complete her degree and play golf in 1982–1983. Sandy Bahan finished the decade as KU women's golf coach in 1979–1980.[70]

Women's Athletics Director Marlene Mawson (1968–1971).

Most athletic competition results during the first decade of KU Women's Athletics were not reported by the sports media on campus or by the *Lawrence Journal-World*. The KAIAW archival documents contain many of the season win-and-loss records of teams but rarely the game or meet statistics for teams or individual athletes. Very little attention was paid to the history of KU Women's Athletics until the NCAA took control of women's intercollegiate sports in 1981–1982, and KU Athletics assigned administrative personnel to record results. Even so, the few records available for KU women's teams' accomplishments during these early years document the successful rise of competition opportunities in different women's sports.

Greater State Funding for KU Women's Intercollegiate Sports

Congress passed Title IX of the Education Amendment Act in summer 1972. Compliance guidelines issued in 1973 required equal opportunity by 1978 in collegiate activities regardless of gender; federal funds would be withheld from noncompliant higher-education institutions. When it became clear that compliance with Title IX included all athletics programs on college and university campuses, KU immediately started initiatives. A half-time salary was budgeted for the KU Women's Athletics director for the 1972–1973 academic year. However, women's varsity coaches remained unpaid for lack of funds. Although since 1968 the KU Women's Athletics

Women's Athletics Director Sharon
Drysdale (1972–1974).

Women's Athletics Director Marian
Washington (1974–1979).

budget had increased incrementally to a total of $9,367 by 1972–1973, with the Title IX compliance regulations issued in summer 1973, the Kansas Board of Regents authorized a more substantial budget for all regents' colleges in Kansas as an initial contribution to women's athletics.[71]

In April 1974 the Kansas Board of Regents approved funds for women's intercollegiate sports at all six state-funded higher-education institutions beginning with the 1974–1975 academic year. The regents awarded the Kansas State Teachers Colleges at Emporia, Fort Hays, and Pittsburg, along with WSU, $48,575 each for women's intercollegiate athletics. KSU and KU each received $58,575 for the 1974–1975 academic year. These funds could be used for hiring coaches and officials, purchasing uniforms and equipment, paying for travel, offering athletic scholarships, and covering other athletics-oriented expenses according to budgeting needs.[72]

The 1974–1975 Kansas Board of Regents appropriations for women's sports enabled sweeping advances for the KU Women's Athletics program. In the same year, the KU Student Senate allocated $63,860 for nine sports in KU Women's Athletics, and the revenue of $122,435 increased the 1974–1975 KU Women's Athletics budget by more than 13.5 times over that of the previous year.[73] The KU chancellor's office directed a move of KU Women's Athletics from the PE Department to KU Athletics beginning in July 1974. Allen Fieldhouse became the new home for KU Women's Athletics, and facility renovations were required to accommodate the women. The Kansas Board of Regents and the KU Student Senate funds were placed with

KU Athletics, and Chancellor Archie Dykes appointed KU Athletics Director Clyde Walker head of both men's and women's athletics. KU women's coaching positions were salaried for the first time, although those positions were part time only, and a larger operating budget was allocated to the coaches of each sport.

The half-time PE faculty position designated for the KU Women's Athletics director was reassigned as a faculty position in the PE Department beginning in 1974–1975. Drysdale's PE faculty appointment was changed from half-time KU Women's Athletics director to a full-time academic teaching position in PE when the women's intercollegiate sports program was moved to KU Athletics, but she continued as women's softball head coach until 1976.

KU Women's Athletics Merged

When KU Athletics merged the men's and women's athletics programs under its administration in summer 1974, Walker appointed Coach Washington the KU Women's Athletics director, a half-time position she held for five years while she continued as the women's basketball coach. In 1979, Athletics Director Bob Marcum eliminated the position of KU Women's Athletics director, perhaps in anticipation of the NCAA takeover of women's athletics. In 1980, Chancellor Dykes appointed Susan Wachter to a position in KU Athletics as an interim assistant athletics director for business, and she also served as the designated women's administrator in KU Athletics. The following year Marcum hired her full time as assistant athletics director, with supervisory responsibility for women's sports. She held various administrative positions in KU Athletics for the next thirty-two years, serving nine different KU athletics directors, and she retired in 2012 as chief financial officer (CFO) for KU Athletics.[74]

When the NCAA took over women's athletics, Marcum resigned as KU Athletics director. Monte Johnson became the KU Athletics director in 1982, and he did not hire anyone to direct women's athletics. In fact, there was no designated administrative position for a woman in KU Athletics for another ten years. In 1992, Athletics Director Bob Frederick named Wachter the first full-time KU senior woman administrator in athletics, a position she held for one year. However, the position became permanent in KU Athletics, and six other women have held this administrative position in the department since then.[75]

A Decade of Achievement for KU Women's Athletics

KU Women's Athletics had an inauspicious beginning in 1968 because few had a vision of what was to come, and most others had no interest in the fledgling program. Over the first decade of struggle, women athletes overcame much resistance from others in sports who desired the time and space taken by women's intercollegiate sports, but women coaches and athletes expected that at every institution. KU women athletes persisted in their sports even without much financial support because they experienced the joy of athletic competition, and they built comradery and unity within their teams.

The 1960s and 1970s were times of political and social tumult in the United States, with antiwar and civil rights movements changing the culture. This prompted a shift in public opinion regarding sport as primarily a masculine domain and offered an opportunity for women to step up and be respected as athletes. It was a time to press forward with a mission to provide equal opportunities for women to enjoy the thrill of elite sport competition. Even so, few people took notice of a decade-long, mounting groundswell of enthusiasm for intercollegiate women's sports.

CHAPTER SIX

EARLY KU WOMEN ATHLETES
ON THE NATIONAL SCENE

Uncertainty and turmoil pervaded the University of
Kansas (KU) campus of more than 17,000 students during the 1970 spring
semester. It was a time of unrest, with college students engaging in political
and social movements on many large campuses across the nation. Within
a semester, college men's crewcuts had become long hair, accompanied
by beards. Women who had formerly worn skirts and hose to class now
wore jeans and sockless shoes; young women's bouffant hairdos changed
to straight, long hair; and women no longer had curfews on campuses. As a
twenty-nine-year-old faculty member at KU then, I felt vulnerable between
the professional behavior expected of me as an educator and the cultural
transformation of students in my classes, who were not much younger
than me.

Known afterward as the "Days of Rage" at KU, the weeks of late April and
early May 1970 were tumultuous, with student protests, racial conflicts,
bomb threats, arson at a KU fraternity and the KU Student Union, destruc-
tion of downtown businesses, and sniper fire throughout town. The radical
behavior sparked on the evening of April 20, 1970, with the firebombing
of the KU Student Union. On May 6, 1970, incited by the Ohio National
Guard killing of Kent State University students two days earlier, the ROTC
review at KU was cancelled for the second consecutive year because more
than a thousand protesters rallied at the KU Memorial Stadium against
it, then rallied in front of Allen Fieldhouse calling for a student strike and
termination of the academic year. KU students protesting the expansion
of the Vietnam War into Cambodia attempted to burn the campus ROTC
building later that day.[1]

After class hours and through the nights during that anxious week, KU
faculty members were asked to monitor the buildings where they taught
by keeping vigil from the rooftops and notifying law enforcement if groups

of protesters came toward their buildings. The KU physical education (PE) male faculty were assigned as lookouts on the roof of Robinson Gym in rotating overnight assignments. The unrest on campus continued even though most classes convened, albeit with many absences.

On May 8, 1970, Chancellor Chalmers announced a Day of Alternatives at an open meeting of students and faculty in the KU Memorial Stadium.[2] I was in the stadium as more than 13,000 students and faculty gathered to hear the chancellor's three options for students to finish the spring semester. They could take the grade they had earned by that time or take a pass-fail grade and leave campus for the year; attend and finish their spring semester classes as scheduled; or participate in independent academic courses to complete classes under the tutelage of a willing professor. More than half of the students chose the option to go home early. Many faculty members cancelled their classes and arranged independent studies for students who stayed on campus. I recall empty classrooms and few students using Robinson Gym or walking around campus. In retrospect, this alternative to dismiss the restless KU student body probably saved the campus from further destruction. It was the end of my second year as a faculty member, and the radical developments of that time were indelibly etched in my mind.

When the 1970 fall semester began, protests and riots had calmed, repairs had been made to damaged buildings, and campus life seemed to go on as usual, other than the altered apparel and grooming of the students. Four months earlier, the Commission on Intercollegiate Athletics for Women (CIAW) had notified KU that the bid I had submitted for the Division of Girls and Women in Sport (DGWS) National Volleyball Championship had been accepted, and KU was designated to host the second national intercollegiate tournament in 1971. Much planning and action had to occur during the fall 1970 semester for the tournament to be held without duress.

KU Hosts a National Intercollegiate Volleyball Championship

Joie Stapleton was delighted that KU had won the volleyball championship bid. She was instrumental in securing travel funds for me to attend the first DGWS National Volleyball Championship at Long Beach State University April 23–25, 1970. She agreed that it was essential for me to see firsthand how the tournament was operated. While attending that championship, I took notes on what worked well, along with ideas for enhancing the

experience for participants. I conferred with the other two national volleyball championship committee members as we evaluated the planning and outcomes of various aspects of the first championship tournament. I also took notes about what directing a national volleyball tournament entailed and ways I would do it differently.

In late spring semester 1970, the national volleyball committee began to plan for KU to host the second championship.[3] The DGWS commissioner requested that the championship be held in February rather than in April because many institutions scheduled their volleyball season during fall semester, and many fall semesters stretched into January. The second championship tournament was set for February 2–6, 1971.

Specific plans for this event were confirmed in June 1970 with the guidance of Joanne Thorpe from Southern Illinois University, who chaired the DGWS national volleyball championship committee. The other committee members were the national tournament directors of the first three host institutions: Dixie Grimmett from Long Beach State University, me from KU, and Roberta Boyce from Miami-Dade University. Each year, the longest-serving committee member was to rotate off the committee, and the new member would be the host college's director for the next championship. The committee of four determined the tournament schedule and team seeding and established and monitored policies that would affect subsequent tournaments.[4]

The match schedule ensured that the top teams would be playing in the finals and provided for all teams to play a series of matches throughout the tournament rather than being eliminated immediately upon losing. The committee limited the tournament to twenty-eight teams. Thus, four pools of seven teams were seeded with regard to regions of the country, win-loss records from the previous two years including identified opponents, and strength of competition in the current season. The committee finalized the seeding after receiving the relevant information from teams requesting an entry.

Each team in a competition pool was scheduled to play during the first stage of the tournament. The collective win-loss records of the teams from each pool then provided the top two pool teams to compete in the quarterfinals, and the two winners of the quarterfinals would compete in the finals in an eight-team elimination bracket. The committee followed this format in all of the subsequent volleyball championships during the decade of the Association for Intercollegiate Athletics for Women (AIAW).

Organizing for Hosting the National Volleyball Championship

Of the twenty-eight colleges that played in the first DGWS National Volleyball Championship at Long Beach State University, seventeen of them were California colleges.[5] Their travel expenses were obviously less than for those coming from farther east, and most institutions had not begun to fund women's teams adequately for long-distance travel. Although four universities entered from Illinois, only two others were from east of the Mississippi River. New Mexico, Oregon, and Utah each sent one team. In addition to Sul Ross State University from Texas, the only team from the central area of the country was Southwest Missouri State University (SMSU; now Missouri State University), a team with players against whom I had competed when I played for Kansas City in the Missouri-Oklahoma US Volleyball Association (USVBA) League before coming to KU. I knew the SMSU players and their coach, Mary Jo Wynn, very well and was pleased to cheer them on to fifth place in the single-elimination tournament finals, while listening to California coaches asking in amazement where these players learned the skills of competitive volleyball.

The preparation for the Long Beach championship had begun with a local planning meeting in December prior to the 1970 April event, but I noted that the next such meeting should be moved up to early September because the second championship was scheduled for February 1971. I listed the several tasks that had to be accomplished and how long it might take to complete each of them. I observed how the teams were scheduled for practice and play in Long Beach and assessed whether that schedule would work on the four courts in the two gyms in Robinson Gym at KU. Observation at the first championship was very valuable in planning the tournament the next year at KU.

By the end of that first tournament, I realized that because the Long Beach volleyball coach was also the championship director, this dual responsibility required her attention to be diverted from her team at crucial times and likewise from directing the tournament while coaching, thus rendering her ineffective in both instances. It was evident to me that someone else should coach KU women's varsity volleyball the following year while I was directing the national championship. There were no open faculty positions at KU, but there would be an open graduate assistant teaching position, so I considered graduating seniors from the SMSU volleyball players who might be interested in such a position at KU while earning a master's degree.

Conferring with Coach Wynn, I confirmed that three of the SMSU play-
ers were graduating seniors. One was getting married, one had already ac-
cepted a graduate assistantship at the University of Maryland, and one had
just signed a letter of intent to teach PE in a St. Louis school. I asked for
permission to speak to this third player and possibly convince her to renege
the teaching position in St. Louis to coach volleyball at KU while earning
her master's.

Presenting my view of the heavy workload of directing a national cham-
pionship while teaching full time and coaching four sports, I convinced
Stapleton and Department Chair Henry Shenk to interview Linda Dollar as
a potential graduate teaching assistant in PE, so she could also volunteer
to coach volleyball and softball. I knew she would be a knowledgeable and
skillful coach. The position was created, and Dollar accepted a one-year
graduate assistant teaching/coaching position. She earned her master's
degree that year, then returned to SMSU as assistant volleyball coach for
a year, and finally became head coach at her first alma mater for the next
twenty-four years, competing in AIAW Region 6 Volleyball Championships
against KU in 1972 and 1973.

Student and Faculty Assistance for the Championship Tournament

The second DGWS National Volleyball Championship was a main item
on the agenda at the first PE faculty meeting at KU in September 1970. As
director of the event, I presented my plans for conducting it. We named
two student tournament cochairs and identified eleven tournament prepa-
ration committees. Students volunteered to participate on each of the com-
mittees, and both male and female PE faculty members served as advisors
for the student committees.

Two mature seniors in my junior-senior PE lecture classes, Harriet Ducy
and Sandy Stanek, cochaired the supervision of all eleven tournament com-
mittees. The committee chairs solicited their own committee assistance
from their underclass-women peers. Student chairs of each committee
contributed most of the time and effort and reported progress to Ducy or
Stanek each week. In carrying out their responsibilities on these commit-
tees, all the students learned about planning, organizing, and directing a
large sporting event, just as I had learned from experience during my un-
dergraduate sports administration class.

All student committee members were selected and briefed by the sec-
ond week of September. I gave each of the eleven committee chairs lists
of duties I had outlined with specific responsibilities and timelines for

completion, most of which they would finish prior to the tournament. When the two cochair supervisors met with me every two weeks, each of them reported on the several committees they monitored regarding progress made on their respective tasks. We discussed problems in completing the tasks and suggested options for assisting various committees, and the cochairs followed up with the respective committee chairs. This delegation of responsibilities and duties allowed us to enact the plans, accomplish the tasks, and meet the anticipated timelines during the fall and early spring semesters of 1970–1971.

Communications for the Championship Tournament

As director, in September I mailed 600 packets of information to colleges and universities across the nation regarding tournament entrance requirements, and by October, 105 institutions had expressed interest in participating. Of those, 45 colleges met the entrance requirements and submitted the entrance fee of fifty dollars by the November deadline. The national volleyball championship committee conferred with me by conference call on December 1 to select twenty-eight teams, each of which we seeded in one of four round-robin pools for preliminary tournament competition. These teams represented seventeen states, and alternative teams were designated in priority order.

Late Friday evening on December 11, 1970, I was in my Robinson Gym office, sealing envelopes to send to the twenty-eight teams, when a loud explosion reverberated outside. After hurriedly completing the stack of envelopes, I climbed the interior stairs to the front door of the building, looked outside across the entrance catwalk, saw flashing lights, and heard police and fire engine sirens. They were headed up Sunnyside Avenue, the street that runs between the front door of Robinson Gym and Summerfield Hall, where the KU School of Business was then located. Summerfield Hall was also where the university computer was housed, which contained the KU database and all student transcripts. Because my car was parked in the lot on the south side of Robinson, and police had cordoned off the area across the street, I left the building through the east-side door, walked away from the scene, and drove to the downtown post office to mail the packets without knowing the reason for the swirling red lights and sirens.

The following day I learned that dynamite had been placed in the stairwell of Summerfield Hall. It exploded at 11:00 p.m., apparently intended to destroy the university computer. However, the result was destruction of a cinder-block wall beside the stairwell, blowing out entry doors and windows

and injuring three KU students in the building. The Federal Bureau of Investigation (FBI) was called in to investigate the explosion and find the perpetrators. Because the KU Black Student Union had called for a strike on December 8, and because the Weathermen, a radical offshoot of the national Students for a Democratic Society (SDS), had executed a similar bombing on the University of Wisconsin campus and were known to be present in Lawrence, both groups became suspects. Governor Robert Docking offered a substantial reward for information leading to an arrest and conviction, but the debris revealed no clues, and law enforcement never determined who was responsible for the explosion.[6]

In less than fifty days, KU would host the volleyball championship. Within that time, the fall semester would end, the Christmas holiday would delay preparations for the tournament, and the spring semester would begin in January 1971. The many student committees preparing for the national tournament had been on task prior to the holiday and continued to complete tasks by their deadlines throughout January. But unforeseen changes beyond my control kept me alert and adapting as tournament director.

Within ten days after the January 5, 1971, deadline for making travel, lodging, and meal reservations, two institutions from California called to withdraw from the tournament for lack of adequate funds, so I notified the first two alternate teams. One of these teams was from Iowa and the other from Oklahoma, and both teams were glad to have the opportunity to participate. This caused a seeding revision for pool play within three weeks of the tournament, but that was sufficient time to make the adjustments.

Committee Preparation for the Championship Tournament

The eleven student committees were wrapping up their tasks by the end of January. The publicity committee had sent news releases to local and national media. The local arrangements committee had reserved blocks of rooms at the Best Western Virginia Inn, Holiday Inn, Ramada Inn, and Travel Lodge and identified local restaurants with affordable entree costs. Each team replied with its preference for lodging reservations in Lawrence and estimated time of arrival.

Other committee chairs completed their assigned tasks on a scheduled timeline. The signage committee constructed directional hallway signs inside Robinson Gym, pointing toward the locker room and lockers designated to each team, along with the hospitality lounge and courts. The hospitality committee selected women students to meet each team and

accompany it to each scheduled match. Its members also linked Lawrence Chamber of Commerce members who had volunteered to host during the tournament with each team. The registration committee typed more than 500 name badges for participants and committee members and attached ribbons for identification. The program committee designed the program, inserted team photographs according to tournament bracket, sought local business advertisements, and arranged for printing and distribution to participants and spectators.

The match schedule had been determined, and a tournament bracket was drawn on a large poster and hung in the hallway outside the two gymnasia in Robinson Gym, showing the court assignments for each match, the time of each match, and the teams competing in it. The twenty-eight teams, grouped into four pools, were scheduled for nine matches a day on each of the four courts in north and south Robinson. Matches were scheduled for ninety minutes each and occurred between 8:00 a.m. and 8:00 p.m. for the first two days and in the morning of the third day; thus, during pool play, teams played eighty-four matches in the two Robinson gymnasia. The first- and second-place winners in each pool were then seeded in an eight-team, single-elimination/consolation tournament for the championship finals, scheduled for Saturday afternoon and evening. Winners of the first round in the bracket played in the semifinals, and losers in that round competed to be the consolation winner. The second round of the bracket constituted the teams for the consolation finals and for the championship finals. The scheduling committee chair posted final scores of each match as she learned them throughout each day.

At DGWS national championships, entering teams were required to bring a DGWS nationally rated official with travel compensated by the team. The officials committee requested a list of nationally rated officials from participating teams, then contacted those individuals regarding their availability. Twenty-eight officials were offered seven dollars per match, with a minimum of six matches to officiate. In December, potential officials were contacted, and in mid-January their scheduled matches were confirmed.[7] Most officials traveled with teams and paid their own expenses because no tournament funds were available for their travel or per diem. All officials met before the first match to clarify ground rules and rule interpretations. KU and SMSU played a demonstration game for the evening before the tournament started so that officials and coaches could experience the judgment calls officials would make during the tournament. There was a strong likelihood that volleyball officials' calls might vary because

officials designated by each team were coming from different areas of the country. The student officials committee named KU students from officiating classes as scorers, timers, and linesmen. The officials committee also scheduled the student scorers and table officials and supplied the score sheets, timing devices, and striped pinnies for those officials on all four courts. The scorers' table officials showed the game scores on flip cards at their tables.

KU Tournament Facilities for the National Volleyball Championship

The equipment and facilities for the tournament presented a challenge. The DGWS had approved the Wilson SV-5Star as the official tournament ball. However, the company that produced the balls did not deliver them in time for the tournament, so we had to use new USVBA balls originally purchased for PE classes. The PE Department provided nets for the four courts; they were to be used for classes following the tournament. Scorers' and timers' tables were borrowed from the four classrooms in Robinson Gym, and folding chairs were set up for each team's bench along the sidelines. The KU Memorial Union loaned additional folding chairs for the finals matches.

In 1971, there were no commercial volleyball net standards that provided for tight nets with officials' stands, so the Robinson building superintendent custom-built four net standards. He welded two-inch-diameter steel piping as a frame for a seven-foot tricornered stand, with a plywood officials' platform four feet above the floor. These volleyball platform net standards were placed at the center of each outside wall of the two gyms. Two regular, black-enameled steel net standards were used to hold the ends of each net for each court at the center of each gym. A cable wire stretching the width of the gymnasium was attached on each end to bolts on the side walls of the two gymnasia and hung above the center volleyball court lines, seven feet above the floor. The volleyball nets were strung along this cable, attached to the four net standards on each side of the two courts. Hand wenches on the sideline net standards were wound to tighten the nets to the official height. The platforms on the net standards at the outside wall of each court served as the head officials' perches during matches. Folding chairs and classroom tables were placed along the sidelines at the center of each gymnasium for the table officials.

Portable pullout bleachers had been placed along the side walls in the south gym when Robinson was constructed a decade earlier, but they had never been moved away from the walls since the building opened. The

north gym in Robinson had no bleachers, so folding chairs for spectators were set in rows on the unused center volleyball court. The match schedule required that four courts be available every hour for three days of the tournament, so the two sets of bleachers in the south gym were rolled to the center of the gym on top of the middle volleyball court and placed back to back, each facing a volleyball court on one side of the gymnasium. For the finals on Saturday evening, the bleachers in the south gym were moved back to the sides so that the matches could be played on the center court. The rollers under the bleachers were small steel discs and did not roll easily after ten years, so grand-piano truck dollies had to be borrowed from the KU Music Department to get the bleachers moved in a timely fashion without gouging the floor. Even so, the length and weight of the bleachers required several men to move them, and KU shot-putters and discus throwers were recruited to help. The four-tiered bleachers seated 300 spectators along each wall of the gymnasium, and an additional 300 folding chairs were lined up in front of the bleachers to accommodate spectators from eliminated teams at the final matches. The bleacher rearrangement and setup of folding chairs had to be completed during the tournament luncheon on Saturday.

An all-tournament luncheon was scheduled at the Ramada Inn banquet hall at noon on Saturday at the end of pool play and before the elimination bracket began. Teams had made lunch reservations for each of their players and coaches at a cost of $2.75 each. The DGWS policy included a social element engaging all participants, and the luncheon allowed time for the elimination-seeding committee to seed the winning teams from pool play according to their respective tournament records. The Ramada Inn was the only space in Lawrence that could serve 400 place settings in one room, and each team had a designated table. The program included acknowledgment of KU administrators and tournament leaders. Fran Schaafsma, volleyball book author, former CIAW commission chair, and PE professor at Long Beach State University was the keynote speaker.

The Second DGWS National Volleyball Championship Opens

February 1 was a Monday, and all preparations were in place for the tournament that week. After registration began on Wednesday afternoon, February 3, the event began to roll, and it was evident that the detailed preparations were providing for the needs of the participants. Lists of checkpoints paid off because each student committee had completed its tasks to near

perfection, and few glitches occurred. As director, I was in Robinson Gym for registration and well before the first matches began each day at 8:00 a.m., and I remained after the 8:00 p.m. match concluded each evening. Most of my attention was directed to unforeseen situations, but the two student cochairs and eleven committee chairs took care of minor adjustments and notified me of any incidents beyond their authority.

Visiting teams that wanted practice time on the unfamiliar courts were given a one-hour practice time on one of the four Robinson courts on Wednesday prior to 4:00 p.m. The facilities committee put up and took down volleyball courts for the several different court arrangements for practice time on Wednesday, pool play Thursday through Saturday morning, and the consolation finals on Saturday afternoon and evening. Only a few volleyball teams arrived early enough to take advantage of pretournament practice time.

Opening ceremonies were held on Wednesday evening at 7:00 p.m. in the south Robinson gym. The uniformed teams gathered with their coaches in the north Robinson gym and entered the south gym in a double-file line in alphabetical order by college to designated seating on the side bleachers. The Baldwin High School band played an Olympic-style march for participants because the all-male KU band was not accessible for women's athletics in 1971, and the Lawrence High School band was not available that day. After all teams had been seated in the south Robinson gym, KU student National Guard members carried in the American flag and the Kansas state flag, and the Baldwin High School band played the national anthem. Each team and their coach was introduced and asked to stand for recognition, and the other teams and audience applauded. Vice Chancellor for Student Affairs William Balfour, along with Henry Shenk, department chair for Health, Physical Education, and Recreation, welcomed them to the event.

Carole Oglesby of Temple University, 1971 CIAW commissioner for national championships, gave the "Opening Declaration" of the second DGWS National Volleyball Championship. Following these remarks, the KU team and the SMSU team played the demonstration match on the center court to show the expectations of officiating calls for the tournament.

Following the opening ceremonies on Wednesday evening, a players' mixer and song fest was held in the north Robinson gym, with Charlie Oldfather, KU professor of law, playing guitar and singing familiar folk songs of the early 1970s. During this mixer for the athletes, coaches and officials met in the large upstairs Robinson classroom to ask questions and resolve

KU women's volleyball team with Coach Linda Dollar outside the huddle, 1971.

any regional differences about the manner of officiating the tournament based on the demonstration match. At the same time, the facilities committee was moving the bleachers in the south gym from the two side walls to their back-to-back position on the center court, where the demonstration game had been played, to free the two outside courts for the next morning. The committee strung and tightened the nets to the correct height and maneuvered the officials' stands into place at the side walls. Following the players' mixer in the north gym, the facilities committee set up rows of folding chairs on the center court.

At 8:00 a.m. on Thursday morning, the round-robin competition began on the four courts in the north and south Robinson gymnasia. Each team had been seeded and assigned to one of the four pools based on its placing in the previous year's championship, representation from each American Association for Health, Physical Education, Recreation, and Dance (AAH-PERD) district (AIAW regions were not yet developed), team records within each district, and meeting mailing deadlines for team and player registration and entry fees. Seven teams competed in each scheduled pool. Each team had six matches during the two days of pool play. Four matches were scheduled simultaneously in ninety-minute increments from 8:00 a.m. to 8:00 p.m. on Thursday and Friday and on Saturday morning at 8:00 a.m.

and 9:30 a.m. DGWS matches ended when one team won two of three sets, with a score of fifteen points and a two-point advantage. Contemporary Fédération Internationale de Volleyball (FIVB) rally-scoring rules, with best three of five sets, twenty-five points in a set, and a point scored with every serve, were not yet used in 1971. With DGWS rules, only the serving team could score, so the sets took approximately the same time to play using either set of rules, even though the total winning score was less. Some matches were completed in two sets, and other closer competitions required three sets, but all matches in the four pools were completed by 10:00 p.m. each evening.

Early on Friday morning, snow began to fall in Lawrence, and the several teams from southern campuses were delighted to experience the novelty of it. Players had snowball fights outside Robinson Gym, and some learned to make snow angels. The Auburn University team, from Alabama, had brought along bedrolls and was welcomed to sleep on the lower level of the Osness home in Lawrence. As the snow fell, the Osness family supplied sleds and toboggans for the women to slide down slopes in their neighborhood. One Southwest Texas State University (now Texas State University) official tried cleaning the snow off her windshield by turning on the windshield wipers and found that the whole windshield became icy. The snowfall was only about four inches, so the city had cleared the streets long before there was any difficulty driving, and it turned into a fun and memorable occasion for many of the southern teams.

Round-robin pool play went on until all twenty-eight teams had played six matches, and then the seeding committee considered the win-loss records of all teams for elimination bracket seeding. The same committee that did the finals elimination bracket seeding handled any protests. The seeding/protest committee included JoAnne Thorpe, the DGWS national volleyball championship chair from Southern Illinois University; Jan Sayre, a DGWS nationally ranked volleyball official from the University of Nebraska; and Joie Stapleton from KU. Long Beach State University, Sul Ross State University, and the University of California–Los Angeles (UCLA) each had 6–0 records in pool play, winning all their matches in two sets. Oregon State University (OSU) and the University of Oregon each had 5–1 records in pool play, with all their wins in two sets and their losses in two sets. Lamar State College also had a 5–1 record, but the team won two matches in two sets and two matches in three sets and lost in a two-set match. SMSU, Southwest Texas State University, and Texas Woman's University (TWU) each had a 4–2 record, but SMSU had three match wins in two sets and

one match win in three sets, with two match losses in two sets, whereas Southwest Texas State University had four match wins in three sets and two match losses in two sets. TWU had three match wins in three sets and a match win in two sets but also two match losses in two sets and three sets, respectively. These top eight teams were ranked accordingly and seeded for the single-elimination portion of the tournament.[8]

Sul Ross State University had dominated volleyball nationally because some of its team had played in USVBA championships, and senior Mary Jo Peppler was a renowned Olympic player. Similarly, both Long Beach State University and UCLA had USVBA players who had been playing power volleyball for several years. Power-volleyball skill in Oregon was comparable because USVBA competition had spread along the West Coast before it had become popular in the heartland.

The Disqualification Ruling

The pool play seemed to indicate that Long Beach State University, Sul Ross State University, and UCLA would continue to dominate the national championships just as they had placed first, second, and fourth, respectively, the previous year. San Diego State University won third place in that first tournament.

However, on Saturday morning as pool play was concluding, the KU student cochair supervisors informed me that when filling in names on tournament award forms from the official score sheets on Friday evening, they were two forms short of the number of participants registered as eligible players. They had recounted the forms and checked the team rosters, and they had found the same number of forms as eligible players, so they had retraced the names on the official score sheets and found the UCLA manager had been entered on a score sheet as a player, and an OSU player not listed on its team eligibility document had been entered on a score sheet.

Immediately I called a meeting to notify the DGWS national volleyball committee before the end of pool play. After deliberation, the committee determined that the two players not listed on their team rosters when the teams registered for the tournament were ineligible to play, and that the national tournament rules required their teams be disqualified. The OSU player was added to the tournament roster after the team earned enough funds to bring one more player, but the extra player was not added to the official team eligibility roster. The UCLA player was undisputedly listed on the UCLA team roster as team manager; she had entered a game on a lark when the score was lopsided. Thus, both teams were declared ineligible for

the remainder of the tournament, allowing two other teams to qualify for the finals.

The DGWS commissioner notified the coaches of both the OSU and the UCLA teams immediately after pool play ended. She also notified the DGWS seeding committee members before noon so that they could adjust the seeding of teams in the elimination bracket for the finals. An announcement of the eight seeded teams for the elimination bracket was made at the tournament luncheon on Saturday at noon, surprising many who had recognized the dominance of the disqualified teams. Correcting the violation and realigning the finals gave great credence to KU's committees' timely adjustment during a difficult situation.

The eight-team, single-elimination bracket was reseeded according to the new teams' win-loss records in the round-robin pool play. The two courts in the north gym were used for the four semifinal matches in the afternoon, and the center court in the south gym was used for the third place and the championship finals matches in the evening. While all teams were attending the tournament luncheon, the bleachers in the south gym were repositioned to open the center volleyball court for the final elimination tournament. During the finals, players from eliminated tournament teams were asked to sit in the folding chairs, leaving the bleachers for paid spectators.

The first stage of competition for the top eight teams was on Saturday afternoon in a consolation tournament format. In that first round, top-seeded Sul Ross State University defeated TWU, second-seeded Long Beach State University defeated Lamar State College, Southwest Texas State University defeated Miami-Dade University, and the University of Oregon defeated SMSU. Teams who lost in the first round were consolation contenders. SMSU defeated TWU, and Miami-Dade University defeated Lamar State College to set up the consolation finals between SMSU and Miami-Dade University. Miami-Dade University won the consolation tournament in a three-set match, one set with an extended score of 20–18. In the second round of the winner's bracket, Sul Ross State University defeated the University of Oregon, and Long Beach State University defeated Southwest Texas State University, with each match in two sets. These match results set up the third-place competition in the evening between the University of Oregon and Southwest Texas State University, which the latter won in three sets. Then, Sul Ross State University and Long Beach State University battled for the championship in a three-set championship match, and Sul Ross won. During closing ceremonies, a small plaque was awarded to the

champions at center court acknowledging their victory (the DGWS did not condone flashy trophies for women's intercollegiate competition then).

Financial Account of the Second DGWS National Volleyball Championship

Cost estimates for conducting the national tournament within the KU bid totaled $2,752. The PE Department bore many incidental costs, such as secretarial time, facility utilities, custodial services and maintenance, sports equipment, and heavy use of the copy machine. Revenues included the $50 team entry fees, a $100 CIAW advance, and the sale of spectator tickets for the finals.[9]

Tickets were not required for pool-play matches but only for the semifinals and finals. Tickets were priced at $1.50 for adults and $1.00 for students for the semifinal matches and $2.00 for adults and $1.50 for students for the finals. No discount was offered for purchasing a combination of semifinal and final tickets. The tickets were printed by December 1970, and advanced sales began when the spring semester started in early January. Tickets were sold in the Robinson Gym main office and issued to a local drugstore for community sales. Mail-order tickets had to be purchased one week in advance of the event, and tickets were also sold at the door. Several orders of advance tickets were sold to Kansas college teams and coaches.

KU sold 332 tickets for the semifinals and an additional 535 tickets for the third-place match and championship, for a total of 867 tickets. All players, coaches, officials, and student committee volunteers wearing a nametag with a ribbon were admitted free. Others attending the championship finals free included the six teams defeated in the elimination bracket earlier on Saturday and at least a hundred or more player-spectators from four or five teams that elected to stay to watch the finals. Because a few hundred spectators attended the finals at no cost, the gym was standing room only. The crowd at the championship match was estimated to be more than a thousand in the south Robinson gym. This was by far the largest crowd to have attended a women's intercollegiate sports event in Kansas. That level of interest in a sport that had not even attracted more than a half dozen spectators at any home match was amazing.

DGWS policy in 1971 was for national championships to break even, not to make a profit. Any profits were to be returned to the DGWS so that any financial exploitation of the women's intercollegiate athletes could

be controlled. The revenues for the second national championship were $3,181, with expenditures at $2,802, resulting in a $379 profit.

Officiating was the greatest expense of the tournament. The officials were collectively paid $1,320 (again, at $7 per match officiated), but team entry fees totaling $1,400 covered that cost. The officials' rate was increased to $9 per match for the third and fourth championships. Printing 500 copies of the program cost $432, more than six times the $70 in revenue from program sales, but $308 in advertisements helped cover that expense.

The tournament accounting included written documentation for the PE Department's many in-kind donations. Local businesses and other campus entities donated in-kind as well. Detailed records and evaluations of the various tournament committees' activities were collected and bound in the 1971 *DGWS National Volleyball Championship Report*, distributed to the four national championship committee members and to the DGWS headquarters.[10]

The second national tournament was successful beyond expectations. The student committees were creative, frugal, resourceful, and responsible, which enabled KU to host a high-quality event with reliable student and faculty volunteers. With minimal funding, KU women's volleyball players were given the opportunity to compete with teams on a national level and gain competitive maturity at a level of skill and strategy that could be gained in no other way. Participants departed realizing that the KU campus was welcoming and beautiful and that the steep campus hills did not reflect how they previously might have stereotyped Kansas. Not only did the participants respond with accolades about their tournament experience but the evaluations revealed that they appreciated the opportunity to compete on the national level. Likewise, spectators were amazed at the skill level of college women volleyball players and were gratified to witness it. The KU student volunteers who prepared and conducted the tournament had a hands-on opportunity to experience the work of a large team effort to host a national sports event that few other college students would have.

KU Volleyball Championships: A Pioneer Legacy

Hosting the second DGWS National Volleyball Championship gave KU an advantage in terms of the team's perspective of the skill level and strategy necessary for national competition, and it also gave KU national visibility as a contender among other AIAW institutions across the country. KU earned berths in four of the first five national intercollegiate volleyball

University of Kansas

KU women's volleyball team with Coach Linda Dollar, 1970–1971.

championships, creating an early legacy for other KU teams to follow. The achievement of each of those four national-championship-caliber volleyball teams was significant.

In the national championship tournament we hosted, KU's pool-play matches resulted in defeating the College of Wooster from Ohio in three sets and Central State University from Oklahoma in two sets; KU lost matches to OSU and UCLA in two sets and to Lamar State College and the University of New Mexico in three sets, for a pool-play record of 2–4. Like twenty of the twenty-eight teams, KU did not qualify for the elimination finals even though OSU and UCLA were disqualified. Sul Ross State University won for the second consecutive year, Long Beach State University was second, Southwest Texas State University was third, and the University of Oregon was fourth.[11] But KU had earned a berth in the tournament by winning the state championship, and the players learned the caliber of play required to compete well in a national championship.

For the 1971–1972 season, Interim Coach Ann Laptad coached KU women's volleyball during my one-year absence. The KU team dominated Kansas Association of Intercollegiate Athletics for Women (KAIAW) competition and won the state championship again that year in an undefeated season, thus qualifying as the Kansas entry for the third DGWS National Volleyball Championship, held at Miami-Dade Junior College in Florida February 3–5, 1972. The KU Student Senate funded the women's volleyball team to drive to the tournament. In pool play there, the team defeated Lamar State College, State University of New York (SUNY)–Oneonta, and

KU women's volleyball team with Coach Marlene Mawson, 1972–1973.

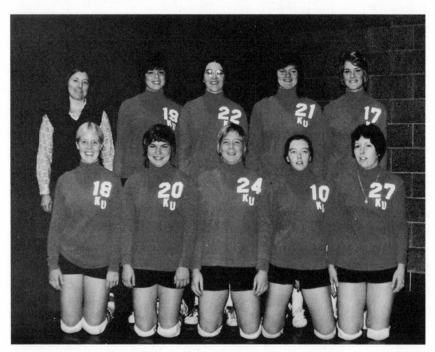

KU women's volleyball team with Coach Marlene Mawson, 1973–1974.

Western Michigan but lost to Florida State University, San Fernando State University, and SMSU for a 3–3 match record. For its second year in national competition, KU was one of the twenty teams that did not qualify for the final elimination bracket. UCLA won the third DGWS National Volleyball Championship, Long Beach State University took second, and San Fernando State University came in third.[12]

The fourth national volleyball championship tournament was at Brigham Young University (BYU) in Provo, Utah, February 1–3, 1973, and several major changes were made to its structure. It was the first AIAW championship because the DGWS had relinquished women's intercollegiate sports governance. Entries into the national championship as of the 1972–1973 season were the winner and runner-up in each of the nine AIAW regional championships. Only twenty-four teams were selected; thus, each of the four pools consisted of six teams rather than the previous seven, so each team played five other teams in pool play. The host school automatically received one of the at-large berths unless it already qualified at the regional level, and the other five at-large berths were selected based on placement in recent national championships.

The KU team earned entry into the fourth national championship as the 1972 AIAW Region 6 runner-up in December, having been defeated by SMSU in the regional final held at the University of Minnesota. In Utah at the national championship, KU defeated West Georgia College (now the University of West Georgia) in two sets and SUNY–Oneonta in three sets but lost to California State University–Fresno in three sets and to both Southwest Texas State University and BYU in two sets each, for a 2–3 match record in pool play. For the third year, KU was among the sixteen teams that did not earn a berth in the single-elimination finals, but of its formidable opponents in pool play, BYU was second and Southwest Texas State University was fourth in the championship finals. These two teams in the final four were in the same competition pool with KU. Long Beach State University was the AIAW national volleyball champion.[13]

The fifth national volleyball championship was scheduled in December rather than in February. Most colleges began the fall semester in late August, and the semester ended prior to the holidays in December. The three-week holiday break did not provide the same continuity from conference and regional competition in December to national competition nearly two months later, compared with having the entire season within the same semester.

The KU team earned a national berth in this AIAW National Volleyball Championship, held in Wooster, Ohio, December 12–15, 1973, by winning the AIAW Region 6 Championship in Minneapolis. The University of Minnesota was the regional runner-up, and SMSU was selected as an at-large team primarily based on its season record and having earned a berth in all four previous national championships.

Although KU won pool-play matches over the College of Wooster and SUNY–Brockport in two sets, the team lost to BYU, TWU, and West Georgia University in two sets, for a 2–3 pool-play record. Although KU did not win enough matches to compete in the elimination finals, the team faced stiff opposition as TWU went on to take second place and BYU fifth place. UCLA was fourth and University of California–Santa Barbara third. Long Beach State University won for the second consecutive year, tying with Sul Ross State University, which had won the first two championships.[14]

The 1973 volleyball team was the last one I coached because KU women's intercollegiate sports moved from the PE Department into KU Athletics in the summer of 1974. It was also the last time a KU women's volleyball team would earn a berth in the national championship until after the turn of the century. It was a terrific run.

KU in National Basketball Tournaments

Three DGWS National Invitational Basketball Championships with sixteen teams each were held prior to the CIAW sanctioning the first AIAW National Basketball Championship. West Chester State College in Pennsylvania hosted the first basketball invitational in 1969, and the host school won with a notable senior player, Marian Washington. The second national invitational took place at Northeastern University in Boston in 1970, and the third occurred at Western Carolina University in 1971. The invited teams played the first two tournaments using six-player rules, but at the third, they used the experimental five-player rules. Illinois State University hosted the first sanctioned AIAW National Basketball Championship in 1972.[15]

Defeating Kansas State University (KSU) in the 1971 AKWIS Basketball Championship finals qualified the KU women's team for the DGWS National Basketball Invitational Championship at Western Carolina University in Cullowhee, North Carolina. Two of the KU season wins and two losses were attributed to the 1970 national tournament. The first loss was a heartbreaking game against the University of California–Davis, when KU lost by one point in double overtime in the first round of the consolation

tournament. This loss put KU into the consolation bracket. The KU team then defeated the University of South Carolina and Winthrop University in the consolation bracket. Finally, KU lost by seven points in the consolation finals to California State University–Fullerton. California State University–Fullerton, coached by Billie Moore, a US Olympic coach, won the previous AIAW National Invitational Basketball Championship. It was the last KU women's college basketball game I coached.

Washington became the KU women's basketball coach in 1973–1974. The KU team's accomplishments during the last four years of the AIAW were memorable because of the elite athletes on the team. In the 1978 postseason, KU was selected for the Women's National Invitational Tournament (WNIT) in Amarillo, Texas. With Lynette Woodard compiling scoring records, KU won the 1979, 1980, and 1981 AIAW Region 6 Championships but lost to Louisiana Tech the first two years and to UCLA the third year of those national championships. The AIAW ceased national championships in the 1981–1982 season. Washington went on to coach KU in nine consecutive NCAA National Basketball Championships between 1992 and 2000. She retired in 2004.[16]

National Gymnastics Competition for KU Women

During spring break in 1971, the KU women's gymnastics team of four drove with their coach, Anise Catlett, to the DGWS National Gymnastics Invitational Championship at the Pennsylvania State University in University Park, Pennsylvania. Two KU juniors, Sue Tagg and Cindy Price, and two KU first-year students, Joanie Smith (now Starks) and Lisa Galbreath, competed at the nationals. In spring 1972, although Ruhl was named KU gymnastics coach, Laptad accompanied the KU gymnastics team to the first AIAW Region 6 Gymnastics Championship in Brookings, South Dakota, where the team placed third. Following that, at the 1972 AIAW National Gymnastics Championship at Grandview College in Des Moines, Iowa, the KU team finished fourteenth based on meet points.[17] KU did not qualify for AIAW National Gymnastics Championship again during the 1970s, and in 1980, KU discontinued women's gymnastics.

KU Softball and the Women's College World Series

Between 1969 and 1972, the DGWS cosponsored the Women's College World Series, a national intercollegiate competition, with the Amateur

Softball Association (ASA). The AIAW sanctioned this consolation-bracket championship and the ASA administered it between 1973 and 1981. The University of Nebraska–Omaha hosted this national intercollegiate championship from 1969 to 1979, and the University of Oklahoma–Norman hosted it afterward. Although KU had a women's softball team in the spring semesters of 1969–1972, it only began to win state softball championships in 1973 with Sharon Drysdale as the coach. The team won the KAIAW State Softball Championship in 1973, 1974, 1975, 1976, and 1977, and in each of these years the team went on to compete in the College World Series in Omaha.[18] In spring 1973, when the KU team won state for the first time and qualified for the College World Series, eighteen teams participated in the national tournament. The KU team had an exceptional pitcher, Penny Paulson, who pitched for the Jayhawks three seasons. KU was initially defeated in the 1973 tournament by the eventual champion, Arizona State University, and then won two games in the consolation bracket for a 2–2 tournament record.[19]

In 1974, the College World Series was held during a weekend of continuous rainstorms in Omaha. The double-elimination games were shortened to five innings, and the Saturday games were moved to the artificial turf of the University of Nebraska football field. KU started the 1974 championship by defeating Winona College, from Minnesota, 10–0 and California Golden West College 2–1 on Friday, but then lost to the University of Northern Colorado (UNC) 1–0 on Saturday. In the losers' bracket, KU played the University of Arizona at 11:00 p.m. Saturday night on the artificial turf, winning 8–0, then playing Eastern Illinois University at 1:15 a.m. (Sunday) and winning 2–0. KU next defeated the University of Massachusetts 13–3 early Sunday morning. In the semifinal game Sunday afternoon, KU faced UNC once again, but having just played four consecutive games with little rest, KU lost 19–0, ending with a 5–2 tournament record that year but claiming fourth place nationally. SMSU won the 1974 College World Series, UNC was second, and Wayne State University was third.[20] In 1975, Paulson's senior year, KU lost its first College World Series game to defending champion University of Nebraska–Omaha and earned a 2–2 tournament record in the consolation bracket.[21] The 1976 season was the last one Drysdale coached at KU, and for the fourth consecutive year the team competed in the 1976 College World Series, but I found no records for that year.

In 1977, the College World Series was limited to sixteen teams. Bob Stanclift was the new KU softball coach that year. KU retained several of the team members from previous years, and because KU earned the Big

Penny Paulson, KU women's softball pitcher, 1974.

Jill Larson, AIAW first team third base, All-American, 1981.

Eight Conference title in 1977 and 1979, the team competed in the College World Series those years. In its first game of the 1977 tournament, KU was shut out by the University of Northern Iowa, the eventual champion, but KU recorded a 2–2 tournament record.

In 1979, with Stanclift as the coach and Shelley Sinclair as an outstanding pitcher, the KU team faced eventual champion UCLA team and lost

2–0.[22] Jill Larson (now Bradney) played third base for KU from 1978 to 1981 and led the team in batting records. She was named to the Big Eight All-Tournament team for three years and was the first All-American in softball at KU. Larson is in the KU Athletics Hall of Fame, and her softball jersey has been retired. The next time the KU softball team qualified for the College World Series was in 1992, when it had been an NCAA tournament for a decade.

KU in Early National Track-and-Field Meets

Although track was not sanctioned as a KAIAW sport until 1974, and thus KU did not offer track and field for women until then, individual athletes were eligible to compete in the AIAW National Track and Field Championship if they could post qualifying scores in their events. KU athlete Mary Jacobson placed third in the shot put at the 1972 US Olympic Trials in Fredrick, Maryland, and qualified for this event at the 1973 AIAW National Track and Field Championship, where she won second. Jacobson was also a halfback in field hockey, made first team in volleyball, and was one of forty female and male athletes inducted into the Outstanding College Athletes of America Hall of Fame in 1974. KSU won the first sanctioned KAIAW Track and Field Championship and thus qualified for the 1974 AIAW National Track and Field Championship, where two KSU women produced a total national score of twenty for ninth place. KU's Jacobson finished second nationally in the shot put in 1974, but her individual score was not sufficient for KU to contend as a team.[23]

KU Women in Early National Golf Tournaments

The Boozer family dominated early KU women's golf. With Nancy Boozer as the coach, her daughters Barb and Beth led the team to national competition for six years during the AIAW decade. Barb played in AIAW National Golf Championships in Las Cruces, New Mexico, in 1972; at Mount Holyoke, Massachusetts, in 1973; and at San Diego State University, California, in 1974. Beth was the leading golfer on the KU team at the AIAW National Golf Championships for her first three years (1975–1977), playing in Tucson, Arizona, in 1975; at Michigan State University in East Lansing in 1976; and in Kuilima (now Turtle Bay), Hawaii, in 1977, where she placed in the top twenty. In her senior year, 1978, Beth played in the AIAW National Golf Championship in Orlando, Florida.[24] Beth continued to golf professionally

after graduating from KU. She also played volleyball during her first three years at KU and was a scholarship athlete in both sports.

Overall, the KU women's volleyball, basketball, softball, and golf teams of the early years made a notable impact during the decade of the AIAW national championships. KU women's gymnastics was recognized nationally in early AIAW national competition, but for fewer years. During the decade of the 1970s, KU was recognized for having a leading program in women's intercollegiate athletics nationally. These early KU athletes set the stage for the greater opportunities and feats of future women Jayhawks. Although these pioneering women endured hardships to compete nationally, they played for the love of sports and the joy of competing with the best teams in the country.

OVERARCHING REGULATIONS
INFLUENCING WOMEN'S
INTERCOLLEGIATE ATHLETICS

Early in the development of women's intercollegiate sports, women athletics directors in Kansas established a state organization to standardize competition regulations. Soon thereafter, a national organization was formed to offer uniform guidance through regulatory governance of women's national sports championships. Also, in the first decade of women's intercollegiate competition, federal regulations ensured that educational funding for colleges would follow sex-equity guidelines issued by Congress, thus offering legal enforcement for college women athletes to have equal opportunities with college men. Each of these three major developments significantly advanced women's intercollegiate athletics across the nation. As these three governing influences grew throughout the decade, women's athletics evolved into a nationally recognized force and gained more social acceptance.

Kansas Organizations for Women's Athletics

The spring conference of several college Women's Recreation Associations (WRAs) in Kansas, as affiliates of the national Athletics and Recreation Federation for College Women (ARFCW), was held at the Rock Springs 4-H Ranch each year. The Rock Springs 4-H Ranch, in a remote area in the middle of rural Kansas in the Flint Hills, provided economical housing and a centrally located meeting space for WRA faculty sponsors and WRA student presidents planning for women's intramural programs on campuses. In spring 1969, in conjunction with the annual Kansas Athletics and Recreation Federation for College Women (KARFCW) conference, several of the women college physical education (PE) teachers in Kansas responsible for women's intercollegiate sports programs on their respective campuses also came to the Rock Springs 4-H Ranch to discuss the development of a statewide women's intercollegiate sports organization.

The spring 1969 KARFCW conference was held Friday evening through Sunday, March 14–16. It was only the seventh month of my faculty appointment at the University of Kansas (KU). Having been director of the KU women's intercollegiate sports program since the previous fall semester, I had not yet met many Kansas women colleagues from other institutions, so I was looking forward to becoming better acquainted in order to initiate intercollegiate competition with more opponents.

Participants attended KARFCW conference sessions at the ranch's main education center throughout the day and spent the nights in cottages with bunk beds for eight. In the evening on both Friday and Saturday, the attendees gathered informally in the fireplace lounge of Weatherwax Cottage for conversation about women's sports competition and the initiation of a new women's athletics governing organization in Kansas.

This initiative was separate from the KARFCW intramural organization, which also supported extramural club sports for college women. The recently designated women's intercollegiate sports directors from nine Kansas colleges who participated in these initial, informal meetings included Mary Estes from Kansas State Teachers College–Emporia (KSTC–Emporia), Pat Duncan from Fort Hays State College, Judy Akers from Kansas State University (KSU), Doris Coppock from McPherson College, Emma Palmer from Mount St. Scholastica College, Millie Warren from Southwestern College, Jan Nuzman from Washburn University, Natasha Fife from Wichita State University (WSU), and me, representing KU. Other interested women PE teachers were present but were not the designated directors for women's intercollegiate sports at their institutions. The organization title approved at the first meeting of women athletics directors was the Association for Kansas Women's Intercollegiate Sports (AKWIS).[1]

Establishment of the AKWIS in Kansas

The main purpose of this first meeting in March 1969 was to organize competitions for Kansas institutions wishing to participate in women's intercollegiate sports and to establish standardized guidelines for those competitions. Several stipulations for membership in the AKWIS were established at this first meeting: Kansas colleges intending to become AKWIS charter members needed to complete a membership application with identification and contact information for the women's intercollegiate sports director and for the coaches of each sport. Payment of institutional membership dues would ensure that their administrations intended to join and

abide by the AKWIS guidelines. Scheduling of competition with AKWIS member schools would be allowed only after the institutions had submitted membership dues for the current year. AKWIS was to be open to any college or university PE department sponsoring and coaching women's intercollegiate sports.[2]

The women at the first organizational meeting established four specific purposes for the AKWIS:

1. to unite Kansas colleges in administering women's intercollegiate sports within a single state organization,
2. to establish and maintain standards for women's sport competition among colleges,
3. to establish scheduling and participation guidelines for women's intercollegiate sport competition, and
4. to regulate and enforce sport rules and officiating for women's intercollegiate sport competition.[3]

To ensure maintenance of consistent standards for college women's sports participation, the Kansas women athletics directors adopted a similar state structure to that of the national Division of Girls and Women in Sport (DGWS)/Commission on Intercollegiate Athletics for Women (CIAW); that is, they established a state commission of three women leaders to enforce sport participation standards and to sanction women's state championship competition. Three Kansas commissioners—Akers, Jeanne Galley (from KSTC–Emporia), and Warren—were appointed and charged with sanctioning forthcoming state championships and monitoring intercollegiate competition among Kansas women athletes beginning in fall 1969. I was surprised and honored to be elected as the first AKWIS president.[4]

For the upcoming 1969–1970 academic year, AKWIS sports seasons would extend for only half a semester each for four team sports and two individual sports. Field hockey and volleyball were scheduled as the outdoor and indoor sports in fall semester, and basketball and softball were the indoor and outdoor spring semester sports. Gymnastics and swimming would use the DGWS National Championship dates as the end of the season for scheduling of in-state competition, but no season opening date was established.

Membership dues for AKWIS were five dollars per institution plus two dollars per sport the institution sponsored. The total budget for the first year of AKWIS statewide operations was less than $200 because many of

the incidental expenses of the organization were covered as in-kind donations from the PE Department budgets of member institutions. KU paid a total of seventeen dollars in 1969–1970 for AKWIS membership dues.

One month later, KSU hosted a second meeting of women's athletics directors to complete scheduling of the state competition for the 1969–1970 season. By the end of spring semester 1969, seven institutions had paid AKWIS dues for the upcoming academic year and were recognized as charter members: Fort Hays State College, KSTC–Emporia, KSU, KU, Southwestern College, Washburn University, and WSU. Representatives from McPherson College and from KSTC–Pittsburg attended the April 1969 scheduling meeting, but their colleges did not join at that time.[5]

The second annual AKWIS meeting was held at the Rock Springs 4-H Ranch in March 1970, during which the women's athletics directors discussed policies and procedures for the member institutions. I was one of the three women leaders, along with Nuzman and Warren, named to a committee to develop a proposed constitution. Discussions about content for the AKWIS bylaws concerned designating seasons, scheduling competition, officiating, qualifying coaches, and establishing sports rules, among other issues.[6]

KSU again hosted a follow-up meeting, in April 1970, to complete scheduling the competition for the 1970–1971 season. Also, our committee presented a draft of the AKWIS constitution. It indicated the purposes of the organization, affiliation with the state and national DGWS, institutional eligibility and dues for membership, and terms of office and duties for leaders. Discussions continued on designation of sports seasons, structuring tournaments for each sport, selecting officials, selling tickets, and other issues for the bylaws, but we deferred final decisions until the next meeting.[7]

At the September 1970 AKWIS meeting at Rock Springs 4-H Ranch, three additional colleges joined AKWIS: Marymount College, McPherson College, and Mount St. Scholastica College, making the total AKWIS membership ten colleges for the coming year. The main agenda of the fall AKWIS meeting was scheduling seasons and determining sports governing rules, passed as constitutional bylaws. We also discussed player eligibility, maximum team roster numbers per sport, and selling tickets at the gate.[8]

At this fall meeting, leaders shared the results of an AKWIS survey from late spring 1970 in which eleven Kansas institutions reported their funding sources for women's athletics. The survey indicated that all responding institutions received funding for women's athletics from student activity

fees for women's student recreation, including three colleges that received student activity funds earmarked for women's intercollegiate athletics. In addition, of the eleven institutions, four received additional funds for women's athletics from men's athletics, three received additional funds from their PE Departments, one got extra funding from the institution's general fund, and three got no additional funding beyond student activity fees. Nine institutions reported that their travel expenses were paid out of their PE faculty travel budget, and two provided no compensation for transportation. Five reimbursed players when the team stopped for meals while traveling to events, four provided players a meal allowance on away trips, and two did not reimburse meals. Three institutions paid for team lodging on away trips from the PE faculty travel fund, two reported staying in host campus dormitories at no charge, two indicated their players paid their own lodging, and four scheduled no overnight trips. This information was used to leverage budget requests at each college and university for the coming year.[9]

In April 1971, four additional institutions joined AKWIS for the 1971–1972 year: Benedictine College, Haskell Indian Junior College, Sterling College, and Tabor College (in Hillsboro), for total of fourteen AKWIS members. Galley invited AKWIS representatives to her vacation home at Lake Kahola, near Emporia, for the annual 1971 spring meeting. The women's athletic directors approved the final version of the AKWIS Constitution there.[10]

The September 1971 meeting of AKWIS was filled with discussion of AKWIS bylaws. The delegates approved ticket prices of five dollars or less for AKWIS sports events and decided that state championships gate profits would be split evenly between the host college and the AKWIS. We tabled other decisions until the spring meeting. That same fall, the AKWIS held a special meeting in November 1971 in Topeka in conjunction with the Kansas Association for Health, Physical Education, and Recreation (KAHPER) convention to alert AKWIS representatives of the impending establishment of a new national intercollegiate women's sports organization offering institutional membership. Representatives discussed the new Association for Intercollegiate Athletics for Women (AIAW), proposed to become official in July 1972.[11]

The AKWIS met every September and April at the Rock Springs 4-H Ranch from 1969 through 1974. Each year, membership in AKWIS grew beyond the original seven charter institutions, until by 1978 it totaled

twenty-one member institutions. Each meeting within the first five years had a main agenda of establishing sports governance policies and standards for participation in statewide competition, along with scheduling for the following year. In the years after 1974, with less frugal budgets, the women athletics directors and representatives met at hotel conference centers near the current AKWIS president's campus. In the remainder of the decade (1973–1982), because of the formation of the AIAW and AIAW Region 6, several policies and procedures the AKWIS had already approved were revised, including a change in the organizational title to the Kansas Association of Intercollegiate Athletics for Women (KAIAW). The state representatives amended their structure and governance to fit the national and regional competition guidelines so Kansas women athletes would be eligible for national championships.

DGWS Seeks a National Organization for Women's Athletics

The DGWS Executive Board received approval from the American Association for Health, Physical Education, and Recreation (AAHPER) in March 1971 to form AIAW, a nationwide organization for women's intercollegiate athletics. This organization would take over the responsibilities the CIAW had conducted since 1967 in governing DGWS National Championships by giving institutional members representation in governing women's intercollegiate athletics nationally. The final DGWS championship the CIAW sanctioned and supervised was the DGWS Invitational Basketball Tournament in 1971, and the first AIAW National Basketball Championship was scheduled for March 1972. The CIAW would continue to sanction all women's sports for national championships but under the governance of AIAW instead of that of DGWS.[12] The DGWS Executive Board planned for the new AIAW to assume its position in July 1972; however, not until November 1972 did delegates from more than 300 institutions meet in Overland Park, Kansas, and vote to establish the AIAW.[13]

In June 1972, a few months before the inauguration of AIAW, Congress passed the appropriations bill for federal subsidization of education in the United States. Title IX of the Education Amendments Act of 1972 would cause significant ripples across the country because it required educational institutions receiving federal funds to provide activities equitably to men and women, including athletics. The full ramifications of the act on PE and athletics were not known until the final compliance requirements were published three years later, in June 1975.[14]

The Education Amendments Act of 1972

As a thirty-one-year-old in spring 1972, I was not interested in political issues when Congress was contemplating a funding bill with ramifications for gender equity in higher education. I was immersed in attending graduate classes, frequenting the campus library, studying for exams, and writing research papers at the University of Oregon (OU). When I learned that Congress was considering a bill to ensure equal opportunity for women in colleges, I did not recognize it as a shift in American cultural views on gender or that it would have career-changing ramifications for me.

It was nearly the end of spring quarter on the OU campus, and I was surrounded in our classroom by nine men and only one other woman in my third seminar on PE administration for doctoral students. In that final PE administration seminar, discussions arose on how passage of the Education Amendments Act of 1972, and specifically Title IX of the act, would affect men's collegiate athletics and sex-separated PE classes as we knew them. It was a troublesome topic, especially for young men preparing to become higher-education administrators in PE or aspiring to be athletics directors. None of us knew the impact this law would eventually have on women athletes, but it certainly was a threat to the domination of men in PE and athletics at the time.

US Senator Birch Bayh (D-IN) introduced the bill in February 1972 as an amendment to the Higher Education Act of 1965, under consideration for funding renewal. The 1965 act provided federal funding for educational resources to colleges and universities, and this bill would reauthorize it, with some new provisions. The 1972 amendment provided federal funding for higher-education institutions when they adhered to specific regulations. US Representatives Edith Green (D-OR) and Patsy Mink (D-HI) had previously worded the amendment to include affirmative action for women, and Bayh used similar wording in his Senate amendment. After five months of debate, in June Congress passed the act into law. One year after this law was printed in the *Federal Register,* it went into effect, but few people understood its full ramifications at the time.[15]

Title IX as Law

The wording of this law and how different entities would interpret it for compliance are important to understanding the vexation it generated. Each year, Congress passes a budget for federal appropriations for public

educational institutions, with stipulations regarding distribution of these funds. Congress provides this funding for public education through educational amendment acts, which require appropriations bills to be passed for discretionary spending. In 1972, the federal appropriations law for education stipulated equal opportunity between the sexes at institutions receiving federal funding. Specifically, Title IX of the Education Amendments Act of 1972 stated:

> No person in the United States shall, on the basis of sex, be excluded from participation in, be denied the benefits of, or be subjected to discrimination under any education program or activity receiving federal financial assistance, except that . . . this section shall apply only to institutions of vocational education, professional education, and graduate higher education, and to public institutions of undergraduate higher education; . . . in regard to admissions to educational institutions, this section shall not apply . . . for one year from June 23, 1972 (for elementary schools), nor for six years after June 23, 1972 (for secondary schools and colleges).[16]

Title IX was most disturbing to men in intercollegiate athletics. In summer 1972, male athletics directors and PE Department chairs held regional caucuses to discuss what Title IX implied and what action could be taken to protect the separation of men's and women's PE programs, but most importantly, how to protect men's intercollegiate athletics from losing funding. In the Northwest, where I attended graduate school, open meetings were announced within AAHPER by the National Association for Sport and Physical Education (NASPE) for discussion among men and women PE teachers, some of whom were also athletics directors in colleges and universities. The National Collegiate Athletics Association (NCAA) announced meetings to discuss this new law, too, but did not invite women to attend. NASPE held meetings concerning Title IX in Boise, Idaho; Portland, Oregon; Sacramento, California; Seattle, Washington; and Spokane, Washington, during the late May break between OU's spring and summer quarters in 1972. Members of Congress were present at these regional meetings to interpret the meaning of the law and to respond to questions. I attended the meeting in Portland with other doctoral students and faculty from OU.

NASPE handed out literature with explanations and positions at its meetings. Both men and women leaders in NASPE and AAHPER defended continued separation of academic PE programs for men and women. Other speakers were more concerned about the financial risk to their institutions

if college and university PE preparatory programs or collegiate athletics were not merged. There was concern about the differences between men's and women's PE curricular requirements for a degree and whether men and women students would be required to enroll and compete for grades in the same physical activity courses when skill and strength differences between the sexes were obvious. But the greatest concern was whether men's athletics would be required to fund women's athletics, when many believed there were already insufficient funds to support men. Various tactics and strategies were addressed, such as cutting men's athletics teams to afford women's teams, or raising the price of tickets for football and men's basketball to cover the added cost of women's sports, or seeking financial endorsements from large corporations. Colleagues expressed anger and frustration, and solutions seemed futile without knowing exactly how the law would be enforced. Everyone present recognized that women's athletics programs had already been formed on most campuses, and equality with men's athletic programs was a financial dilemma. I came away from the regional meeting well informed about the Title IX issues to be resolved.

Delegates Approve a National Organization: AIAW

In fall 1972 I was back on the KU campus. I relinquished my role as KU women's athletics director when I returned from Oregon. Still, I was coaching volleyball during fall semester and teaching PE full time again. Because I had been invested in KU women's intercollegiate athletics since its inception and was well informed of state and national developments in women's sports, KU designated me its faculty representative for women's athletics. In that capacity I was the KU delegate to the national meeting in Overland Park in November. The purpose of this significant meeting was to ratify the constitution for the newly established AIAW.

The crowd of nearly 300 women gathered in great anticipation in the largest ballroom of the Glenwood Manor Conference Center on Sunday evening, November 4, 1972. For the previous four years, women's athletics directors on campuses across the nation had been garnering scarce resources and volunteering many hours beyond their faculty assignments to provide intercollegiate competition for women.

The CIAW had continued to sanction and organize DGWS National Championships from 1969 until mid-1972, when it officially acknowledged the AIAW as the national organization for women's intercollegiate sports. This meeting confirmed the AIAW as the new governing

body. Representatives from institutions across the country assembled to approve the AIAW to take over the national responsibilities of the CIAW, even though the CIAW would retain national championship sanctioning authority.[17]

The primary business at the November 1972 delegate assembly was to consider the proposed AIAW constitution. Sunday evening speakers addressed the need for the national organization representing institutions and the contents of the constitution and bylaws as the proposed governing document for the organization. They advised institutional representatives of their opportunity for input prior to voting on the documents. Regional caucuses conferred all morning Monday on issues of wording in the proposed constitution and bylaws as well as issues of financial aid and recruitment. The representative assembly met en masse on Monday afternoon. Motions were presented for voting concerning each article of the proposed AIAW constitution and bylaws.

The activity on the floor of the AIAW assembly was high drama. Several women delegates were concerned about implications of the wording of the proposed constitution and bylaws. There was much consternation at the assembly throughout the afternoon as women waited in line to speak to the assembly. The parliamentarian provided alternating opportunities for pro and con remarks on the issues at hand, and each person's time to speak was limited to three minutes. When the delegate at the microphone did not directly address the issue on the floor, the parliamentarian declared that speaker out of order and directed her to step aside.

The assembly reconvened again after dinner, even though the agenda had not listed a meeting time in the evening, but the proposal for the AIAW constitution and bylaws had not yet passed because financial aid and recruiting regulations remained contentious. After many motions, amendments, substitute motions, withdrawal of motions, hand-count votes, roll-call votes, and tallied votes on motions, the Monday session finally adjourned at 3:00 a.m. on Tuesday.

At 8:00 a.m. Tuesday, the delegates reassembled for the last session. Financial aid for women athletes was the crucial issue discussed, and recruiting guidelines were an essential aspect of financial aid offers. This combined issue was of immediate concern because of the lawsuit filed against the DGWS for discrimination in eligibility for college athletic scholarships. The DGWS had previously held to the principle of no scholarships for women athletes based on athletic ability in order to retain eligibility for participation in DGWS National Championships, but the *Kellmeyer v.*

NEA lawsuit and Title IX compliance regulations conflicted with that principle in that female athletes were not being treated equitably with male athletes in terms of access to athletics scholarships. The bylaws were finally amended to reflect that grants-in-aid were acceptable for women athletes, but recruitment of women athletes was not.[18]

The assembly approved the constitution and bylaws late Tuesday morning, meaning the voting delegates had officially declared the AIAW viable. The first AIAW delegate assembly adjourned at noon on Tuesday, November 6, to reconvene at the second AIAW assembly in Houston thirteen months later. Among the institutions represented at the first assembly, 278 colleges and universities from all fifty states became charter members of the AIAW. Within the next ten years, most higher-education institutions in the United States joined the AIAW, for a total of 973 members.[19]

The original DGWS proposal was for the AIAW to take control of women's intercollegiate athletics in summer 1972. Thus, beginning with the 1972–1973 academic year, all subsequent championships were AIAW National Championships rather than DGWS National Championships, even though the organization was not formally established until the voting representatives approved the AIAW constitution and bylaws in November 1972. The DGWS/CIAW sanctioned basketball as the eighth sport for a national championship, to begin with the 1972–1973 season. The CIAW had previously sanctioned badminton, golf, gymnastics, swimming, track and field, tennis, and volleyball for DGWS National Championships, and the AIAW continued to sanction all of them.[20]

The AIAW Constitution required that each representative be a full-time faculty member designated by her institution. AIAW officers elected during the 1970s were women's intercollegiate athletics directors and PE professors at their respective member institutions. No officers were paid a salary, and hundreds of professional women served voluntarily as officers in regional and state associations affiliated with the AIAW, much as women in academia had done with the DGWS.

The AIAW functioned financially with a stringent budget, relying on income from annual membership dues, initially $100 to $750 based on the size of the member institution; from championship tournament entry fees; and from meager gate receipts from a few championships. The DGWS initially used half of the AIAW budget to hold the annual AIAW assemblies, organize AIAW National Championships, run a skeleton national office, and fund mailings to officers and the total membership. AIAW leaders interacted with other leaders across the country from their faculty offices at

their institutions, and the AIAW used the executive office of the DGWS in Reston, Virginia, as its administrative headquarters.[21]

Because AIAW state, regional, and national meetings and AIAW officers were not subsidized, institutional representatives were often required to pay their own way to committee meetings and conferences. During the entire ten-year period of my participation in AIAW state, regional, and national meetings and championship events, I usually financed my own attendance. It did not seem unusual or inappropriate to me to pay my own way to attend the athletics meetings and tournaments because my voluntary contributions toward women's intercollegiate sport had never been subsidized by KU.

AKWIS Becomes KAIAW in Region 6

At the April 1972 AKWIS meeting at Rock Springs 4-H Ranch, representatives agreed that the AKWIS would be renamed the KAIAW for the 1972–1973 academic year, to be in alignment with the AIAW. KAIAW institutions were regional affiliates of the AIAW, and each of the seven states paid AIAW Region 6 dues of ten dollars annually. AIAW set its national championship dates for each sport, requiring KAIAW to revise end-of-season dates for Kansas teams to qualify through regional competition for the national championships.

For 1972–1973, the KAIAW divided Kansas institutions into three in-state conferences based on school size for basketball competition. Conference I included Fort Hays State College, KSU, KU, and WSU; Conference II Benedictine College, Haskell Indian Junior College, Southwestern College, and Washburn University; and Conference III Bethany College, Kansas Wesleyan College, McPherson College, and Tabor College. Three colleges joined the KAIAW in spring 1973: Bethany College in Lindsborg, Bethel College in Newton, and Kansas Wesleyan College in Salina. KAIAW membership now totaled seventeen institutions.[22]

New officers were nominated at the April 1973 KAIAW meeting, and I was elected secretary for the 1973–1974 academic year. As secretary, I was responsible for distributing the competition reports for all of the sports to the KAIAW members, and I designed, edited, and published the first *KAIAW Communications*. The newsletter contained sports schedules and results of sports competitions among KAIAW members. Competition results appeared bimonthly in subsequent issues, along with other pertinent information concerning KAIAW.

At the KAIAW meeting in fall 1973, Ottawa University joined the state organization, for a total of eighteen members. The KAIAW commissioners recommended dropping the state championship in swimming because of a lack of competing institutions and sanctioning tennis for state championships beginning in 1974. In October 1973, KSU notified KAIAW institutions competing in field hockey that it was withdrawing from that sport. The team was unable to recruit eleven players in field hockey, could no longer borrow equipment from the PE Department, and could not find a qualified coach. The KAIAW commissioners asserted that KSU was in violation of the KAIAW Constitution by reneging on an agreed sport after the season schedule had been determined. KSU lost an appeal, resulting in the institution paying the designated fine of seventy-five dollars. Because Kansas Collegiate Athletic Conference (KCAC) institutions wished to compete within their men's conference in Kansas, KAIAW member colleges and universities reverted to two conferences for basketball competition in 1973–1974. Conference I included Benedictine College, Fort Hays State College, Haskell Indian Junior College, KSU, KU, Washburn University, and WSU. Conference II consisted of the eight KCAC colleges.[23]

Title IX Compliance Regulations

The wording of Title IX was relatively brief, and implementation of the law needed more detailed direction for evaluation of adherence. President Richard Nixon assigned the Office of Civil Rights (OCR) in the Department of Health, Education and Welfare (HEW) to write compliance regulations for the law. Although the initial compliance regulations were published in July 1973, they were amended prior to the final version. In June 1975, HEW published the final compliance regulations in the *Federal Register*, specifying how Title IX would be enforced. All educational institutions receiving federal funds were subject to the Title IX compliance regulations by July 1978. Noncompliance would result in loss of federal funding for the institution.[24]

The proposed compliance regulations issued in 1973 required that institutions conduct annual self-evaluations concerning their equal opportunities in athletics for both sexes. Title IX compliance regulations were evaluated on whether equal treatment existed in ten areas:

1. the selection of sports and levels of competition that effectively accommodated the interests and abilities of members of both sexes,

2. the provision of equipment and supplies,
3. scheduling of games and practice time,
4. travel and per-diem allowance,
5. opportunity to receive coaching and academic tutoring in mathematics only,
6. assignment and compensation of coaches and tutors,
7. provision of locker rooms, practice and competitive facilities,
8. provision of medical and training facilities and services,
9. provision of housing and dining facilities and services, and
10. publicity.[25]

Later, two more compliance requirements were added:

11. recruitment of student athletes, and
12. support services for athletes.[26]

During the early 1970s, men's intercollegiate athletics were administered separately from women's programs. Virtually no equity in funding, facility access, or educational resources existed for women athletes in higher education. The administrators responsible for reporting compliance with Title IX were very interested in better understanding what the OCR would expect from the institutional programs in order to comply with Title IX.

Members of the NCAA were particularly concerned that men's athletics departments would not be able to sustain their intercollegiate programs if available funds had to be budgeted equally for women's intercollegiate sports programs. They considered the compliance regulations unfair and especially punitive to men's intercollegiate athletics, and they continued to confront HEW after the compliance regulations were issued in July 1973. The Tower Amendment was a 1974 congressional attempt to exempt football and men's basketball from Title IX.[27]

Although enforcement of Title IX began in 1973, it required only that federally funded elementary school districts show compliance immediately. Secondary schools and higher-education institutions were required to comply in five years, by July 1978. Five years might have seemed like a reasonable amount of time to effect change, but it meant that all rectification of inequities had to be completed within that time frame. This required immediate action because large higher-education institutions relied on federal and state funding as well as student tuition for survival, and regardless of whether men's athletics might be separate from academics

and self-sustaining, the law considered men's athletics program part of the institution, and it required compliance in athletics, as in all educational activities, for federal funds to be available to the whole institution.[28]

Title IX compliance regulations made 1973–1974 budgets difficult for collegiate athletics programs. At KU, the men's athletics program was funded separately from academics, but the women's athletics budget was administered within the PE Department. The budget for men's athletics had already been planned for future years and did not include sharing funds with women's athletics.

It became increasingly clear to all collegiate institutions that some men's athletics sports would have to be eliminated, not only because of insufficient funding but also because the total number of male athletes had to be commensurate with the number of female athletes, according to matriculation numbers at the institution. The large number of football players made those equitable numbers of male and female athletes impossible without cutting some men's teams. Nonrevenue sports for men were the most vulnerable because they each cost men's athletics programs more than they earned. Typically, several men's sports teams had to be eliminated, whereas women's teams were added to balance more than a hundred football scholarships with new women's scholarships to meet Title IX compliance regulations. The elimination of men's gymnastics, swimming, tennis, and wrestling as nonrevenue sports was inevitable, and crew and soccer were typical team sports added for women.

Sports historian Ying Wu summarized the unfolding situation succinctly:

> It was coincidental that the year 1972 saw the birth of two significant forces that would give great impact on women's athletics—the passage of Title IX and the official operation of the AIAW. It was also ironic. While women cheered for Title IX and a foreseeable increase in athletic opportunities for female students, the legal system and most feminists would soon judge women's parity in sport by using the men's model. Consequently, the AIAW's policies designed to protect the interests of female students became the subject of legal and social challenges.[29]

A Decade of AIAW Challenges and Changes

Ten AIAW presidents were elected during the AIAW decade. Political and social conditions brought major issues and organizational changes nearly every year. Changing stances on athletic scholarships, membership growth

requiring division by institution size, establishment of regional qualifications for national championships, and philosophical differences about pursuing an educational or a business approach to women's athletics all played a role in the organization's evolution over those ten years. The NCAA opposed the inclusion of intercollegiate athletics in Title IX compliance regulations during the public comment period; nevertheless, the compliance regulations became final on July 21, 1975.[30]

When the AIAW took control of women's national intercollegiate competition in 1972, its new organizational structure comprised nine regions, with designated state lines as borders. Regions were established to hold qualifying competitions for national championships. Kansas was assigned to Region 6, along with Iowa, Minnesota, Missouri, Nebraska, North Dakota, and South Dakota. The first AIAW Region 6 Championships were conducted in the 1972–1973 season.[31]

In January 1973, *Kellmeyer v. National Education Association (NEA)* created an immediate challenge to the AIAW. A former tennis athlete at the University of Miami filed a class-action lawsuit with other athletes and coaches against the NEA and subordinate organizations (the AAHPER and DGWS were organized under the NEA). The plaintiffs declared that the DGWS restriction of athletic scholarships denied them equal protection of the law. They argued for women athletes' right to accept athletic scholarships and still be eligible to compete in AIAW National Championships. In November 1972, when the AIAW delegates voted to change the DGWS regulations to allow scholarships as grants-in-aid for women athletes beginning in 1973, this lawsuit was settled. DGWS and AIAW leaders were aware of the legal action regarding women's athletic scholarships when they were formulating the AIAW constitution and bylaws. Athletic scholarships for women, however, somewhat conflicted with AIAW policies given the organization's intent to be education oriented rather than commercially oriented.[32]

In July 1974, administration of the KU women's intercollegiate sports program moved from the PE Department, in Robinson Gym, to KU Athletics, in Allen Fieldhouse. New budget allocations in July 1974 from both the Kansas Board of Regents and the KU Student Senate represented a substantial funding increase for KU women's athletics and made the accommodation of women's athletics within KU Athletics more acceptable.[33]

When the KAIAW introduced state officer positions at its September 1974 meeting, I was elected the Region 6 representative for a two-year term.[34] Athletics scholarships and recruitment procedures had been key issues at the annual KAIAW meeting in spring 1974. Although the AIAW

opposed recruitment subsidies, off-campus recruiting for women athletes, and eligibility for transfer athletes, Kansas institutions offered athletics scholarships to women student athletes beginning with the 1974–1975 academic year. KU offered athletics scholarships to a few women athletes instead of grants-in-aid for the first time.[35]

NCAA Encroachment on AIAW

At the AIAW Convention in Houston in January 1974, an NCAA executive informed the delegates that the NCAA was considering a motion to create a separate division in the NCAA for women's intercollegiate sports championships. This was a major change since 1966, when NCAA executive director Walter Byers communicated to DGWS leaders that his organization was not interested in governing women's intercollegiate athletics. Immediately afterward, the NCAA amended its documents to include only men or mixed teams of men and women.[36]

In January 1974, the NCAA Convention took place in Washington, DC, the same week the second AIAW Convention convened in Houston. The NCAA Executive Council's report initially recommended that the NCAA Committee on Women's Athletics should determine if a pilot program should offer national championships for women. In a reversal of his previous stance against governing women's intercollegiate athletics, Byers directed the NCAA staff to draft a motion to present to the NCAA delegates for the organization to institute national sports championships for women. AIAW leaders recognized this move as a threat that the NCAA might take over women's athletics and use men's regulations for women's intercollegiate competition; thus, AIAW delegates vigorously opposed the NCAA initiative. AIAW representatives in Houston immediately phoned the NCAA representatives from their institutions attending the NCAA Convention to vote against that motion. Telephone lines between Houston and Washington, DC, were jammed throughout the night. I did not know the KU representative to the NCAA, nor did I have a phone number for him in Washington, DC, but because the AIAW delegates were flooding the phone lines, there was no way to call from our hotel anyway. By morning, the representatives at the NCAA Convention had defeated this initial motion to offer women's national championships, but the NCAA Convention would revisit the motion nearly every year throughout the 1970s.[37]

In April 1975, the NCAA Committee on Women's Athletics presented three positions to the NCAA Executive Council that could be pursued for

governing women's collegiate athletics: (1) continue with two separate athletics organizations, (2) alter the NCAA Constitution to pertain to women athletes, or (3) create a new alliance of the AIAW and NCAA. The committee recommended the third alternative, but the NCAA executives disregarded this and instead continued to pursue an NCAA Executive Council proposal to initiate women's national championships beginning in 1977–1978, the year before Title IX compliance was required. However, the NCAA representative structure would retain just one vote per member institution. Because delegates from men's athletics already represented each institution at the NCAA Convention, this motion would establish women's intercollegiate championships without any women serving as NCAA delegates, members of NCAA committees, Executive Council members, or officers.[38]

HEW issued the final regulations for compliance with Title IX in June 1975, and they became effective July 21, 1975. In September 1975, the Tower Amendment, designed to exempt the NCAA revenue sports of football and basketball, was defeated in Congress.[39] The NCAA legal counsel issued an opinion to the NCAA Executive Council in November 1975 that based on the Title IX compliance regulations, the NCAA was legally obligated to offer national championships for women and that separate national governing organizations would deny equal opportunity for men and women athletes.[40] The NCAA filed suit against HEW in February 1976, challenging the Title IX compliance regulations.[41]

Throughout the 1970s, the NCAA Executive Council pursued control of collegiate athletics for both men and women, and the AIAW insisted on equal representation to the NCAA if the two organizations merged or formed a new governing organization for collegiate athletics. The NCAA was not interested in equal representation for women in its structure but wanted to monopolize intercollegiate athletics because of increased public interest in women's sports and prospective television revenues and because of the increased power of AIAW representation on the US Olympic Committee (USOC) and national governing bodies (NGBs) per sport. Given these developments, along with the NCAA legal counsel's interpretation of Title IX, the NCAA Executive Council continued to bring motions to govern national women's sports championships to the NCAA Convention delegates each year.[42]

In response to the 1976 NCAA lawsuit challenging the Title IX compliance regulations, HEW stated in December 1979 that because the NCAA did not receive federal funding, the organization had no obligation to report compliance with Title IX, although the NCAA member institutions

that did receive federal funding had to offer equal athletic opportunities for men and women. When HEW took this position, the NCAA dropped its lawsuit.[43]

Small- and Large-College Divisions in AIAW

By 1975, three years after its inception, AIAW had increased its membership dramatically, with more than twice as many institutions as in its charter year. AIAW reorganized its national championship competition into large and small divisions in response to the increase in member institutions and range of their enrollment sizes. This reorganization nearly doubled the number of sports championships offered in the nine regions and at the national level. With scholarships permissible, larger institutions with greater funding had advantages in attracting more highly skilled student athletes over smaller institutions with less funding for women's scholarships. Some smaller, private colleges had larger budgets thanks to wealthy donors. The AIAW defined small colleges as having fewer than 3,000 full-time, undergraduate, female students enrolled. Colleges with small enrollments could choose membership as a large college, but colleges with more than 3,000 students could not self-identify as a small-college member. The small- and large-college categories for AIAW competition began in the 1975–1976 season. Far more members declared themselves small colleges than large colleges across all regions.[44] Also beginning in the 1975–1976 academic year, the AIAW sanctioned cross-country, field hockey, and softball for national championships.[45] KU competed in all AIAW and KAIAW sports in the large-college division, as did other major universities in Kansas. But the majority of Kansas colleges chose to compete in the KAIAW and the AIAW Region 6 small-college division, as did the majority of the institutions across AIAW Region 6.

KAIAW Adjusts to AIAW Regional Qualifying Competition

At its 1975 spring meeting to plan for the 1975–1976 season, the KAIAW divided its membership into two divisions for sports in which more than six institutions participated. Two divisions were created for basketball, softball, tennis, and volleyball. Fort Hays State College, KSU, KU, and WSU constituted Division I, and all other KAIAW colleges competed in Division II. I directed the first AIAW Region 6 Basketball Championship for large colleges March 6–8, 1975, in Allen Fieldhouse.[46]

At the September 1975 meeting of KAIAW, AIAW announced that it would offer championships separately for large colleges and small colleges beginning in 1976–1977; it also sanctioned separate national championships for nonscholarship institutions and community colleges in basketball and volleyball. This three-division structure meant that the KAIAW season schedule had to be reorganized after each Kansas institution determined the championship for which it qualified. Also at the fall 1975 meeting, the representatives approved accepting men as coaches for KAIAW teams as requested by a member institution because small Kansas colleges were having difficulty finding women coaches for some sports.[47]

In September 1976, the KAIAW meeting included representatives from nineteen institutional members for 1976–1977. All of these KAIAW colleges and universities competed in basketball and volleyball, thirteen in tennis, eleven in softball, five in gymnastics, and three in field hockey. KU fielded teams in all six KAIAW sports and scheduled golf and track and field independently of the KAIAW. KU hosted the first AIAW Region 6 Golf Championship at the Alvamar Golf Club in October 1976 even though the KAIAW held no state golf championship.

AIAW Region 6 selected two new championship coordinators for fall 1976, one for large-college and one for small-college championships. Mary Jo Wynn at SMSU was beginning her two-year term as Region 6 president, and because there had never been a small-college regional championship, she sought a coordinator who had experience directing championships. Even though I was from a large college, my experience in directing several championships led to her selecting me as the 1976–1977 AIAW Region 6 small-college championship coordinator, and I began that two-year term just as I was completing my two-year term as KAIAW representative to the AIAW for Region 6. Coordinating with women's athletics directors of each of the Region 6 small colleges during those two years, I drove to each of the small-college regional championships to supervise the events.[48]

The NCAA Continues to Plan for Women's National Championships

At the 1976 NCAA Convention, its Executive Council presented a motion to apply NCAA rules to all college athletes regardless of sex. A vote revealed that Divisions I and III delegates were not in favor of the NCAA requiring women athletes to adhere to NCAA rules, even though a majority of Division II delegates were in favor. Executive Director Byers summarized the NCAA's legal position as being required by Title IX to offer women's

national championships, even though the delegates knew that the NCAA and the AIAW membership had consensus on offering the championships separately. The motion to require women athletes to follow NCAA rules was tabled, and NCAA national championships for women were delayed for the second time in two years.[49]

In August 1976, Byers distributed an information form to NCAA institutional representatives inquiring whether their institutions sponsored a men's team, a women's team, or a mixed team in each NCAA sport. Checking "women's team" would obligate the institution to apply NCAA rules to women at that institution. When the AIAW president discovered the NCAA had distributed this form, she asked Byers its purpose. Byers responded that the institutions had discretion as to which organization's regulations to follow, and several colleges with women's teams were not AIAW members. The NCAA president assured the AIAW president that the NCAA would not submit resolutions at the NCAA Convention in 1977 to initiate women's national championships.[50]

National Association of Intercollegiate Athletics (NAIA) Influence on the KAIAW

College and university administrations of NAIA member institutions in Kansas and other AIAW Region 6 states were pressuring their women's athletics directors to hold women's intercollegiate competition within the same conference their men's intercollegiate sports teams did. Thus at its spring 1976 meeting, the KAIAW created a fourth division for four of its member colleges whose male sports teams belonged to the NAIA Great Plains Athletics Conference (GPAC). The new KAIAW Division IV included Fort Hays State College, KSTC–Emporia, KSTC-Pittsburg, and Washburn University. Division I consisted of the three major universities in Kansas; Division II consisted of four other KAIAW member colleges; and Division III consisted of the eight colleges whose male athletes played in the NAIA's Kansas Collegiate Athletic Conference (KCAC). This new structure led to a proposal that eligibility for AIAW Region 6 tournaments not be determined by winning a state championship but by competing directly against other teams in the region according to members' division levels.[51]

In February 1977, the NAIA sent a letter to all its member institutions, which included the small colleges in Kansas, inquiring whether their women's intercollegiate sports teams would be seeking membership in the NAIA, the AIAW, or in both organizations for 1977–1978. In the two NAIA

men's conferences in Kansas, sixteen KAIAW colleges were being urged to abandon KAIAW/AIAW and join the NAIA. Twelve colleges were from the KCAC and four were from the GPAC. That left the three major universities in Kansas: KSU, KU, and WSU. KSU and KU were both scheduling competition with Big Eight universities in addition to in-state KAIAW opponents, and WSU was competing against other women's teams in the Missouri Valley Conference, the NCAA conference to which its men's teams belonged.[52]

AIAW Splits into Three Divisions

At the January 1976 AIAW Convention, the organization adopted a new fiscal year beginning January 1 rather than July 1, making 1976 only a six-month term for AIAW elected officers. A new three-division structure for AIAW members based on their institutional size and capacity to offer scholarships would begin in 1979–1980. The AIAW encouraged member colleges and universities to determine in which of the three national divisions they would compete. As of the KAIAW fall meeting in 1977, the organization had twenty member institutions, and thirteen of these were also members of the NAIA. Of the KAIAW members, the three largest universities selected AIAW Division I for national competition, and fifteen colleges chose AIAW Division II. Baker University and Mid-America Nazarene College were the newest KAIAW member institutions; both chose to belong to AIAW Division III.[53]

A Philosophical Difference in AIAW Leadership

Judy Holland, the women's athletics director at UCLA, was AIAW president-elect beginning in July 1976. At the AIAW Convention in January 1977, when her presidency began, the AIAW delegates had little indication that her views were directly opposed to those of other AIAW leaders. As Holland's contacts within the NCAA became known, former AIAW Executive Council members considered her suspect regarding her intentions as president because she compromised the organization's founding education-oriented principles with her actions. By 1980, the AIAW Executive Council considered former president Holland a coconspirator with the NCAA.[54]

In December 1976, before Holland became AIAW president, she visited the NCAA Executive Council and predicted that the AIAW would merge with the NCAA. That secret meeting was not authorized by the AIAW

Executive Council, and its members considered Holland's message to the NCAA Executive Council a negative vision of the future of the AIAW. Her views and goals reflected those of the younger women in AIAW who viewed the old-guard leaders as delaying opportunities for women's athletic competition.[55]

There were no motions at the NCAA Convention in January 1977 to offer women's national championships, although throughout 1977 the NCAA Executive Council continued to move in this direction. In May 1977, the NCAA Committee on Women's Athletics met with Holland and the AIAW Region 8 representative from Arizona, who served on the AIAW Executive Council. Holland's second meeting was also secret and unauthorized by any other AIAW Executive Council member. A week later, Holland offered a motion to the AIAW Executive Council, seconded by the Region 8 representative, to form the AIAW Committee on Men's Athletics as a cooperative counterpart to the NCAA's Committee on Women's Athletics. Their rationale was that this would allow communication between the two organizations, and the motion was approved. Holland then appointed the AIAW Region 8 representative chair of the new AIAW committee.[56]

When the AIAW and NCAA committees met, a recommendation to offer both organizations' national championships at the same time and same place was rejected. Even so, the NCAA Executive Council informed the AIAW in December 1977 that it would present a motion to the 1978 NCAA Convention to initiate NCAA Division II national women's championships in 1978–1979. Yet at the 1978 NCAA Convention, the delegates defeated that proposal for the third time.[57]

The AIAW Creates Three Divisions for Competition

At the AIAW Convention in January 1978, the organization announced that it would offer championships in three divisions, rather than the existing large- and small-college divisions, beginning in 1979–1980. The AIAW created the new divisions based on the amount of financial aid each member institution awarded athletics per sport. Division I consisted of institutions that awarded athletics financial aid per sport of between 50 percent and the maximum financial aid allowed by the AIAW. Division II was for colleges that gave 50 percent or less of maximum financial aid, and Division III was for colleges that gave less than 10 percent of the maximum financial aid.[58] AIAW member institutions could compete in different divisions for each sport, according to the percentage of scholarship funding for that sport.

The KAIAW had already created three divisions for all sports, so little adjustment was needed in Kansas.

KSU and KU each announced at the 1978 spring KAIAW meeting that they intended to withdraw their membership from KAIAW beginning in 1978–1979 and join the Big Eight Conference for women's intercollegiate sports competition. As members of the Big Eight, the two universities would retain membership in AIAW Region 6 and compete nationally at the AIAW Division I level. It remained to be determined how the Big Eight Conference and the two NAIA conferences that exceeded state boundaries and AIAW region boundaries could enter AIAW Region 6 qualifying tournaments. KSU and KU maintained their dual AIAW and Big Eight Conference membership while this inconsistency was being resolved.[59] At the AIAW Region 6 spring 1979 meeting, Jan Nuzman from Washburn University was elected ethics and eligibility chair, and I was elected president beginning in July 1979. The AIAW Region 6 president represented the region on the AIAW Executive Council, so I was privileged to learn first-hand of the AIAW and NCAA conflicts over the next two years.[60]

At its spring 1980 meeting, the KAIAW learned of new AIAW Region 6 championship qualifications. The regional competition was reorganized into north, central, and south subregion championships for each sport rather than state tournaments that qualified teams to compete at the AIAW Region 6 Championship. For basketball, KU was assigned to the south subregion in Division I along with Central Missouri State College (CMSC), KSTC–Pittsburg, KSU, University of Missouri–Columbia, University of Missouri–St. Louis, and WSU. For volleyball, KU would compete in the south subregion with those institutions in addition to the University of Nebraska. Because of the changes to regional qualifications and scheduling with the Big Eight, KAIAW members agreed to discontinue Division I state championship tournaments in basketball and volleyball after the 1979–1980 season.[61]

Title IX Compliance Deadline

While higher-education institutions edged toward the Title IX compliance deadline, when July 1978 arrived, no collegiate athletics programs were fully in compliance. During that week, fifty-one women athletics directors filed suit against their respective institutions' administrations for failure to comply with Title IX regulations. Administrative friction at KSU over noncompliance caused highly qualified and assertive Women's Athletics Director Judy Akers to resign at the end of spring semester 1979. She had

been there for ten years. Her KAIAW colleagues appreciated and supported her excellent leadership in women's intercollegiate athletics.[62] KU Athletics was not sued over noncompliance with Title IX in 1978.

Because the OCR was besieged with multiple lawsuits from women at other higher-education institutions across the country, HEW placed a moratorium on compliance evaluations until the OCR provided additional compliance specifications. In 1979 HEW issued a policy interpretation that offered a three-part test for ascertaining compliance with Title IX, and institutions were assured of receiving federal funding by satisfying any of the three parts. Enforcement of Title IX in higher education was assigned to the OCR in 1980.[63]

Compliance-Based Mergers of Men's and Women's Athletics Programs

Across the country, NCAA member institutions were encouraged to merge women's athletics programs with men's athletics as a path to compliance with Title IX. NCAA leaders believed that a merger of both campus athletics programs was the best way to organize planning for equitable budgets and resources to meet Title IX requirements. Most higher-education institutions that merged their programs decided to adopt the regulations of one national governing body for athletic competition rather than two. However, AIAW leaders sought to retain the integrity of their separate-but-equal philosophy for women's athletics because the NCAA leadership did not restructure accordingly with equal status for women in sports governance, and this rendered women athletics directors subordinate in the organization. Most women administrators fought merging their women's sports programs with those of the men but were overruled by their college or university chancellor or president. Most higher-education institutions had merged their women's athletics programs into their men's athletics departments even before the 1978 compliance deadline. Although often male administrators were named director of both men's and women's athletics, they were encouraged to appoint women as assistant directors to administer the women's sports programs. Men's athletics conferences followed suit in merging women's intercollegiate competition within their existing structures, including scheduling women's competitions among the same institutions they did for the men's teams.[64]

As college and university chancellors and presidents approved this process on many campuses across the country, decision-making power went to the NCAA proponents. Ironically, even as Title IX ensured equal

opportunity for college women athletes, it undermined the AIAW, as the national sports organization developed by women for women, by giving men administrative power over women's athletics.[65]

At KU, the PE Department's women's athletics program merged into KU Athletics in summer 1974, and the men's athletics director was put in charge of all sports. Clyde Walker, then KU athletics director, appointed Marian Washington as the half-time women's athletics director.[66] KU Athletics delegated some responsibilities to other assistant athletics directors to accommodate the increased numbers of teams and athletes women's sports brought into the department. The KU Women's Athletics program was moved from Robinson Gym to Allen Fieldhouse in July 1974, though little space was available there. But by the compliance date in 1978, Allen Fieldhouse had been renovated with additions to better accommodate KU Women's Athletics. Until 1979, despite the mergers, men's and women's sports were still administered separately, with a women's athletics director appointed specifically to oversee that program.[67]

The NCAA Pursues AIAW's National Championships

The NCAA continued to pursue women's national championships, much to the AIAW leaders' chagrin, even though a January 1978 NCAA survey resulted in NCAA Division I representatives soundly opposing this initiative by 70 percent. Division III opposed it as well, but Division II narrowly supported it by 6 votes, with a total of 118 institutions responding. Most of these were on the East Coast, where NCAA Division II institutions were not NAIA members.[68]

The NCAA had fought with the Amateur Athletics Union (AAU) since the 1920s for control of the development and selection of male Olympic athletes to represent the United States, resulting in Presidents John F. Kennedy, Gerald Ford, and Jimmy Carter intervening to work toward the Amateur Sports Act of 1978. This law authorized the newly established US Olympic Committee (USOC) to establish national governing bodies (NGBs) for each Olympic sport. The new law provided funding and voting power for the NGBs within the USOC. The USOC manages the NGBs in developing and selecting US athletes and conducting Olympic qualification trials for them. Previously, the AAU had regulated amateur sports in the United States, and it prohibited women from participating in Olympic running events. The Amateur Sports Act of 1978 gave the DGWS/AIAW direct input to the NGBs for every women's Olympic sport. Women's athletics

directors' access to the USOC provided more incentive for the NCAA to overtake the AIAW so that it could eliminate the women's representation on the NGBs and gain power within the USOC.[69]

Also, in 1978, HEW interpreted athletic equality on a per-capita basis for compliance with Title IX. This meant counting total numbers of athletes at each institution, regardless of sport, to ensure that both sexes participated in equal numbers in the athletics programs. This had the ramification of institutions dropping some men's nonrevenue sports to balance the large number of football athletes.[70]

In August 1979, Executive Director Byers approved a $2.2 million cost-analysis research project to determine if the NCAA could provide equitable resources for women's and men's national championships. By then, the NCAA had counseled most chief academic officers of member institutions to collaborate with the men's athletics director to merge the women's sports program into that of the men to comply with Title IX. Prior to the Title IX compliance deadline of July 1978, women directed 94 percent of all Division I women's athletics programs separately from men's athletics, but by 1979–1980, only 36 percent of those institutions had separate athletics programs for men and women. In institutions that had merged men's and women's athletics programs, the male athletics director most often held the top position, whereas the women's athletics director was an assistant director and not always in a full-time position.[71]

NCAA Governance Plan for Women's Athletics

When the NCAA Executive Council met in October 1979, it again discussed national governance of women's athletics, including representation on NCAA governance committees, and decided the organization should proceed toward offering women's national championships. The Executive Council recommended that these championships be delayed until at least 1981 to allow it time to enact regulations for women in NCAA competition. At the January 1980 NCAA Convention, the delegates for Division II voted to offer women's national championships in basketball, field hockey, swimming, tennis, and volleyball starting in 1981–1982. Shortly thereafter, delegates approved offering women's national championships in the same five sports for Division III as well. Division I delegates voted their approval of Divisions II and III instituting women's national championships without being informed that the funding for those tournaments would come from their Division I revenues.[72]

In February 1980, the AIAW president sent a memo to AIAW members explaining that competing in NCAA championships would make women athletes ineligible for AIAW championships based on differing eligibility requirements. In March 1980, an NCAA special committee recommended using NCAA rules for women competing in NCAA championships but adopting the AIAW limits on scholarships. Representation of women on NCAA governance committees was to be limited to fewer than 18 percent of the NCAA Executive Council and committee positions. Retaining one vote per member institution at the annual NCAA Convention would block women athletics directors from voting in addition to the men's athletics director from their college or university. In addition, the NCAA special committee recommended that all women's athletics programs be financed for national championships equivalent to men's championships in the NCAA and proposed a dues increase to cover the expenses of adding the NCAA women's national championships.[73] AIAW representatives had much less influence to counter the NCAA initiative because most of their institutions had already merged women's athletics programs into men's athletics departments.

NAIA National Championships for Women

In May 1980, four months after the NCAA Convention delegates voted to initiate Division II and III women's national championships, the NAIA Executive Council approved sponsoring ten women's national championships starting in fall 1980. In July 1980, the AIAW president and president-elect (1972–1982), along with eight past presidents, constructed a resolution with the American Council on Education to intervene. Before it was sent, former president Holland requested that her signature be removed.[74]

In August 1980, the NCAA Executive Council met to plan the financing for women's national championships in its three divisions, even though the delegates had not approved Division I championships. The Executive Council proposed to use "excess receipts" of $1.3 million from 1978–1979 and 1979–1980 Division I men's championships to cover the costs of three women's national championships in 1981–1982. The NCAA planned to schedule these championships at the same time as AIAW National Championships so that institutions would not be able to enter more than one championship per sport. Thus, the NCAA contended, institutions could choose between AIAW, NAIA, or NCAA championships. The NCAA proposed a transition period from August 1981 to August 1985 to allow college

women athletes to qualify under either the AIAW or the NCAA eligibility regulations, according to which rules they followed prior to 1981. Also in August, Byers announced that Ruth Berkey, thrice defeated for the AIAW presidency, had been appointed NCAA director for women's athletics. She was the first of several AIAW defectors the NCAA rewarded.[75]

In November 1980, the *NCAA News* contained the NCAA Governance Plan, with information about the NCAA's interest in women's national championships and claims that this did not threaten the AIAW. The article reasserted that the NCAA was required by Title IX to offer women's athletics programs, a position that the NCAA legal counsel claimed but that HEW had ruled against in 1979. On December 3, 1980, the AIAW Executive Council reacted to the published NCAA Governance Plan by sending a memo to member institution representatives listing its concerns about the plan. The same day, former president Holland sent a letter to chief academic officers of AIAW member institutions advocating support for the NCAA plan. The American College of Education (ACE) also was concerned about the NCAA Governance Plan and F. Sheldon Hackney, ACE chair of Collegiate Athletics, also sent a letter to chief academic officers stating that the NCAA plan appeared to be a unilateral position, with no input from AIAW leaders on what was appropriate for women's intercollegiate athletics. ACE refuted the inference that Title IX legislation required the same athletics regulations for women and men.[76]

The NCAA Announces Women's National Championships

In preparation for the January 1981 NCAA Convention, the NCAA Executive Council proposed at its meeting in March 1980 that the organization offer four incentives to member institutions to bring their women's teams to NCAA championships. The NCAA would promise: (1) to pay expenses of women's teams participating in the NCAA championships, (2) to add no additional institutional membership fee for including women's athletics with existing NCAA membership, (3) to assure women athletes the same eligibility, recruiting, and scholarship regulations as men, and (4) to guarantee greater television coverage for the NCAA women's championships than they could get at the AIAW championships. Although NCAA dues were likely to increase in the future as women's championships were accommodated, the NCAA budgeted $1.3 million of excess receipts from the previous two years' men's championships, primarily men's basketball, to fund the first NCAA women's national championships.[77]

The January 1981 AIAW Convention delegates convened a week prior to the NCAA Convention and adopted a resolution urging the NCAA to postpone the initiation of women's national championships at their convention because the AIAW had secured contracts for television rights with NBC and ESPN for the finals in selected sports for all three division levels of the 1981–1982 AIAW National Championships.[78]

The NCAA Executive Council's proposal for sponsoring national women's championships was on the January 1981 NCAA Convention agenda. The NCAA parliamentarian ruled out of order seven of nine proposals opposing NCAA women's national championships before the agenda was approved. An alternate NCAA agenda item, Proposal 71, was a resolution by men sympathizing with AIAW, calling for postponement of NCAA women's national championships and initiation of discussions between the NCAA and the AIAW concerning "mutually agreeable unified governing structures." Proposal 71 was not approved for consideration. The motion to postpone women's national championships at the Division II and III levels was defeated by the delegates, thus establishing twenty-nine new women's national championships, mostly for small colleges that were not NAIA members. Proposal 72 included NCAA Division I offering women's national championships. The vote on that motion was initially tied, then defeated by one vote, but after a recess the motion was recalled for a roll-call vote and approved by twenty votes. The NCAA delegates had finally approved initiating women's national championships in all three divisions in 1981–1982.[79]

In 1980–1981, the AIAW offered forty-one women's national championships in nineteen sports: badminton, basketball, crew, cross-country, fencing, field hockey, golf, gymnastics, indoor track and field, lacrosse, skiing, soccer, softball (fast and slow pitch), swimming and diving, synchronized swimming, tennis, track and field, and volleyball. In May 1981, the NCAA announced the locations and dates for twenty-three of its twenty-nine women's national championships in 1981–1982, and fifteen of its twenty-nine championships were on the same dates the AIAW already had scheduled national championships, beginning with field hockey in November 1981. The NCAA announced that it would finance women's teams that entered its national championships, unlike the AIAW, which only reimbursed half of teams' expenses.[80] AIAW member institutions had to choose between these women's national championships.

After approving women's national championships, the NCAA sold television rights to ESPN for all of its 1981–1982 Division I women's national

championships except basketball, gymnastics, and swimming, which it sold to CBS.[81] NBC and ESPN informed the AIAW that the networks did not intend to televise any 1981–82 AIAW national championships because of the number of Division I team withdrawals from the tournaments. Eastman-Kodak, which had hosted the AIAW All-America basketball program, indicated that it would not renew the contract with the AIAW; the Broderick Company, which sponsored the AIAW national championship awards program, also did not renew its contract.[82] The NCAA had not only usurped the AIAW National Championships but also undermined the women's organization's financing.

A majority of the top ten women's teams in AIAW Division I chose to enter the 1981–1982 NCAA women's national championships. Undoubtedly, the NCAA financial offers and the preference of male athletics directors more familiar with NCAA governance influenced these decisions. The number of entries in AIAW National Championships shrunk by half for thirty of the AIAW tournaments announced. Because of the significant and uneven number of team withdrawals by AIAW member colleges from state and regional qualifying championships, last-minute adjustments were required for more than 450 scheduled AIAW tournaments. The AIAW lost 64 percent of participating teams in AIAW National Championships in 1980–1981 to NCAA National Championships for 1981–1982. AIAW membership dwindled rapidly by about 50 percent as women's athletics programs defected, and the NCAA or the NAIA membership increased throughout the summer of 1981. In most cases, institutions dropped AIAW membership because their traditional opponents or the top teams against which they wanted to compete had already defected to the NCAA or the NAIA.[83]

Immediately following the January 1981 NCAA Convention and continuing throughout that year, AIAW leaders sought to interact with NCAA leadership to form a mutual governance structure, but the NCAA resisted, indicating that it had already voted for a new governance structure that included women's national championships. By October 1, 1981, the date for AIAW member institutions to pay annual dues, 25 percent of Division I AIAW members did not renew their membership, and an additional 25 percent intended to drop AIAW membership the following year. Of the 961 AIAW member institutions in 1980–1981, only 772, or 80 percent, renewed their AIAW membership for 1981–1982. With lower membership revenue, without large crowds following top teams at AIAW in Division I National Championships, and without sponsorships and television contracts, the 1981–1982 income was expected to drop significantly.[84]

The *AIAW v. NCAA* Antitrust Suit

On October 9, 1981, the day after the first NCAA women's national championship was held, the AIAW filed an antitrust lawsuit against the NCAA in the District Court of the District of Columbia on the grounds that the NCAA scheduled its women's national championships on the same dates in the 1981–1982 seasons that AIAW National Championships had been announced. The AIAW argued that the NCAA, with a great financial advantage, was attempting to monopolize women's athletics and put the AIAW out of business. The legal affidavit, written by President Donna Lopiano of the AIAW, detailed the damage the NCAA's actions had caused the AIAW.[85]

Antitrust law governs the conduct of corporations to promote fair competition between businesses for the benefit of the consumer. Antitrust law ensures that larger corporations do not use their financial capital to monopolize markets by edging out companies offering similar goods and services to the same potential consumers. The larger and better financed corporation could potentially influence the market unfairly and force the smaller company out of business.[86]

The AIAW argued that the NCAA was using unfair practices to put it out of business because the NCAA's greater resources allowed it to offer benefits that the AIAW could not afford to offer. The AIAW antitrust suit claimed that the NCAA used profits from the previous NCAA men's national championships to incentivize women's teams to enter the NCAA National Championships instead of those of the AIAW. Regardless of the lawsuit, the NCAA proceeded to solicit entries into its women's national championships. To block the NCAA from conducting these championships until the case could be finalized, the AIAW filed an injunction, but the district court denied it.[87]

The AIAW Files Breach-of-Contract Suits

The NCAA anticipated dividing profits from its television contracts between the women's teams participating in its national tournaments, similar to the reimbursements it provided men's national championship teams, a further incentive for member institutions to choose the NCAA women's national championships over those of the AIAW. In contrast, the AIAW national office would use all television revenues to help subsidize the thirty AIAW National Championships. The television networks reneged on their contracts for live television broadcasts of AIAW National Championships

in 1981–1982 when they realized that the top women's teams probably would not compete in the AIAW tournaments. AIAW filed suit against these television networks for breach of contract and subsequently filed an injunction to prohibit these networks from broadcasting NCAA women's national championships.[88] The same district court denied the injunction.

Ultimately, a majority of the top AIAW women's basketball and volleyball teams entered the NCAA tournaments, lowering the competitive quality of the AIAW National Championships. There was insufficient time for the court to hear *AIAW v. NCAA* before the NCAA competitions began, and the court had denied the injunction the AIAW filed to delay the NCAA National Championships.

The Demise and Legacy of the AIAW

Like the NCAA, the NAIA also offered women's national championships for AIAW Division II and III institutions in 1980–1981, and many women's athletics programs in small colleges with men's athletics as members of the NAIA dropped their membership in the AIAW. The significant decline of AIAW institutional membership, coupled with the revenue loss from canceled television and sponsorship contracts, caused the AIAW to disband by March 1981. The AIAW became financially insolvent because of the NCAA diverting membership and spectators from AIAW competition.

As the 1980–1981 AIAW Region 6 president and regional representative, I was in Reston, Virginia, at the AAHPERD headquarters when the AIAW Executive Council voted to disband the AIAW. The financial analysis of the organization revealed no other option. The cost of the 1980–1981 AIAW National Championships and the expenses of legal counsel for more than a year had depleted AIAW funds. The court system favored the NCAA, and a majority of the top AIAW teams had accepted the NCAA promises.[89]

The AIAW did not accept institutional memberships for 1981–1982, nor did it plan any future national championships. Likewise, AIAW region- and state-affiliated organizations, such as the KAIAW, ceased operations. The NCAA took over governance of women's national championships in 1981–1982 for member institutions, and likewise the NAIA continued to plan women's championships for its members. The decade-long threat and ultimate decision of the NCAA to offer women's national championships, coupled with the NAIA offering women's national championships for small colleges and the lack of support from the courts, constituted a death knell for the AIAW as a governing organization for women's intercollegiate athletics.

Not all was lost, however. A decade of women's intercollegiate sports, built on the ideal of an educationally oriented athletics program governed by women for women, was achieved with unprecedented growth of women's athletics. Women proved that women's collegiate sports had as great a potential and public interest as did men's collegiate sports, given equal resources and opportunities. The CIAW had sanctioned AIAW tournaments for more than a decade until the 1980–1981 AIAW National Championships. From the initial scheduling of five CIAW-sanctioned DGWS National Championships open to all higher-education institutions in 1969, within ten years, the AIAW was scheduling forty-one national championships in nineteen sports and had an institutional membership of more than 900. Eleven of those national championships were sponsored in three competitive divisions with eight national sports championships open to all division levels.[90]

Title IX was not the lone driving force behind the rise in women's intercollegiate athletics. The five Olympic sports institutes for women in the 1960s provided the impetus, and the DGWS women leaders' initiation of women's national championships in the late 1960s put women's intercollegiate athletics on the map. The CIAW sanctioned women's national sports championships for five years prior to the establishment of the AIAW and Title IX of the Educational Amendment Act of 1972. This dynamic law, with higher-education institutional compliance required by 1978, provided an avenue for women to legally and more readily access formerly unavailable financial resources and facilities to attain equal opportunities with men's intercollegiate athletics.

Even so, in its quest for control over all amateur sports in the United States, the NCAA overtook the AIAW's national governance of women's sports based on its legal interpretation of Title IX, a position the court facilitated by denying the AIAW's antitrust and breach-of-contract suits. It was a tumultuous decade for tenacious college women athletics leaders, but their persistent efforts immensely helped women athletes in generations to come. The growth of women's intercollegiate athletics continues to expand, as compliance to Title IX remains the standard.

MY INTERIM YEAR

Eugene, Oregon, is more than 1,800 miles from Lawrence, Kansas. Driving there in 1969 took thirty hours because there were few interstate highways then. On my first trip to the University of Oregon (OU) for summer school, I drove ten hours for three successive days. I had never traveled that far west before, and the landscape was new to me with miles and miles of high plains and distant mountains. It was a lonesome and adventurous drive for me, but after I arrived on campus, I met other graduate students and made long-lasting friends. After two summers on campus, I was glad to be in Oregon for eighteen months during my doctoral residency.

Late summer and early fall were warm and sunny in the Willamette Valley, but there was rain nearly every day from November until July. Campus sidewalks were always wet in winter; they stretched between the green grassy lawns. Tall Douglas firs dripped on my raingear when I passed under them on the way to classes. My world there seemed detached from Kansas and the Jayhawks as I trudged across campus in the fall, winter, and spring quarters of 1971–1972. Even though the courses for my doctoral studies took the majority of my time, women's athletics were still important to me. I officiated many college and high school ballgames and attended a few women's athletic events at OU in the evenings. Back on the University of Kansas (KU) campus, a new cadre of coaches for women's sports was assigned to the Jayhawk teams I had led for the previous three years.

The 1970–1971 academic year at KU had ended with remarkable success for the women's sports teams. The KU women athletes were making significant strides among leading universities in women's intercollegiate sports nationally, and they made a strong impression in 1971. I felt affirmed and gratified as coach of KU women's basketball, one of the two sports in which KU women's teams qualified for national competition that year. In women's volleyball also, KU qualified for a national championship berth, while

as the national tournament director hosting the event at KU, I watched proudly. Those early KU women athletes were highly competitive and team oriented; their achievements set the standard for KU teams in later years. They deserve great credit for forging the way for future KU women athletes. Inspired first-year student athletes, along with experienced upper-class women, were expected to enhance the upcoming 1971–1972 teams, and a continuation of Jayhawk superior competitiveness in the Kansas Association of Intercollegiate Athletics for Women (KAIAW) conference seemed ensured.

Throughout the later 1970s, even after I completed my coaching career, I continued to follow and support women's intercollegiate athletics, serving in several leadership positions in organizations at the state, regional, and national levels. Although I was not directly involved in KU Women's Athletics after 1974, I found many ways to continue my involvement in women's intercollegiate athletics. The principal way was through my graduate study in sports administration. A doctoral program not only enhanced my understanding of the nuances of leadership in athletics but also qualified me for a permanent academic position in higher education and allowed me to teach courses in sport management.

A Year away from KU

For me, 1971–1972 was an interim year. KU hired Ann Laptad, a KU physical education (PE) graduate, to fill my faculty position. She was responsible for directing Women's Athletics that year while teaching the full load of PE courses assigned to me previously, and, like me, she also served as a volunteer coach. Laptad, a native Kansan, had moved from Wichita with her husband to Oregon, where he was a track coach. Because Joie Stapleton was well acquainted with her as a former PE student, and because Stapleton knew Laptad was moving back to Kansas in summer 1971, Stapleton recruited her for my KU position, and then Henry Shenk hired her. Laptad was also in charge of appointing the volunteer coaches for the KU women's teams that year.

Claire McElroy remained at KU as the women's swim team coach, but Laptad needed to fill every other women's coaching position. Not only was I not present to coach the four team sports plus tennis but also Anise Catlett had resigned as gymnastics coach to move with her husband, Gale, the new head basketball coach at the University of Cincinnati in fall 1971. So, six of

the seven women's sports at KU required new head coaches for 1971–1972: basketball, field hockey, gymnastics, softball, tennis, and volleyball.

Like most women of her era, Laptad had little experience as a coach and none as an athletics administrator, but Stapleton recommended four women graduate teaching assistants in PE as one-year volunteer coaches and remained available as a mentor. Laptad appointed Debbie Artman, a KU graduate student from Fort Hays State College, the head basketball coach, and Veronica Hammersmith, a KU graduate going on for a master's degree there, the head softball coach. Laptad appointed another graduate student at KU, Pat Ruhl, the new gymnastics coach. Laptad also served as head coach for field hockey, tennis, and volleyball, but she depended on Hammersmith as assistant field hockey coach in the fall and Artman as assistant tennis coach in the spring. Laptad then initiated and coached track and field for women in 1971–1972.

In the first three years I coached KU women's teams, I noted how quickly the skill level and strategies for each sport rose each season at all Kansas colleges, especially when the best players at most institutions had played for two to three years previously. In the 1970–1971 season, several KU first-year students were outstanding players in more than one sport, especially in basketball, softball, and volleyball. They became a close-knit group because they spent more time together in practices all year long than other athletes who played only one sport. The dominant first-year students of that class were Cindy Currie from Salina, Ginny Hammersmith from Kansas City, Cindy Kelley from Derby, Sara McBride from Kansas City, Stephanie Norris from Wichita, and Judy Raney from Wellington. In their junior year, Mary Jacobson from Corvallis (Oregon), Bev Plump from Wichita, and Mary Visser from Emporia joined them. These athletes were starters on the basketball, field hockey, softball, and/or volleyball teams during all four years of their eligibility. They left a legacy of success in state, regional, and national intercollegiate competition for later KU teams to follow. I hated to leave those talented and eager athletes just as they were beginning their sophomore varsity year, but not to complete my doctoral residency meant not attaining tenure and ultimately having to leave KU, so for me there was no choice. Those women were still the nucleus of the KU team when I returned after my interim year to coach volleyball again.

During my year away, Laptad wrote and asked for tips for controlling the headstrong women athletes on the KU volleyball team, which she was coaching. She disclosed that they paid little attention to her directives and

were undisciplined regarding the team drills and strategies she tried to introduce, but regardless, the team was successful. I could only advise her with my own approach as a coach, but perhaps she had not understood the increased sophistication of sports skills and strategies and the rising competitive intensity of that era of women athletes because she had participated only in extramural sports during the Sports Day era. The skill level had been markedly refined with three years of intercollegiate competition among state institutions, and the KU women athletes had improved considerably from their recent experience of national competition.

The 1971–1972 KU women's volleyball team qualified for the third Division of Girls and Women in Sport (DGWS) National Volleyball Championship by winning their fourth Association for Kansas Women's Intercollegiate Sports (AKWIS) championship, and they secured KU Student Senate funding to travel to Miami-Dade Junior College for the tournament. I was invited to that championship as a DGWS volleyball championships committee member, but because all national leadership positions in women's athletics were volunteer, there were no travel funds from DGWS. I was officially on leave from KU, so campus funding was not available to me, and my meager graduate school bank account prohibited such a cross-country trip, so I was unable to attend. Also, I could not afford to miss a week of doctoral classes.

Managing a Doctoral Degree Program

Teaching and coaching during my first year as a KU faculty member had kept me very busy. I spent long days teaching and long evenings coaching sports, and between classes I planned the practice and competition schedules for the several sports I coached. In addition, I took responsibility for all administrative paperwork for the new women's intercollegiate athletics program and conducted a national championship. There was no extra time during the academic year to even consider graduate coursework toward a doctoral degree, necessary if I wanted to earn a tenured position at KU, so it was imperative for me to pursue that degree in the summers. Before my interim year, I had enrolled in summer classes at OU in 1969 and 1970. Continuing in graduate school full time during the 1971–1972 academic year, including summers on each end, allowed me to complete the coursework, leaving only a dissertation to complete for the degree.

Because I enjoyed the leadership opportunities I had experienced in athletics, I selected an institution that offered a doctoral degree in PE admin-

istration. At the time, there were no academic programs in sport management, just as there had been no academic programs in coaching during my undergraduate years, but PE administration was the closest to my career aspirations. Stanford University, the University of Illinois, and OU were three leading institutions offering this specialization at the time, and I considered each of them. Stanford's tuition was too expensive for someone earning my meager salary, and Illinois summer temperatures seemed as hot as those in Kansas, but Oregon offered mild summers and winters between the Pacific Ocean and the Cascade Mountains. In addition, OU offered "in-state" tuition to doctoral students from other states, so I chose it. After I took the GRE and submitted transcripts from my master's degree from the University of Colorado (CU), OU accepted me for graduate study beginning in summer 1969. OU limited doctoral students in the School of Health, Physical Education, and Recreation to fifty, accepting ten to fifteen new grads each year, and I felt fortunate to be one of them.

Although I had toured the Colorado Rocky Mountains and Wyoming's Yellowstone National Park as a ten-year-old with my family, I had never been to the Northwest before entering graduate school. Before cell phones, long-distance calls were expensive and thus deemed unnecessary. With only my car radio to listen to whenever a remote station could be found on the dial, and nobody to talk to on the road for hours, I missed the companionship of my twin sister, Darlene, in Kansas City. My thoughts as a twenty-nine-year-old were on the unknown future before me. Mixed with the anticipation of new horizons and experiences were some doubts about my high aspirations and the undiscovered aspects of a new campus so far away.

As I drove westward in 1969, I recalled my pursuit of a master's degree at CU, my first extended summer excursion without my twin sister, and I knew no one on that campus when I arrived. I recalled the close friends I had made while living in the graduate students' dormitory in Boulder. Arranging for housing in a similar dorm in Eugene was the first step in making acquaintances on that campus, and within a week of my arrival, I was involved in classes and developing new friendships. It was the first quarter of eight academic quarters within five years that left indelible memories of my time as a doctoral student.

My graduate advisor was Betty McCue, who had been a visiting professor at CU, and I was in her class while earning my master's degree. In 1969, she was the Women's PE Department chair at OU and a national leader at the DGWS, advocating for women's intercollegiate athletics. She

made graduate school more welcoming, and she was a kind and patient mentor. One of my first doctoral courses was a seminar on women's intercollegiate sport administration with her. Other women class members that quarter had directed various women's national intercollegiate championships, and we had a special comradery. Perhaps the class members taught each other as much about conducting a national tournament as we learned from our professor because even at her career stage, she had not ever had the opportunity to direct a national championship. She was delayed a week in arriving at her summer classes my first year at OU because she was a main speaker at the June 1969 DGWS National Conference on Sports for College Women in Estes Park, Colorado.[1]

Coursework for the PhD

OU, like most colleges along the West Coast in the 1960s–1970s, scheduled college courses with four quarters of twelve weeks each, rather than fifteen-week semester-length courses as at KU. Doctoral students in PE chose a specialization and a minor field of study as well. My specialization was thirty-six quarter-hours of PE administration, and I chose a double minor with eighteen quarter-hours of sociology and fifteen quarter-hours of psychology. A full load of courses each quarter for graduate students was twelve quarter-hours, or four courses of three quarter-hours each. My plan to complete the doctoral degree in five years was to enroll in thirty-six quarter-hours' worth of courses over three summers (1969, 1970, and 1971). Then, during the yearlong campus residency required for doctoral students, I would enroll in fifty-two quarter-hours as an overload in fall, winter, and spring 1971–1972 and another summer of twelve quarter-hours (1972) to finish the ninety-seven quarter-hours of required coursework and my residency year. After that there would be doctoral exams and completion of eighteen quarter-hours of dissertation writing.

This academic plan would result in earning my PhD in August 1973, the same year of my tenure review at KU. There was no time or option to drop a course or to get a C and then need to repeat a course for a higher grade for it to count as credit toward my degree. It took foresight for each quarter's enrollment to determine when the required courses would be offered and then persist in completing the courses under these "now-or-never" conditions. Attention to my coursework was much the same as that of an athlete dedicated to practicing a skill repeatedly to be a starter on the team.

Arthur Esslinger was the elderly dean of the School of Health, Physical Education, and Recreation at OU in the 1960s. He taught the three required graduate courses in PE administration, and all doctoral students in this field took the series of administration theory courses under him in three sequential quarters. Esslinger served in World War II as commander of the US Army Fitness and Recreation Program for GIs, and his interactions with students were blunt. Often, he expressed his authority and responsibility for administrators as he had experienced it as a military commander. He always came into the classroom with the course textbook; he dropped it heavily on the desktop, leaned back in his chair, threw his arm around the back of his head, tweaked his opposite ear, and looked at the class members through his horn-rimmed glasses, which slid down his nose. He always began his courses with the biased announcement that even though the PE administration courses were open to both men and women, the women in the class should understand that they might become administrators in women's PE but would never be athletics administrators because athletics was not a professional career for women. He emphasized his point by deliberately never giving a grade higher than a B to women in his classes because the men needed the A on their transcripts.

Other esteemed senior professors of both genders taught required courses in specific areas of PE administration, including Philosophy of Sport and Physical Education, History of Sport and Physical Education, Professional Preparation for Physical Education, Curriculum Construction for Physical Education, and Administering Physical Education Facilities. There were summer seminars in Administration of Recreational Service Programs and Social Bases of Physical Education. In addition, there were three required PE statistics courses in sequential quarters other than summer.

Considering that a sport management career would require people skills and knowledge about human behavior, I believed it would be beneficial to take courses in sociology and psychology. Both of these academic fields were in the College of Social Sciences, but OU offered no graduate-level academic courses in sport psychology or sport sociology. I chose to enroll in these psychology courses: Theory of Personality, Psychology of Human Performance, Psychology of Learning, Group and Individual Differences, and Abnormal Psychology. My sociology courses included Social Theories of Small Groups, Group Dynamics, Theory of Organizations, Sociology of Leisure, and Sociology of Women. A sociology professor mentored me in

formulating an independent study curriculum augmented with research literature for a sport sociology course I could teach when I returned to KU. At the time, there were only four textbooks recently published in sport sociology. By the time I had completed my doctoral degree, I had used several of my graduate courses to develop academic subject matter in a format for potential new courses at KU in sport sociology, sport psychology, and sport management.

Another requirement for a PhD was nine graduate quarter-hours of a foreign language, and neither Spanish nor computer programming languages were permissible. Spanish was considered a common language on the West Coast because of an influx of Central and South American immigrants, and computer programming was considered a nonverbal language. I chose German to fulfill my foreign language requirement because I had taken a two-semester course in that language in undergraduate school as a requirement, even though that was ten years earlier. The three-course series for doctoral students completing the foreign language requirement (as opposed to German majors) was German for Reading Knowledge.

A doctoral graduate teaching fellow in Germanic languages taught the three courses, and she was quite patient with the class. Seven PE doctoral students enrolled in her series, and I was the only woman. The men were not as focused as I was to pass each course, and they often came to class unprepared. The first and second quarters, the instructor had copied simple German passages as homework for the class to read and interpret and then repeat in class. Gradually, she assigned more complex texts for us to read as homework and then read aloud in German and translate into English during class. For the third quarter, she asked us to find a PE book in the library, bring her the book so that she could copy pages from the book for all others in the class, and then read them aloud in German and interpret them in English. I was the only student who found a PE book in German, *Die Deutsche Turnkunst* (*The German Gymnastics*), by Friedrich Ludwig Jahn, known in PE as the father of German gymnastics, who wrote it in 1816. Jahn was a famous leader in the Turnverein, nationwide community organizations for advocating physical fitness, a system that German immigrants brought to the United States. His book contains descriptions of and instructions for teaching gymnastics and tumbling.

Our instructor distributed chapters from the German book to the class members. She assigned the students to read pages of it aloud in German during class and then interpret them in English. I spent hours turning pages of my German dictionary to find all of the unusual German words.

In preparing for class recitation, I wrote the English version in pencil on my copy above those German words, so that during class I could read the German words aloud easily and then explain the passage in English. The guys in class were not so good at it. I passed the three courses with two As and a B and was happy, but I am not sure if some of the men passed the last course. I can still read German words with good pronunciation, but I am not as good at interpretation now, after not using the language for fifty years. I believe that language requirement was designed to test academic discipline and perseverance.

At the end of summer school in 1972, I had completed all of the classes required for the PhD other than the dissertation, and that made me eligible to take the final comprehensive examination. I took my comps before leaving OU at the end of my yearlong leave of absence from KU. The final exams began with an eight-hour, handwritten exam, writing essay responses to eight questions encompassing my major specialization in PE administration. The main purpose of the exam was for me to describe in my own words the major principles taught in the courses. That PE administration portion of the exam was a matter of knowing several categories of facts I could elaborate on after I had expressed the main idea.

I studied for my comps by writing outlines of the major course content on notecards and then memorizing key words from the cards that could lead me into details on each subtopic. That way, I knew that I would not have a mental block on any subtopic. I paced myself by devoting no more than an hour to answering each question, so that I would be able to answer all eight questions without running out of time. This exam required gripping a pencil for four hours in the morning and another four hours in the afternoon while writing complete sentences in paragraph form as though it was a composition. No notes were allowed during the exam, and in those days personal computers did not exist.

The second sequential day of doctoral exams was another four hours of handwritten responses to questions on statistics and research methods. The questions consisted of data sets for which research results were to be tested statistically, using the appropriate research method and statistical formula. The exam required writing an analysis of the results of the statistical computations to be determined from the data sets provided. This exam required doing the math by hand without a calculator, choosing the correct statistical equation and method to find a correct numerical answer, and then explaining the results of the statistical analysis. The data sets were all taken from a large databank collected as part of a statewide physical fitness

study of high school youth, for which the statistical results were already known. This was the most difficult of the comps for me. Thankfully, my double minor was sociology and psychology, and neither of those programs required doctoral exams. I passed the administration portion of the comprehensive exams easily but received notice that I would have to repeat the statistical exam within a year.

I did not pass the research and statistics exam that summer because I did not comprehend the overview rationale for statistical methods, even after three quarters of statistical methods courses, mainly because the statistics professor seated a class of eighty masters' and doctoral graduate students in alphabetical order so that the homework would be collected in that order, and my designated seat was near the back of the large room. Because of my hearing loss since childhood, I could not hear him well enough or see him well enough to read his lips. Also, I could not see the chalkboard very well. I didn't seek assistance from him or any classmates or explain my hearing handicap. I did the math homework for each class session and turned it in on time, resulting in passing the three courses with two As and a B. But I still had a very poor concept of which statistical methods should be used for which types of data, and statistical interpretation was a crucial part of the comprehensive exams.

Throughout the winter quarter of my residency, I officiated basketball with Lorraine "Moe" Davis, a young OU instructor of statistics in health education, and when she learned of my failing the statistics portion of the comps, she offered to tutor me so I could pass the exam on the second try. I accepted her assistance and her invitation to come out to Oregon a week early the next summer and stay at her home. Because she was a very good teacher, I learned the basic premise of each of the several statistical methods and applications. I passed the statistics exam with flying colors. Ironically, back at KU I would teach a required graduate course to PE students in research methods, including appropriate statistical research applications, for eight years.

After returning to KU in fall 1972 as a faculty member following my doctoral residency year, I collected research data for my dissertation while supervising student teachers during the 1972–1973 fall and spring semesters. The doctoral program required enrollment in dissertation writing for a minimum of eighteen quarter-hours. I enrolled in three quarter-hours of dissertation writing during my residency winter term 1972 when I presented my dissertation proposal, and three more quarter-hours during spring term 1973 when collecting dissertation data, even though I was not

on the OU campus. The total quarter-hours required for the degree was 116, so I returned to OU in summer 1973 to enroll in thirteen quarter-hours of dissertation writing to complete my PhD. My degree plan left no option for diversion because completing the doctoral degree was essential to be considered for tenure at KU within five years of first being appointed.

Doctoral seminar courses that included students' discussions of major topics, a semester research paper, and a final essay exam were my favorite endeavors in graduate school. Completing a research paper on a course-related subtopic was interesting because it provided for deeper investigation in an area of special interest and encouraged insightful reflection. After the end of my doctoral studies, I presented graduate course papers at regional and national conferences and published my research papers in recognized professional journals. These presentations and publications were vital for the "publish-or-perish" tenure dictum at KU.

Financing Graduate School

Graduate school presented a financial dilemma for me because during each of my first three years at KU, I had to distribute my $7,000-to-$7,500 nine-month KU salary over the full year for monthly rent, utilities, food, clothes, insurance, taxes, and incidentals and still save enough to pay for tuition and housing for summer school. In the late 1960s and early 1970s, women could seldom obtain credit to secure a bank loan, especially when their annual salary was so much lower than that of a male wage earner. My checking account balances were always quite low, so all I had available for summer class funds were my meager savings. Those yearlong savings tided me over for a summer quarter but not for an entire year. It was not reasonable for me to apply for a graduate teaching assistantship to cover my residency year tuition because I would have only been able to enroll in doctoral courses part time while teaching, and it would have taken me too long to finish the degree to meet the time limit for tenure requirements at KU. Without a salary during a year's leave of absence from KU, I had to find other financial resources than my annual savings to fund my residency year.

My overall degree-financing plan included terminating my rental apartment contract in Lawrence for the first two summers of 1969 and 1970 and storing my few home furnishings with my oldest sister in Baldwin. For my residency year in Eugene in 1971–1972, I subcontracted my furnished, two-bedroom rental duplex in Lawrence to two women graduate students

at KU. That meant I did not have the hassle of moving and storing my furniture while I was gone, and I charged the two women the same rent I paid on the duplex. This arrangement enabled me to retain my rental unit in Lawrence during my absence.

Money was scarce during my required residency, spanning from summer quarter 1971 through the fall, winter, spring, and summer quarters into 1972. For the first summer, I used my previous year's savings to cover expenses, but for my fall and winter quarter tuition and expenses, I withdrew the scant accumulation of my six years of teachers' retirement pay from the Kansas City, Missouri, schools. To finance my spring and summer quarters, I applied for and received $1,000 for a federal Teacher Education Assistance for College and Higher Education (TEACH) grant by showing good standing as a doctoral graduate student and signing an "agreement to serve" promissory contract. This federal grant waived repayment if I taught for a minimum of five years in higher education following completion of my degree. My KU administrator had to submit verification of my employment each year for five years following the completion of my PhD, and I intended to teach at KU for at least five years afterward. The loan would be reduced 20 percent each year that my teaching in higher education was verified. This financial contract gave me added incentive to complete my degree and be retained by KU.

With my credentials as a DGWS national official in basketball and volleyball, I officiated secondary school and college games around Oregon and earned enough money for food and gas during my residency year. After completing classes on campus for the day, I often accepted a late afternoon or evening officiating engagement at a high school or junior high in the area. After each game or match, I got a paycheck for travel and officiating, and then I cashed it at a grocery store on the way home and purchased food. Officiating pay in the early 1970s for women was five to seven dollars per game/match plus five cents a mile for travel when gas was about twenty-five cents a gallon, so accepting officiating gigs at least three to four times a week provided adequate food and gas money. Weekends were when most college games and matches were scheduled, and sometimes I drove as far as the 180 miles to Southern Oregon College in Ashland, or 110 miles north to Portland State University, and once I carpooled 475 miles to the University of Idaho–Moscow to officiate several games in a regional weekend tournament. Both Oregon State University and OU ballgames were closer, of course, and I officiated a lot of games on those two campuses.

When I returned to Kansas in August 1972, I had less than fifty dollars in my bank account. I was ready to resume my teaching at KU and eager to return to volunteer coaching. Once more I was paid a nine-month salary, and in my fourth year at KU my salary was $7,520 for the academic year. My final summer of doctoral studies was in summer 1973, and I had saved enough for that last quarter of graduate school.

During my doctoral years, there were no extra funds for leisure activities or fashion shopping, but there wasn't much time for that anyway. A most fortunate phenomenon of the 1970s was the informal apparel worn by college students. Jeans, a T-shirt or sweatshirt, and sneakers or rain-repellant shoes were considered appropriate for classroom attire and, of course, a rain jacket with a hood for the winter months in Oregon. Even haircuts were infrequent because long hair was the norm for both women and men.

Oregon Life

School in Oregon was one of the most rewarding times of my life. I loved the seasons, respected the outdoor orientation of native Oregonians, guarded my time for studying, and established lasting friendships with other graduate students. During my residency year, I moved from the on-campus graduate students' dormitory to a furnished, one-bedroom, second-floor apartment in a house because there was no dorm designated for graduate students during the regular academic year. The rental house had two one-bedroom apartments downstairs and two upstairs. The house was five blocks from campus, so I walked to classes every day. Outside my upstairs window, a grapevine crawled up the brick chimney, full of plump, ripe, purple grapes in the fall, and I would stretch out the window to pick and eat some. Before supper each evening, rain or shine, I jogged a couple of miles through the neighborhood to maintain my physical and mental fitness. The wet winter days in Oregon kept temperatures in the fifties with no wind, but also in the dampness, it always seemed chilly. The outdoors smelled of fresh woods, refreshing when I was walking home from campus and clearing my cluttered mind after being in classes or the research library much of the day. Summer sunshine in the Willamette Valley after the Fourth of July brought warm days that made everyone want to be outside every day.

At KU, I was used to having all of my waking hours filled with back-to-back teaching and coaching responsibilities, so I managed my heavy

doctoral class load at OU each quarter similarly by choosing which courses required lots of reading and paperwork, and which had less homework, and then enrolling in a balanced curricular load. Even so, because of overloading myself with courses each quarter, I had little time for trips to the Pacific Ocean or for hiking in the Cascade Mountains like there had been for weekend outdoor recreation in the Rockies during summer school at CU, but I enjoyed the comradery of new graduate student friends in my doctoral classes.

By the end of my residency year, I was thirty-one years old, my brain was filled with current information in my field, and I was in the best physical shape of my life. At the end of each summer, other than the first summer of my residency year, I loaded my car with clothes, books, and a manual typewriter and headed back to Kansas to be on the opposite side of the teaching desk. The drive home took two fifteen-hour days, and usually my one overnight stop would be in mid-Wyoming, preferably Rock Springs. On one summer trip back, however, there were no vacancies in any hotels or motels in central Wyoming, and I had not considered needing a room reservation. Thus, I ended up sleeping a few hours in my camping bedroll, which I spread under the stars on a picnic table at a roadside rest stop until the sun woke me up.

Following a One-Year Leave of Absence

Upon my return to KU from the year's leave of absence in Oregon, I found a much different situation with my academic appointment and in women's athletics. Wayne Osness had been named department chair in July 1972, succeeding Shenk (chair 1941–1972), who had retired that summer. Stapleton (KU faculty, 1939–1972) retired at the same time, and these faculty vacancies allowed for new appointments. In addition to a new exercise physiology/kinesiology faculty member, there was a half-time appointment to teach women's PE coupled with a half-time women's intercollegiate sports director position. For the first time, the KU women's athletics directorship was a part-time, paid position in 1972–1973, and my former position as volunteer director of women's intercollegiate sports was no longer available. However, I still had the option of continuing to coach KU women's sports voluntarily. Despite the disappointment of losing the former opportunity, there was something positive for me to celebrate. As a result of completing all of my doctoral coursework except the dissertation, I was promoted from instructor to assistant professor, with the opportunity to be reviewed for

tenure and promotion to associate professor within the year. My academic accomplishments were on pace to fulfill my goal of remaining at KU.

Sharon Drysdale, a doctoral candidate from the University of Iowa who had completed all but her dissertation there, had been appointed as the new half-time faculty and half-time women's athletics director in the PE Department. Her doctoral specialization was in sport psychology, but she also taught PE courses. She asked me to continue volunteering as the KU volleyball coach because she had no experience in that sport. Even though I had wanted to continue coaching basketball, too, for the first time since coming to KU, I was coaching only one sport. In fact, I was destined to coach as a volunteer for only two more years because beginning in 1974–1975, the women's intercollegiate sports program would be merged into KU Athletics with the men's program, and all coaches for women's sports would be paid part-time salaries.

The choice of staying in academics with tenure as an assistant PE professor at KU, as opposed to taking a part-time coaching position on an annual contract with KU Athletics, was an obvious decision for me. Although I really enjoyed coaching, a part-time annual contract extension, possibly connected in future years to the team's win-loss record, was not a reasonable alternative for me. I chose to continue in the academic track because it offered a much better opportunity for continuous full-time appointment at KU and for salary stability. Plus, I had to repay my graduate education grant over a five-year period if I was not employed as a full-time instructor in higher education. Even so, I was sad to leave the realm of women's intercollegiate sports because opportunities for women athletes were increasing rapidly, much faster than anyone could have predicted.

So, I resumed my full-time faculty position at KU, teaching PE education courses. Previously, Stapleton had supervised the women PE undergraduates in student teaching, and I inherited that assignment. Supervision was a fortuitous assignment because I planned to gather data during the 1972–1973 academic year from the student teachers for my dissertation and to solicit data from their cooperating teachers. With that research, I could return for my final quarter of enrollment at OU in summer 1973 to write my dissertation and defend it. That plan would finish the requirements for the PhD, and I could graduate in August.

My dissertation committee approved my dissertation proposal before I left the OU campus. My topic would be the teaching behaviors of student teachers and the influence of their cooperating teachers and university supervisors on those behaviors. Each time I visited a student teacher, I used a

paper-pencil systematic-incident behavioral model to tally and record nine different types of teaching behaviors that I observed during a lesson or class hour. I also recorded the length of time in five-second intervals that each behavior type was used. In addition, I collected questionnaire answers from the cooperating teachers and the university supervisors of the student teachers at the secondary-school teaching sites. This research was proposed to determine if the teaching behaviors were influenced more by their own learning experiences as student teachers, by the cooperating teachers' guidance, or by the university supervisors' evaluations.

Ten years later, as chair of the Health, Physical Education, and Recreation Department at Illinois State University, I led the faculty there in establishing a teacher education laboratory to use this research technique for enabling the same type of teaching data to be collected but using new technology. With video cameras, pairs of student teachers could collect data at the teaching site and later, in the teaching laboratory, review the teaching behaviors, applying a computer program to analyze them rather than the paper/pencil observation method I had used. Because the student teachers videotaped themselves and analyzed their own teaching behaviors, this laboratory exercise accelerated positive changes in their teaching. This teacher education laboratory was the first of its kind in the country and was emulated at other institutions after the Illinois State University faculty demonstrated its use at national conferences.

The Final Summer of Doctoral Study

In June 1973, I returned to OU for my final summer quarter, with the goal of completing my dissertation and graduating in August. I brought the data I had collected from observing student teachers during the previous year and also the surveys completed by the student teachers and their cooperating teachers and university supervisors. The first draft of the dissertation included the introduction, review of literature, and procedure chapters, which I completed by the July Fourth holiday, and I turned in those chapters to my doctoral advisor for her review.

My typing skills were imperfect. I hated to make mistakes that had to be erased. In those days, I had a manual typewriter, and making copies of what was typed required putting carbon paper between the white sheets of typing paper and typing along until I made a typo. Then it was a tedious chore trying to erase the mistyped word, plus erase the error in each of the carbon copies. Then I had to get the original page and the carbon-copied

pages matched up again on the typewriter roller. It made typing multiple copies a nightmare. I had learned from experience that handwritten paragraphs to be typed later should be entered on alternate lines of lined paper, so that if a correction or an insertion of a word or a phrase was needed, there was space to place it in the correct location. Similarly, if a passage longer than the open line on the handwritten page was needed, an arrow could indicate that I had inserted that paragraph on the back of the written page. All of this writing experience became obsolete when photocopy machines made copies easily and cheaply and personal computers allowed a copy-paste action and spellcheck ten years later.

I scheduled the first weeks of July 1973 to analyze my data and receive the computed results from the room-sized mainframe computer on campus. In 1973, a keypunch machine with a keyboard, available at the computer center, was used to punch tiny holes into stiff computer data cards about the same dimensions of a business envelope. The cards were individually punched with instructions to run the computer program, and the statistical formula for calculation was punched on the cards. Finally, the card stack with the collected data recorded as numbers were keypunched for the research analysis. One would take the stack of more than 100 punched cards to the campus computer center window as a "batch" to be hand-fed by a computer manager into the mainframe. A long line of other student researchers' batches of data was to be expected, and several hours would necessarily pass between leaving the data cards at the computer center and having the data computation completed. Usually this was overnight. Often, one or more data cards had errors punched into the programming data, and the whole batch of cards would be rejected from continuing to run through the computer at the point of the first detected error. If the mainframe rejected the batch because of a card-punch error, the batch was handed back to the researcher with the error noted, and the card with the error had to be repunched and the entire batch resubmitted. When the whole card batch had run without error, there was a continuous printout page that folded back and forth from the beginning to the end that could be read to determine the statistical relevance of the data.

So first, I punched my collected data on cards for computer analysis. By the beginning of the second week of July, I had entered my collected data on more than 200 computer punch cards and submitted the cards to the computer lab. In those days before personal computers, data analysis by the mainframe campus computer was considered a marvel. During my statistics courses, complicated data were analyzed using heavy tabletop

calculators. All that remained for finishing my dissertation in time for the August graduation was computing and analyzing my data, and then writing and typing the results and conclusion chapter. I had a whole month to complete the last two dissertation chapters because it was early July.

After finding computer card-punch errors in my first two batch submissions, finally on the third try the entire batch computation ran through the mainframe, and I had my hard copy of the data analysis. I brought the hard-copy sheets back to my apartment only to learn that my sister had called from home on the farm in Missouri, informing me that my mother had passed away that July 12 morning of a sudden heart attack in the Butler, Missouri, hospital. I was in shock: my mother had flown to Chicago to visit one of my sisters in June. She had driven with my twin sister from Kansas City to visit a sister in Denver in early July and had stopped by another sister's home in Baldwin, Kansas, on the way back to her Missouri farm next door to another sister's home. My mother had planned to fly to San Francisco to visit my sister there and ride with her to Oregon for my expected graduation in early August, just three weeks away. Immediately, I arranged to fly back to Kansas City and ride with my twin sister to my hometown of Archie for our mother's funeral. I knew that all six of my sisters would be there. It was a very sad and disheartening time for me, and I was not motivated to return to Oregon to complete my dissertation and get my degree.

My six sisters insisted that our deceased parents would both expect me to finish my degree, and I knew they were right. My dad always told us girls that we could do anything we set our minds to, and he valued education as something that could never be taken away from us. My mother had always been supportive of all of my graduate study and proudly announced my accomplishments to her friends and neighbors. With my sisters' support and a renewed outlook, I flew back to Oregon in the last week of July to write the final two chapters of my dissertation.

There were only two weeks until the end of the 1973 summer semester when I arrived back on the OU campus. Upon my return, I was informed that an assistant professor was teaching a two-week summer session at the University of Idaho and wanted someone to stay at her home and water her lawn daily. When I flew home for my mother's funeral, I had collected all of my belongings in my car and left it in the driveway of some friends because I had negotiated an emergency release from my summer rental apartment before I left. I needed a place to stay while I finished my dissertation. Just back from Missouri and in a daze of grief, I gladly volunteered to housesit, where I was able to type undisturbed all day, every day.

Each morning of the thirteen days left, I typed my manuscript drafts and then took them to my dissertation advisor, Betty McCue, each afternoon for her review, and then I picked up the pages from her the next morning with her editorial corrections. There were two chapters to complete, and one was an analysis of my statistical research results, including charts and application of the results. The last chapter was my conclusions drawn from the research and recommendations for further research. McCue called me her "phantom" writer because I dropped off my manuscripts for her to review overnight without needing to converse with her.

I produced my chapters on my manual typewriter with seven carbon copies for dissertation committee members, so the work was slow and laborious. McCue was very prompt and resourceful in guiding me to completion of the final two dissertation chapters and arranging for the defense of my dissertation with five committee members by the end of that summer quarter.

Two days before summer graduation on August 3, I passed my dissertation oral exams. The committee required minor changes to my 161-page dissertation. Immediately, because the typing had to be perfect and quick, I hired an expert typist to type the required five final copies of my dissertation on an electric typewriter. After proofing all the pages as she typed, I took the copies to a bookbinder that afternoon. McCue signed the five required dissertation copies in the parking lot the next morning just before I got in line for graduation.

My twin sister, Darlene, flew from Kansas City to San Francisco and rode with our older sister Eleah; her husband, Chester; and their junior-high son, Curt, up the West Coast to Eugene for my graduation. It was the trip my mother had planned to take with them. They stopped at a bakery on the Oregon coast to purchase a celebration cake. They didn't know the OU school colors, but the baker knew. They brought Oregon green-and-yellow frosted cake and champagne for a celebration, and I invited my graduate student friends still on campus to come over for the occasion. My two sisters' presence represented all six of my sisters and my parents. It was an exhilarating graduation day! With a deliberate and careful plan, commitment, perseverance, and lots of support, I had succeeded in completing my PhD by the end of summer 1973.

Within five years of my initial appointment at KU, I had managed to earn my PhD. I was now eligible for tenure review and possibly a permanent academic position. Completing the degree led to my next expectation. KU was a "publish-or-perish" institution, and I had not had time to conduct

more research and write for publication yet. I was granted tenure in spring 1974, but my promotion to associate professor had to wait until I had time to provide more evidence of publishing in professional journals.

The doors of opportunity would continue to open for me in my future as a KU faculty member. At my graduation, I had no distinct vision of where my career path might lead. Many possibilities, experiences, and expectations in leadership positions in sports and academics would become available for me in my extended career in higher education, but that is a story to be continued in another chapter.

CHAPTER NINE

BEYOND ATHLETICS: AN ACADEMIC CAREER IN SPORT MANAGEMENT

The August 1973 ceremony for doctoral students graduating from the University of Oregon (OU) was held outside on the lush bluegrass lawn of the Memorial Quadrangle of the OU Library. Graduates sat facing a stage with the large green emblem of OU hanging on gold backdrop curtains. For our degree conferral, we paraded in single file across the stage to be announced by name and congratulated by the university president and the dean of the graduate school, who handed each of us an OU diploma and a doctoral hood to be presented to our doctoral advisor. Betty McCue draped my doctoral hood over my shoulders in the time-honored ceremony.

Graduating with a PhD from OU seemed like a dream as I accepted my diploma and my doctoral hood just five days after I turned thirty-three. My hood was a long, black shell trimmed in dark-blue velvet along the outside edges, indicating the PhD. The hood sported the university colors of yellow and green, sewn-in satin wide interior chevrons, with gold velvet trim down the inside borders of the hood, representing the sciences as my field of study. The doctoral gown was black polyester with three black velvet chevrons sewn across the top of each puffed sleeve, representing a third degree in higher education. The black mortarboard was adorned with a gold tassel. Thereafter, I proudly wore that gown, hood, and mortarboard to every University of Kansas (KU) graduation ceremony I attended amid the multicolored hoods of other faculty members representing many higher-education institutions.

My two sisters were present to represent everyone in my family. I was elated to have earned the degree because I had completed the academic requirements over an eight-quarter enrollment taking four years, at times with adverse challenges. I was proud to return to the KU campus for fall semester 1973 to be addressed as "Dr." Mawson! My student athletes began to call me "Doc."

Marlene Mawson receives her PhD at the University of Oregon, 1973.

Departmental Changes on the KU Campus

Back at KU in late August 1973, my career in academics continued with heavy curricular and teaching responsibilities. No longer was I the KU director of women's athletics. Beginning that year, volleyball was the only sport I was assigned to coach, so I had more time for academics and publishing for promotion.

When I returned to campus with my new degree, Wayne Osness had been appointed the new Physical Education (PE) Department chair when Henry Shenk retired. Because the existing separate PE undergraduate programs for men and for women were in violation of Title IX regulations, their curriculum requirements were slated to be merged. Osness announced a new departmental administrative structure, delegating curriculum responsibilities to three department coordinators: a graduate coordinator, an undergraduate coordinator, and a coordinator for activity courses in PE. He appointed me as the undergraduate coordinator beginning that fall. I was charged with leading the faculty in revamping the required PE courses to be a single academic curriculum for undergraduate PE students.

Most of the PE faculty members at KU in the 1970s were men who had been tenured for several years and were somewhat set against change. There were not enough women faculty and new men faculty to carry votes

for immediate change, so persuasion became a necessity. Bit by bit in many faculty committee meetings, amending course content became possible, and curricular standards for educational accreditation were met. Each faculty meeting throughout the year included proposals and votes for passage of portions of new course materials.

It was a year of compromise between the male faculty members, who did not see the need for teaching men students skill development in sports, and the female faculty members, who knew that women students needed to develop good sports skills and be able to teach sports skill development. Female faculty members desired to retain four types of dance in the PE preparation curriculum, whereas male faculty members saw no need to require dance instruction at all. Eventually, all of the sports and dance skill development courses were titled Instruction and Analysis in . . . (name of each sport/dance). Two to four of these sports and/or dances were offered in a single course during a semester, and student majors were allowed to choose among sets of these courses. Faculty advisors were tasked with steering students into the optional courses when they lacked sports or dance skills and needed a better background. With lecture courses such as kinesiology and exercise physiology, it was easier to compromise on the content and requirements for PE majors because the size, strength, and playing experience of the students made no difference. By the end of spring semester 1974, new PE courses had been approved by the faculty, a new curriculum for all PE majors had been established, and the new PE major requirements were merged as one program and approved by the School of Education. I had been successful as the undergraduate coordinator in my first attempt at leading the faculty in an administrative capacity.

Beginning in fall 1974, the KU women's athletics program was merged into KU Athletics and was no longer administered within the PE Department. Coaches of women's sports were contracted by KU Athletics for part-time coaching positions within the new administrative structure. It seemed ironic that I would not be involved in women's intercollegiate sports any longer after spending so much volunteer time creating, guiding, and coaching the fledgling program for KU women.

Even though I was finished coaching at the end of the 1973–1974 academic year, I continued to be involved indirectly with KU Women's Athletics at the Kansas Association of Intercollegiate Athletics for Women (KAIAW) meetings and through several elected positions in Association of Intercollegiate Athletics for Women (AIAW) Region 6. Because I held national ratings in officiating women's basketball and volleyball, I accepted

many opportunities to continue officiating. Throughout the 1970s, I held an elected office on state and regional AIAW governing organizations and was on the AIAW Executive Council. Being involved in each of these AIAW offices, I attended all ten of the AIAW Conventions during the 1970s as well as meetings of the organizations in which I held office. These sports leadership positions were considered "service" toward promotion and tenure at KU, especially because they were within my academic specialization.

My Appointment as Coordinator for Undergraduate PE

The PE Department was growing dramatically during the 1970s as older faculty retired, the number of student majors increased, and new faculty positions were allotted to the department. As the undergraduate coordinator, I served on several departmental search committees to recruit new faculty, and I chaired some searches, interviewing many candidates at national conventions. Jean Pyfer was hired in fall 1970 to teach motor learning and adapted PE after she graduated from Butler University in Indiana, following Bob Carlson's resignation at the end of spring 1972 to take a department chair position in Texas. In 1973, Phil Huntsinger, from James Madison University in Virginia, with a specialization in health education, and Carole Zebas, a newly graduated PhD from Indiana University specializing in kinesiology and biomechanics, were each appointed to the department faculty. In 1975 Leon Greene came from the College of Idaho, with a PhD from University of Utah as a specialist in elementary school PE. Tom Thomas, with two graduate degrees from the University of Missouri, was appointed as an exercise physiologist in 1976. Janet Hamburg replaced Elizabeth Sherbon as head of dance in 1979. Jim LaPointe graduated from the University of Toledo and was hired as a specialist in sport sociology and teaching of sports in 1978, and David Cook graduated from the University of Virginia and was appointed as a specialist in sport psychology in 1984.

My appointment as undergraduate coordinator for PE continued for eight years, from fall 1973 through summer 1981. During those years, it was my responsibility to schedule courses, recommend course instructors, and schedule classrooms for the undergraduate PE curricular program. The department also offered courses in health education, recreation, and dance as a curricular minor for PE majors and for minors outside of PE. During the next seven years, the faculty specialists in each of these three areas worked with me to propose sequential courses and receive approval from the School of Education for new majors with a curriculum of study

in these areas: health education in 1975, recreation in 1977, and dance in 1979. Because of the addition of majors, the name of the department was changed to the Department of Health, Physical Education, Recreation, and Dance (HPERD) in 1980.

As undergraduate coordinator for the department during the 1970s, I was the principal curriculum and enrollment advisor for PE students, particularly for the upper-level classes. I reviewed transcripts of students wishing to transfer into one of the four undergraduate majors in the HPERD, and I pointed out the courses each transfer student would need to take to earn a degree in that major. I checked each graduating senior's enrollment in their final year to ensure they would be able to complete their degree requirements. My class teaching load continued to be twelve hours each semester even with the added coordinator responsibilities, but I spent fewer hours at work than when I was coaching.

Having graduate students under my tutelage would be helpful in gaining promotion, so I wanted to have an opportunity to teach graduate courses because I had newly acquired information and research in PE administration, sociology, and psychology from my doctoral study. Finally, after the retirement of faculty who had traditionally taught the sections of the required undergraduate course Physical Education Administration, my teaching assignment included teaching one section of this course at the undergraduate level. Walt Mikols had priority to teach the graduate course Physical Education Administration until his retirement because administration courses were his teaching domain, even though I had doctoral specialist credentials in that subject and his highest degree was a master of science in PE. The 1970s were still an era of male domination and privilege, chauvinistic attitudes, and sex discrimination among faculty assignments, but I was being given opportunities for administrative leadership, which I appreciated.

Student-Teaching Supervision

When the undergraduate PE curriculum was merged for men and women, I was assigned to take over as director of student-teaching supervision in PE and health education. This was a major teaching assignment of mine during the last half of the 1970s. Administering the student-teaching program for PE meant assigning each KU student teacher to a school after communicating with potential cooperating teachers and identifying them as master teachers from schools in Douglas County, where Lawrence was located, and also for schools within the surrounding counties, including

the several schools in the Topeka area, the greater Kansas City metropolitan area, and other schools mostly on the Kansas side of the state line. After I had been to the schools and interviewed the master teachers and the school administrators, I recommended schools and cooperating teachers in the surrounding schools to the School of Education as master schools and master teachers. I assigned student teachers to the approved schools with specific cooperating teachers where they would student teach. These recommendations and assignments meant many forms and much paperwork.

Being the director of student teaching for PE required a great deal of planning and organizing to travel and visit the many schools to which student teachers were assigned during the time the student teacher could be observed teaching. Each student teacher was to be visited at least twice by the university PE supervisor, who observed and conferred with the student and also consulted with the cooperating teacher. During each supervisory visit, I reviewed lesson plans, evaluated classroom control and teaching effectiveness, and systematically observed teacher-student interaction and class presentations. The university supervisor assigned a letter grade at the end of the semester. The university supervisor's evaluation was handwritten, and a carbon copy was given to the student teacher during consultation at the end of each supervisory visit. Each supervisory visit to a student teacher was planned to last at least two hours, and, when added to travel time to the school, it usually meant half a day. Sometimes, more than one student teacher could be visited in less time if they were assigned to the same school district and if travel time between schools was minimal.

Assignment of as many as twenty-five to thirty PE student teachers in one semester was common during the late 1970s, often requiring that the school assignments for student teachers be creative. There usually was no more than one health education student teacher in a semester because in the 1970s few schools had full-time teaching positions for a health educator. In the semester prior to student teaching, seniors expecting to enroll in student teaching completed applications indicating their school choices. Because of students' informal communication networks on campus, there seldom was more than one student applying to student teach at the same school in the same half of the semester.

Student teachers in PE were advised to spend half of the semester (eight weeks) at the elementary school level and half at the secondary school level, either at a junior high or a high school, so that they could be K–12 teacher certified after student teaching at all levels. Often, in order to get placement for the high number of student teachers in a given semester, two student

teachers would be placed in the same school district, with one assigned at an elementary school during the first half of the semester and the other at the secondary school. Then, at midsemester, they would switch so that each of them had experience at both levels and both could still choose the same school district. When two student teachers were of the opposite sex, as many as four student teachers could be placed in one school district if there was more than one master cooperating teacher and more than one elementary school in the district. The male and female student teachers would each have a different cooperating teacher at the same secondary school but in a different gymnasium, and if there were two elementary schools in the district, the two student teachers at each level could trade with another two at midsemester. This arrangement was scheduled often in the Shawnee Mission, Kansas, School District. Planning and organizing the student-teaching assignments was much like matching practice time, coaching schedules, and game officials throughout a sports season.

Occasionally, a school where a student teacher was assigned had a resignation or a retirement at the end of the semester, providing that student an early opportunity to demonstrate how well they could fill the anticipated opening during student teaching, and often that student was hired for the vacant position. Sometimes, I had calls from schools where we had placed student teachers inquiring if we had graduating seniors who could interview for PE and coaching positions there, and those with experience in athletics had an edge.

I spent many hours on the road, driving my own car to schools in the surrounding area. The university provided compensation for student-teaching supervision travel according to the location of the student teachers assigned. Travel compensation was offered only for supervising student teachers outside the Lawrence city limits. During the 1970s, I supervised secondary school student teacher placements, and Kelly Rankin, a doctoral graduate teaching assistant at KU who taught the elementary school PE course on campus, supervised elementary school student teachers as his half-time teaching load.

Promotion to Associate Professor

In spring 1975, I was promoted to associate professor as a PE faculty member, and it was a momentous occasion for me. My office was moved from the windowless former women's PE office suite to a new office across the hall with an outside window in the main suite of the PE Department. My

new office window looked eastward toward the field hockey and softball fields, where I had coached many hours, and I felt content in an office where sunshine filled the mornings.

Although gaining tenure meant that I would be able to stay at KU as long as I performed satisfactorily as a teaching professor, I would not be eligible for promotion from assistant professor to associate professor unless I could publish research-based journal articles or books in my area of specialization. Though I had been busy teaching and coaching during my first three years, I had seven seminar papers from my doctoral courses published in nationally reviewed periodicals within the first year following my leave of absence, and it enabled me to show publications in addition to teaching accolades and service commitments for attaining the promotion.

There were no professional mentors who helped me set up research data collection or provided editing or recommended avenues for publishing professional work in journals because none of the faculty at KU had published in PE administration. With a twelve-semester-hour teaching load along with the travel time required for supervising student teaching, there was little time remaining for conducting research and writing it up for publication. Another barrier for me was that no academic journals existed in PE administration or in sport management as a specialization as early as the mid-1970s, and PE and sport administration research were not priorities for publication in education-affiliated journals. Therefore, I decided to conduct research and publish in the field of sociology of sport because that academic discipline had been established with a national journal the same year I returned from my leave of absence. Sport sociology was a specialization in which I taught a course at KU, and it was my minor field of study in my PhD preparation. It would be ten years before the academic field of sport management was developed.

Teaching Graduate Courses

My alternative to waiting for faculty to retire so I could teach graduate courses at KU was to construct and propose new courses in sport sociology and sport psychology. By the mid-1970s, these were two new specialties in the discipline of PE, and none of the faculty at KU had a background in either area. I had accumulated related literature in sport sociology through my independent study course with a sociology professor at OU, and as the major focus of that independent study, I constructed a course outline and lecture notes, so I had a course readymade to teach in sport sociology. In

1971, there were only four textbooks published on sport sociology, so I collected additional sports-related sociological studies from research journals to construct a reading list for graduate students. With this preparation, I offered a new graduate sport sociology course at KU in summer 1975, and it proved to be a popular elective course. Subsequently, the PE Department created a new faculty position in 1978 for a specialist in sport sociology. Similarly, after I developed a new graduate summer course in sport psychology, and it also attracted strong interest among graduate students, the PE Department appointed a specialist in sport psychology in 1980. In 1985, university faculty in the United States and Canada initiated the discipline of sport management. The North American Society for Sport Management (NASSM) and the *Journal of Sport Management,* initiated by this new organization, offered publication opportunities specific to my field of study.

In summers during the late 1980s, I introduced new sport management graduate courses. Like the sport sociology and sport psychology courses, initially I offered them as minicourses of a topical specialty; that is, I offered each for one semester-hour credit and scheduled them for three afternoon hours per day for five sequential days during only one week of summer school. It meant that the course curriculum had to be planned to cover the essential portions of the topic with assignments that could be completed overnight by graduate students. Graduate courses I proposed and taught as minicourses in different summers included Foundations of Sport Management, Sport Organizations, Event Management in Sport Facilities, Sport Finance and Marketing, Sport Ethics and Law, and Sport History. Some of these minicourses became three-hour courses in the sport management specialization in PE.

Some graduate students who enjoyed my courses invited me to be their thesis advisor. My first thesis advisee at KU was Patty Dick, who wrote her master's thesis in sport administration in 1975. She had served as Athletic and Recreation Federation for College Women (ARFCW) president for Kansas as an undergraduate at Washburn University, earned a bachelor's degree in PE there, and was the women's basketball coach at Washburn University while working on her master's degree at KU. I had been introduced to the rigor of being a faculty thesis committee member through interaction with my KU colleagues, but my own experiences in defending my master's thesis and my doctoral dissertation also made it familiar. With my promotion to associate professor, KU granted me approval for chairing both master's theses and doctoral dissertations. Most of my graduate advising was for master's degree students because few doctoral students

pursued PE administration in the early 1980s. Exercise physiology was the only PE specialization approved for doctoral students by the KU Graduate School during the 1970s. Those interested in PE administration were required to complete the exercise physiology curriculum regardless of their dissertation topic.

My first doctoral dissertation advisee was Joella Mehrhoff, an instructor of dance at Washburn University who wanted to collect data about state and federal dance education grants for her dissertation in 1979. She pursued a dissertation topic in PE administration because that seemed closer than exercise physiology to her academic focus on dance. She gathered data from colleges across the country, seeking information about the extent of those colleges' state and federal grant applications for dance and whether state, federal, and commercial awards had been granted for dance. She learned that few grant applications were filed by colleges for dance funding, but among the grants obtained, most were awarded commercially. She was the first graduate student in the department to use computer-designed pie charts in analyzing her data, and her dissertation exam earned her honors. After graduation, Mehrhoff left Washburn University to become a professor at Emporia State University and eventually became department chair there, where she retired in 2018.

More than fifty graduate students became master's thesis or doctoral dissertation advisees of mine between 1975 and 1990. My first doctoral advisee in sport management was Ming Li from Beijing, China, a master's and doctoral student at KU in the 1980s. He was completing his dissertation in sport management the same year I resigned from KU to become a department chair in Illinois, but he still considered me his doctoral advisor. The same year he received his doctoral degree, I was proud that his research manuscript was selected internationally as the first winner of the NASSM President's Graduate Student Research Competition in 1991. His career has been outstanding: he was appointed and promoted to professor at the University of Pennsylvania, since then has become a higher-education administrator, and is currently dean of education at Western Michigan University.

A One-Year Coaching Revival

In fall 1980 women's basketball player Cheryl Burnett had just completed her college athletic eligibility at KU, but her PE student-teaching semester at Lawrence High School remained to be finished to achieve her bachelor's

degree. She was an excellent defensive guard from 1976–1980 on the same KU teams with two renowned KU basketball players, Lynette Woodard and Adrian Mitchell. Burnett aspired to be a basketball coach, and she wanted to continue playing basketball during the winter she was completing her bachelor's degree after she had completed her eligibility for collegiate basketball. She dropped by my office in Robinson Gym one afternoon in late fall 1980 to ask if I would consider coaching an Amateur Athletics Union (AAU) women's basketball team she would captain during the winter. At the time I had a heavy academic load as undergraduate coordinator, in addition to teaching a full load of undergraduate and graduate courses, supervising student teachers, and advising many undergraduate majors, and I told her that I had retired from coaching and had very little time for extracurricular volunteer responsibility. She knew I had coached basketball at KU, and she pursued her request, promising me that I needed only to appear at practices and at games and that she would handle all of the administrative duties of league entrance, registration payments, equipment and uniform procurement, and travel arrangements. I did miss the opportunity to coach young women and to be on the basketball floor, so it didn't take me long to agree to coach her team.

The team players Burnett recruited were stars of several university teams in Kansas, and they had also completed their college athletics eligibility and were employed or were in graduate school in or near Lawrence. The season seemed so much like the years when I had coached basketball at KU because the players had little funding and few fans but played competitively because they loved the game. The AAU team name was the same as our funding sponsor, Land-Air Delivery (LAD), a Lawrence family-owned business of former KU basketball player Karen Schneller, who also played on the AAU team. The LAD team played weekly in two AAU leagues: in Topeka on Tuesday evenings and in Kansas City on Saturday afternoons. At the end of the ten-week season, our LAD team won the Topeka league easily and was second in the Kansas City league season standings. After winning the postseason AAU regional tournament in Kansas City, the LAD team qualified for the AAU National Women's Basketball Championship in St. Joseph, Missouri.

Luckily, St. Joseph was only ninety miles away, so our LAD team shared rides in a couple of players' cars to the single-elimination tournament. The team won its first game but lost to our next opponent, the previous year's national AAU champions from Pennsylvania, and was eliminated. Even so, it was a very rewarding season and a nice way to finalize my basketball

coaching career. Burnett went on to become a highly successful coach of NCAA Final Four women's basketball teams at Missouri State University and retired in southern Missouri. All of those talented and competitive young women athletes pursued other successful careers after that one exhilarating season, and most remain in touch with me.

Appointed Graduate Coordinator

In summer 1981, Pyfer resigned from KU to become a faculty member at Texas Woman's University (TWU), leaving the PE graduate coordinator position open. Osness appointed me graduate coordinator in fall 1981, a position I held for the next nine years. In 1980, an expansive addition was built onto the west side of Robinson Gym, including a large gym with four basketball courts that could be divided by hydraulic doors, a twenty-five-meter pool beside the existing twenty-five-yard pool to form an aquatics center, a strength-and-conditioning center for instruction, laboratories for exercise physiology and biomechanics, and a new suite of department offices near the new entrance on the west side of the building. The graduate coordinator's office was next to the department chair's office in the new front office suite. It was a large office with two wall-sized picture windows facing Allen Fieldhouse (with Rose of Sharon bushes blooming outside the windows!). My office had space for an academic desk as well as a table and chairs for student conferences and advising.

The graduate coordinator's first responsibility was to review transcripts of PE graduate applications and GRE scores. Further, applications for graduate school required a review of previous transcripts for any transferred coursework from an accredited higher education institution. Finally, the graduate coordinator's responsibility was to check for a required grade-point average (GPA) and appropriate course preparation in the bachelor's degree program for the PE specialization the student wished to pursue in graduate school. I made the recommendation for each PE applicant as either favorable or not, and I sent the application on to the KU Graduate School. Later the applicant would be notified regarding admission or rejection as a graduate student.

I initially advised newly admitted graduate students, and I was usually the curriculum advisor for a prospective graduate student. I counseled each graduate student to pursue a specialization within PE based on their undergraduate preparation and career interests. I then outlined the thirty hours of graduate coursework for a master's degree each student should follow

Marlene Mawson in her KU academic office advising student Terry Flynn, 1981.

semester by semester, plus any prerequisite courses, based on their special-
ization choice and which semester each course would be offered. I spent
at least an hour with newly admitted graduate students, making sure they
understood their plan of study. Each student knew when they could com-
plete their degree if they followed the prescribed courses because I gener-
ally controlled the semester rotation of course offerings in the department.
Doctoral students were advised by a PE faculty member with expertise in
their preferred specialization of study.

At the beginning of the 1980s, KU offered master's degree specializa-
tions in adapted PE, elementary school PE, exercise physiology, health edu-
cation, kinesiology, motor learning, psychology of sport, sociology of sport,
PE administration, and recreation. These specializations attracted many
master's degree students, particularly teachers who enrolled in summer
sessions. The doctoral specializations would expand beyond the single ex-
ercise physiology specialization by the end of the 1980s. During the 1980s,
when I served as KU graduate coordinator in the HPERD, its graduate stu-
dent admissions more than doubled; by 1989, sometimes the number of
PE and health education graduate students enrolled in classes each semes-
ter exceeded seventy. Many young PE teachers in the Kansas City metro-
politan area took graduate courses on weekday evenings, seeking a degree
to enhance their faculty salary. The increase in graduate students occurred

as older faculty members in the HPERD without doctoral degrees retired, and young faculty who replaced them had credentials to enhance the graduate course offerings, particularly in PE specializations. This injection of cutting-edge faculty expertise resulted in the department being able to offer a broader spectrum of PE specializations for graduate students.

In the early 1980s, the department began to offer evening courses at the KU–Edwards campus in Overland Park. Faculty members and the courses they taught were rotated there so that graduate students in the Kansas City area could take many of the required courses without incurring extra driving time. The Edwards classes had strong enrollments, similar to those of the same courses on the Lawrence campus, so the course rotation offerings continued throughout the decade. No teaching assignment release time was given to the faculty members who drove weekly to teach a class at Edwards because everyone who taught graduate courses sometimes taught there.

As graduate coordinator, I scheduled graduate courses and recommended graduate-course teaching assignments for faculty. In addition to teaching graduate courses in sport administration, I taught the research methods course for all PE and health education graduate students, offered each semester including summer. Evaluation of students' work in this research methods course required a large amount of reading time for me to grade their research papers. The course included students researching and writing a literature review for their thesis or dissertation, an introductory chapter for their research, and a chapter explaining their research methodology. The students wrote each chapter initially as a first draft, and then after I had evaluated it, they put the three chapters together as their final paper for the course. This meant I read and evaluated six chapters per student in the class each semester, and often the class enrollment was twenty to twenty-five graduate students. The benefit for the students in writing three chapters of a research paper was that these chapters addressed the requirements for a thesis or dissertation proposal for a faculty committee, so the students already had that proposal in hand when they finished the course. One benefit of all that reading for me was that during the 1980s, I was well versed in the published research literature for most specializations offered by the department. Because I had critiqued their work initially in the research methods class, many graduate students invited me either to serve as their thesis or dissertation advisor or to be a member of their thesis or dissertation committee.

Over my nine years of teaching the research methods course three times a year, more than 300 graduate students completed the course I taught. I

served as the thesis or dissertation committee chair or member for more than one-third of those students. During the 1980s, the department averaged a completion rate of twenty to thirty graduate degrees per year in PE or health education, and seldom was there a student who did not complete a thesis or dissertation as a part of the degree requirements.

Assistant Department Chair at KU

Osness appointed me assistant department chair in 1983 in addition to my duties as graduate coordinator. My additional assignment as assistant chair did not reduce my teaching load or increase my salary, but the designation authorized me to act as department chair during his absence from campus. He had become American Association for Health, Physical Education, Recreation, and Dance (AAHPERD) president-elect in 1982 and then served as president and past president from 1983 through 1985. He was appointed to the US Olympic Committee (USOC) in 1985, so he was occasionally involved in national organizational meetings for a week or more at different times during several years of the 1980s. Generally, documents that required a department chair's signature included student admissions, student-related issues, faculty concerns, or curricular approvals, but I was not authorized to sign financial accounts or reimbursements, so my assistant chair duties were mostly academically oriented. Department faculty meetings were scheduled only once a month, and Osness was able to fit his schedule around those.

During the 1986–1987 academic year, the North Central Association Commission on Accreditation (NCACA) evaluated HPERD academic programs for continued academic accreditation. Within the School of Education, the National Council for Accreditation of Teacher Education (NCATE) also conducted the evaluation visit. These evaluations, conducted every ten years, required documented evidence of curricular content for all courses in the several programs in the department. Osness appointed me chair of the department's accreditation committee for this intricate and voluminous review.

Documentation of faculty credentials and curriculum vitae, an overview of the administrative structure for the programs, descriptions of classroom and laboratory facilities, and documentation of student success in graduating from the several programs were all gathered for the visiting accreditation team's evaluation. This required collecting and organizing a vast number of documents from the previous ten years from departmental records

and from current faculty and then producing evidentiary documentation for the accreditation team members to read both prior to and during the evaluation visit. It also meant that a descriptive analysis of each of the curricular programs had to be written to link each of the various documents to the summary of the evaluation. The curricular program evaluation included syllabi from each course offered in each curriculum, and the syllabi were required to be formatted in a uniform style. Each national organization outlined an evaluation scheme for KU to follow, and any omission or incomplete explanation or documentation could jeopardize the institution's or the department's approval for accreditation.

Each of the PE, health, recreation, and dance programs were to be evaluated separately in a written report prior to the visit and also evaluated on campus by the visitation team for NCACA and NCATE accreditation based on accomplishments and adherence to national curriculum standards over the previous ten years. If no outstanding issues were discovered, KU would be given ten years before the next accreditation review. If there was concern about any of the evaluative guidelines, the institution or a program could be put on probation and reviewed again within five years. I delegated specific tasks to faculty as we worked diligently on collecting the required documents and writing a thorough departmental self-evaluation. Following the on-campus evaluations, I was relieved to learn that all of the HPERD programs were found to be excellent and were accredited for another ten years.

During this extra effort of covering the department chair's responsibilities, I became confident that I had the skills and experience to serve and lead as an academic administrator. Even though I was performing the administration tasks, I was not being paid as an academic administrator; my salary had not increased significantly in the twenty-two years since I was appointed in 1968. My salary was not even as high as those of newly appointed assistant professors in the department because the annual salary appropriations for faculty from the Kansas Board of Regents had been between a zero increase and a 2 percent increase during the two decades I had been at KU, and I had been given no additional adjustments to my salary for administrative assignments.

In higher education, when annual salary increases for faculty are less each year than the market increases for new hires, it is known as "salary compression." The annual increments approved by the state for professorial salaries are often minimal, yet the market in comparison with other institutions for incoming faculty positions can increase entry-level salaries

faster than the incumbent faculty salaries rise. My only hope for an equitable salary increase under those conditions was either to be appointed to an administrative position with an accompanying administrative salary at KU or to be recommended for full professor for a smaller, one-time salary boost.

Everyone in HPERD understood that Osness would continue to be the department chair at KU for as long as the dean of education continued in his position, and, therefore, no foreseeable opportunity for me to be appointed to an official academic administrative position would arise. Also, because Osness held the only full professor status in the department during the early 1980s, and he had not mentored anyone among the faculty toward accumulating credentials for a raise in rank to full professor other than Thomas, and because a recommendation for promotion in rank was the purview of the department chair, I knew that neither my promotion potential nor my salary was likely to change. As long as I had been in the department with my low salary, I could not foresee a reasonable retirement income for myself in fifteen years when I would turn sixty-five. Thus, I began to look elsewhere in higher education for an academic administrative position.

Professional Organizations Provided Networking Opportunities

Membership and participation in academic-related organizations are important to faculty because they provide opportunities for the professional service expected of professors, and they help establish connections within professional networks among faculty in the discipline. National academic organizations have branches at the regional and state levels, too. Involvement with these organizations brings familiarity with other professionals in the field and allows interaction with those individuals to create new ideas, methodologies, and program evolution. These professional organizations also provide opportunities for faculty to demonstrate service as a criterion for tenure and promotion.

The first professional organization in which I became a member was AAHPER (renamed AAHPERD), founded in 1885 and thriving toward its centennial in 1985. Within AAHPERD were seven associations (originally called divisions), and the ones that fit my career best were the National Association for Girls and Women in Sport (NAGWS) and the National Association for Sport and Physical Education (NASPE). I joined the national

organization and participated in these two divisions as a college student and continued when I started my teaching career in 1962. Soon after its centennial, the national association for research, the association for girls and women in sport, the association for recreation, and the association for dance each disassociated from AAHPERD. By 2013, with K–12 PE, health education, and physical fitness as its top priorities, the national organization changed its title to Society for Health and Physical Educators (SHAPE) America.[1]

In 1974, I joined the North American Society for Sport Sociology (NASSS) because I needed an opportunity to publish research and present papers recognized by the university faculty, and the NASSS conferences and the *Journal of Sport Sociology* offered an opportunity to earn associate professor and professorial ranks in the "publish-or-perish" life at KU. In 1990, I was elected sport sociology chair for NASPE in its research consortium, which required that I solicit, evaluate, and select research proposals in sport sociology for presentation at the annual AAHPERD Convention. Two years later, I was elected research chair for NASPE, which included being a member of the NASPE cabinet, with the responsibility for organizing the chairs of eight specialization areas in sport and PE to schedule research presentations across the various specializations representing NASPE at the AAHPERD Convention. During the 1970s, my membership in NAGWS had been mostly supporting AIAW as its affiliate, and I held elected positions at the state, regional, and national levels of AIAW. For 1998 to 2000, I was elected vice president of NAGWS and was a member of the NAGWS Executive Board.

My professional networking beyond the KU campus also included membership in the Central Association for Physical Education for College Women (CAPECW) and the National Association for Physical Education for College Women (NAPECW). During the 1970s and 1980s, I held various elected offices in CAPECW and NAPECW, and I was elected to serve as CAPECW president in 1990. Because the organization merged that year with the National College Physical Education Association for Men (NCPEAM) to become the National Association for Physical Education in Higher Education (NAPEHE), I never presided at a meeting as the regional president because of the disbanding of the regions when the men's and women's national organizations merged. I maintained my membership and participation in the national organization and was given the NAPEHE Service Award in 2000 for twenty years of serving on national organizational committees and as a regional officer.

The North American Society for Sport Management

The North American Society for Sport Management (NASSM) was an academic organization established in 1985 for college professors pursuing theory and research in sport management. It was the most recent specialization identified and acknowledged as an academic area of expertise in PE. Eleven professionals from Canada and the United States met in October 1985 to form this professional organization to support academic study of theoretical and practical research in sport management. The founders held its first international conference in June 1986, and I discovered its existence two years later.[2]

After I joined NASSM in 1988, I began to present sport management research at its conferences and submitted manuscripts to the *Journal of Sport Management*, so finally I was able to publish research in my specialization during the late 1980s and 1990s. My first major involvement in NASSM was through development of curricular and program guidelines. A NASPE sport management task force was developed to establish and distribute curriculum guidelines for sport management in 1987. In June 1989, the NASSM president formed a committee on curriculum and accreditation. NASSM and NASPE formally collaborated in 1989 to create a committee that would oversee the continued development of curricular guidelines for sport management, approved by the membership in 1990. From this joint effort came the creation in 1993 of the Sport Management Program Review Council (SMPRC) within NASSM/NASPE, and I was appointed to serve for two years on the original council of five to review new sport management academic programs being proposed in universities across the United States. That council met to review as many as ten to fifteen newly proposed university curricular programs at meetings twice a year because membership in NAASM was growing rapidly.

In 1994 I was elected to the NASSM Executive Board, and two years later I was voted NASSM president-elect at the convention in Fredericton, New Brunswick, Canada. I served as NASSM president at the San Antonio conference in 1997; then as NASSM past president, I was the international conference program director in Buffalo in 1998. For the first time, I announced that NASSM presentation proposals should be sent to me from around the world via email, and an appointed panel of three colleagues from different universities evaluated and selected the presentations to be scheduled on the conference program. As the twelfth president of NASSM, I held the most esteemed position I had ever achieved in my career. In

1997, not only did members of NASSM include professors from the United States and Canada but also the organization included professional members from more than fifty countries. The number of delegates at the annual 1997 conference at which I presided was more than 800. While NASSM president, I was invited as a sport management scholar to lecture in classes at the University of South Korea and Yonsei University, in Seoul, in August 1997, and while there, I stayed at the Olympic Village.

Department Chair Interview at Illinois State University

My leadership experience was recognized through my professional networking and enhanced by national elected positions in NASPE, NAPEHE, and NASSM. Thus, I was in a favorable position to apply for an administrative position elsewhere than KU. In April 1990, among several higher-education institutions, Colorado State University (CSU), Illinois State University (ISU), and Oregon State University (OSU) each had an open department chair position beginning July 1, 1990, and I applied for all three positions. I was a finalist at all three and was invited to interview on each campus.

ISU was the first to offer the chair position to me, but I had some reservations from my visit on campus. At the interview, I was not impressed with the credentials of the faculty there in comparison with my KU colleagues, and the dated curricula and particularly the aging and crowded department facilities did not appeal to me. But it was a much larger department than the one at KU, with several faculty retirements eminent, so there was enormous potential for me to lead in changing the programs there, and best of all, the department chair's salary there tripled my KU salary.

The ISU Health and Physical Education Department was recognized as the leading institution for PE teacher education in the state. More than 80 percent of the Illinois PE teachers in public schools were ISU graduates. In 1990, the undergraduate students enrolled in the department's academic programs numbered more than 900, but the student numbers rose even higher as other academic programs in the department developed stellar reputations during the 1990s. PE academic programs offered undergraduate students specializations in teaching, exercise science, or athletic training. The therapeutic recreation program at ISU was recognized nationally because of excellent young faculty, and the recreation administration curriculum featured a strong internship opportunity for undergraduates. The graduate program at ISU was much smaller than the one at KU. It of-

fered only a master's degree in general PE, with a hodgepodge of graduate courses. Leadership that would enhance of the graduate program was one of several reasons my candidacy for the new department chair appealed to the dean.

The ISU position was exciting because it was much more expansive and challenging than chairing the department at KU. Rather than being administered within the School of Education as at KU, the ISU undergraduate health education and physical education programs were administered separately in departments within the College of Science and Technology (CAST), although the graduate program for health education remained in the HPER Department throughout the decade. The dean was a woman a few years younger than me with a vision of expanding technology in academia. At KU there were fourteen full-time faculty and six graduate teaching assistants in the HPERD in 1990, whereas at ISU there were forty full-time faculty and thirty-five graduate teaching assistants working in two buildings, three blocks apart. Some compelling factors appealed to me about leading the ISU department, but I hated to leave the KU graduate students, who were far superior to those at ISU. The ISU dean suggested that the young faculty there would seem just as challenging and eager to me as my graduate students at KU.

Attaining tenure at ISU would not be difficult for me because my KU academic credentials acquired toward promotion to professor far surpassed those of any among the department faculty at ISU. Even with being offered the position with full-professor status, until I was tenured in my third year, I would be required to teach at least one course per semester in addition to the administrative work so that I had a record of teaching, research, and service. In three years, my dossier would be evaluated for tenure, as with those of all new faculty members.

I knew that in addition to academics, ISU had a very strong reputation for leadership in women's athletics. Phebe Scott was one of the pioneers for initiating national intercollegiate championships for women in the 1960s, and she was a former PE department chair and professor emeritus at ISU. Laurie Mabry was the fourth AIAW president in 1975–1976 and the ISU women's athletics director during the 1970s, and at the time I interviewed, she had retired as professor emeritus. Edna Vanderbeck was an Oregon classmate of mine and the director of the first Division of Girls and Women in Sport (DGWS) National Swimming Championship, in 1969 at ISU, and when I interviewed, she was retired as a professor emeritus. Jill Hutchison initially had been a faculty member in PE, then became the ISU women's

basketball coach and director of the first AIAW National Basketball Championship in 1972. When I interviewed, she was still the head women's basketball coach. Having been involved in national AIAW functions, I was acquainted with all of these leaders from ISU, who had been PE faculty while involved in national leadership positions in women's intercollegiate athletics. Even more of the women faculty members who coached ISU women's sports teams had been successful at national tournaments I attended.

On balance, there were more advantages and opportunities than barriers in moving into this administrative position at ISU, and after returning to KU and contemplating leaving the campus I loved, I decided to accept the offer. I negotiated arriving on the ISU campus fifteen days later than the position was to begin because I was scheduled to teach summer school courses at KU that graduate students needed for a degree, and there were eight master's degree students for whom I was thesis chair that summer. I informed these students, after I had submitted my resignation at KU in April, that they had the same deadline as mine to complete their theses, and six of them finished by July 1. Finally, I had reached my goal of becoming an academic administrator. Even though I was sad to leave KU, the anticipation of taking full advantage of my doctoral degree specialization and my administrative experience at KU was liberating.

On a May follow-up trip to Illinois to find housing, I learned that building a new house was less expensive than finding a reasonable house for sale because housing was scarce in Bloomington-Normal at that time. The twin cities are the home of four colleges and the world headquarters of State Farm Insurance, so most of the residents were white-collar employees. I decided to have a house built for me in an east Bloomington development about four miles from campus, and although the house was supposed to be finished by July 1, spring rains prevented construction from being done on time. It was not completed until October 1. My house in Lawrence did not sell for five months, either. During an intensive July week of boxing up every item in my KU office and my Lawrence house, I stored all of my household goods in my two-car garage, locked all of the garage doors, gave the garage door opener to my neighbor, and left for Illinois with what I could carry in my car. I left the only key to my house with a Lawrence realtor.

Meanwhile, I rented the home of PE professors who had retired in August and were planning to vacation for three months in Florida. On October 1, I closed on the sale of my Lawrence home in the morning by faxing the documents, and I closed on the purchase of my Bloomington home that same afternoon. Because I had called my Kansas neighbor earlier in

the week to open my garage doors when the moving truck pulled up, the movers arrived at my new Illinois home in late afternoon of October 1. It was another of those situations where planning and organizing ahead was the only way to stay sane.

Department Chair at ISU

My administrative position at ISU began July 15, 1990, and I was not yet fifty years old. I had been engaged in leading curricular initiatives with colleagues and focused on becoming an academic administrator since earning my PhD. I embraced the opportunity to provide resources faculty needed to fulfill their teaching and research aspirations. During my first three years at ISU, I was responsible for scheduling more than 200 classes each semester and assigning each of the seventy-five faculty members and graduate teaching assistants a full or a half teaching load within their area of expertise. Not only did I need to schedule courses for each faculty member and teaching assistant but also I needed to schedule their courses in the same building in which they were assigned a faculty office. Also, all of the classes students needed for their curricular program had to be offered within the expertise of the faculty in a sequential time frame that allowed students to take all of the courses required for their degrees within four years. It was a real challenge to accomplish that complex course scheduling with faculty assignments using paper and pencil before there was a computer software program to make it a swifter and more accurate task by 1993.

The two ISU buildings in which the HPER Department had faculty offices and offered courses were Horton Fieldhouse, opened in 1961 on the west edge of campus, and McCormick Hall, built in 1925 as the original PE building, on the main campus quadrangle. Horton Fieldhouse had the Athletics Department's main offices and coaches' offices next door, and they had the only outside windows in the building. The ISU student recreation program scheduled late afternoon and evening intramural activities on the large floor spaces in the building. The HPER Department's main office suite was in a cramped, three-room space in the nearly thirty-year-old Horton Fieldhouse. Eight faculty offices were constructed on the remodeled balcony to a gymnasium below, also without windows. Half of the HPER Department faculty members had an office assigned in one of the two buildings, according to the subdiscipline they taught. Exercise science specialists had offices in Horton, and PE teacher education and recreation

faculty offices were in McCormick. Each building had a main office and a set of secretaries assigned there. As department chair, my small, interior office was part of the main office suite in Horton, and I frequented the sixty-five-year-old McCormick often, even though it was about a half mile between the two buildings.

In 1990 there were two personal desktop computers in the HPER Department, one for each of the head secretaries in the PE buildings. By fall 1993, with annual allocation proposals for technological equipment that I sent to the dean, all forty of my department faculty members had personal desktop computers in their offices, and all secretaries in each building had desktop computers, too. The decade of the 1990s was a relatively affluent period for higher education, during which much could be accomplished that required more resources after frugal planning and negotiation of financing with the dean. It was an opportune time to outfit new research laboratories with the most recent technological equipment.

When I arrived at ISU in 1990, my department had only one research laboratory, housed in a small room under the far fieldhouse balcony bleachers. It held a few rudimentary exercise physiology evaluation instruments. During the ten years I was chair, the department renovated vacant facility spaces in both buildings and opened seven new research laboratories with the latest technological assessment equipment. The laboratories were for biomechanics, exercise physiology, life fitness, motor learning, PE teaching analysis, sports medicine, and therapeutic recreation.

The new Redbird Arena for basketball opened on campus in 1989 next to Horton Fieldhouse, allowing the ISU men's and women's basketball programs to move out of that old building. Because revenue athletic events were no longer scheduled inside the fieldhouse, the cleared interior space was used for PE laboratories. The new biomechanics lab was situated in the retrofitted concessions area with $200,000 of matching National Institutes of Health (NIH) grant funding for a force plate, a treadmill, high-speed video cameras, and integrated computer equipment. The exercise physiology and life fitness labs, in a suite reconstructed under the west fieldhouse balcony bleachers, were outfitted with respiratory gas analysis and metabolic measurement equipment, a metabolic cart, an underwater-weighing tank, a treadmill, and computer-integrated stationary and mobile exercise testing equipment. The sports medicine program was enhanced with A.D.A.M. "interactive anatomy" software, providing digitized anatomical dissection models on twelve dedicated desktop computers arranged as dual student stations in an anatomy classroom. In a renovated basement storage

room formerly used for storing cases of adhesive tape for football players, athletic training tables for practice in injury examination and taping and high-tech testing equipment used by athletic trainers were set up as a lab.

In McCormick Hall, a renovated women's locker room served as the new PE teaching analysis labs. Twelve student stations were constructed as individual work pods, with a portable video camera, a videocassette recorder (VCR), a television monitor, and a desktop computer at each two-seat station. The motor learning lab was constructed in a pillared former dance studio in the basement, and the recreation lab shared the teacher analysis lab equipment for scheduled computer and video equipment access. Even though these laboratories were in makeshift locations during the 1990s, they thrived with the production of much data for many research projects used for teaching analysis assigned in the labs.

By 2004 a new facility was completed on the same site as McCormick Hall; it is so large that it now extends west over University Street into the adjoining block. The new building houses all of the faculty offices, classroom spaces, and specialized laboratories in one place. At the same time as the construction of the new building, the department title was elevated to the School of Kinesiology and Recreation because of its large number of students and faculty as well as the multiple specializations and research labs.

During my ten years as department chair at ISU, fourteen of the forty faculty positions opened because of retirements and resignations, and an additional three faculty earned promotions to dean positions, so we were continually searching for new faculty, and we were successful in recruiting and appointing highly qualified young professionals. While I was chair, three young department professors won university researcher-of-the-year awards, three faculty members won university teacher-of-the-year awards, two became ISU deans, one became a dean at another institution, four left ISU to become department chairs elsewhere, and one left to become the exercise physiology lab director at Duke University.

Each time talented faculty members left for a better position because of their success in the department, I considered it similar to athletes completing their college athletic eligibility and going on to the pros. Resignations of these career faculty members meant that we could look forward to recruiting more talented young professionals and mentor those individuals to develop the skills, experience, and credentials to move on to better positions, too. I enjoyed writing recommendation letters for my faculty members for university awards and for applications for higher positions because it

gave me a sense of accomplishment and pride. They were dynamic and resourceful, and I respected them as colleagues. The dean was correct: those young faculty members were much like the KU graduate students I mentored toward their full-fledged careers.

In the School of Kinesiology and Recreation, I assembled an administrative council of faculty coordinators representing the four curriculum programs: the elective PE activity program, the PE program, the recreation program, and the graduate program, similar to how the administrative structure operated in the PE Department at KU. Unlike the coordinators at KU, who seldom met, the council at ISU met twice a month to discuss issues regarding their respective curricular programs and how the department was functioning as a whole. The council's discussions generated future plans and directions for the department and agenda items for monthly faculty meetings.

ISU required the department to evaluate all forty faculty members annually for one or more of four purposes: salary increases; tenure consideration; promotion to associate professor or full professor; and assessment once every five years of all full professors' teaching and research productivity. A five-member, university-mandated committee, the Departmental Faculty and Staff Committee (DFSC), consisted of four tenured faculty members nominated from within the department and elected by the whole department faculty, plus the department chair. The elected faculty members each served two years in staggered terms, with two new committee persons elected each year for terms that could be repeated only once consecutively. As head of the department, I always served as chair of the DFSC. This committee met for a week during the first half of every January from 9:00 a.m. to 4:00 p.m. daily. The evaluations were to be completed and forwarded to the university Faculty and Staff Committee (FSC) by the end of January, and considering dossiers of forty faculty took an extensive amount of time. The faculty members were required to submit evidence of their achievements prior to the end of fall semester each year. Each of the five committee members read the credentials presented by each of the forty faculty members prior to the week of discussion, and committee members had an opportunity to present their views on the evaluations for all forty faculty members.

We rotated initiating each faculty member's evaluation discussion to a different committee member so that no one committee member could dominate the discussion by being the first speaker, and I always voiced my opinions last. Usually there was consensus, but if not, the majority held,

with either pro or con votes. As discussion occurred, I took notes of main points about each faculty member's achievements and always wrote the final evaluation letter. The committee members edited the wording of each final evaluation prior to the letters being sent to the faculty members.

As an administrator, I enjoyed the planning, organizing, delegating, co-ordinating, and generating of resources that gave the faculty and students every opportunity available. It was gratifying to visualize the larger picture of what was possible within the department and to find ways to make those things happen. Managing a department was somewhat like coaching a team: winning was always the ultimate goal.

After eight years, the dean was promoted to associate provost. A new dean was appointed for CAST. Ironically, the new boss was a professor of recreation interviewed for the department chair position eight years earlier, when I was appointed instead of him. At the end of the first year he served as CAST dean, he informed me that he was replacing me as department chair because, in his estimation, two four-year terms were long enough for anyone to be a department chair. Because his abrupt decision was made prior to initiating the search for a new chair, he maintained my position as department chair for the following academic year while candidates were sought.

With counsel from the university retirement director, I had to decide between continuing as a tenured professor at ISU with the possibility of summer appointments and forgoing the bonus I would receive in retiring as an administrator or taking the bonus and retiring at the end of my appointment as department chair. Because I would receive only 80 percent of my annual administrative salary without the assurance of a continuing summer appointment under an incoming department chair, I chose early retirement in 2000.

My Early Retirement

Sudden early retirement left me with lots of time on my calendar, and I took up golf. I tried it before, but I was unable to give either the time or the money required to form consistent skills when I was employed full time or without a summer salary. I joined the ISU Ladies Golf League, which had about eighty members, and played eighteen holes once a week. I volunteered across the street from my home at the OSF St. Joseph Medical Center's information desk one day a week. In addition, I volunteered as a driver for the Faith in Action organization transporting senior citizens to

their health appointments around town. These activities kept me some-
what busy and feeling purposeful, but I still had time on my hands and
more to offer.

Administrator at the University of West Georgia

In July 2002, I received a phone call from a former classmate of mine at
OU, then assistant dean at the University of West Georgia in Carrollton,
about forty miles west of Atlanta. The university was seeking a department
chair in health and PE beginning in August that year, and she called to
invite me to interview for the position. I replied that I was retired, but she
responded that because I was retired, she thought I might be available for
the position on short notice. I finally agreed to fly down to Georgia for an
interview. I learned that the University of West Georgia department had
ten faculty members, and only three of them had been there more than one
year. Within the next two years, the department would be reviewed for two
national accreditation evaluations and two state curriculum evaluations,
and that was the principal reason the university sought a department chair
with experience in this type of administrative preparation. At the interview,
I negotiated a salary commensurate with the salary I was making at ISU
when I retired, and amazingly, they offered me the position. I decided that
this administrative position held challenge and purpose for me again, and
with the same salary for doing much less than at ISU. After some consid-
eration, I accepted the offer.

By August 1, I had packed my car with clothes and other essentials,
driven to Carrollton, found a rental townhouse, furnished it, and moved
into the department chair's office on campus a week before classes began.
For the next two years, 2002–2004, I assumed the normal administrative
duties of department chair. I scheduled course offerings and teaching as-
signments each semester, handled financial requests for the department,
and taught a graduate course each semester, but my principal responsibil-
ity was collecting and writing the supporting documentation for the accred-
itation and curricular evaluations, one each semester. I had completed this
type of national accreditation preparation at KU twice and at ISU once, so it
seemed like a routine task for me, but it would have been overwhelming for
any of the new faculty members. It was a matter of following the accredita-
tion guidelines, collecting the required documents, formatting the syllabi
of curricular offerings, writing the accompanying descriptions, and con-
vincing an external review panel that all academic expectations had been

met according to the guidelines. Guiding the University of West Georgia faculty was much like mentoring graduate students, and I learned at dean's council meetings that I had much more administrative experience than most of the other department chairs. I was admitted immediately to the Graduate School faculty and given graduate chairing privileges based on my accumulated publications, presentations, and chairing of masters and doctoral research. At the end of two years, all four accreditation reviews were approved, and I was ready to return to Illinois, glad to be retired. I had completed a forty-year career; thirty-four of those years in higher education.

Final Retirement

My second retirement was more satisfying. Returning to my home in Illinois, I rejoined the ISU Women's Golf League and was successful at the sport. It was especially rewarding to golf occasionally with Phebe Scott, who still lived in Illinois during the summers, although she spent winters in Florida. That was when I learned that she still possessed the original copies of the speeches she presented some forty years previously at the national Olympic institutes, along with her other notable presentations for DGWS and AIAW. She mused that probably nobody would want her speeches anymore, but I suggested that she place them in the ISU archives. She gave them to me, and they are archived now.

In 2007, I had the misfortune of undergoing four unforeseen surgeries that restricted my independent walking mobility and also the manipulation of my right hand. I was in a wheelchair for six weeks recovering from metatarsal osteotomy surgery on my left foot in January to correct a condition called hallux valgus, or deformity of the big toe. In June, an orthodontist grafted tissue from the roof of my mouth to replace receding gum tissue along the outside of my lower teeth. In October and again in December, I had a cast over my right hand and wrist, recovering from hand surgery for removal of a tumor in the palm of my right hand, found to be malignant and subsequently diagnosed as hypo adeno carcinoma, or a rare cancer of the sweat gland. Margin surgery required removing the pisiform bone, at the corner of my right-hand palm, and the abductor digiti minimi muscle, which controls the little finger, but the chief microvascular surgeon at Loyola Medical Center in Chicago was able to preserve the nerves and tendon to my little finger and replace the missing hand tissue with a graft from the inside of my right forearm. Because no traces of malignancy were found in the extracted margin tissue, no oncological therapy

was recommended, but monitoring by an oncologist was scheduled for five years. Rehabilitation to regain my hand and finger movement and strength required ten months with an occupational therapist, and I gained new left-handed skills and dexterity.

Having never needed extensive medical assistance previously, I realized that although friends are helpful for two to three hours several times a week, there was no one nearby to assist me more. In addition to the emotional depression from being isolated by my injuries, I lost a brother-in-law and my oldest sister unexpectedly in fall 2007, making life seem even sadder. As I spent lonely days at home in Illinois recuperating from these surgeries, I seriously considered moving closer to my twin sister, Darlene, who still lived in the Kansas City area.

In February 2008, KU invited me to Kansas to celebrate the fortieth anniversary of women's intercollegiate athletics and to present the first Exemplary Woman Athlete of the Year Award named after me. I was back on campus again in 2009 to be inducted into the KU Athletics Hall of Fame. I realized that KU Athletics recognized my efforts in the early years of women's intercollegiate athletics, and I felt appreciated and gratified. These honors made me feel connected and loyal to KU more strongly than I had felt at any other university, and I contemplated moving back to Kansas.

Returning to Lawrence seemed like coming home. In February 2010 I traveled back to Lawrence to give the Exemplary Woman Athlete of the Year Award for the third year, and while in town, I checked out homes for sale and made appointments with builders in town. In March, I bought a lot in the Monterey Bluffs area and arranged for a new home to be built for me. On October 1, 2010, I moved from Bloomington to my new house in Lawrence. So many things had changed in the town I had left twenty years earlier. Among the most gratifying were the strides that KU women athletes had made toward equity with men athletes.

CHAPTER TEN

THE MISSION:

A DREAM BECOMES REALITY

Driving along Sixth Street in Lawrence toward the sunset in early spring 2010, I realized that the city limits were much farther than Kasold Drive, the farthest street west in town when I moved away in 1990. Now, twenty years later, the corner of Wakarusa and Sixth Street was a busy commercial intersection. The town of Lawrence that I knew had doubled in area and population and was now a small city. The University of Kansas (KU) campus had spread, too.

More than four decades had passed since I had first come to KU, and I had been gone from Lawrence for two decades, completing my professional career primarily in Illinois. New academic buildings had been erected on the West Campus of KU and were expanding on the main campus. Even though the traditional buildings still stood on Jayhawk Boulevard atop the hill, many of the academic assignments for the campus buildings had changed, and additional modern classroom and laboratory buildings stood between and beside them. In addition to discovering that the campus had spread westward, what really surprised me were the advances KU Athletics had made for women in sports under Title IX.

Not only had a sustainable women's athletics program been developed at KU but also, as at other institutions across the country, women athletes had demonstrated that there were no limits for them as they developed competitive sports skills through science-based physical conditioning and well-coached strategies. At last, KU's female athletes had similar opportunities to participate in intercollegiate sports to those of the male athletes, and in athletic competition as well as in the classroom, they excelled.

Women athletes who played for KU before Title IX compliance were now mothers and aunts, some even grandmothers. Many early KU women athletes had completed a successful career and were retired or planning to retire. Several had been and still were coaches of girls' and women's athletic

teams. These women athletes had set the foundation for a thriving KU women's athletics program.

Concluding the Twentieth Century for KU Women's Athletics

Three major milestones marked the progress of women's athletics at KU and across the country during the final four decades of the twentieth century. The national Olympic institutes during the 1960s ignited interest in women's elite sports competition in the United States. The formation of the Commission on Intercollegiate Athletics for Women (CIAW) in 1967 to initiate national women's sports championships, followed by the Association for Intercollegiate Athletics for Women (AIAW) governing organization, formed in 1972, boosted achievement in women's intercollegiate athletics. The value of national sports competition to women was substantiated with more than 900 member institutions joining the AIAW during ten successful years of intercollegiate championships for seventeen sports at three AIAW division levels. The third driving force in the establishment of women's sports was Title IX compliance beginning in 1978, and this sustained women's intercollegiate athletics indefinitely. Title IX has ensured equal opportunity for women and men in intercollegiate sports.

Women's intercollegiate athletics had been under the governance of the National Collegiate Athletics Association (NCAA) for three decades when I returned to Lawrence in 2010. When the NCAA took over the women's national championships in 1981–1982, colleges and universities already faced Title IX compliance requirements in athletics. Equal opportunity for women in athletics made slow gains because Office of Civil Rights (OCR) easing of compliance regulations for Title IX during the 1980s allowed institutions to provide evidence of *progress* toward compliance even if they were not able to demonstrate *total* compliance with Title IX. The courts sided with the NCAA's position that Title IX compliance required it to offer national championships to both sexes and forced the AIAW out of existence in 1981, but women's intercollegiate sport opportunities have gradually become more similar to those for men under NCAA governance as the turn of the century came and went.

Cultural Changes for Women in Sports

The cultural image of women athletes changed in the United States during the 1970s and 1980s because of evolving public perception of the place of

women in sports. Significant social events outside of national intercollegiate sports competition and the enforcement of Title IX in educational institutions contributed to the acceptance of women athletes. Women who excelled in sports became professional athletes, especially in individual sports such as golf and tennis.

Billie Jean King and eight other top women tennis players boycotted the US Open tournament in 1970 because the prize money for the women was little more than one-tenth of that for the men. Instead of entering the US Open, these women accepted one-dollar contracts to play in the Phillip Morris–sponsored tennis tournament in Houston, which eventually became the much more lucrative Virginia Slims Tennis Tour. The women's boycott was one of King's first public demonstrations showing that women were as capable as men in sports competition. In 1973, a few days before Wimbledon, eighty-one top players in the international men's tennis players' union, called the Association of Tennis Players (ATP), boycotted Wimbledon because a Yugoslavian member had been suspended from the International Lawn Tennis Federation (ILTF) for appearing in an obligated tournament in Montreal rather than representing his country in the Davis Cup. The men's boycott was not about money but about ILTF control versus freedom of tennis professionals to enter the tournaments they chose. When these leading men tennis players boycotted Wimbledon, King called forty professional women tennis players together in a London hotel to establish the Women's Tennis Association (WTA). The women filled the empty courts at Wimbledon that year, starting their rise toward winning equal money in the Grand Slam.[1]

One of the most impactful events for the place of women in sports was the "Battle of the Sexes," broadcast on September 20, 1973, on national television. King accepted a challenge from aging tennis professional Bobby Riggs to play a match against him in the Houston Astrodome before 30,500 spectators and 48 million television viewers. Following a pompous introduction of King and Riggs, the match seemed as if it would be a comedy performance. However, King came to compete as a conditioned athlete, and Riggs soon realized that he faced more than expected as he chased her returns deep into his half of the court. Her unforgettable win in straight sets, 6–4, 6–3, 6–3, contributed immensely to the cultural and social change of attitude about women's opportunities and their appropriate place in competitive sports.[2] Because of this, King is historically recognized as one of the most influential athletes promoting women in sports.

King's win emboldened women athletes to be proud sports competitors. This tennis battle started a cultural revolution for women's sports in the

United States that occurred almost simultaneously with the introduction of Title IX compliance regulations. But King led the fight for women's equal play and pay outside of educational institutions. She founded the Women's Sports Foundation in San Francisco in 1974, and that organization has continued to offer incentives and opportunities for girls' and women's sports through the support of individuals, corporations, and government entities. The foundation's board is made up of female champion athletes, prominent businesspeople, major benefactors, and leaders of women's sports organizations. The Women's Sports Foundation sponsors the annual National Girls and Women in Sports Day, celebrated at women's athletic events across the country each February.[3]

Women had participated in intercollegiate athletics for more than thirty years by the turn of the twenty-first century, and Olympic successes included US gold medals as soon as the 1980s. Before the NCAA takeover of women's intercollegiate athletics in 1981–1982, a decade of successful women athletes proved that the Olympic institutes during the 1960s had provided the impetus for expertise in coaching sports for women, and women's national intercollegiate athletics competition had honed the expertise of women athletes. In the 1984 Olympic Games in Los Angeles, the US women' s basketball team, the coxed-eight women's rowing team, and an individual woman gymnast and a woman cyclist won Olympic gold medals for the first time. US women Olympians in seven track events and fourteen swimming events were gold medalists in 1984.[4]

In the 1996 Atlanta Olympics, the US women's teams became stars, witnessed by a television audience of millions. US women's gymnastics won its first-ever team gold medal, and the US women's basketball team defeated Brazil for the gold. The US women's soccer team and the softball team each won the gold over China, and Colorado swimmer Amy Van Dyken became the first US woman to win four gold medals in a single Olympics. More than 76,000 spectators watched the 1996 US women's soccer team win over China, but unfortunately, NBC had the Olympic broadcasting contract and gave no television time to that championship game.[5]

Selective television exposure of women athletes at the 1996 Olympics introduced Americans to talent and skill of women athletes not previously acknowledged. But it was the 1999 women's World Cup in Los Angeles, televised for more than 18 million viewers worldwide, and the cheering of more than 90,000 spectators in the stadium that marked the explosion in the popularity of soccer among girls. The US women's soccer team won with Brianna Scurry's goal save and Brandi Chastain's winning goal on

the fifth and final penalty kick. The US women's soccer team won Olympic golds in 2004, 2008, and 2012. Women's intercollegiate athletics after the turn of the century became even more popular, bringing new revenues from gate receipts, television contracts, endorsements of sports companies, and other corporate sponsorships.[6]

Contemporary women athletes might never fully appreciate the difficulties of early women pioneers engaged in competitive sports. These early women athletes' dedication and perseverance paved the way for opportunities for today's young women to thrive as collegiate and professional athletes. By the end of the twentieth century, there was increased funding had for women's intercollegiate athletics, enabling women's teams to train with contemporary exercise equipment, to be equipped with appropriate playing attire and sports gear, to travel great distances for competition, and to have athletic scholarships pay for their college education.

The political and legal struggles between the AIAW and the NCAA for governance of women's intercollegiate athletics did not concern many collegiate women athletes at the time because they were just glad to have the opportunity to compete. Although the US District Court's Title IX interpretation and ruling on antitrust law in 1981 ultimately led to the demise of the AIAW and the NCAA takeover of college women's athletics, the AIAW had thrived long enough to demonstrate the desire and ability of these women to compete spectacularly in sports.

KU Athletics' compliance with Title IX brought progress toward women's equality in athletics with men. Undoubtedly, for higher-education institutions, the legal threat of losing federal funding accelerated opportunities for women to engage in intercollegiate sports, considering the entrenched sociocultural acceptance of sports as a masculine domain. Compliance with Title IX has mitigated the dominance of men's athletic sports since the NCAA began to govern women's intercollegiate athletics in the early 1980s. And over the past thirty-five years, KU Athletics has continued to develop sports facilities for women athletes comparable to the facilities for men.

Celebrating Thirty Years of KU Women's Athletics

The KU Women's Athletics program grew rapidly from its inception in 1968 and accelerated after significant funding increases and its merger with KU Athletics in 1974. In 1998, the program celebrated its thirtieth anniversary. Athletics Director Bob Frederick invited me to return to campus to celebrate the occasion, and I was thrilled to attend this event. Of the four

Thirtieth anniversary celebration of KU Women's Athletics with Athletics Director Bob Frederick and Marlene Mawson, 1998.

women who had served as KU women's athletics director and of the several coaches who had mentored KU women's teams over those formative twelve years, I was the only one present. All KU women athletes who had competed on teams during the late 1960s and 1970s were invited to attend the celebration, and more than fifty of them returned to campus for the event.

The highlight of the weekend was KU awarding athletic letters and membership in the university's K-Club to each of those deserving women alumni athletes at brunch at the Eldridge Hotel. Former KU women ath-

letes were happy to receive their athletic letters, even though they had earned them decades before. Each former athlete was acknowledged by name, along with the sports in which she had participated, as she stepped forward to accept her blue "K."

Many of these women had played on more than one nationally success-ful team for KU, and all had completed a degree at KU. A majority of them had been students in my physical education (PE) classes. It was such a re-warding experience for me to witness each of these pioneering women be recognized for her exceptional accomplishments on fields, courts, and in pools as far back as three decades, and I was thrilled for each one of them. These former athletes were accomplished women, and I remembered all of them. My greatest satisfaction was to learn of their career and life successes following graduation at KU.

Frederick honored me as the first KU women's athletics director with a crystal vase inscribed with the KU Jayhawk insignia and his words of com-mendation. In addition, he presented me a framed commemoration from the Lawrence mayor of October 1998 as the thirtieth anniversary of KU Women's Athletics. It was a wonderful reunion for these former women athletes, sharing their successful lives with each other and recalling their memories of sports competition at KU. KU Athletics recognized the sacri-fices these women had made as athletes, and I felt a renewed kinship with the KU Athletics program.

KU Women's Athletics Fortieth Anniversary Celebration

KU Athletics Director Lew Perkins invited me to celebrate the fortieth an-niversary of the beginning of KU women's intercollegiate sports. At this event I read in the women's basketball program for the game that evening this reference to me: "Mother of KU Women's Athletics." I am not sure who coined the phrase, but it surprised me because I had not thought of myself as anyone's mother, even though I had nurtured many students and women athletes while at KU.

At this celebration, KU Athletics presented the first Marlene Mawson Exemplary Woman Athlete of the Year Award at the women's basketball game. Frederick had proposed this award during his time as athletics direc-tor, but it was not finalized until after his retirement from KU Athletics in 2001. It seemed fitting to me that KU basketball player Jamie Boyd received the first award, in 2008, because she played a sport I had coached at KU.

The first Marlene Mawson Exemplary Woman Athlete Award, presented to KU women's basketball player Jamie Boyd by Marlene Mawson with Associate Athletics Director Debbie Van Saun, 2008.

Since then an annual award winner has been recognized at a KU women's basketball game in Allen Fieldhouse during the nationally celebrated Girls and Women in Sport week in late January or early February.

This award has no monetary value other than that of an inscribed glass vase, but it is quite an honor. Each year, the head coach of each women's sport nominates one athlete who fulfills the criteria for the award. Nomi-

nees must be seniors with at least a 3.5 overall grade-point average (GPA), starting players on a KU team who have participated all four years, team leaders, and service-oriented students on campus and in the community. A KU Athletics committee of women administrators selects the award winner. From 2008 to 2020, three volleyball players, two track sprinters, two softball players, a basketball player, a cross-country runner, a golfer, a crew member, a soccer player, and a swimmer have won the award.

KU Athletics asked me to give a brief presentation to the women alumni athletes at the fortieth anniversary brunch, held on the volleyball courts in the Horejsi Family Athletics Center. I recounted the beginning of KU women's intercollegiate athletics in 1968 and the story of KU hosting and playing in the DGWS National Volleyball Championship in February 1971. I acknowledged several players from that volleyball team in attendance. I described the tenacious KU women's basketball team qualifying and travelling to the DGWS National Invitational Basketball Championship in North Carolina but struggling financially to get there in March 1971. Then I recounted a few details of their memorable road trip and their success at the national tournament. Most members of that talented basketball team were at the brunch, and it gave me great pleasure to introduce them to the other women's sports alums present.

The following year, Athletics Director Perkins invited me to campus again. KU Athletics had voted to induct me into the KU Athletics Hall of Fame. I was honored that my alma mater continued to recognize my early efforts in offering intercollegiate competitive sports for women. An induction dinner was held at the KU Memorial Union, with more than 400 guests in attendance. I was the only KU Athletics Hall of Fame inductee honored that evening. Among the guests at the table reserved for my family were my proud sisters, who had surprised me when they stood at the top of the stairs and waited for a congratulatory hug as I entered the ballroom.

Before the induction ceremony, the audience viewed a slide presentation of my accomplishments for KU Women's Athletics along with photos of early KU women's sports teams I had coached. Perkins called me to the podium and presented me a crimson wool blanket with the blue "K" sewn on it. My full name and "KU Athletics Hall of Fame" was embroidered in white on it as well. Also, KU awarded me honorary lifetime membership in the K-Club. Perkins handed me a black slate plaque containing a photo of me as a young professional, identical to the plaque that would be displayed in the KU Hall of Fame in Allen Fieldhouse. Normally the name of the inductee's sport, either as coach or athlete, accompanies the name on the

plaque. Mine stated "Special Admittance" because I coached several KU sports teams and served as KU women's athletics director, and there wasn't enough space to include all of that. Since then, the slate photos have been replaced with black-and-white photos under Plexiglas in the showcases lining the walls of the KU Athletics Hall of Fame, and a touch-screen display provides the viewer information about each of the inductees.

Upon being inducted, I expressed my appreciation for the honor and recognized those who recruited me to KU and then supported my early efforts in initiating and nurturing KU women's intercollegiate sports. Also, I acknowledged those early KU women athletes who contributed their talent and dedication, for without their courage and determination as leaders in women's sports, the success of the program would not have been as great as it was.

After the induction dinner, the audience was encouraged to attend the KU women's basketball game in Allen Fieldhouse. KU played Iowa State in a Big 12 game on Naismith Court and won. The KU women athlete alums in attendance surrounded the floor at halftime, and my induction into the KU Hall of Fame was announced to the fans as I stood at center court. It was a wonderful evening and an experience that will always be vivid in my mind.

Bonnie Hendricks was the KU women's basketball coach in 2009, and she invited me to speak to the KU women's basketball team after the game. It was the first time I had been inside a women's locker room in Allen Fieldhouse designed for a specific women's sport because in the 1980s, when women's athletics was moved to Allen Fieldhouse from Robinson Gym, all KU women's athletics teams shared the same locker room. The KU Athletics facilities had expanded dramatically since I had been on campus, and KU women athletes had more practice and competition space than I had ever imagined.

KU Women's Athletics was advancing in a manner relatively comparable with the departments of other Big 12 institutions. Yet, according to Title IX regulations, still more resources were needed for the KU Women's Athletics program to provide equal opportunities for women athletes.

Title IX Compliance at KU

The OCR at the Department of Health, Education, and Welfare (HEW) distributed Title IX compliance guidelines throughout the nation on July 28, 1973. The Education Amendments Act of 1972, containing Title IX, had

been passed a year earlier, but it took a year for the Nixon administration to generate and publish the compliance regulations. Many sports historians and others who credit Title IX as the catalyst for the evolution of women's collegiate athletics have assumed this law was the turning point because of the publicity it received. However, it is evident from the history of the 1960s and 1970s that although Title IX did provide legal recourse for ensuring equal opportunity for college women athletes, their women's intercollegiate sports were on the map before 1972.

Because higher-education institutions receiving federal funding knew that they would be required to file a self-evaluation report of compliance with the OCR every year beginning in July 1978, most colleges and universities designated an administrative position for this purpose. Since then, the compliance regulations require that every higher-education institution employ a Title IX coordinator to oversee these efforts and to investigate any complaints of sex discrimination. Institutions are now required to publish their annual report including the activities they evaluated for compliance.[7]

The KU chancellor established a compliance officer position immediately after the OCR published the Title IX compliance guidelines. That administrator coordinates the compliance with Title IX requirements, completes the annual report for all programs across campus, and notifies the KU chancellor and the Kansas Board of Regents of the results. The annual report includes notification and education of students and faculty about Title IX; consultation, investigation, and disposition of any Title IX–related incident; and monitoring and ensuring compliance with Title IX. At least one full-time compliance officer for athletics is now required to be appointed at all NCAA Division I institutions because of the number of athletes and sports.

One section of the OCR guidelines is devoted specifically to athletics. Title IX compliance in athletics affects three areas: student interest and ability in sports, athletic benefits and opportunities, and financial assistance for athletes.[8]

In order for an athletics department to show progress toward Title IX compliance with regard to student interest and ability in sports, the OCR formulated a three-part test in 2003. Institutions may choose to show equal opportunity compliance by (1) demonstrating that the number of athletes of each sex is proportionate to the enrollment number of each sex, (2) expanding sports programs for the underrepresented sex, or (3) proving that the sports programs offered fully accommodate students' interests.[9] At most NCAA Division I institutions, the first option of showing equal

proportionate numbers of student athletes to students of each sex has been fulfilled for several years, and that is the primary reason most colleges reduced the number of men's teams and increased the number of women's teams, especially if retaining football as a men's sport was a priority.

Athletics Conference Competition and Compliance Regulations

KU men's teams have been members of the same athletics conference since the inception of the original Missouri Valley Conference in 1907. The conference was renamed the Big Six in 1928; with the addition of the University of Colorado in 1947, the conference became the Big Seven. In 1957, Oklahoma State University joined, and the conference was called the Big Eight. Women's intercollegiate teams were invited to join the Big Eight Conference for seasonal sports scheduling purposes in 1978, even though most institutions still held membership in AIAW, but when the NCAA took over women's athletics in 1981–1982, all women's teams in Big Eight institutions scheduled sports events within the conference.[10]

The Big 12 Conference formed in February 1994, when four institutions from the former Southwest Conference with comparably competitive teams joined the Big Eight Conference: Baylor University, Texas A&M University, Texas Tech University, and the University of Texas–Austin. In 2011, because of uneven media rights and television revenue sharing, the Big 12 Conference lost the University of Nebraska–Lincoln to the Big Ten Conference and the University of Colorado to the Pac 12 Conference. Texas Christian University and West Virginia University joined the Big 12 Conference in October 2011, filling the two vacant positions. In 2012, Texas A&M University and the University of Missouri–Columbia left the Big 12 Conference for the Southeast Conference. Although the number of Big 12 Conference was ten, the conference name remained. The number of sports per institutional member did not change, and existing Big 12 Conference women's teams compete in the same sports they did before the rearrangement of institutional members.[11]

KU Athletics has supported six men's teams and ten women's teams in the Big Eight Conference and the Big 12 Conference since the NCAA took over governance of women's intercollegiate athletics. Currently, KU men compete in baseball, basketball, cross-country, football, golf, and track and field. In addition to four of the original six women's sports KU offered, it now offers cross-country, crew, golf, soccer, tennis, and track and field. To comply with Title IX in providing an equal number of athletic scholarships

for women athletes as for men athletes, KU Athletics dropped men's gymnastics, swimming, tennis, and wrestling. Of the original six women's sports, KU eliminated field hockey and gymnastics because of the lack of teams competing in the Big Eight and Big 12 Conferences, but women's basketball, softball, swimming, and volleyball remained.

Demonstrating Title IX compliance in athletic benefits and opportunities specifically benefitted KU women athletes in twelve required areas: sports equipment, scheduling practice and competition events, travel and per diem funds, coaching and tutoring, assignment and compensation of coaches, locker rooms and practice facilities, medical and training facilities, housing and dining facilities, publicity, recruitment, and support services.[12] Compliance regulations for Title IX allow each institution to show progress toward equity in these requirements, and KU has continued to improve funding and resources for KU Women's Athletics year after year. Certainly, KU's improvement in these twelve provisions has made a visible difference in KU Women's Athletics since Title IX became law, when compared with the early years of women's intercollegiate sports.

Scholarships, Recruitment, Coaches, and Tutoring for KU Women Athletes

Among the positive developments by the 1990s, KU women athletes were awarded full athletic scholarships equal in number and amount to those for men and proportionate to the ratio of KU women and men students, as required by Title IX. When women athletes were first eligible for athletic scholarships under AIAW regulations in 1974, KU could afford only partial scholarships as grants-in-aid for women's sports. In 1976, basketball player Cheryl Burnett was the first KU woman athlete to be awarded a full athletic scholarship, and more athletic scholarships for all women's teams became available each year thereafter.[13] In order to provide an equitable number of scholarships for women and men, as scholarship funds became available women's soccer was added in 1995–1996 and crew in 1996–1997.

Donations provided additional funding for scholarships in the 1980s. Fred Anschutz, a KU alum, established a $750,000 annual scholarship fund in 1980 for KU Athletics without designating the money for athletes of either sex. More athletic scholarship contributions came through annual donations to the KU Williams Education Fund. Increasingly, these kinds of funds benefited KU's female athletes until the late 1990s, when there were an equitable number of athletic scholarships between them and male

athletes. This meant that funds budgeted for coaches to pursue and recruit women athletes were necessary, too. Coaches of women's teams use the same budgeting and accounting procedures for recruitment of athletes, but currently their recruitment funds are not always equitable to recruitment funds available to coaches of men's sports.

Dedicated recruitment meant that additional assistant coaches were needed to help find top athletes and help coach them year-round. Salaries for women coaches comparable to those of men coaches in the Big Eight and Big 12 Conferences had to be added to the KU Athletics budget, initially for full-time head coaches of women's sports. As funds became available, women's sports added multiple assistant coaches' salaries with commensurate coaching contracts to those of men's sports. According to NCAA regulations, coaching expertise, the market value of the sport, the number of coaches, and support personnel for women's teams must be similar to those of men's teams in the same sports.

Recruitment evaluation for scholarships requires assurance that the athletes selected maintain a viable GPA in college courses to be retained as student athletes at KU. Thus, with the demands on athletes for practice and competition time, KU Athletics developed a student-tutoring program for both men and women athletes. The KU Athletics tutoring program assists student athletes with study habits, class attendance, completion of assignments, and strategies for test preparation. Currently, the KU associate athletics director for student-athlete support services supervises seven academic and career counselors, four tutoring assistants, and two administrative assistants working with student athletes of both sexes.[14]

Sports Equipment, Uniforms, and Team Travel for KU Women Athletes

Unlike the single set of uniforms shared by the early athletes in all women's sports at KU, more than one set of practice uniforms is now issued to twenty-first century teams, and each team can choose from several competition uniforms. The abundance of sports attire and equipment is the result of sports company contracts with KU Athletics and sometimes sports company contracts with other Big 12 Conference members. Athletes no longer need to purchase and care for their own equipment or launder and pack their own uniforms for competition. Now an equipment manager prepares sports equipment and uniforms for each women's team, just as with men's teams.

In twenty-first-century style, women's teams are now treated to the same "away-event" transportation available only to men's teams in the 1970s. Then, women coaches and student athletes used their own vehicles to transport women's teams to away games. Travel to away games in the 1970s meant requesting university vehicles from the KU transportation pool. The coach drove one vehicle and found qualified volunteer drivers when more than one vehicle was needed. Even in the later 1970s, vans from the KU fleet were used, and often the coach was the designated driver. Women's athletics teams in the twenty-first century are driven in a motor coach by a contracted driver when sports events are close enough to be reached by ground transportation within three hours; if the distance is greater, the motor coach is used to transport the team to the Topeka Metropolitan Airport or the Kansas City International Airport for flights. For individual sports, a KU Athletics van with a contracted driver might be used instead of a bus, but to distant competitions, flights are arranged.

An equipment manager prepares the sports gear, loads it onto the bus, and in some cases travels with the team or ahead of the team to transport it to the venue. Traveling with the team are the head coach, assistant coaches, athletic trainers, student team managers, and a director of team operations. The group also might include a director of team development, a strength coach, a team tutor, a video specialist, or an athletic administration representative assigned to the team. In some cases, there seem to be as many support personnel traveling with the team as there are players. This level of support seems incredible now because all of these tasks were the sole responsibility of the one women's coach per team during the early 1970s.

Sports Medicine for Women Athletes

Certified athletic trainers are currently assigned to attend to women athletes on every KU sports team, and in some cases, student interns in athletic training augment the athletic training staff. Whereas in the early years, women athletes taped their own injuries after they occurred, presently injury prevention is prescribed for athletes. Strength trainers develop the physical capacity of each athlete scientifically, and athletic trainers give advice to take precautions to prevent injury. Team physicians are available for specialized evaluation and treatment for women athletes just as for men athletes. Several types of modalities and technological devices are now available in the athletics training rooms adjacent to the sports locker rooms, allowing athletic trainers to assess and treat injuries quickly and

successfully. When KU women athletes first moved to Allen Fieldhouse, a rudimentary athletic training room was available to them, and a single woman athletic trainer administered care to all women athletes.

Nutrition and Housing Accommodations for KU Women Athletes

KU women's dormitories were the campus home of early women athletes in the 1970s, and each team member found her own lodging on campus. Oliver Hall was a popular location for early women athletes because of its proximity to Robinson Gym, but several first-year student athletes chose the Gertrude Sellards Pearson (GPS) Residence Hall, northeast of the Memorial Student Union, and a few upper-class-women athletes lived in one of the five-story dorms on Daisy Hill. Some upper-class-women athletes chose to live in apartments near campus, but the women coaches were never involved in choosing the living quarters of early women athletes. Currently, coaches designate certain dormitories as preferred for athletes, but other students are also assigned to those dorms; thus, there are no dorms specifically reserved for athletes on the KU campus. Dining facilities in some dormitories now provide a "training table," with nutritious menus for all athletes as prescribed by team strength and athletic trainers. In comparison, in the beginning years for women athletes, food choices were ordinary dorm cafeteria fare, food prepared in an apartment, or fast-food takeout. Currently, special dining services with team menus for pregame meals are reserved for any KU team and are served in the De Bruce Center adjoining Allen Fieldhouse.

Enhancement of KU Athletic Facilities

The most obvious indication of KU Athletics' compliance with Title IX over the past fifty years has been the expansion of sports facilities on campus. An account of the facility enhancements reveals the magnitude of renovations and new construction, particularly state-of-the-art facilities for women's teams.

In the decade before and especially after the turn of the twenty-first century under the leadership of Athletics Director Frederick, KU Athletics began to change incrementally from a fieldhouse-centered program to a multifacility athletics complex with double the personnel because of the inclusion of women's sports. Athletics facilities comparable with those of other Big 12 institutions and NCAA Division I universities across the coun-

try are important to impress recruits seeking a college campus where they wish to accept a scholarship and participate in varsity athletics. Presently KU is approaching a state of equity in athletics facilities for women's sports.

In 1974, when KU Women's Athletics were merged into the KU Athletics Department, additional space was needed to accommodate women's teams and coaches. Allen Fieldhouse was the main facility for KU Athletics at that time, and doubling the number of teams, athletes, and coaches meant crowding in the existing facilities. Spaces behind the second-floor permanent bleachers were enclosed to arrange coaches' offices for women's sports. The basketball visitor locker room in Allen Fieldhouse was the only women's locker room for all women's sports for a time, but the first women's basketball games in Allen Fieldhouse in 1973 required the women athletes to use the Robinson Gym locker room, cross Naismith Drive to play the ballgame, and have their half-time coaching in the women's restroom in Allen Fieldhouse.

Renovations and additions to Allen Fieldhouse provided some relief of the crowding, and gradually women athletes have been provided similar space to what the men have. During the twenty-first century, facility improvements have continued to be at the forefront of KU Athletics enhancements for women's sports.

Allen Fieldhouse was the center for all of KU Athletics when men's basketball left Hoch Auditorium in 1955, and since then it has been the home of the KU men's basketball team. No KU Women's Athletics team played inside Allen Fieldhouse when the PE Department administered the initial intercollegiate program in 1968, not even when KU hosted the DGWS National Volleyball Championship in 1971. The KU women's basketball team played a tournament in Allen Fieldhouse for the first time when KU hosted the AIAW Region 6 Basketball Championship in 1973, although it played a few games there earlier in the season. Naismith Court in Allen Fieldhouse also became the KU women's home basketball court in the 1974–1975 season and thereafter.[15]

When KU men's basketball moved into Allen Fieldhouse in 1955, the coaches' offices remained in old Robinson Gym, on Jayhawk Boulevard, because most coaches were also KU faculty, and they taught classes in Robinson Gym. But when the original Robinson Gym building was demolished in 1967, coaches' offices and practice facilities for men's varsity sports were relocated to Allen Fieldhouse. As coaching staffs and numbers of athletes grew per sport, fewer of the coaches were also appointed as academic faculty, and more office space was needed.

The Wagnon-Parrot Athletics Center was constructed in 1970 as an addition to the west side of Allen Fieldhouse for the KU Athletics administrative offices. The Parrot area of the addition housed the KU athletic director's office suite, the athletics administrative staff, the business office, the Williams Education office, and media relations and coaching offices for both men's and women's teams. The Wagnon Student Athlete Center, completed in 1998, was an addition to the Parrot building; it was originally constructed to provide a space named the Hale Achievement Center for the KU Athletics student academic counseling and tutoring area. By 2009, with more than a thousand hours of student athlete tutoring per week, a Wagnon-Parrot Athletics Center expansion added twenty-four tutoring rooms and sixteen staff offices for tutors. On the lower floor, part of a 2005 renovation was the Dean Nesmith Training Room and Aquatic Rehabilitation Center, a media room and offices, the travel services office, information technology, the mail room for athletics, and Hadl Auditorium, with 155 seats.[16]

Several construction projects enhanced KU Athletics facilities beginning in 1984 during Athletics Director Monte Johnson's (1982–1987) administration. A synthetic surface had been laid over the dirt track inside Allen Fieldhouse in 1972, creating a six-lane, 200-meter indoor track with surrounding space for other sports teams to work out indoors during their respective seasons, so the dust of Allen Fieldhouse had already been controlled. KU basketball had been played on the smooth tartan surface in Allen Fieldhouse from 1979 until 1985, when a raised wooden basketball floor was centered on top of the tartan floor surface during the basketball season each year. The basketball floor was dismantled after the season each spring and reconstructed before preseason basketball practice each fall to protect the wooden court surface when other uses of the fieldhouse were scheduled. In 1992 a permanent sunken wooden basketball floor was laid to sit evenly with the synthetic floor surface. Permanent bleachers were constructed on the indoor track to make Allen Fieldhouse a dedicated basketball arena because indoor track and other indoor sports had moved to the new Anschutz Pavilion.[17]

Anschutz Pavilion, west of Allen Fieldhouse, was completed in 1984, providing 40,000 square feet of new indoor space for men's and women's teams to share without causing hazardous situations by practicing more than one sport on the same fieldhouse surface simultaneously. Anschutz Pavilion was the new home of KU indoor track and field for both men and women, and it also had sixty yards of artificial turf for an indoor football

practice field. It was resurfaced in 1999 but was again renovated and resurfaced with turf and a new textured surface on the track in 2011.[18]

The 5,000-square-foot Shaffer-Holland Strength Center was originally situated in the north end of Anschutz Pavilion in 1984. At first, women did not work out in the Shaffer-Holland Strength Center because the dominance of male athletes discouraged their presence, but when women's coaches began to bring them there as a group, strength training became the norm for women athletes. Because all men's and women's teams used the Shaffer-Holland Strength Center, it became so crowded that it was replaced in 2003 by a one-and-a-half times larger strength and conditioning area, constructed west of Anschutz Pavilion and connected to its northwest corner.[19]

Arrocha Ballpark replaced Jayhawk Field for the KU women's softball team in 2004, with a generous donation from a KU alumna, Cheryl Womack, who asked that the softball stadium be named after her father, Demostenes Arrocha, a Panamanian immigrant. Jayhawk Field was the original outdoor softball field, southwest of Allen Fieldhouse, which was graded, seeded, and fenced in 1985 to support the KU women's softball team ten years after KU Athletics had merged women's sports with men's athletics and four years after the NCAA had taken over women's intercollegiate athletics. Previously, KU women's softball teams had practiced at Robinson Gym and Shenk intramural fields and played competitively on Lawrence Recreation and Parks softball diamonds. Jayhawk Field was a rudimentary field with a tricornered fence behind home plate, untreated fields, and portable benches for teams. The new Arrocha Ballpark was built on the same location as Jayhawk Field, but the field orientation to the sun was reversed, the outfield was fenced, and the new ballpark had a graded and drained infield of combined dirt and synthetic compound, sunken dugouts, batting cages, an electronic scoreboard, and concrete-foundation spectator bleachers for 300 fans with a press box above the bleachers behind home plate.[20]

Athletics Director Frederick (1987–2001) oversaw a series of construction projects for KU Athletics. Ten years after the original Jayhawk Field for women's softball was constructed, soccer was introduced as an intercollegiate sport for KU women when it began as a Big 12 sport in the 1995–1996 academic year. The first KU soccer field was seeded and opened in 1995, directly south of the Arrocha Ballpark and abutting Nineteenth Street. It was a fenced, grassy field mowed and lined each week for practices and games. A set of portable bleachers was placed on one side of the field for the few

spectators who attended games. The KU women's soccer team moved in 2014 to a natural-turf pitch on the soccer field at Rock Chalk Park.[21]

The $3.8 million Horejsi Family Athletics Center opened in spring 1998 to house a practice court for men's and women's basketball and a volleyball practice and competition court. The new Horejsi Family Athletics Center included a home volleyball locker room, but a visitor's locker room was not a part of the new facility. This facility was built as a stand-alone building immediately south of the Wagnon-Parrot Athletics Center.[22] When the Horejsi Family Athletics Center opened, KU basketball and volleyball teams were required to go outside from their Allen Fieldhouse locker rooms to enter for practice and games in Horejsi Center. In 2005, an additional basketball practice court was constructed between the Horejsi Center and the Wagnon-Parrot Athletics Center and joined to Allen Fieldhouse by interior hallways. The addition also provided public restrooms, a limited concession stand, an outside ticket booth, and fold-out bleachers on each side of the volleyball court to hold 1,300 spectators.[23] KU volleyball finally had its own dedicated home court in Horejsi Center without sharing the court with basketball, but visiting volleyball teams were still assigned a locker room inside Allen Fieldhouse. Horejsi Center was dismantled after the 2018 season and expanded to provide seating for 2,400 volleyball spectators beginning with the 2019 season. Permanent balcony seating was added to each side of the competition court, and new folding bleachers were installed along each courtside with narrow bench seating and stair railings, but the new facility still did not include a volleyball visiting team's locker room. With the seating expansion, KU volleyball was qualified to host an NCAA regional tournament in Horejsi Family Athletics.

The Anderson Family Strength and Conditioning Center opened in 2003, adjoining the Anschutz Pavilion to the northwest as a facility enhancement for KU Athletics. The 42,000-square-foot center replaced the former Shaffer-Holland Strength Center in Anschutz Pavilion. The interior space is arranged on two floors, with the main floor for weight training and the upper floor for cardiovascular training. Meeting rooms are used by both men's and women's teams, and both men's and women's locker rooms are included in the facility. Synthetic turf is on the floor of the 7,500-square-foot cardiovascular workout area upstairs, and a rubber athletic floor is in the 15,000-square-foot weight room. Between the former Shaffer-Holland Strength Center weight equipment and $560,000 worth of new technological equipment for the cardiovascular area, KU men and women athletes now share an excellent facility for individualized physical development.

KU women's volleyball game in Horejsi Center, 2016.

Former assistant athletics director for Sports Performance Andrea Hudy joined KU Athletics in 2004, introduced KU coaches and athletes to equipment and technique in the cutting edge of enhancing sport performance based on research, and was instrumental in leading all KU strength and development programs specific to each sport until 2019.[24]

The Anderson Football Complex was constructed southwest of Memorial Stadium on the north edge of campus and opened in 2008 under the leadership of Athletic Director Perkins (2003–2010). KU football gained much-needed expansion of locker room space and coaches' office space. Vacating the Allen Fieldhouse locker room and office area, which the football team had filled, provided office and locker room space for women's teams.[25]

During summer 2008, $55 million for "upgrades, additions, and expansion" of Allen Fieldhouse provided much-needed space for women's teams. The old football locker rooms were renovated to include new locker room spaces for women's soccer, women's softball, and women's track and field. A second floor was added to the Wagnon-Parrot Athletics Center to house a student study area and tutoring offices. New men's and women's basketball clubhouse areas were designed as a part of the construction added between

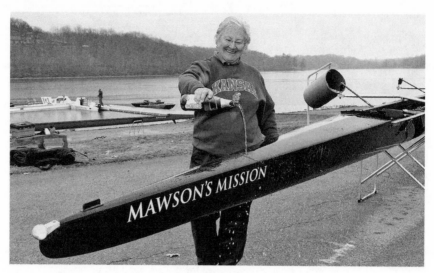

Marlene Mawson christens KU scull boat Mawson's Mission, *2013.*

the Wagnon-Parrot Athletics Center and Horejsi Family Athletics Center. The two basketball clubhouses were accessed on the ground floor behind the west bleachers in Allen Fieldhouse. Each included large lockers, a film room, a players' lounge, a training room with hydrotherapy pools, show-ers, restrooms, laundry, and a basketball equipment room. Visiting teams' locker rooms, a press conference room, and concession stands were also a part of the renovations.[26] Amazingly, KU women's basketball now has a team clubhouse facility similar to that of the KU men's basketball team, and the two basketball clubhouses adjoin each other through a locked door midway along the west side of Allen Fieldhouse, with the women's basket-ball clubhouse on the south end and the men's clubhouse on the north end. All along the corridor behind the westside bleachers are plaques with the names of all basketball players, women and men, who have played at KU, and on the opposite wall are large photos of notable KU players.

The $6 million KU rowing boathouse is a two-story, 14,000-square-foot facility on the banks of the Kansas River in Burcham Park, at the north end of Indiana Street. It was built on 2.5 acres and completed in January 2009. For fourteen years before this new facility was built, KU rowers stored their crew boats inside a chain-link fence along the river there. Only an open pic-nic pavilion and two outdoor porta-potties constituted the athletes' shelter beside the dock prior to the boathouse. Built to withstand a flood of eight feet, the boathouse can house sixty-five boats in the lower-level storage area. The crew team locker room and strength-training room are on the upper

level of the boathouse, along with a full kitchen and catering room, a rowers' lounge, and an outside deck for viewing the finishes of races on the river. Below, on a boat rack inside the boathouse, the KU crew scull bearing my name is stored.[27]

Robinson Natatorium, across Naismith Drive from Allen Fieldhouse, contains a six-lane, twenty-five-yard competition pool with an adjacent diving well and an adjoining eight-lane, twenty-five-meter competition pool. The diving well contains one-meter boards, three-meter boards, and a diving platform. The diving well and the six-lane, twenty-five-yard pool were included in the original construction of Robinson Gym in 1965, and the additional twenty-five-meter, eight-lane pool was added in 1980. The two pools can be open for one swim meet or divided by closing a hydraulic folding glass door for two separate activities. KU Athletics renovated the women's swimming and diving team locker room prior to the 2011–2012 season. New lockers and showers, a swim-club lounge, and a training room for swimmers were included in the recent renovations.[28]

The spectacular $39 million Rock Chalk Park opened in 2014 as a three-stadium sport facility in northwest Lawrence under the leadership of Athletics Director Sheahon Zenger (2011–2018). Rock Chalk Park includes a soccer stadium, a softball stadium, and a world-class track stadium.[29] Beyond a rock-walled ticket office, a wide asphalt pedestrian ramp leads to the top of the spectator seating for all three areas, with the soccer field on the left, the softball ballpark on the right, and the track complex just beyond the top of the ramp, providing a view of all three stadiums. A separate indoor/outdoor tennis arena was added to Rock Chalk Park in 2017, just south of the outdoor stadiums. Both men and women athletes share the track-and-field stadium, but the soccer, softball, and tennis facilities at Rock Chalk Park were constructed for KU women's athletics teams.

Memorial Stadium had been the site for the KU track-and-field program during its first ninety-three years of competition. It was initially the home of the KU men's track-and-field team and, after 1975, for the KU women's track team as well. Memorial Stadium originally contained a cinder track built in 1921 around the football field. In April 1923, the first Kansas Relays were held on that track. In 1970, when artificial turf replaced the grass football field, an artificial track surface with painted lane lines replaced the cinder. The artificial surfaces of the football field and track were replaced again in 1978, 1990, 1999, and 2009. In 2015, the KU track was removed from Memorial Stadium because the KU track-and-field teams had a new home in Rock Chalk Park.[30]

KU women's soccer game at Rock Chalk Soccer Field, 2014.

Rock Chalk Park's 400-meter, nine-lane track with a butyl rubber and polyurethane layered surface is one of only five International Association of Athletics Federation (IAAF) Class I Certified tracks in the United States. This world-class track has a 7-foot-wide jogging lane on the outside of the racing lanes. The park also sports a 436-foot, straightaway, six-lane warm-up track west of the oval track that can also be used to run the 100-meter and the 110-meter hurdles. Field throwing events take place in netted areas northwest and outside the oval track infield, but the jumping events occur on the infield. The stadium has bleachers for 7,000 spectators on both sides of the field, with enclosed press-box windows at the upper level. The track team locker rooms, men's and women's athletic lounges, and track coaches' offices are on the lower concourse level, under the east track bleachers. Visiting track team locker rooms for men and women are also on the lower concourse level. Equipment rooms for uniforms and equipment are on the lower concourse as well, and all pole-vaulting equipment is stored under the west bleachers.[31]

The new KU women's soccer field opened in fall 2014 with a 2,500-seat, lighted stadium on the east side of the track-and-field facilities. After twenty years of practicing and playing on the makeshift field south of Allen Fieldhouse, the soccer team embraced its new stadium home. Landscaped earthen berms gird the edges of the field, electronic scoreboards stand at each end, and there are concession stands above the bleachers. The beautifully manicured natural grass pitch is chalk-lined by the Rock Chalk Park

KU women's softball game at Arrocha Ballpark at Rock Chalk Park, 2015.

facilities director for each home soccer game. The permanent stadium bleachers were constructed back to back with the track stadium bleachers, providing spaces underneath for both soccer and track-and-field teams. The soccer stadium features home and visitor locker rooms behind their respective sidelines, a players' lounge, coaches' offices, an athletic training room, and an equipment room. The soccer team shares the weight room, a media room, and a video viewing room on the lower concourse with the softball and track-and-field teams. A shared multilevel press box is located above the soccer and track bleachers, with windows overlooking each stadium and separate rooms for a public-address system and both television and radio broadcasts.[32]

In fall 2014, Arrocha Ballpark, for women's softball, was moved from south of Allen Fieldhouse to Rock Chalk Park, and the site on campus was abandoned. The new outfield and field apron are covered with artificial turf, and the infield consists of a clay mixture. Directly behind the KU third-base dugout is the softball clubhouse, which includes a locker room and separate lounge for the team members. Offices for the softball coaches and an athletic training room are also part of the clubhouse. The softball opponents' accommodations are behind the first-base dugout and include a locker room, a coach's area, and a small athletic training room. The ballpark complex also features a softball-only cardiovascular training room, a

film room, and an equipment room in the lower concourse. An equipment manager maintains the inventory of balls, bats, and field equipment. Towels and uniforms are laundered and sorted for each of the players. Bullpen areas are fenced along each baseline and adjacent to the two dugouts for each team to use during the game. The ballpark facilities director has a crew that prepares the infield markings, monitors ground-surface moisture levels, and levels the infield prior to and during the softball games. Beyond the right-field wall is a separate hitting area featuring two batting cages with a knockdown net. With cold winters leading up to the start of softball season at KU, one of the best additions to the softball facility is the climate-controlled indoor building beyond the right-center-field wall. The 11,000-square-foot venue houses a regulation clay-turf infield and four automatic drop-down batting cages indoors. The new softball stadium seats 1,100 spectators behind home plate and first and third baselines. Above and behind home plate, there is a multilevel press box with separate rooms for a public-address system and for television and radio broadcasts. Umpire locker rooms are also on the upper level. The ballpark also has its own concession stands and spectator restroom facilities on the upper level.[33]

KU first built tennis courts behind the old Robinson Gym, on Jayhawk Boulevard, in 1914. Later, tennis courts for men were constructed behind Allen Fieldhouse. When the new Robinson Gym was built in 1966, tennis courts were constructed for PE classes southwest of Robinson Gym, along Naismith Boulevard across the street from Allen Fieldhouse. The men's tennis courts west of the fieldhouse were destroyed in 1997 when the Horejsi Family Athletics Center was built. During home tournaments, the KU men's tennis team previously used the Robinson Gym tennis courts. KU women's tennis players used these courts for practice and competition beginning in 1969. A commercial tennis complex in Lawrence, First Serve, on Clinton Parkway west of Wakarusa Drive, had three indoor courts, which KU contracted for winter practice beginning in 2006.[34] Two additional indoor courts and six new outdoor courts were constructed at First Serve in 2008, and KU Athletics contracted this indoor/outdoor facility for KU women's tennis practice and tournaments. This off-campus tennis facility had limited spectator seating, and spectators could not see matches on all courts at once. In 2010, KU Athletics purchased the First Serve tennis complex, which became home court for KU women's tennis during the next seven years.[35]

In 2017, the new $9 million, 78,000-square-foot Jayhawk Tennis Center opened at Rock Chalk Park, with six indoor courts and six outdoor courts. It

was another facility constructed exclusively for women's athletics because in 2001, KU eliminated both men's tennis and men's swimming to accommodate Title IX compliance regulations. The new tennis center has elevated stadium seating for 500 spectators, and fans can view every court both indoors and outdoors. The outdoor courts have lights for evening matches, and every court has its own scoreboard. The new tennis facility has coaches' offices, a women's locker room, a team lounge, an athletic training room, and a multipurpose room for watching films or giving interviews to the press. It also has meeting rooms and multiple locker rooms for guests. All of this interior space is in addition to another eight outdoor tennis courts the city owns at Rock Chalk Park, adjacent to the Lawrence Sports Pavilion. That provides a total of twenty tennis courts available at Rock Chalk Park for large tournaments.[36]

The most recent addition to KU Athletics' facilities is the Jayhawk Golf Club, originally constructed as Alvamar Golf Club in 1970, along Bob Billings Drive. It began as an eighteen-hole course and was expanded within three years to become one of two thirty-six-hole courses in Kansas. The Alvamar Golf Club was previously the home of the KU men's golf team; the KU women's golf team first played there in 1973. In 2017 Alvamar Golf Club became private and was renamed the Jayhawk Club, and KU retained access for its golf teams. The new $2 million indoor golf training and practice facility at the Jayhawk Club features seven hitting bays with launch monitors, a chipping green, and a putting green. Outside are tee boxes with zoysia and bent grass on a hitting range, along with a short-game pitching area. The revamped golf complex has locker rooms for both men and women athletes and a lounge.[37]

In all, the athletics facilities at KU have improved immensely over the past forty-five years, to provide more than twice as much playing space as when KU Women's Athletics merged with KU Athletics in 1974–1975. This is a dynamically visible aspect of all the improvements for KU women athletes.

The Glory of KU Women's Athletics

Nearly a half century after the initiation of KU women's intercollegiate athletics, the final stages of three new stadium construction projects were evident in Rock Chalk Park in summer 2013. As I walked up the ramp from the park entrance gate to the overlook of the new softball field and soccer field on either side, I had my first glimpse of the beautifully groomed

Aerial photo of Rock Chalk Park, Lawrence, Kansas, 2018.

bluegrass field spreading across the soccer field to the left, and over to the right side of the ramp was the shimmering green outfield turf surrounding the ochre-colored soil compound of the white-lined softball infield. The view took my breath away as I surveyed a scene I never could have imagined. It seemed so surreal that facilities as beautiful as these two stadiums had been built just for KU women athletes, and these new fields certainly were not a renovated hand-me-down from a former men's sports facility.

Such a wonderful facility was beyond reality for women athletes when I coached at KU fifty years ago. I reflected back on the tractor-mowed, unseeded open fields where my KU field hockey and softball teams practiced and engaged in competition, and I felt proud of those KU women athletes who had endured so much adversity in their own college years, leading to this meticulously landscaped soccer field, state-of-the-art softball diamond, and world-class track. And a couple of years later, the new tennis facility stood at the south end of the stadiums. Just recognizing that several new KU sports facilities were built because KU women athletes deserved to have high-quality spaces for practicing and competition made me feel fulfilled that all the effort and perseverance of all those years had been worth it. It had paid off.

On my several trips to KU and even after I had moved back to Lawrence, it was an awakening for me as the accolades kept coming regarding my

early accomplishments for KU. The recognition of my efforts for women's intercollegiate athletics so long ago was gratifying, when my efforts were merely responsible actions on behalf of young college women eager to compete in sports. The honor of having an annual award for an exemplary KU woman athlete named after me, being inducted into the KU Athletics Hall of Fame, having a KU crew boat named after me, being named a KU Pioneer Woman, being the first woman given the K-Club Service Award, having an endowed KU graduate sport management scholarship named after me, and having an annual KU scholarly speaker series named after me seems to be overamplified acknowledgment. I had never sought notoriety or fame for myself because my primary aim was to find ways to provide intercollegiate sport opportunities for women student athletes, so it has seemed amazing that these honors now acknowledge what occurred so long ago.

The boat title the KU crew team chose for one of their new sculls in 2011 aptly identified what I had always aspired to achieve in my career; that is, a mission of offering opportunities for young women to experience the joy in elite sports competition. I was glad I was perceived by contemporary women athletes as an early advocate and mentor for women athletes.

Realizing that KU women athletes currently have access to high-quality programs for competition and for academic pursuits and that they choose to come to KU for a valuable education, excellent coaching, and respected teammates, with full support from students and from the community, has been exciting and fulfilling for me. Returning to the KU campus after a long absence during the second half of my career has enabled me to grasp the significant advancement in women's athletic opportunities at a glance rather than watching the progress incrementally over time, and it has made the positive changes all the more astounding to me. Truly, the KU Women's Athletics program has become even greater than anything I had ever dreamed. KU women have improved not only in athletic achievements but also in academic excellence and expanded life goals.

Young women athletes today seem to accept this gift of equality for women athletes, and they take it in stride as though their intercollegiate sports competition opportunities were always there. Yet, still-living KU pioneers of women's intercollegiate athletics can attest to the tribulations of their sports experiences. These women recall the perseverance required to participate in sports competition with little attention or support for the availability or the quality of their athletic endeavors.

Those pioneer KU women athletes have made their mark in coaching, in teaching, in business as successful entrepreneurs, and in mothering the

next generation of athletes. They are the heroines for today's athletes because they led the way. Realizing after fifty years the progress and opportunities afforded KU women athletes demonstrates that my original ambitions and aspirations, which might have seemed like pipe dreams at one time, actually became real.

APPENDIX: MEMORIES FROM
EARLY KU WOMEN ATHLETES

I invited coaches and athletes who participated in University of Kansas (KU) women's intercollegiate sports between the beginning of the program (1968–1969) and the last year of the Association for Intercollegiate Athletics for Women (AIAW; 1980–1981) to contribute some of their sports memories. The years during which these women coached or competed for KU are listed, along with their sports. I also included information about their post-KU careers. Their memories illustrate the importance of competitive sports for the women who shaped the formative decade of KU Women's Athletics.

Jo Ann Houts, 1966–1970, Field Hockey, Softball

As a KU physical education (PE) major, I was active on both extramural and intramural teams before there were intercollegiate sports for women. Joie Stapleton was the department head, and our coaches and instructors were Marlene Mawson and Delores Copeland. These women were great role models. They were always challenging us to become our best. KU was the perfect learning environment, and it was fun!

I was the goalie on the first KU intercollegiate field hockey team, under Coach Mawson. I did not want to do all that running up and down the field, smacking that little ball, so the goalie position suited me just fine. I was also one of the pitchers on our KU softball team. During the summers, I played on the Ohse Meats "farm club" softball team in Topeka. I was just happy that we had college teams, especially softball, because that was my main sport and passion. My best memories are from the close relationships we formed during our KU team practices, our competitive games with other university teams in the area, and many of our antics during and after PE classes. We were college students just before new opportunities in women's athletics were created through Title IX. My classmates, teammates, coaches, and professors helped build a solid foundation together through our love of sports during the late 1960s that helped launch intercollegiate women's sports at KU for the 1970s and beyond.

I am most thankful that our coaches led us to know our potential and taught us how to be part of winning teams. I learned how to be a contributing

team member and how intense concentration and presence led to me being my best. I had the sense of peak experience in sports and being in the flow of the moment. It was a college high point for me to have my writing on peak experience in softball published in the student section of the *Journal of Health, Physical Education, and Recreation* when I was a senior.

Career notes: Jo Ann Houts earned an MS in clinical psychology from the University of North Texas in 1973 and a PhD in clinical psychology from the California School of Professional Psychology–San Diego in 1980. She is now retired from private practice and consulting as a clinical psychologist.

Paige Carney, 1967–1971, Basketball, Field Hockey, Softball, Volleyball

Playing sports has been a big part of my career and life, not only because that is who I am but also because of the experience and education I was fortunate to receive at KU. The small high school in Kansas from which I graduated did not offer opportunities for girls to compete in sports. When I entered college in 1967, the only intercollegiate competitions available were occasional Sports Days with other universities, but I accepted it. Basketball was my love, and college was the first opportunity for me to play that sport competitively rather than recreationally. Back in those days, you could play whatever sport you wanted to, so I tried intercollegiate field hockey and volleyball, neither of which I had ever played before, and made both teams. I had so much fun just being active and trying to get better at those new sports.

Playing basketball and volleyball in 1968 required practicing both sports on many days. We would go to class, practice volleyball from 4:00 p.m. to 6:00 p.m. in Robinson Gym, go to dinner at Taco Grande on Twenty-Third Street as a team, and come back to practice basketball from 7:00 p.m. to 9:00 p.m. Many of the same women were on both teams. Coach Mawson coached both sports and accompanied us, often buying cokes for winners of drills, which would be a National Collegiate Athletics Association (NCAA) violation now. I have a vivid memory of the polyester uniforms we wore for every sport, every season, every year. No breathable material, nothing wicking, nothing lightweight, and every woman who wore that shirt remembers it for what it was: awful, yet we were so proud to put it on.

Maybe others could tell about the time I missed a shot, hit a spike into the net, or missed a serve at a critical time, but those things are gone for me. I remember the sheer joy of playing. There were no scholarships, no

money, and no free meals most of the time. We paid our way, worked hard, sweated tons, loved what we did, loved who we played with and for, and certainly developed loyalty to the university that provided us these opportunities. Many of those things are still true today because that is what sports do for a person. I am so very grateful to have been born just in time to be able to play. My career is a result of the offerings first presented in 1968 to women athletes at KU. I am forever grateful and influenced by those days, grateful for the opportunities, grateful to my coach for the mentoring, and grateful to KU for beginning women's athletics.

Career notes: Paige Carney taught PE at Lawrence High School (1972–1997) and at Free State High School, also in Lawrence (1997–2002). In retirement, she is an instructor and a national competitor in pickleball.

Joan Lundstrom Wells, 1967–1971,
Field Hockey, Softball, Tennis, Volleyball

As an incoming first-year student at KU in fall 1967, I was disappointed by the lack of organized sports for women. This was a time when young women truly played for the love of the game and enthusiastically participated in whatever sports-related activities were available. It was also a time when those who realized the value of competitive sports for women were striving for more, and by the time I graduated in spring 1971, the women's sports program at KU had made significant progress.

My first organized competition at KU was with the field hockey club my first year there. The extramural club was led by a couple of seniors, our season was in the fall, and we practiced in the late afternoon on the second field east of Robinson Gym. We wore white blouses under royal blue tunics as our uniforms. We competed against other field hockey clubs in the area, and I remember attending one field hockey Sports Day at Pittsburg State.

Most of my other memories of competing in sports are of playing Jayhawk volleyball. KU competed in a volleyball Sports Day at Wichita State University (WSU) during my first year, and KU's famed dance instructor, Elizabeth Sherbon, accompanied us as our faculty sponsor. In fall 1968, the PE department hired Marlene Mawson and Delores Copeland, and both were instrumental in initiating the change from extramural to intercollegiate women's sports. Coach Mawson had some background in power volleyball and coached us my sophomore and junior years. When KU began women's intercollegiate sports in 1968, we got our first official set of Broderick game uniforms: blue shorts and shells.

My most vivid sports memory involved competing in the Division of Girls and Women in Sport (DGWS) National Volleyball Championship, which KU hosted in Robinson Gym my senior year. Linda Dollar, a former Southwest Missouri State University (SMSU; now Missouri State University) volleyball player and a graduate teaching assistant, was our coach. Coach Mawson had taken a year off from coaching volleyball to serve as the national tournament director. Two things I remember most about that tournament were that our KU team defeated SMSU in the pretournament demonstration match the evening before competitive play started, and that was a huge win for us! Also, the Sul Ross University team, clad in multicolored shorts and led by US Olympian Mary Jo Peppler, defeated Long Beach State University in the championship match.

During the late 1960s and early 1970s, the PE and Women's Athletics Departments were closely interwoven. PE majors took methods classes in teaching and officiating during their junior year. Coach Mawson encouraged us to become proficient in officiating volleyball, and some of the volleyball team members assisted with power volleyball coaching clinics in the Kansas City schools. At this time there was a great need for women knowledgeable in competitive sport and athletics.

Career notes: Joan Lundstrom Wells taught PE at Lawrence High School (1971–2003) and coached volleyball for twenty-seven years, softball for fifteen years, and girls' basketball for two years. Her volleyball teams won fifteen state championships and were runner-up seven times. The Lawrence High School volleyball team was ranked in the top twenty-five teams nationally in 1990, 1992, and 1995, and Joan was named state coach of the year in Kansas six times. She has been inducted into five halls of fame: Kansas State High School Activities Association (2003), National High School Athletic Coaches Association (2005), National Federation of State High School Associations (2007), State of Kansas Sports (2010), and Kansas Volleyball Association (2012).

Veronica Hammersmith, 1968–1972, Coach of Field Hockey, Softball

My memories of KU are very fond ones, and my whole career was based on what I learned there. I played club basketball and softball (not well organized during my undergraduate years), but the PE Department started to sponsor women's intercollegiate sports after I completed my undergraduate degree. I became a graduate teaching assistant in 1968 and was appointed to coach field hockey in fall 1971 and softball in spring 1972. We played field hockey

east of Robinson Gym, where the campus computer center is now. We played softball in 1972 at Twenty-Third and Iowa Streets, on Shenk Field, with a backstop and nothing else. We measured out the bases and put them down for every game and practice. I remember driving to Kansas State Teachers College in Emporia (KSTC–Emporia) to meet with coaches from around the state to schedule sports within the Association for Kansas Women's Intercollegiate Sports (AKWIS). Competition was organized on the state level at that time, rather than by divisions and regions. I will always be grateful for the opportunities I had at KU to coach and start my lifelong career in coaching.

Career notes: Veronica Hammersmith became a softball coach at West Virginia University (WVU) in 1972, where she earned her EdD in 1985 and coached for forty-one years, thirty-five of those years at WVU.

Suzi Cammon, 1970–1971, Coach of Tennis

As the first coach of the KU women's tennis team, like the other women's coaches, I received no compensation. The team was allowed to practice on half (four) of the new tennis courts south of Robinson Gym. The team had no uniforms but competed in white shirts and dark shorts or a tennis skirt. Each player supplied her own tennis racquet, balls, clothes, and shoes. Paige Carney and Joan Lundstrom were on our team, along with about six others. The players brought sack lunches from their dorms because we did not have a budget for meals. We traveled to area meets in a university vehicle that I drove. The team had a lot of fun, gained in skill, and never questioned why KU did not provide funding. The team just appreciated the opportunity, the courts to practice on, and a university vehicle to get to meets. How times have changed, thank goodness!

Career notes: After completing her master's degree in exercise physiology at KU in 1971, Suzi Cammon got a second master's degree in counseling and student personnel at Kansas State University (KSU) in 1989. She held counseling and scholarship director positions in the Lawrence public schools, the Blue Valley School District, the Shawnee Heights School District, and the Kansas City (Kansas) School District.

Virginia "Ginny" Hammersmith, 1970–1974, Softball, Volleyball

My memories of my KU years are the fun, the camaraderie, the pride, and the people. I was fortunate to play softball and volleyball with a talented team who loved to play the game and hated to lose. During my first and

second years at KU, the basketball, softball, and volleyball teams all wore the same light blue, sleeveless uniform with red numbers. Before playing in the 1972–1973 AIAW Regional and National Volleyball Championships, we players bought red turtleneck tops and navy-blue PE majors' shorts from the student union. For the 1972 and 1973 softball College World Series in Omaha, Nebraska, we were outfitted in new red-and-blue uniforms, and we were proud the uniforms were only for our softball team.

We practiced and played softball on several fields: Robinson Gym's west field or in the city at Broken Arrow Park, Shenk Field, South Park, or Woody Park. We practiced and played volleyball in Robinson Gym, along with the women's basketball and gymnastics teams. I do not remember ever thinking we deserved or even needed our own field or facility. My teammates and I simply loved playing softball and volleyball, and the field or facility was inconsequential. Traveling was also different then because cars were our mode of transportation, even when we traveled to regional and national tournaments.

We had dedicated and qualified coaches who spent an enormous amount of time teaching, practicing, organizing, driving, and finding the funds to lead our teams. We never considered ourselves pioneers or adventurous. We never received or expected any individual financial assistance or recognition because we did not play in front of large crowds. We simply enjoyed competing, winning, and becoming the best athletes we could be.

Career notes: Ginny Hammersmith earned a master of science degree at WVU in 1979 and a master's in education at WSU in 1994. She was a teacher and school counselor for thirty-four years, including twenty-one years as an elementary school counselor/teacher in Wichita.

Lou Ann Thomas, 1970–1972, Basketball, Softball

I have so many fond memories of those early days playing basketball and softball at KU. In my first year, I was thrilled to find my name on the basketball and softball team rosters! It was a dream come true to don crimson and blue and take the court and field to represent my school. But our uniforms were not really crimson and blue; they were more turquoise with faded red numerals, and we wore them for all women's sports. It was 1970 and I was playing ball at KU, so I could have been dressed in cutoffs and a T-shirt and would have been happy. Those stretchy polyester duds were not comfortable and did not wick moisture. We usually played and practiced softball at Broken Arrow Park, but if another team or group was already

there, we moved to another field in town. I can remember playing at least one home game on a makeshift field west of Robinson Gym and across from Summerfield Hall.

In my first year, our basketball team was predominantly first-year students. We practiced and played our games in Robinson Gym, often with intramural teams playing at the same time on neighboring courts. Nearly every home game, the refs would whistle our play dead to toss an errant ball back to one of the other courts. During practice we would often apologize to each other when we fouled. Coach Mawson stopped practice one day to impress upon us that apologies for fouls were unnecessary. Our coach and older players drove us to away games in their own cars. The team drove all the way to North Carolina in leased station wagons when our team qualified to play in the DGWS National Basketball Championship there, and the team also slept in those cars on the way there and back because there was no budget for travel expenses.

In the 1990s, some KU players asked me about our shoe contracts back then. We did not even have scholarships in those early days; we played for the love of the game. It did not matter that we did not have a field, a shoe contract, or even anyone to watch our games. What mattered was that we were playing on a KU team, and we were representing our school with pride and commitment. Being part of the basketball and softball teams are among my most precious life accomplishments. I still feel that pride today when I watch KU's outstanding women's teams, and I could not feel more grateful to have had the opportunity to be one link in the beginning of women's intercollegiate sports.

Career notes: With a double major at KU in journalism (1974) and education (1977), Lou Ann Thomas taught high school journalism and English at Ottawa High School in Kansas and at Harrisonville High School in Missouri. She coached volleyball at Ottawa (1978–1983) and volleyball (1983) and track (1984–1986) at Harrisonville. She has worked in broadcast journalism, advertising, and marketing and has been an editor, freelance writer, newspaper columnist, and magazine feature writer/photographer for forty years.

Linda Dollar, 1970–1971, Coach of Softball, Volleyball

As a twenty-two-year-old KU graduate teaching assistant in the PE Department for one year, I was a full-time student, taught two PE classes each semester, and was head softball coach and volleyball coach, all of which left

me little free time. I was recruited to coach these two teams so Coach Mawson would have time to prepare for hosting the second DGWS National Volleyball Championship as the tournament director in February 1971.

Volleyball season was scheduled in late September through December. There were open tryouts because no recruiting was permitted back then. Most of the players were PE majors. I taught basic skills and strategies to play a six-two offense with the setter coming in from the back row. It was a relatively new concept beginning to catch on in intercollegiate volleyball. For my first match as a volleyball coach, we travelled to WSU.

We did not have money for travel, but we had to take the Kansas Turnpike, and with the misdirection of a couple of players from Wichita, we got off too early on an exit and almost missed our match, which made me extremely nervous. Back then we did not do many, if any, overnight trips. We just got into a car or van and drove, arrived at the gym, started a warmup, played, and afterward drove right back home.

Our volleyball team was very successful throughout the season. We knew we were going to play in the DGWS national tournament and were determined to do well. KU also was hosting the AKWIS State Volleyball Championship. KU won the tournament under stressful conditions. The morning of the AKWIS tournament in early December 1970, I arrived at Robinson Gym, where we practiced and played our matches, only to find the outside doors padlocked and a fire truck nearby. I tried my keys but to no avail. Finally, a police officer showed up and said there was an explosion the night before, and Robinson Gym was being searched. A small bomb had been placed and went off in a stairwell across the street, and that was why the officials were being very cautious. But there were visiting teams, officials, and fans about to arrive and final preparation for the tournament to do. When we were finally cleared to enter, only the athletes and officials were allowed inside.

The second DGWS National Volleyball Championship was a fabulous experience for KU to host. Coach Mawson really put KU on the map for women's intercollegiate athletics. Her organization and planning skills made the championship a first-class experience for all who attended. It was fun having twenty-eight teams come from across the country. The first DGWS National Volleyball Championship was held in Long Beach, California, in April 1970, and as an undergraduate, I had played for SMSU there. When we hosted the second national tournament, it was very cold outside. Some athletes had never experienced the cold or the snow. KU faced off against SMSU for an exhibition game the night before the tournament started.

That game was not just for watching the teams play but also to see how the officials were going to call the matches. There was some disparity with how illegal hits were called, especially with what was known as "dinking," or tipping the ball over the hands of blockers. Volleyball officials came with teams from across the country and had no way of knowing how games were called in other locations. There were no televised women's matches or film to study. KU was in pool play with six teams and did not make it out of pool play to continue into the final elimination tournament. KU did have volleyball uniforms but no warm-up outfits. An anonymous donor came through with funds to purchase matching warm-up jackets just in time to wear at the championship. It was not enough money to purchase the long pants as well, but the team did look good!

Softball season was in the spring, and as the coach, I held open tryouts and did not need to cut too many prospective players. One player was a decent pitcher, so I felt we had a chance at doing well. We held practices on the field outside of Robinson Gym, and we played our games in a city park. We did not have many games to play. A few times when it was too cold or too wet outside, the softball team was allowed to practice on the dirt surface in Allen Fieldhouse after the men's basketball season was over and the wooden floor had been taken up. Dust was flying all around, but at least we could get in some softball practice. The AKWIS State Softball Championship was at KSU, and KU finished third.

Several KU women athletes played both softball and volleyball. Some also played basketball and other sports. The sports seasons did not overlap much. One of the first weekends I was on campus, Coach Mawson asked me if I would like to help drive the field hockey team to Manhattan, Kansas, for a tournament. After she told me my meals were paid for, I jumped at the chance to help because anything free for a graduate teaching assistant on a meager budget was a good thing.

I would not have traded a thing for all of the experiences I had while getting an advanced degree and learning how to coach. KU provided me an excellent education and an enormous amount of coaching experience. No graduate teaching assistant today would ever have the opportunity to be a head coach. I realize that I was thrown into the fire, but what a fabulous experience! I will always have a special place in my heart for KU and all that it provided me. And, a special thank you to Coach Mawson for nurturing and providing guidance for me through a very tough year, when I earned a graduate degree, got experience in college teaching, and learned to be a college coach at such a young age.

Career notes: After one season as a KU head coach in two sports and earning her master of science degree in 1971, Missouri State University (MSU) appointed Linda Dollar a full-time volleyball coach. Linda was head coach for twenty-four seasons at MSU, where her volleyball teams compiled a record of 758–266–21, the second highest win total in Division I at the time of her retirement. She was the first AIAW/NCAA Division I volleyball coach to reach the 700-match win plateau. Linda was inducted into the Missouri Sports Hall of Fame (2011) and the Missouri Valley Conference Hall of Fame (2014).

Debbie Artman, 1971–1973,
Coach of Basketball, Field Hockey, Softball, Tennis

My many fond memories of being at KU as a basketball and softball coach are from the two years that I was a graduate teaching assistant working on my master's degree. My first year at KU, I was the head women's basketball coach, and I was an assistant coach in field hockey and tennis with Ann Laptad. My second year, I was the assistant women's basketball and softball coach for Sharon Drysdale.

We played most of our basketball games in Robinson Gym, but we did play a memorable game in Allen Fieldhouse against KSU that we won in overtime. It was a night game, and we had around a hundred spectators! We could not use the fieldhouse scoreboard, so the scorers kept it on a chalkboard. Once, our team was scheduled to play an afternoon game in Allen Fieldhouse, but when we arrived the rims were down for painting, so we went back to Robinson Gym. The KU women's basketball team shared uniforms with the volleyball team. The volleyball team had taken the uniforms to Florida for the DGWS National Volleyball Championship. Not only did the basketball team not have KU uniforms for a scheduled game but also a few basketball players played volleyball, so we were short players. Our team wore shorts, T-shirts, and numbered pinnies for that game. For away games, the coach drove a university van containing all the players. The team drove to Hays, Kansas, for a basketball game, and when the game was over, we came outside to heavy snow. It was a long trip back to Lawrence, driving slowly with only one highway lane open.

KU played softball games in South Park and practiced at fields in south Lawrence. My favorite memory is driving station wagons to the College World Series in Omaha and taking sandwiches to eat along the way. The team actually had funding to stay in a motel, a big deal for all of us. Under Coach Drysdale, KU took third place that year, and I learned so much from

her. Needless to say, Title IX had a huge impact on women's sports after I coached at KU. I like to think I was a pioneer along with many others in those early years.

Career notes: After Debbie Artman left KU, she taught elementary school, middle school, and high school PE. She also coached girls' basketball and softball at Center High School in Kansas City, Missouri, and retired after thirty years.

Diana Gaines Skinner, 1971–1975, Basketball, Field Hockey, Softball

During my first two years at KU, I was a guard on the women's basketball team. Debbie Artman was the graduate teaching assistant basketball coach my first year, and we practiced and played all of our games in Robinson Gym. My sophomore year, Coach Drysdale was the women's basketball coach. We practiced and played in Allen Fieldhouse that year, and I remember we had to practice from 7:00 p.m. to 9:00 p.m. because that was the only time available to us on that floor. For one game we had to switch to Robinson Gym at the last minute because the school had taken down the rims in Allen Fieldhouse for painting even though we were scheduled to play there that day. The next year, when I was a junior, Marian Washington was named coach of women's basketball, and I did not make the team.

My sophomore, junior, and senior years, I also played softball under Coach Drysdale. We had a great pitcher from Iowa, Penny Paulsen, and the team went to the College World Series all three years, finishing sixth, fourth, and fifth, respectively. In 1972 the softball team practiced in South Park; there was not really a field there, just a backstop and worn base paths. We played our games at Woody Park. In 1973, we practiced and played our games at Broken Arrow Park. The Holcomb fields were new in 1974, and we practiced and played there my senior year. I remember that the Holcomb outfield was horrible because the grass was newly planted, and it was all little tufts. Two outfielders had major ankle injuries that year from running on the uneven turf, and as a center fielder I was one of them.

My junior year, in 1974, was the best. The College World Series was in Omaha, and that year a big tornado had just gone through there. It rained all during the games, and by the second day the series had to relocate to the artificial turf on the University of Nebraska's football field. Games were rescheduled all night long to make up for having only one field. We had a great team and a chance to win it all that year, but our only pitcher, Penny, was exhausted, and we finished in fourth place.

While earning my PE degree in nine semesters, I played goalie on the field hockey team in my junior, senior, and fifth years. The first year I played under Coach Drysdale, and my last two years were with graduate teaching assistant coach Jane Markert. We played our games on the second field east of Robinson Gym, where the KU computer center is now. A well-worn trail cut diagonally through the field where the students walked back and forth from the parking lot onto campus. A game in progress did not stop students from walking right through the field. Field hockey was not very popular in the Midwest, and most of us had never played it before, but we always had three or four good players from either St. Louis or private schools. The rest of the team members supported them as well as we could. My last year of playing field hockey was the first year we played on Shenk Field at Twenty-Third and Iowa Streets. The 1975 field hockey team was the first to play there, and it was so much better than the old field with the trails running across it, even though there were no other facilities.

The basketball and softball teams shared uniforms until my junior year, when the softball women got their own uniforms. We started weight training in 1975, when we were allowed to use the weight room in Robinson Gym. We had no team buses in the 1970s. The coaches drove either university cars or rental cars. I was a driver for the team during my last three years because I was a university employee and approved to drive a car, and during my last year the team used rental cars, which required drivers to be at least twenty-one years old.

Career notes: After graduating from KU, Diana Skinner Gaines worked as a hydrologic technician for the US Geological Survey in Lawrence. She earned a master of science degree in recreation at KU in 1986 and was a director of recreation camps for several years. She worked at the KU enrollment center for ten years and then was an employee at Eagle Bend Golf Course in Lawrence. Diana also worked at a dude ranch in Colorado for a season and at the Grand Canyon for a season.

Joanie Smith Starks, 1970–1974, Gymnastics, Swimming

The women's swim coach during my first year at KU was Claire McElroy, but swimming was dropped that year, so I went out for gymnastics and made the team. In spring 1971, KU sent four gymnasts to the DGWS National Gymnastics Championship at the Pennsylvania State University, and I was one of them. Coach Anise Catlett drove the team in a leased car. In

Pennsylvania, she drove into a pole, set into a concrete parking stall curb-stop and damaged the car!

At the championship meet, the team met George Nissen, who invented the trampoline, and he said he loved the girls from Kansas! He asked the team which piece of gymnastic equipment we would like to have, and we unanimously said a new balance beam, but KU had no money to buy one. He said he would send KU a complementary balance beam! We came back to gymnastic practice at KU and told the men's gymnastics coach, Bob Lockwood, about our experience and that we would be getting a beam. He replied skeptically that we were not getting a beam. But several days later, a message came over the gym intercom for him to sign for a freight order, and we got excited that maybe our beam had arrived. As he left to sign for the freight order, he again said there would be no beam! Then he came back shaking his head and said he did not want to know how we got that beam!

The KU women's intercollegiate sports budget had had no money for us to compete at the DGWS National Gymnastics Championship, so we wrote letters to KU Endowment to ask for funding. They gave us enough travel funds so we could represent KU, and then the university got a free balance beam out of the deal! My gymnastics coaches after Anise Catlett (1968–1971) were Patricia Ruhl in 1972 and Judy Jones in 1973.

Swimming was reinstated with Coach McElroy in 1974, my senior year, so I chose to join the team. Our diving coach was Jim McHenry, who coached the male divers as well. Nancy Hogan and I did a synchronized div-ing performance at the Quack Club Synchronized Swim Show, a new idea of Coach McElroy's because she was also the synchronized swim sponsor. (Who knew in 1974 that eventually there would be synchronized diving and swimming in the Olympics?) During the synchronized swim part of the show, Nancy and I were waiting at the women's locker room door to come out and dive, and a "streaker" came running out of the men's locker room and across the deck in front of the spectators. He was nude under a trench coat, and he flashed the audience! Everyone was surprised and shocked even though "streaking" was a campus fad in full swing then. Coaching gymnastics and swimming have been my career, and I always said that if you find a job you love, you will never work a day in your life!

Career notes: Joanie Smith Starks first taught preschool through eighth grade PE at Cure of Ars, a parochial Montessori school in Leawood, Kan-sas. In 1976–1977 she became a PE teacher at Lawrence High School and coached girls' gymnastics. In 1980, Joanie began coaching girls' swimming

and diving with KU alum Pat Madden Grzenda at Lawrence High School, and the team won the Girls' State Swim Championship in 1986. After Free State High School opened in 1997, Joanie taught PE there for fourteen years.

Becky Millard Johnson, 1972–1976, Basketball, Softball, Tennis

I was not a star in any of the sports I played at KU, but I loved playing. When we traveled to softball games in a van driven by the coach, we studied together along the way. When I took human anatomy, several of us made flashcards to study the bones, muscles, innervations, and circulation because there was so much to memorize. When the team played in the College World Series in Omaha, Nebraska, it rained so much that we ended up playing on the AstroTurf on the University of Nebraska–Omaha football field. My best college friend was Penny Paulsen. She had a fantastic windmill pitch, and she was also a strong basketball player on offense. Because there were no scholarships, there was not a commitment to play four years without financial support, but we played because we loved the game and the team camaraderie.

Kerry J. "Boo" Kapfer, 1972–1973, Swimming, Tennis, Volleyball

Fall 1972 was one of the most exciting times of my life because I had finally arrived as a student athlete at KU. When classes started, so did volleyball practice with Coach Mawson in Robinson Gym. Each day the nets had to be set up because the gyms were used in many ways. There were many athletic, tall, and strong players trying out for the volleyball team. Coach Mawson was always organized, and she taught us a multitude of skills, plays, and strategies at practice. Sometimes at the end of practice we would scrimmage with the KU men's club volleyball team. Our team was fun, competitive, and filled with many multisport athletes. I will always remember the trips when we would arrive very early at Robinson Gym with our sack lunches/dinners, pile into two station wagons, and hit the road. It was exciting, and we had good comradery and high spirits. We were all so happy to have a chance to play volleyball for KU at the dawn of Title IX, and we all knew what it meant for girls and women. What an honor it was to participate in this historic change. My years at KU were so impactful that I was inspired to become a high school volleyball coach, which continued for many years. Thanks to Coach Mawson for her teaching and guidance

of her students and athletes. She has been a true mentor, fearless leader, and friend.

Career notes: Kerry Kapfer was a science teacher in middle schools and high schools in Topeka for forty-two years, where she coached volleyball for thirty-three years, track and field for twenty-two years, and girls' basketball for ten years.

Vicki Shirley Lowe, 1973–1977, Basketball, Softball

My fondest memories from when I was a KU student were the times I spent on the women's basketball and softball teams. When our teams were transferred to Allen Fieldhouse from Robinson Gym, we had no training room and were not allowed to use the men's training room. The first women's athletic trainer, Irene Maley, converted the Robinson Gym's PE majors' lounge into an athletic training room, and she did an incredible job treating athletes' injuries. We got to play basketball in Allen Fieldhouse, but there was no locker room for women, so our halftime team gathering was in the women's restroom. We sat on the floor under the sinks listening to Coach Washington while women spectators came in to use the restroom. With such a meager budget, we used the same uniforms for basketball and softball, but we got to play the games!

My most special memory is the softball team placing fourth in the College World Series in 1974. The team returned to Lawrence late at night, and no one even knew that we just placed in the top four in the nation. Today, it might have been on the front of the sports page! Our team, under Coach Drysdale, was very good and could compete with the caliber of softball teams today. We did not receive the recognition back then; however, thirty years later the KU Athletics Department made us feel that we did matter and that we were a part of the history of Kansas women's athletics. We did not have all the sports perks that college women athletes have today, but I love knowing how far women's sports have come. It brings tears of joy to my eyes when I see people stand in line to get into the KU women's volleyball games and when I see the beautiful facilities now available to our female college athletes. We were a part of that journey, and we feel like we were pioneers. The current status of intercollegiate athletics for women was our goal; this is what we fought for.

Career notes: With a bachelor of science degree in PE in 1977 and a master of science degree in PE and health in 1988, Vicki Shirley Lowe taught

in the Lawrence public schools from 1978 to 1984 and from 1990 to 2011, and she also coached girls' basketball and track.

Debra "Debbie" Webb, 1973–1979, Basketball, Softball, Tennis

The first season for KU women's basketball was 1968–1969, under Coach Mawson, and many team members were multisport athletes. Title IX became law in 1972, and KU awarded its first athletic scholarships to women in 1975. I played softball and tennis my first year and basketball for five years, but one memory is prominent.

My special memory is of basketball uniform no. 31. In 1977, Lynette Woodard, a high school basketball star from Wichita, came to KU to play for the Jayhawks under Coach Washington. She changed the image of women's sports with her exceptional skill in basketball. From her four years as a Jayhawk, Lynette still holds many KU records and has received many awards for her exemplary achievements. I was a teammate of Lynette's in 1977 and a team manager. It was picture day prior to the season, and the team came in to dress for photos, but the first-year students had not yet been issued their uniforms. As the team manager, I was handing out uniforms in the equipment room when Lynette came to the window, and I knew that her high school jersey had been no. 33. I told Lynette that a KU senior named Shebra Legrant wore no. 33. Lynette insisted that Shebra keep that number and that she would be pleased with any number in her size. I checked the few unclaimed uniform numbers in Lynette's size, and I gave her jersey no. 31. That uniform number became history in women's intercollegiate basketball. Lots of little girls emulated Lynette by wearing a no. 31 jersey. University of Southern California basketball star Cheryl Miller wore no. 31 because she was inspired by Lynette, and later the two played together on the US Olympic women's basketball team. Cheryl's little brother, Reggie Miller, wore no. 31 because he was inspired by his sister, and when he became a star, lots of little boys wanted to wear no. 31. I handed several first-year students uniforms that day, but none were as special as no. 31.

Career notes: Debra Webb was a sports official, a restaurant manager, a veterinary technician, and a nursery specialist during her career.

Beth Boozer Buford, 1974–1978, Golf, Volleyball

My mother recruited me to play golf at KU, but as a first-year student I went to volleyball tryouts with Coach Jack Isgur without telling my mother.

Coach Isgur said after volleyball tryouts that I would either play junior varsity or be an alternate on the varsity team. Needless to say, my mother and father were furious that I tried out for volleyball because I was on a scholarship for golf, but KU then split my scholarship between golf and volleyball. I think the scholarship was in-state tuition of $400, but I do not think it included books. I lettered my first three years in volleyball and all four years in golf. I also bowled for my dad's KU bowling team all four years, but bowling was an extramural club sport and not an AIAW intercollegiate sport.

Coach Mawson had asked my mother, Nancy Boozer, to start the women's golf program on a financial shoestring. My mom coached my older sister Barbie in golf and took her to a couple of AIAW National Golf Championships; one of them was in New York and one was in San Diego at the same time as the men's NCAA golf tournament. She sewed some team outfits for us to wear to pretournament golf banquets. She also coached the only undefeated KU women's basketball team several years before intercollegiate sports began, when it was a club sport. My mother was a Ladies Professional Golf Association (LPGA) golfer, and during her college years she played with LPGA cofounder and KU Hall of Famer Marilyn Smith.

I played in all four of the AIAW National Golf Championships while I was in college because there was no qualifying for them. If golfers could scrape together the money to go and they had a previous record of a low handicap, they could play. The AIAW National Golf Championship sites were Tucson, East Lansing, Kuilima (now Turtle Bay), and Orlando. I finished in the top twenty in Hawaii.

I won several tournaments, but my highlight was beating Betsy King in a sudden-death playoff at a tournament in Texas my junior year. I was in the playoff only because I hit the wrong ball, costing me a two-stroke penalty; otherwise, I would have won by two strokes. I won the Kansas Ladies' Amateur Golf Tournament in 1977 as a college junior. I do not know how many golf scholarships were issued to other KU women while we played. We were mostly in-state players, so tuition would have been the only money given. I know my tuition was paid in 1974–1975, and I believe that in 1975 the national rules permitted out-of-state tuition because I remember saying that I was going to college one year too soon.

Career notes: After college at KU, Beth Boozer became an LPGA golfer. She played on the tour at St. Andrews in 1986, where her father caddied for her. She was on the LPGA European tour in 1987 and played in the US Open, the British Open, and the Asian Open Championships. Beth is retired and lives in San Antonio with her husband, R. C. Buford, general

manager for the Spurs basketball team. Their daughter, Chelsea "C. C." Buford, who played golf at the College of Charleston, is now assistant golf coach at Campbell University in North Carolina.

Terry Flynn, 1973–1977, Volleyball

In fall 1973, I tried out for KU's volleyball team. I do not remember much about the tryouts, but I will never forget looking for my name on the roster and finding that I had made the team. It was one of the happiest days of my life! As a first-year student, I had much to learn because my high school team had not been particularly strong. Coach Mawson and the seniors had much to do with me learning more about the game during my first year in college. Some of the memories I have are hot practices and games in Robinson Gym, learning to play the setter position, red turtleneck jerseys, and road trips to Wichita. In the postseason we traveled to Wooster, Ohio, to the AIAW National Volleyball Championship. Paige Carney officiated many of our games during those years, and she was a tough official!

I had three coaches over four years. My sophomore year, Coach Isgur, a lawyer and a volleyball player from Kansas City, took over the women's volleyball team, and Sheila Moorman was assistant coach. Practices took on a new intensity, roles on the team were defined, and we all learned to play the game at a different level. Extension rolls, diving for the ball, and running the middle became the norm. I did not realize it at the time, but the game of volleyball was changing at a rapid pace. Teams learned to run faster offenses and varied defenses just as the Olympic volleyball teams did. Practices were tough: Coach Isgur had little time for less than our best effort, and I remember ball bins flying at us more than once. We learned a new offensive system in which setters called the offense before each play. Coach Isgur created "cat" and "bird" series plays, with the object that if you called the play with one bird name and a playset number and then used a different type of bird on the second play call, your opponent would expect a different offensive play. I do not know whether this worked, but I do remember laughing at some of the unique "bird" names we used. Mary Jo Peppler, a volleyball legend at the time, came to campus and presented a clinic that gave us even more upper-level skills to learn. One of our favorite teams we played that year was SMSU. Former KU coach Linda Dollar was the head coach for SMSU, and Cecile Reynaud, the future president of the American Volleyball Coaches Association, was the setter on that team. We ran special plays against Coach Dollar's players and had a great time competing against them.

The volleyball uniforms changed during Coach Isgur's two years. In my junior year, 1975, the team wore new, white, long-sleeve jerseys with blue and red piping, with warm-up jackets, and we felt like we had moved into the big leagues. We upper-class-women players began taking over the reins of the team during Coach Isgur's last year. I remember more than one steak dinner on a road trip and wondered whether the KU Athletics Department was approving the money we were spending, but I am sure it would not begin to compare with what the teams spend on road meals now.

Bob Stanclift and assistant Dianna Beebe coached the volleyball team during my senior year. This was a particularly difficult year for me, in that Coach Stanclift was hired to coach volleyball even though he had little to no volleyball coaching experience. His expertise was in softball, and his attempts at running practices and changing offensive and defensive systems we had learned previously were extremely frustrating. Coach Beebe had a volleyball background, and she became the shoulder for us to lean on. In 1976, we played our matches in Allen Fieldhouse for the first time, and KU awarded its first women's volleyball scholarship to Laura Frost that year. Although some days were challenging, it was exciting to participate in the early days in women's collegiate volleyball. I took all that I had learned from the experience and applied it as a volleyball coach during my career.

Career notes: Terry Flynn taught PE and coached volleyball at Shawnee Mission Northwest High School while completing her master of science degree at KU. She coached volleyball for thirty-seven years at four Kansas City area high schools, at KU, at SMSU, and at Park University. In 1993, Terry cofounded the TEAM KC volleyball club to enhance competition opportunities for high school girls in Kansas City. She has retired from coaching but continues to teach PE and health at Blue Valley West High School.

Donna "Spud" Sullivan, 1974–1978, Basketball, Field Hockey, Softball

What fun and success we had with so little! We all traveled in suburban vans for miles and miles to competitions with sack lunches to eat on the way. The KU Athletics Department finally purchased fifteen-passenger vans; we filled a van and thought we were riding in style! Head Coach Drysdale would throw our luggage and equipment bags to Assistant Coach Karen Harris, on top of the van, when loading for the trips. How proud we were of our new softball uniforms. Those short shorts exposed a lot of leg surface to "strawberries"—skin abrasions from sliding into bases on rough soil— playing softball on city-managed fields, and there were no softball helmets.

The field hockey team played in the fall, and our coach had to find old warmups from the 1950s in a Robinson Gym storage room so we would not freeze to death. On road trips we sometimes put five people in a double motel room to save money. The short players got the rollaway beds, and I am five feet, three inches. Our team shared a chartered bus with the University of Nebraska team to travel to the regional field hockey tournament in Fargo, North Dakota, in November, and a blizzard stranded us for three days in Vermilion, South Dakota. No rooms were available at the local motel, so the manager offered our teams couch cushions in the basement for our beds. We waited tables for food at the Country Kitchen restaurant next door because the regular staff could not get there.

There are so many great memories and so little time and space to write about all I remember. I will always be grateful to my special coaches, who had a huge impact and made a difference in my life; and I thank Coach Mawson for her consistent support and persistent fight for KU women's intercollegiate athletics for the past fifty years. What great times and memories my "lifers" and "roomies" made for me, on and off the field.

Career notes: Donna Sullivan is now retired from teaching PE and coaching in Arlington, Texas, schools.

Laura "Frostie" Frost, 1974–1979, Softball, Volleyball

I have so many memories of KU athletics! In softball, I played outfield, primarily in left field, and was part of two Big Eight championships and three College World Series under Coaches Drysdale and Stanclift. My favorite softball memory was from the regional semifinals in 1979, when Kelly Phipps dove and caught a foul ball for the last out, which put us in the College World Series for a third consecutive year! Instant team celebration pile!

I played middle blocker/hitter in volleyball and was selected to the All Big-Eight Team in 1978. Coach Isgur was the volleyball coach my first year and Coach Stanclift my sophomore through senior years. My favorite volleyball memory was in fall 1978 during the Big Eight tournament. KU was hosting, and we beat the University of Nebraska in the first match of pool play. I will never forget the joy of that win and the stunned looks on their faces! We lost our second match, and it was not until recently that KU won a volleyball match against the University of Nebraska again.

Although most of my career has been outside athletics, I played softball and volleyball in highly competitive leagues until I was forty, and I was a

distance runner for almost thirty years. So, in addition to the camaraderie and forever friendships, I learned the value of being in physical shape from all those practices and conditioning sessions! But most importantly the friendships that have endured for the past forty years were made stronger by reunions through the years and made lasting through our support of each other through good times and bad. To the current Jayhawks, I would say treasure these moments and the friends you have made; this is your foundation, and many of these people will be your friends for the rest of your life! Rock Chalk forever!

Career notes: Laura Frost was the assistant volleyball coach at the University of Iowa for two years (1980–1981), then returned to Kansas City, Kansas, and worked for ten years at UMB Bank as a credit analyst. She returned to KU to earn her certification in graphic communications with an emphasis in illustration. Laura has been teaching art for the past twenty-four years at Blue Valley North High School in Overland Park, Kansas.

Debbie Kuhn, 1974–1978, Softball, Volleyball

As I recall my career as a KU athlete, the impact it had on my life is immeasurable. I got the opportunity to play at the highest level of intercollegiate competition in two sports I loved, softball and volleyball. I played with some of the greatest teammates on the planet; a few remain close friends today. And I have so many memories that will stay with me forever.

A common thread that runs deep through the hearts of many of my softball teammates is Coach Drysdale. She played a critical role in directing my future career path. She was our rock. She was a strong, steady leader and quiet motivator. She was a coach who could recognize the differences in players, draw out their strengths, and guide them through their weaknesses.

She was a coach who made you want to give her your best so as never to disappoint. She was a coach who made me want to coach and be given the opportunity to have the kind of impact on young people's lives that she had on mine. After finishing my playing career at KU, I got an opportunity to coach Division I softball with one of my KU teammates. It was an easy decision! To coach a sport that I loved with one of my Jayhawk teammates was a dream come true! And in no small measure, Coach Drysdale was the catalyst for me choosing a career in coaching. Trying to put into words what it meant to be a KU athlete is difficult. My Jayhawk athletic experience, my teammates, and my coaches touched and molded my life. So, thank you

teammates, thank you Coach Drysdale, and thank you KU Athletics for an amazing opportunity. I have memories and friendships that will last a lifetime. It was an honor to wear the crimson and blue!

Career notes: Debbie Kuhn earned her master of science degree in PE at KU in 1980. She served as assistant softball coach and assistant volleyball coach at Iowa State University from 1980 to 1982 and then was appointed head softball coach there, where she coached for fourteen more years (1982–1996).

Marci "Moss" Penner, 1975–1979, Basketball, Softball

Sports were everything to me in my youth. We had no sports camps in those days. I was a farm kid who trained for basketball by shooting baskets in the cemented sheep pen where we had the basket attached to the barn. I simply loved being athletic. We fought to have girls' sports in high school, and finally in my junior year, the girls got to compete in basketball.

Before I transferred to KU, I played intercollegiate sports at Fort Hays State University as a first-year student in 1974–1975. My major at KU was radio, TV, and film, but it was the ninth major I had tried. I was there to play basketball and softball, and we did not have the academic advisors that students have now. My sophomore year was at KU in 1975, and I was selected as a starter in basketball and was just in heaven! Then in preseason basketball that year, I tore my ACL. KU had a rubberized court in Allen Fieldhouse at the time, and my feet did not slide, and it resulted in an ACL injury to my knee. I had surgery in September, and by December, for our last game before the semester break, I was cleared to play again. I tore my ACL again within the first thirty seconds I was in the game. I had another ACL surgery but tore it again the next year. ACL surgeries seemed to be in a pioneer stage then, and this type of surgery repair is much better now. I played KU basketball for parts of my junior and senior years. Before the first surgery I was a guard, after the next surgery I became a forward, and in my final year I set picks for Lynette Woodard.

I began playing catcher in women's softball for Coach Drysdale, but I ended up playing first base after the surgeries. Those early sports days at KU were both thrilling and devastating to me. Though we wore weird uniforms for softball and traveled in vans, we did not think it was backward. We just knew we had a chance to play ball, and nothing was better than that. In 1976–1977, our new basketball uniforms were royal blue with a red-and-white pattern around the elastic at the bottom of the shorts. The

elastic was tight enough for the shorts to pucker. We also had a white version of uniforms, but it was the elastic I will not forget. I noticed that no other team had uniforms like those.

Many things about my college years were very difficult for me, and Jackie King was an important person in my life as my physical therapist. With all the injuries to my knee, I had to choose a different path for a career than athletics, and I had to leave my sports friend circle. You have a huge and loyal following, Coach Mawson, and your reputation is stellar with the oldsters. "Doc" is how I always heard my close friends in athletics refer to you. In the groundwork you laid before my time, I am sure you fought many battles with the administration and had to tolerate many injustices. I would not trade those pioneer days for anything. It really is important that you have accepted the challenge to put those early days in writing.

Career notes: After KU, Marci Penner coached a summer fast-pitch softball team in Madison, Wisconsin, where she earned her master of science degree at the University of Wisconsin in counseling and guidance. She coached softball at Holy Family College in Philadelphia, where she was also an elementary school guidance counselor. After an accident in the training room that left her with a debilitating cranial condition, Marci moved back home to recover in Inman, Kansas, where she is now director of the Kansas Sampler Foundation, an organization that preserves and sustains rural culture in Kansas. She gives presentations as an author of travel guidebooks with photographs of sites in every county in Kansas.

June Koleber James, 1976–1980, Basketball, Softball, Volleyball

My most memorable stories come from my first year at KU as a softball player. We had such outstanding athletes, and after about half of my first season I earned a chance as a starter at center field and contributed to the team in competition. Our van trips included stopping along the route to pick up signs our fans had left for us, and of course, being a first-year student, I was always expected to run and pick up the signs. For many years I have enjoyed seeing some KU Jayhawk signs hanging on the overpass of I-35 as I traveled from Texas back home to Lawrence. Even though I was a first-year student, the other players accepted me and pushed me to be a strong team player for the team's success. This team concept has stayed with me throughout my coaching career because playing time should be earned and not given, and all the effort should be toward a team goal and not individual success.

I received a basketball scholarship at KU and was named to the All Big-Eight Softball Team in 1977 and to the All Big-Eight Volleyball Team in 1977 and 1978. Joannie Wells, my coach at Lawrence High School, was influential for me when in my senior year of high school our team had a 22–0 season record. Because of the continuing influence of my high-quality coaches at KU, I coached for the majority of my educational career.

Career notes: With her bachelor of science degree from KU, June coached volleyball at Washburn University and basketball at Baker University during the 1981–1982 seasons. She moved to Killeen, Texas, in 1982, where she taught PE and coached basketball, softball, and volleyball at Killeen High School for twenty-two years. After raising two children, she completed her master of science degree at Tarleton State University in Stephenville, Texas, in 2001. In 2004, June retired from her coaching career and since then has been an assistant principal at Killeen High School.

Jill Larson Bradney, 1976–1981, Basketball, Softball, Volleyball

My most successful sport at KU was softball, as a third-base player and pitcher, but I was also a forward on the basketball team my first year, and I played outside and middle on the volleyball team my sophomore and junior years. My most vivid memories are of softball. I remember the day before a Big Eight softball doubleheader at KU. It had been a very rainy spring, there had been a lot of rain every day that week, and we were to compete the next day. At that time, the women's softball team practiced and played at the Holcomb sports complex in Lawrence. After practicing as much as we could on the grass in the outfield that day, our team mopped the infield by hand and squeegeed and raked the muddy surface to get it dry enough to play. We had towels and three-pound coffee cans, and we soaked the towels in the standing water on the infield, squeezed dirty rainwater into the coffee cans, and carried them outside the field to dump them. We did end up playing the games on that same field the next day. We all had some blisters and sore hands, but we won the doubleheader!

The Big Eight softball tournament was in Ames, Iowa, in 1979. We lost the first game in the double-elimination tournament and came back to compete in the finals through the losers' bracket. It was so cold that they lit fires in fifty-five-gallon barrels where we could warm our hands. We faced Iowa State University a second time in the finals, and we won the Big Eight tournament that year!

In 1981, my senior year, for the first time ever the softball team had reserved rooms in a hotel for a home game during the Big Eight tournament hosted by KU. We had played through the tournament week and had lost one game. Late Saturday night, it rained a lot and turned cool, and officials threatened to end the tournament with the records as they stood. But Julie Snodgrass was one of our players, and her dad brought his big mower and mowed the Shenk Field for two makeshift softball fields, with the infield shorter, and the tournament resumed later that Sunday morning. Our softball team played in the College World Series, and amazingly, I was named the AIAW first-team All-American at third base that year.

Career notes: Jill Larson completed her bachelor of science degree in 1981 in PE with minors in health and psychology, and she earned her master of science degree at KU in 1990. She has taught PE, health education, and psychology at the Perry-Lecompton High School, Middle School, and Elementary School over the past forty-two years. She coached basketball, track, and volleyball at Perry-Lecompton High School before starting its softball program in 1994 and has been the only softball coach there since then. Jill was inducted into the KU Athletics Hall of Fame in 1981. Her KU no. 22 softball jersey was retired in 2006.

Karen Loudon, 1976–1979, Athletic Trainer, Field Hockey, Volleyball

In my first two years at KU, I was on the volleyball team; in my junior and senior years I was a student athletic trainer; and in my senior year I played club field hockey. One memory I have regarding the volleyball team was when Coach Stanclift arranged for the team to play one of our home matches in Allen Fieldhouse. Some type of temporary paint was used on the floor to mark all the lines for the court. That did not go over very well with the fieldhouse facilities people, and we were not allowed to hold any more matches there and had to return to our former site, Robinson Gym. For conditioning, Coach Stanclift required us to run all the stairs in Allen Fieldhouse and up and down the rows of bleachers. I developed anterior knee pain from all the running and had to get treatment from physical therapist and athletic trainer Jackie King. She diagnosed me with chondromalacia patella, and I had to go to Watkins Health Center to receive ultrasound treatments from her because the women's athletic training facilities in Allen Fieldhouse at the time were bare bones, and they did not have that modality. Because I became interested in a career in sports

medicine, I became a student athletic trainer in my junior year, working in a small room separate from the KU men's athletic training room in Allen Fieldhouse.

Career notes: Karen Loudon taught PE and coached volleyball after graduating from KU. She pursued a sports medicine career, earned a degree in physical therapy at KU Medical Center, and became a certified athletic trainer. She has been a sports medicine and orthopedic physical therapist for more than thirty years at KU's Watkins Health Center.

Janice Loudon, 1977–1979, Field Hockey, Track, Volleyball

As a physical therapy major, I was on the Lawrence campus for three years before I transferred to the Medical Center in Kansas City for my last two years. While in Lawrence, I had the wonderful opportunity to participate in several sports, a different one each year. Two were intercollegiate sports, and one was a club sport. Several fond memories come to mind.

In the fall of my first year, I played volleyball for Coach Stanclift, and the team spent half of practice time doing physical conditioning. One of his favorite drills for shoulder strengthening was handstands. In the spring of that year, KU track coach Teri Anderson recruited me to throw the javelin. I had never thrown the javelin before, and the javelin practice area was the field behind Naismith Hall. One day while warming up with javelin tosses, I pulled the javelin out of the ground and grazed the area just above my eyelid, and there was a lot of blood. The other javelin thrower practicing with me rushed into Allen Fieldhouse telling everyone I had stabbed myself in the eye with the javelin.

I played KU club field hockey with my sister, Karen, under Coach Beebe. I found field hockey a little rough because in our first game against Emporia State University, one of our forwards, Beth Easter, ran off the field with blood flowing down her face from being hit by a high stick, and another teammate left the game later with a thigh contusion.

Career notes: Janice Loudon earned her bachelor of science degree in physical therapy at KU and a PhD in biomechanics from Washington University in St. Louis, Missouri. Her career has been teaching physical therapy. She taught at the University of Kansas Medical Center (KUMC) for more than twenty years; at Duke University in Durham, North Carolina, for one-and-a-half years; and at Rockhurst University in Kansas City, Missouri, for six years. She is currently teaching at Creighton University in Omaha, Nebraska.

Shelley Fox Dyche, 1978–1982, Softball, Volleyball

I am so fortunate to have been a female athlete entering intercollegiate sports in the late 1970s. I have always been extremely proud of my days at KU as a student athlete, not only for the tremendous opportunities in women's sports gaining ground at that time but also because I truly believe those times were the best for being a female student athlete. From 1979 to 1981, I was a softball and volleyball player, and I was a graduate assistant for the softball team after graduation. Coach Stanclift recruited me to play softball at KU, and my most important experiences were the relationships I made on the softball and volleyball teams. I loved and valued the experiences of being a Jayhawk softball assistant coach. I have wonderful memories of faces, laughter, flooded shower rooms, old blue vans with the air-conditioning stuck on, soggy fields, old gyms, melting Easter rabbits, flapping jock straps, and so much more. I am the coach that I am today because of the great experiences I had as a young athlete. I appreciate all the people who helped shaped me, and I consider myself fortunate in so many ways.

Career notes: After Shelley Fox Dyche received her degree and teacher certification in K–12 PE and health at KU, she coached and taught PE at various levels for more than twenty-five years. She is currently an assistant coach for the University of Alabama volleyball team in Tuscaloosa.

Jill Stinson, 1980–1986, Assistant Volleyball Coach, Volleyball

At Cowley County Community College, I played basketball, softball, and volleyball, and KU coach Bob Lockwood offered me a volleyball scholarship in my junior year. I played outside hitter on the volleyball team for my last two years of college and was elected captain in my senior year. While completing my master of science degree in exercise physiology and PE administration at KU, I continued with the volleyball team as assistant coach from 1983 to 1986. My most distinct memory was of Shelly Fox Dyche, a great storyteller. She sang a song to the tune of "K-K-K-Katy" that stuck with me, and that song, along with the KU alma mater, became regular lullabies I sang to my children at bedtime. The words were: "K-K-K-KU, KU Jayhawk. You're the only b-b-b-bird that I adore-o–or. When the m-m-m-moon shines over the fieldhouse, I'll be waiting at the v-v-v-van door."

Career notes: Jill Stinson coached volleyball at Benedictine College in Atchison, Kansas, and at Penn Valley Community College in Kansas City

after being assistant volleyball coach at KU. In 1990, Jill taught PE and coached volleyball at Johnson County Community College in Kansas City, Kansas, where her teams won five conference titles and four regional championships. Her team won the National Junior College Volleyball Championship in 2005 and was runner-up in 2007. Jill has been inducted into three halls of fame: the National Junior College Athletics Association Volleyball Hall of Fame (2006); the Cowley County Community College Hall of Fame (2007); and the Johnson County Hall of Fame (2010). When she was a USVBA player, Jill's team was the Heart of America regional champion thirteen times in fourteen years (1986–1999), she was named a USVBA first-team All-American six times, and she was the most valuable player at the USVBA Championship in 1997. Jill played professionally for the Kansas City Lightning volleyball team in 1998, and in 2013 she became the first professional coach of the Heart of America Havoc volleyball team. Jill still teaches at Johnson County Community College.

Beth Walker, 1981–1984, Volleyball

As a young girl, I always loved basketball, and I anticipated playing the game in college. In ninth grade I was introduced to the game of volleyball and thought it was a great way to stay in shape for basketball. My high school volleyball coach was more aware than my basketball coach was of when and where college tryouts were held, and she encouraged us to visit campuses and participate in tryouts. In my senior year of high school, I traveled to several volleyball tryout camps with my dad, including one at KU. The tryouts were held in Robinson Gym, and I was the only player from Nebraska there among dozens of girls from towns throughout Kansas and Missouri. As we ran through numerous drills and scrimmaged through-out the morning, Coach Lockwood tried several different combinations of players and spent time evaluating all the "hopefuls" for his current roster. As the tryout wrapped up, Coach Lockwood asked me a few questions and spoke with my dad. As the oldest of five children, I had always known two things: I was expected to go to college, and I needed to get a scholarship to pay for it. But I always thought I would accomplish this playing basketball. Good fortune smiled on me that day and set the course of my life. I ac-cepted an offer to become a Jayhawk volleyball player. I played four years of KU women's volleyball, and the life lessons I received as a member of the team and a student athlete have provided me a rock-solid foundation for a very successful personal and professional life. My experience as a student

athlete probably could not be repeated in this day and age because of the level of competition and time commitment required. I was an academic All-American and volleyball team captain.

Career notes: Beth Walker graduated from KU with a bachelor of arts in journalism and worked for Procter & Gamble and for Clorox before going into business for herself. She is currently the owner and founder of College Funding Coaches. She has published two books and resides in Colorado Springs, Colorado. Her memories represent KU women athletes who played under both AIAW and NCAA governance regulations during the transition year of 1981–1982.

ACKNOWLEDGMENTS

Books are not written exclusively by the author. Many others lent their perspectives, expertise, advice, and support in the completion of this book. I appreciate everyone who contributed to the content and publication of this book.

The suggestion and encouragement of Senior Director of K-Club Candace Dunback that I should write this book was the initial inspiration for recalling past events about the early years of KU women's intercollegiate sports. I was motivated to verify facts and locate documentation for the information to be presented in this book. KU professors Jordan Bass and Bernie Kish have requested me to present this information to students in their graduate sport management classes over the past few years. This required me to condense the early story of KU women's athletics into a ninety-minute lecture. Several civic organizations in Lawrence asked me to present the major points of this book in a half-hour program, and those audiences' extraordinary response convinced me this story was of value to many people supportive of KU women's sports.

Records collected by the late Janet Nuzman, the volunteer archivist for the Kansas Association for Intercollegiate Athletics for Women, are now in the Kansas Historical Society Archives in Topeka. These archived records were essential for reporting the developmental stages of the state organization for women's collegiate sports and for providing records of early sports competition in Kansas. The first women athletics directors in Kansas colleges in 1969, who attended the inaugural meeting for the development of women's intercollegiate sports competition, were very insightful and are recognized in this book as preeminent colleagues in the development of women's intercollegiate sports five years before there was a national organization.

Associate Athletics Directors Jim Marchiano and Nicole Corcoran offered access to information and photos from the first decade of KU women's sports, held by KU Athletics. Photographs in this book were shared with permission of KU Athletics, with the assistance and support of KU Athletics Hall of Fame Director Abbi Craig. Associate Archivist and Records Manager of the University of Kansas Archives in Spencer Research Library Letha Johnson identified many century-old photographs and granted permission for me to use them in this book. My niece Dianne Hon

photographed me with the KU crew boat along the Kansas River, which appears on the book jacket, and she also took the photos of my parents' farmhouse, where my sisters and I grew up, along with our barn. The aerial photograph of the Rock Chalk Park soccer, softball, and track-and-field stadia taken by pilot John English was an unexpected treasure. My niece Amy Helman, whose profession is architectural design, provided technological assistance and expertise in photograph design for the book.

I am most indebted to Barbara Watkins, my editor, who advised succinctness in the content and meticulously reviewed the text for grammatical, stylistic, and typographical errors to be corrected. Furthermore, Barbara guided me through the steps toward publication of this book. As an editor for me, a first-time book author, she was patient and superb. Editor in Chief Joyce Harrison of the University Press of Kansas and her excellent staff were very supportive in the publication of this book.

My gratitude is extended to the early KU women athletes, who experienced this story firsthand. Without their enthusiasm and persistence to compete in sports and their cooperation with coaches and teammates, KU women's intercollegiate athletics would not have happened, and this story would not have been written. I particularly enjoyed reliving the stories of some of those early athletes included in the Appendix. When I consider their athletic achievements amid the difficult conditions those early women athletes endured, I am reassured to know their experiences will not be forgotten but rather memorialized as an essential aspect of KU history and tradition.

For my friends and acquaintances who have encouraged my writing efforts and patiently awaited the publication of this book, I am finally able to share this story. I am grateful to my sisters, nieces, and nephews, who have been supportive of my career and my work on this book; more importantly, I appreciate their interest in my professional life, which they followed from a distance, because this book might provide an enlightened perspective of the athletics involvement of someone they know as "Sister" or "Aunt M." This book is my gift of gratitude to KU Athletics and to all the women athletes who have been KU Jayhawks.

LMM

NOTES

CHAPTER TWO. A HALF CENTURY OF SPORTS
FOR WOMEN IN THE UNITED STATES

1. Sara Shepard, "KU Celebrates 150 Years," *Lawrence Journal-World,* August 23, 2015, http://www2.ljworld.com/news/2015/aug/23/ku-celebrates-150-years.

2. John A. Lucas and Richard A. Smith, *Saga of American Sport* (Philadelphia: Lea and Febiger, 1978), 250–256.

3. Lucas and Smith, *Saga of American Sport,* 143.

4. Ken Polsson, *Chronology of Sport,* last updated May 5, 2017, http://worldtimeline .info/sports.

5. Deobold B. Van Dalen and Bruce L. Bennett, *World History of Physical Education* (Englewood Cliffs, NJ: Prentice Hall, 1971), 422–423.

6. Arlisha R. Norwood, "Amelia Bloomer," National Women's History Museum, 2017, https://www.womenshistory.org/education-resources/biographies/amelia -bloomer.

7. Kenna Howat, "Pedaling the Path to Freedom," National Women's History Museum, last modified 2012, https://www.womenshistory.org/articles/pedaling-path -freedom.

8. World Baseball and Softball Confederation, "The History of Softball," 1991, http://www.wbsc.org/softball/history-of-softball/.

9. Betty Spears and Richard Swanson, *History of Sport and Physical Education in the United States* (Dubuque, IA: Brown, 1988), 129.

10. Spears and Swanson, *History of Sport and Physical Education,* 173.

11. Bernice L. Webb, *The Basketball Man: James Naismith* (Lawrence: University Press of Kansas, 1973), 60.

12. Webb, *Basketball Man,* 61–67.

13. Webb, 104, 175–226.

14. Joanna Davenport, "The Tides of Change in Women's Basketball Rules," in *A Century of Women's Basketball: From Frailty to Final Four,* ed. Joan S. Hult and Marianna Trekell (Reston, VA: AAHPERD, 1991), 84–85.

15. Lynne F. Emery and Margaret Toohey-Costa, "Hoops and Skirts: Women's Basketball on the West Coast, 1892–1930s," in *A Century of Women's Basketball: From Frailty to Final Four,* eds. Joan S. Hult and Marianna Trekell (Reston, VA: AAHPERD, 1991), 137–138.

16. Davenport, Tides of Change in Women's Basketball Rules," 89–95.

17. Spears and Swanson, *History of Sport and Physical Education,* 178.

18. John Kessel, "History of Volleyball Rules," USA Volleyball, updated 2006, adapted from "A Summary of Seventy-Five Years of Rules," by William T. Odeneal, https://www.teamusa.org/USA-Volleyball/About-Us/~/media/8B32C6A5304A4475.

19. Spears and Swanson, *History of Sport and Physical Education*, 225–226.

20. Lucas and Smith, *Saga of American Sport*, 242–245.

21. Spears and Swanson, *History of Sport and Physical Education*, 238–239.

22. Van Dalen and Bennett, *World History of Physical Education*, 452–453.

23. Spears and Swanson, *History of Sport and Physical Education*, 239; Van Dalen and Bennett, *World History of Physical Education*, 452.

24. Spears and Swanson, 239–242.

25. Joan S. Hult, "The Governance of Athletics for Girls and Women," in *A Century of Women's Basketball: From Frailty to Final Four*, eds. Joan S. Hult and Marianna Trekell (Reston, VA: AAHPERD, 1991), 70–71.

26. Spears and Swanson, *History of Sport and Physical Education*, 246.

27. Lucas and Smith, *Saga of American Sport*, 359–360.

28. Spears and Swanson, *History of Sport and Physical Education*, 244.

29. Spears and Swanson, 312.

30. Nancy Nygaard Pilon, *Women's Athletics at the University of Kansas During the Progressive Era, 1890–1920* (PhD diss., University of Kansas, May 31, 2008), 38–40, https://kuscholarsworks.ku.edu/bitstream/handle/1808/19068/umi-ku-2370_1.pdf.

31. Pilon, *Women's Athletics at the University of Kansas*, 57.

32. Pilon, 57.

33. Pilon, 53.

34. Van Dalen and Bennett, *World History of Physical Education*, 410–411.

35. Van Dalen and Bennett, 448, 490–491.

36. Spears and Swanson, *History of Sport and Physical Education*, 194.

37. Lucas and Smith, *Saga of American Sport*, 349–350.

38. Spears and Swanson, *History of Sport and Physical Education*, 239–242.

39. Lucas and Smith, *Saga of American Sport*, 350.

40. Lucas and Smith, 356.

41. Lucas and Smith, 356–359.

42. International Olympic Committee, "Key Dates in the History of Women in the Olympic Movement," updated 2014, https://www.olympic.org/women-in-sport/key-dates.

43. Roxanne M. Albertson, "Basketball Texas Style, 1910–1933," in *A Century of Women's Basketball: From Frailty to Final Four*, ed. Joan S. Hult and Marianna Trekell (Reston, VA: AAHPERD, 1991), 155–166.

44. Lucas and Smith, *Saga of American Sport*, 364–366.

45. International Olympic Committee, "Key Dates in the History of Women in the Olympic Movement."

46. Spears and Swanson, *History of Sport and Physical Education*, 258.

47. Spears and Swanson, 299; Phebe M. Scott, "What Is DGWS's Responsibility for the Highly Skilled Woman Competitor?" speech delivered to DGWS Executive Council, Washington, DC, December 28, 1961, Illinois State University Archives.

48. Nancy Weltzheimer Wardwell, "Rachel E. Bryant: Twenty-One Years of Women's Leadership in Basketball—in Sport," in *A Century of Women's Basketball: From Frailty to Final Four*, ed. Joan S. Hult and Marianna Trekell (Reston, VA: AAHPERD, 1991), 256.

49. Joan S. Hult, "The Saga of Competition," in *A Century of Women's Basketball: From Frailty to Final Four*, ed. Joan S. Hult and Marianna Trekell (Reston, VA: AAHPERD, 1991), 233.

50. Wardwell, "Rachel E. Bryant," 256.

51. Hult, "Saga of Competition," 233.

52. Van Dalen and Bennett, *World History of Physical Education*, 533.

53. Phebe M. Scott, "Promoting Girls and Women's Sports," speech delivered at the First National Institute for Girls and Women's Sports, University of Oklahoma, Norman, Oklahoma, October 1963, Illinois State University Archives.

54. Phebe M. Scott, "Women's Sports in 1980," speech delivered at the Second National Institute on Girls and Women's Sports, Michigan State University, Lansing, Michigan, September 30, 1965, Illinois State University Archives.

55. Phebe M. Scott, "Reflections on Sports for Women," speech delivered at the Third National Institute on Girls and Women's Sports, Salt Lake City, Utah, January 23, 1966, Illinois State University Archives.

56. Phebe M. Scott, "Food for Thought for the Future," speech delivered at the Fourth National Institute on Girls and Women's Sports, Indiana University, Bloomington, Indiana, December 9, 1966, Illinois State University Archives.

57. Fran Koenig and Mary Weston, "Women's Basketball Officiating," in *A Century of Women's Basketball: From Frailty to Final Four*, ed. Joan S. Hult and Marianna Trekell (Reston, VA: AAHPERD, 1991), 27–68.

58. Wardwell, "Rachel E. Bryant," 257.

59. Koenig and Weston, "Women's Basketball Officiating," 268.

60. Phebe M. Scott, "Women's Programs Should Be Different: Commissioner's Program at AAHPERD," speech delivered at the CIAW session at AAHPERD Convention, Kiel Auditorium–Convention Hall, St. Louis, Missouri, April 1, 1968, Illinois State University Archives.

61. Hult, "Saga of Competition," 230–231.

CHAPTER THREE. SPORT LEADERSHIP EXPERIENCE

1. Daryl Limpus, "The Archie Whirlwinds: A History of Archie High School Basketball," unpublished manuscript, 1984, 1–7.

2. Limpus, "Archie Whirlwinds," 27.

3. Archie 2000 History Book Committee, *Archie: A History of a Railroad Town* (Rich Hill, MO: Bell Books, 2000), 33–35.

4. Archie 2000 History Book Committee, *Archie*, 16.

5. Archie 2000 History Book Committee, 33.

6. "Kansas City Basketball Team Nicknames," *Kansas City Sport* (blog), updated December 9, 2017, http://www.allstarrsports.com/index.php/kansas-city-sports/78 -kansas-city-basketball-team-nicknames.

7. Joan S. Hult, "The Saga of Competition," in *A Century of Women's Basketball: From Frailty to Final Four*, ed. Joan S. Hult and Marianna Trekell (Reston, VA: AAHPERD, 1991), 233.

8. Mildred Barnes, "Coaching and Game Reflections, 1940s to 1980s," in *A Century of Women's Basketball: From Frailty to Final Four*, ed. Joan S. Hult and Marianna Trekell (Reston, VA: AAHPERD, 1991), 339.

CHAPTER FOUR. FORMATION OF
WOMEN'S INTERCOLLEGIATE SPORTS AT KU

1. "Affidavit of Donna A. Lopiano: *AIAW v. NCAA*," in the US District Court for the District of Columbia (October 9, 1981), 65–66.

2. "Affidavit of Donna A. Lopiano," 67.

3. Joan S. Hult, "The Legacy of AIAW," in *A Century of Women's Basketball: From Frailty to Final Four*, ed. Joan S. Hult and Marianna Trekell (Reston, VA: American Association for Health, Physical Education, Recreation, and Dance, 1991), 282–283.

4. Hult, "Legacy of AIAW," 231.

5. "Affidavit of Donna A. Lopiano," 68, 70.

6. "Affidavit of Donna A. Lopiano," 71–72.

7. "Affidavit of Donna A. Lopiano," 72–73.

8. "Affidavit of Donna A. Lopiano," 76.

9. Commission on Intercollegiate Athletics for Women, *Procedures for Intercollegiate Athletic Events* (Washington, DC: American Association for Health, Physical Education, and Recreation, 1967).

10. Nancy Weltzheimer Wardwell, "Rachel E. Bryant: Twenty-One Years of Women's Leadership in Basketball—in Sport," in *A Century of Women's Basketball: From Frailty to Final Four*, ed. Joan S. Hult and Marianna Trekell (Reston, VA: American Association for Health, Physical Education, Recreation, and Dance, 1991), 257.

11. Joan S. Hult, "The Saga of Competition," in *A Century of Women's Basketball: From Frailty to Final Four*, ed. Joan S. Hult and Marianna Trekell (Reston, VA: American Association for Health, Physical Education, Recreation, and Dance, 1991), 226.

12. Jill Hutchison, "Women's Intercollegiate Basketball: AIAW/NCAA," in *A Century of Women's Basketball: From Frailty to Final Four*, ed. Joan S. Hult and Marianna Trekell, (Reston, VA: American Association for Health, Physical Education, Recreation, and Dance, 1991), 310–311.

13. Mark D. Hersey, "They've Come a Long Way Maybe," KU History, February 8, 2012, kuhistory.com/articles/theyve-come-long-way-maybe.

14. Nancy Nygaard Pilon, "Women's Athletics at the University of Kansas during the Progressive Era, 1890–1920," PhD diss., University of Kansas, May 31, 2008, 57, https://kuscolarsworks.ku.edu/bitstream/handle/1808/19068/umi-ku-2370_1.pdf.

15. Personnel History of the KU Athletics Women's Sports Head Coaches, 2016.

16. Pilon, "Women's Athletics at the University of Kansas," 57.

17. Pat Kaufman, Chief Financial Officer, University of Kansas Athletics, email to author, January 14, 2020.

18. Jeanne Urlaub, "AKWIS Survey of Sources of Funding for Women's Intercollegiate Sports," research results presented at the AKWIS Fall Meeting, Rock Springs 4-H Ranch, Kansas, September 1970, Kansas Historical Society Archives (Topeka), Janet Nuzman documents.

19. Urlaub, "AKWIS Survey."

20. *KAIAW Communications*, meeting minutes and sports competition results, April 1975, Kansas Historical Society Archives (Topeka), Janet Nuzman documents.

21. Kelly H. Foos, "Toward a Rational Seat Belt Policy in Kansas," *Kansas Law Review* 56 (August 24, 2008): 1006, https://kuscholarworks.ku.edu/bitstream/handle/1808/20004/Foos_Final.pdf.

CHAPTER FIVE. THE FIRST DECADE OF
KU WOMEN'S INTERCOLLEGIATE SPORTS

1. Second DGWS National Volleyball Championship, University of Kansas: Final Report, February 4–6, 1971, University of Maryland Archives.

2. *AKWIS Newsletter*, April 1969.

3. *AKWIS Newsletter*, March 1969–April 1973; *KAIAW Communications*, September 1973–1981, meeting minutes and sports competition results, Kansas Historical Society Archives (Topeka), Janet Nuzman documents.

4. *AKWIS Newsletter*, April 1971.

5. KU Athletics, "Personnel History of the KU Athletics Women's Sports Head Coaches," 2016.

6. Jack Dodd, "Once a Jayhawk, Always a Jayhawk: Marilyn Smith," *Rock Chalk Weekly* September 12, 2017, https://kuathletics.com/news/2017/9/12/rock-chalk-weekly-once-a-jayhawk-always-a-jayhawk-marilyn-smith.aspx.

7. Bill Mayer, "Buford's Roots Run Deep," *Lawrence Journal-World,* May 25, 2007, http://www2.ljworld.com/news/2007/may/25/mayer_bufords_ku_roots_run_deep/.

8. *AKWIS Newsletter,* November 1970.

9. *AKWIS Newsletter,* November 1971.

10. *AKWIS Newsletter,* April 1969.

11. *AKWIS Newsletter,* April 1970.

12. *AKWIS Newsletter,* February 1971.

13. *AKWIS Newsletter,* February 1972.

14. *KAIAW Communications,* February 1973.

15. *KAIAW Communications,* February 1973.

16. *KAIAW Communications,* February 1974.

17. Charles Kyle and Theresa Kurtz, eds., *Kansas University Women's Basketball Media Guide: 2015–2016* (Lawrence: KU Athletics, 2016), 141.

18. Kyle and Kurtz, *KU Women's Basketball Media Guide,* 141.

19. Kyle and Kurtz, 141.

20. Kyle and Kurtz, 141.

21. In 1971, St. Benedict's College for men merged with Mount St. Scholastica college for women to become Benedictine College.

22. *AKWIS Newsletter,* April 1971.

23. Kyle and Kurtz, *KU Women's Basketball Media Guide,* 141.

24. *AKWIS Newsletter,* March 1972.

25. *AKWIS Newsletter,* April 1972.

26. Kyle and Kurtz, *KU Women's Basketball Media Guide,* 141.

27. *KAIAW Communications,* April 1973.

28. *KAIAW Communications,* April 1974.

29. *KAIAW Communications,* April 1973.

30. Kyle and Kurtz, *KU Women's Basketball Media Guide,* 141.

31. *KAIAW Communications,* April 1974.

32. Kyle and Kurtz, *KU Women's Basketball Media Guide,* 141.

33. *KAIAW Communications,* April 1974.

34. *KAIAW Communications,* April 1975.

35. Kyle and Kurtz, *KU Women's Basketball Media Guide,* 141.

36. *KAIAW Communications,* March 1977.

37. *KAIAW Communications,* April 1977.

38. Kyle and Kurtz, *KU Women's Basketball Media Guide,* 141.

39. Kyle and Kurtz, 141–142.

40. Kyle and Kurtz, 142.

41. *AKWIS Newsletter*, April 1971.

42. *AKWIS Newsletter*, April 1972.

43. *AKWIS Newsletter*, April 1973.

44. *KAIAW Communications*, April 1974.

45. *KAIAW Communications*, March 1975.

46. "Personnel History of the KU Athletics Women's Sports Head Coaches."

47. *AKWIS Newsletter*, May 1970.

48. *AKWIS Newsletter*, May 1971.

49. *AKWIS Newsletter*, May 1972.

50. *AKWIS Newsletter*, May 1970–1972.

51. *KAIAW Communications*, May 1973.

52. *KAIAW Communications*, June 1974.

53. Bill Plummer III and Larry C. Floyd, *A Series of Their Own: The History of the Women's College World Series* (Oklahoma City: Turn Key Communications, 2013), http://plummersoftball.com.

54. "Personnel History of the KU Athletics Women's Sports Head Coaches."

55. *AKWIS Newsletter*, September 1969.

56. *AKWIS Newsletter*, November 1971; *KAIAW Communications*, October 1973.

57. *KAIAW Communications*, December 1973.

58. *KAIAW Communications*, April 1974.

59. "Personnel History of the KU Athletics Women's Sports Head Coaches."

60. *AKWIS Newsletter*, April 1971.

61. *KAIAW Communications*, February 1974.

62. "Personnel History of the KU Athletics Women's Sports Head Coaches."

63. *KAIAW Communications*, February 1974.

64. *KAIAW Communications*, June 1976.

65. "Personnel History of the KU Athletics Women's Sports Head Coaches."

66. *KAIAW Communications*, June 1974.

67. *KAIAW Communications*, June 1975.

68. *KAIAW Communications*, June 1977.

69. Mayer, "Buford's Roots Run Deep."

70. "Personnel History of the KU Athletics Women's Sports Head Coaches."

71. Nancy Nygaard Pilon, "Women's Athletics at the University of Kansas During the Progressive Era, 1890–1920," PhD diss., University of Kansas, May 31, 2008, 63, https://kuscholarsworks.ku.edu/bitstream/handle/1808/19068/umi-ku-2370_1.pdf.

72. *KAIAW Communications*, April 1974.

73. Linda Schild, "Student Senate Approves Funds," *Lawrence Daily Journal World*, July 22, 1974, https://lawrencepl.newspaperarchive.com/lawrence-daily-journal-world /1974-07-22/page-11/.

74. Andy Hyland, "Finance Officer Counts Down to Retirement," *Lawrence Journal-World*, January 15, 2012, http://www2.ljworld.com/news/2012/jan/15/16-things-fi nance-officer-counts-down-retirement/.

75. Hyland, "Finance Officer Counts Down to Retirement."

CHAPTER SIX. EARLY KU WOMEN ATHLETES
ON THE NATIONAL SCENE

1. Christine Metz, "1970: Memories of Violence in City Still Strong," *Lawrence Journal-World*, April 20, 2010, http://www2.ljworld.com/news/2010/apr/20/1970/.

2. Brenna Hawley, "A Generation Ablaze," *University Daily Kansan*, April 20, 2010, http://www.kansan.com/news/a-generation-ablaze/article_07027d68-c405-5d8c -bb83-23b9adae6449.html.

3. DGWS Second National Volleyball Championship, University of Kansas: Final Report, February 4–6, 1971, University of Maryland Archives.

4. DGWS Second National Volleyball Championship.

5. DGWS First National Volleyball Championship, Long Beach State University: Final Report, April 23–25, 1970, University of Maryland Archives.

6. Jerry Schwartz and Hub Meyers, "Three Injured in Bomb Blast on KU Campus," *Lawrence Journal-World*, December 12, 1970, http://www.lawrence.com/news/1970 /dec/12/three-injured-bomb-blast-ku-camp.

7. DGWS Second National Volleyball Championship.

8. DGWS Second National Volleyball Championship.

9. DGWS Second National Volleyball Championship.

10. DGWS Second National Volleyball Championship.

11. DGWS Second National Volleyball Championship.

12. DGWS Third National Volleyball Championship, Miami-Dade College: Final Report, February 5–7, 1972, University of Maryland Archives.

13. AIAW National Volleyball Championship, Brigham Young University: Final Report, February 1–3, 1973, University of Maryland Archives.

14. AIAW Fourth National Volleyball Championship, Wooster College, Ohio: Final Report, December 13–15, 1973, University of Maryland Archives.

15. Jill Hutchison, "Women's Intercollegiate Basketball: AIAW/NCAA," in *A Century of Women's Basketball: From Frailty to Final Four*, ed. Joan S. Hult and Marianna Trekell, (Reston, VA: AAHPERD, 1991), 309–311.

16. Charles Kyle and Theresa Kurtz, *KU Women's Basketball Media Guide: 2015–2016* (Lawrence: KU Athletics, 2016), 141–142.

17. *KAIAW Communications*, June 1972.

18. *KAIAW Communications*, June 1973–1978.

19. Bill Plummer and Larry C. Floyd, "A Series of Their Own: The History of the Women's College World Series," Turn Key Communications, December 13, 2011, http://plummersoftball.com.

20. *KAIAW Communications*, June 1974.

21. Plummer and Floyd, "Series of Their Own."

22. Plummer and Floyd, "Series of Their Own."

23. *KAIAW Communications*, June 1974.

24. *KAIAW Communications*, June 1973–1978.

CHAPTER SEVEN. OVERARCHING REGULATIONS
INFLUENCING WOMEN'S INTERCOLLEGIATE ATHLETICS

1. Jeanne Urlaub, "History: The Organization of AKWIS," *KAHPER Journal* 39, no. 1 (October 1970): 7.

2. *AKWIS Newsletters*, Association of Kansas Women's Intercollegiate Sports meetings and sport competition results, March 1969–April 1973, Kansas Historical Society Archives (Topeka), Janet Nuzman documents.

3. Urlaub, "History."

4. *AKWIS Newsletter*, April 1969.

5. *AKWIS Newsletter*, April 1969.

6. *AKWIS Newsletter*, March 1970.

7. *AKWIS Newsletter*, April 1970.

8. *AKWIS Newsletter*, September 1970.

9. Jeanne Urlaub, "AKWIS Survey of Sources of Funding for Women's Intercollegiate Sports," research results presented to AKWIS representatives, Rock Springs 4-H Ranch, Kansas, September 1970.

10. *AKWIS Newsletter*, April 1971.

11. *AKWIS Newsletter*, September 1971; *AKWIS Newsletter*, November 1971.

12. Jill Hutchison, "Women's Intercollegiate Basketball: AIAW/NCAA," in *A Century of Women's Basketball: From Frailty to Final Four*, ed. Joan S. Hult and Marianna Trekell (Reston, VA: AAHPERD, 1991), 131.

13. Joan S. Hult, "The Legacy of AIAW," in *A Century of Women's Basketball: From Frailty to Final Four*, ed. Joan S. Hult and Marianna Trekell (Reston, VA: AAHPERD, 1991), 282–284.

14. Betty Spears and Richard Swanson. *History of Sport and Physical Education in the United States* (Dubuque, IA: Wm. C. Brown, 1988), 313–314.

15. Jake Simpson, "How Title IX Sneakily Revolutionized Women's Sports," *Atlantic*, June 21, 2012, https://www.theatlantic.com/entertainment/archive/2012/06/.

16. US Department of Labor, Education Amendments of 1972, Title IX, sec. 1681–1688, https://www.dol.gov/oasam/regs/statutes/titleix.htm.

17. Hult, "Legacy," 284.

18. Hult, "Legacy," 285.

19. "Affidavit of Donna A. Lopiano: *AIAW v. NCAA*," in the US District Court for the District of Columbia, October 9, 1981, 46.

20. "Affidavit of Donna A. Lopiano," 45.

21. Hult, "Legacy," 297–297.

22. *KAIAW Communications*, Kansas Association for Intercollegiate Athletics for Women meetings and sport competition results, October 1973–May 1980, Kansas Historical Society Archives (Topeka), Janet Nuzman documents.

23. *KAIAW Communications*, September 1973.

24. National Women's Law Center Margaret Fund, "The Living Law," http://www.titleix.info/history/the-living-law.aspx.

25. US Department of Education, Office of Civil Rights, "A Policy Interpretation: Title IX and Intercollegiate Athletics," *Federal Register* 44, no. 239, last modified December 11, 1979, https://www2.ed.gov/about/offices/list/ocr/docs/t9interp.html.

26. Catherine Lhamon, "Title IX Resource Guide" (Washington, DC: US Department of Education, Office for Civil Rights), updated April 2015, http://www2.ed.gov/about/offices/list/ocr/letters/colleague-201504-title-ix-coordinators.pdf.

27. "Affidavit of Donna A. Lopiano," 124.

28. US Department of Education, Office of Civil Rights, "Policy Interpretation: Title IX and Intercollegiate Athletics," *Federal Register* 44, no. 239 (December 1979).

29. Ying Wu, "Early NCAA Attempts at the Governance of Women's Intercollegiate Athletics, 1968–1973," *Journal of Sport History* 26, no. 3 (April 1999): 585–601, http://library.1a84.org/SportsLibrary/JSH/JSH1999/JSH2603/JSH2603i.pdf.

30. "Affidavit of Donna A. Lopiano," 126–127.

31. Hult, "Legacy," 284–288.

32. Hult, "Legacy," 285.

33. Nancy Nygaard Pilon, "Women's Athletics at the University of Kansas during the Progressive Era, 1890–1920," PhD diss., University of Kansas, May 31, 2008, https://kuscolarsworks.ku.edu/bitstream/handle/1808/19068/umi-ku-2370_1.pdf.

34. *KAIAW Communications*, September 1974.

35. *KAIAW Communications*, April 1974.

36. "Affidavit of Donna A. Lopiano," 67.

37. "Affidavit of Donna A. Lopiano," 140–148.

38. "Affidavit of Donna A. Lopiano," 151.

39. "Affidavit of Donna A. Lopiano," 157–159.

40. "Affidavit of Donna A. Lopiano," 175.

41. "Affidavit of Donna A. Lopiano," 191.

42. Hult, "Legacy," 300–301.

43. "Affidavit of Donna A. Lopiano," 264–265.

44. Hult, "Legacy," 293.

45. *KAIAW Communications*, May 1975.

46. *KAIAW Communications*, May 1975.

47. *KAIAW Communications*, September 1975.

48. *KAIAW Communications*, September 1976.

49. "Affidavit of Donna A. Lopiano," 185–189.

50. "Affidavit of Donna A. Lopiano," 199–201.

51. *KAIAW Communications*, April 1976.

52. *KAIAW Communications*, April 1977.

53. *KAIAW Communications*, February 1976.

54. "Affidavit of Donna A. Lopiano," 333.

55. "Affidavit of Donna A. Lopiano," 204.

56. "Affidavit of Donna A. Lopiano," 207.

57. "Affidavit of Donna A. Lopiano," 216, 218.

58. Hult, "Legacy," 294.

59. *KAIAW Communications*, April 1978.

60. *KAIAW Communications*, April 1979.

61. *KAIAW Communications*, April 1980.

62. *KAIAW Communications*, September 1979.

63. US Department of Education, Office of Civil Rights, "Policy Interpretation."

64. Hult, "Legacy," 300.

65. Wu, "Early NCAA Attempts at the Governance of Women's Intercollegiate Athletics."

66. KU Athletics, "Personnel History of the KU Athletics Administration," 2016.

67. "Kansas Athletics to Celebrate 50 Years of Women's Sports," KU Athletics.com, August 16, 2017, https://kuathletics.com/news/2017/8/15/cross-country-kansas -athletics-to-celebrate-50-years-of-womens-sports.aspx.

68. "Affidavit of Donna A. Lopiano," 223.

69. "Affidavit of Donna A. Lopiano," 595–596, 661; Hult, "Legacy," 238–239.

70. Lhamon, "Title IX Resource Guide."

71. "Affidavit of Donna A. Lopiano," 235, 247.

72. "Affidavit of Donna A. Lopiano," 259–261, 286, 290.

73. "Affidavit of Donna A. Lopiano," 297, 306–307, 311.

74. "Affidavit of Donna A. Lopiano," 323, 332–333.

75. "Affidavit of Donna A. Lopiano," 304, 368, 370.

76. "Affidavit of Donna A. Lopiano," 411–412, 420–422, 426–427.

77. "Affidavit of Donna A. Lopiano," 311, 335.

78. "Affidavit of Donna A. Lopiano," 429, 589–590.

79. "Affidavit of Donna A. Lopiano," 396, 475, 477.

80. "Affidavit of Donna A. Lopiano," 537–542.

81. "Affidavit of Donna A. Lopiano," 519.

82. "Affidavit of Donna A. Lopiano," 586, 591.

83. "Affidavit of Donna A. Lopiano," 562, 567–569, 579.

84. "Affidavit of Donna A. Lopiano," 566–568.

85. "Affidavit of Donna A. Lopiano," 560, 593.

86. Federal Trade Commission, "The Antitrust Laws," https://www.ftc.gov/tips
-advice/competition-guidance/guide-antitrust-laws.

87. Hult, "Legacy," 301.

88. "Affidavit of Donna A. Lopiano," 589–590, 696.

89. Hult, "Legacy," 301–302.

90. "Affidavit of Donna A. Lopiano," 59.

CHAPTER EIGHT. MY INTERIM YEAR

1. Phebe M. Scott, "Intercollegiate Sports for Women: Present Problems and Future Directions," speech delivered to the DGWS National Conference on Sports Programs for College Women, YMCA of the Rockies, Estes Park, Colorado, June 23, 1969, Illinois State University Archives.

CHAPTER NINE. BEYOND ATHLETICS:
AN ACADEMIC CAREER IN SPORT MANAGEMENT

1. American Alliance for Health, Physical Education, Recreation and Dance, "AAHPERD Becomes SHAPE America," December 5, 2013, https://www.prnewswire.com/news-releases/aahperd-becomes-shape-america-234624081.html.

2. Jacquelyn Cuneen, "Oral History: North American Society for Sport Management," updated March 13, 2002, https://www.nassm.com/InfoAbout/NASSM/History.

CHAPTER TEN. THE MISSION:
A DREAM BECOMES REALITY

1. Paul Newman, "Forty Years On, How Billie Jean King Led the Revolution That Propelled Women to Greater Equality," *Independent* (June 18, 2013), https://www.independent.co.uk/sport/tennis/forty-years-on-how-billie-jean-king-led-the-revolution-that-propelled-women-to-greater-equality-8664164.html.

2. Jesse Greenspan, "When Billie Beat Bobby," *History*, September 20, 2013, https://www.history.com/news/billie-jean-king-wins-the-battle-of-the-sexes-40-years-ago.

3. "Our Athletes: Billie Jean King," Women's Sports Foundation, July 20, 2016, https://www.womenssportsfoundation.org/athletes/our-athletes/billie-jean-king/.

4. Wikipedia, "United States at the 1984 Summer Olympics," March 28, 2018, https://en.wikipedia.org/wiki/United_States_at_the_1984_Summer_Olympics.

5. Amiee Berg, "Flash Back 20 Years to the Atlanta 1996 Olympics—When Women Reigned Supreme," ESPNW, July 20, 2016, http://www.espn.com/espnw/sports/article/17078201/flash-back-20-years-atlanta-1996-olympics-women-reigned-supreme.

6. John D. Halloran, "The Rise and Fall of the United States Women's National Team," *Bleacher Report*, April 23, 2013, https://bleacherreport.com/articles/1614739-the-rise-and-rise-of-the-united-states-womens-national-team.

7. Catherine Lhamon, "Title IX Resource Guide," US Department of Education, Office for Civil Rights, updated April 2015, http://www2.ed.gov/about/offices/list/ocr/letters/colleague-201504-title-ix-coordinators.pdf.

8. Lhamon, "Title IX Resource Guide."

9. Title IX and Gender Equity Specialists, "Three-Part Test: Title IX Athletics Q & A," September 2009, http://titleixspecialists.com/wp-content/uploads/2013/09/Q-A-Three-Part-Test.pdf.

10. Wikipedia, "Big Eight Conference," August 13, 2013, https://en.wikipedia.org/wiki/Big_Eight_Conference.

11. Wikipedia, "History of the Big 12 Conference," September 3, 2016, https://en.wikipedia.org/wiki/History_of_the_Big_12_Conference.

12. Title IX and Gender Equity Specialists, "Three-Part Test."

13. Derek Starks, "RCW: Once a Jayhawk, Always a Jayhawk: Cheryl Burnett," *Rock Chalk Weekly*, December 20, 2017, https://kuathletics.com/news/2017/12/20/rock-chalk-weekly-rcw-once-a-jayhawk-always-a-jayhawk-cheryl-burnett.aspx?path=wbball.

14. *Directory of Kansas University Athletics*, updated 2018, https://kuathletics.com/staff.aspx.

15. KU Athletics.com, "Facilities: Allen Fieldhouse—Pay Heed All Who Enter," last modified June 27, 2013, https://kuathletics.com/sports/2013/6/27/facilities-allen-fieldhouse-mbb.aspx.

16. Grant Treaster, ed., "Student Athletics to Have New Study Area," *University Daily Kansan*, February 16, 2009, http://www.kansan.com/news/student-athletes-to-have-new-study-area/article_be021744-fb05-5752-8a07-9e207058a153.html.

17. KU Athletics.com, "Facilities: Allen Fieldhouse."

18. KU Athletics.com, "Facilities: Anschutz Pavilion—the Inside Track," last modified June 27, 2013, https://kuathletics.com/sports/2013/6/27/facilities-anschutz-pavilion.aspx.

19. KU Athletics.com, "Facilities: Anschutz Pavilion."

20. KU Athletics.com, "Walk Down Memory Lane: A Decade at Arrocha Ballpark," last modified May 11, 2014. https://kuathletics.com/news/2014/5/11/SB_0511145206 .asp.

21. KU Athletics.com, "Athletics Facilities: Jayhawk Soccer Complex," *cstv.com* (blog), Summer 2007. http://grfx.cstv.com/photos/schools/kan/sports/w-soccer/auto _pdf/07-mg-wsoccer-eightb.pdf.

22. KU Athletics.com, "Facilities: Horejsi Family Athletics Center—a Home Court Advantage," last modified June 27, 2013, https://kuathletics.com/sports/2013/6/27 /facilities-horejsi-family-athletics-center.aspx?id=198.

23. Gary Bedore, "Self Lauds New Practice Facility," KU Sports.com, August 25, 2009, http://www2.kusports.com/news/2009/aug/25/self-lauds-new-ku-basketball -practice-facility/.

24. KU Athletics.com, "Facilities: Anderson Strength and Conditioning Center—in Pursuit of Peak Performance," last modified June 27, 2013, https://kuathletics.com /sports/2013/6/27/facilities-anderson-strength-center.aspx.

25. KU Athletics.com, "Facilities: Anderson Family Football Complex," last modified June 6, 2013, https://kuathletics.com/sports/2013/6/27/facilities-anderson -family-football-complex.aspx.

26. Jonathan Kealing, "Sports Facility Upgrades Expanded," KUSports.com, May 8, 2008, http://www2.kusports.com/news/2008/may/08/sports_facility_upgrades _expanded/.

27. KU Athletics.com, "Facilities: Rowing Boathouse—along the Banks of the Kansas River," last modified June 27, 2013, https://kuathletics.com/sports/2013/6/27 /facilities-rowing-boathouse.aspx.

28. KU Athletics.com, "Facilities: Robinson Natatorium—Historic Robinson Natatorium," last modified June 27, 2013, https://kuathletics.com/sports/2013/6/27 /facilities-robinson-natatorium.aspx.

29. KU Athletics.com, "Facilities: Rock Chalk Park Track and Field—a Dream Fulfilled." last modified January 18, 2017, https://kuathletics.com/sports/2014/12/29 /facilities-track-and-field-complex.aspx.

30. Myles Schrag, "Historic Track Is Torn Up for Football," *Runner's World*, September 3, 2014, https://www.runnersworld.com/advanced/a20811488/historic-track-is -torn-up-for-football/.

31. KU Athletics.com, "Facilities: Rock Chalk Park Track and Field."

32. KU Athletics.com, "Facilities: Soccer Field at Rock Chalk Park—a Grand Opening," last modified June 27, 2013, https://kuathletics.com/sports/2013/6/27/facilities -arrocha-ballpark.aspx?id=195.

33. KU Athletics.com, "Facilities: Arrocha Ballpark at Rock Chalk Park," last modified June 26, 2013, https://kuathletics.com/sports/2013/6/27/facilities-arrocha-ballpark.aspx.

34. Brooke Sutherland, "KU Tennis Tournament Showcases New Courts," KUSports.com, July 18, 2009, http://www2.kusports.com/news/2009/jul/18/ku-tennis-tournament-showcases-new-courts/.

35. Mark Fagan, "Kansas Athletics Buys Lawrence's First Serve Tennis Center," *Lawrence Journal-World*, February 1, 2010, http://www2.ljworld.com/news/2010/feb/01/kansas-athletics-buys-lawrences-first-serve-tennis/.

36. KU Athletics.com, "Facilities: Jayhawk Tennis Center—an Exciting Time for Jayhawk Tennis," last modified January 1, 2018, https://kuathletics.com/sports/2017/1/18/facilities-jayhawk-tennis-center.aspx.

37. KU Athletics.com, "KU Golf Nears Completion of New Practice Facility," last modified January 1, 2018, https://kuathletics.com/news/2018/1/25/mens-golf-ku-golf-training-facility-officially-open.aspx.

BIBLIOGRAPHY

Albertson, Roxanne M. "Basketball Texas Style, 1910–1933." In *A Century of Women's Basketball: From Frailty to Final Four,* edited by Joan S. Hult and Marianna Trekell, 155–166. Reston, VA: American Association for Health, Physical Education, Recreation, and Dance, 1991.

American Alliance for Health, Physical Education, Recreation, and Dance. "AAHPERD Becomes SHAPE America." December 5, 2013. https://www .prnewswire.com/news-releases/aahperd-becomes-shape-america-234624081 .html

Archie 2000 History Book Committee. *Archie: A History of a Railroad Town.* Rich Hill, MO: Bell Books, 2000.

Association for Intercollegiate Athletics for Women Fifth National Volleyball Championship, Wooster College: Final Report. December 13–15, 1973. University of Maryland Archives.

Association for Intercollegiate Athletics for Women Fourth National Volleyball Championship, Brigham Young University: Final Report. February 1–3, 1973. University of Maryland Archives.

Association of Kansas Women's Intercollegiate Sports. *AKWIS Newsletters.* Minutes of the Association of Kansas Women's Intercollegiate Sports meetings and sports competition results. Kansas Historical Society Archives (Topeka), Janet Nuzman documents, March 1969–April 1973.

Barnes, Mildred. "Coaching and Game Reflections, 1940s to 1980s." In *A Century of Women's Basketball: From Frailty to Final Four,* edited by Joan S. Hult and Marianna Trekell, 335–344. Reston, VA: American Association for Health, Physical Education, Recreation, and Dance, 1991.

Bedore, Gary. "Self Lauds New KU Basketball Practice Facility." KUsports.com. August 25, 2009. http://www2.kusports.com/news/2009/aug/25/self-lauds-new -ku-basketball-practice-facility/

Bell, Richard C. "A History of Women in Sport Prior to Title IX." *Sport Journal,* March 14, 2008. http://thesportjournal.org/article/a-history-of-women-in-sport -prior-to-title-ix/

Berg, Amiee. "Flash Back 20 Years to the Atlanta 1996 Olympics: When Women Reigned Supreme." ESPNW. July 20, 2016. http://www.espn.com/espnw/sports /article/17078201/flash-back-20-years-atlanta-1996-olympics-women-reigned -supreme

Charles, Kyle, and Theresa Kurtz, eds. *Kansas University Women's Basketball Media Guide, 2015–2016.* Lawrence: University of Kansas Athletics, 2016.

Commission on Intercollegiate Athletics for Women. *Procedures for Intercollegiate Athletic Events.* Washington, DC: American Association for Health, Physical Education, and Recreation, 1967.

Cuneen, Jacquelyn. "Oral History: North American Society for Sport Management." Updated March 13, 2002. https://www.nassm.com/InfoAbout/NASSM/History

Davenport, Joanna. "The Tides of Change in Women's Basketball Rules." In *A Century of Women's Basketball: From Frailty to Final Four,* edited by Joan S. Hult and Marianna Trekell, 83–84. Reston, VA: American Association for Health, Physical Education, Recreation, and Dance, 1991.

Division of Girls and Women in Sport First National Volleyball Championship, Long Beach State University: Final Report. April 23–25, 1970. University of Maryland Archives.

Division of Girls and Women in Sport Second National Volleyball Championship, University of Kansas: Final Report. February 4–6, 1971. University of Maryland Archives.

Division of Girls and Women in Sport Third National Volleyball Championship, Miami-Dade College: Final Report. February 5–7, 1972. University of Maryland Archives.

Dodd, Jack. "Once a Jayhawk, Always a Jayhawk: Marilyn Smith." *Rock Chalk Weekly,* September 12, 2017. https://kuathletics.com/news/2017/9/12/rock-chalk-weekly -once-a-jayhawk-always-a-jayhawk-marilynn-smith.aspx

Emery, Lynne F., and Margaret Toohey-Costa. "Hoops and Skirts: Women's Basketball on the West Coast, 1892–1930." In *A Century of Women's Basketball: From Frailty to Final Four,* edited by Joan S. Hult and Marianna Trekell, 137–154. Reston, VA: American Association for Health, Physical Education, Recreation, and Dance, 1991.

Fagan, Mark. "Kansas Athletics Buys Lawrence's First Serve Tennis Center." *Lawrence Journal-World,* February 1, 2010. http://www2.ljworld.com/news/2010/feb/01 /kansas-athletics-buys-lawrences-first-serve-tennis/

Federal Trade Commission. "The Antitrust Laws." https://www.ftc.gov/tips-advice /competition-guidance/guide-antitrust-laws

Foos, Kelly, H. "Toward a Rational Seat Belt Policy in Kansas." *Kansas Law Review* 56 (2008): 1006. https://kuscholarworks.ku.edu/bitstream/handle/1808/20004 /Foos_Final.pdf

Greenspan, Jesse. "When Billie Beat Bobby." *History,* September 20, 2013. https:// www.history.com/news/billie-jean-king-wins-the-battle-of-the-sexes-40-years-ago

Halloran, John D. "The Rise and Fall of the United States Women's National Team." *Bleacher Report,* April 23, 2013. https://bleacherreport.com/articles/1614739 -the-rise-and-rise-of-the-united-states-womens-national-team

Hawley, Brenna. "A Generation Ablaze." *University Daily Kansan*, April 20, 2010. http://www.kansan.com/news/a-generation-ablaze/article_07027d68-c405 -5d8c-bb83-23b9adae6449.html

Hersey, Mark D. "They've Come a Long Way Maybe." KUHistory.com, February 8, 2012. kuhistory.com/articles/theyve-come-long-way-maybe

Howat, Kenna. "Pedaling the Path to Freedom." National Women's History Museum. Last modified 2012. https://www.womenshistory.org/articles/pedaling-path -freedom

Hult, Joan S. "The Governance of Athletics for Girls and Women: Leadership by Women Physical Educators, 1899–1949." In *A Century of Women's Basketball: From Frailty to Final Four*, edited by Joan S. Hult and Marianna Trekell, 53–82. Reston, VA: American Association for Health, Physical Education, Recreation, and Dance, 1991.

———. "The Legacy of AIAW." In *A Century of Women's Basketball: From Frailty to Final Four*, edited by Joan S. Hult and Marianna Trekell, 281–309. Reston, VA: American Association for Health, Physical Education, Recreation, and Dance, 1991.

———. "The Saga of Competition." In *A Century of Women's Basketball: From Frailty to Final Four*, edited by Joan S. Hult and Marianna Trekell, 233–248. Reston, VA: American Association for Health, Physical Education, Recreation, and Dance, 1991.

Hult, Joan S., and Marianna Trekell, eds. *A Century of Women's Basketball: From Frailty to Final Four*. Reston, VA: American Association for Health, Physical Education, Recreation, and Dance, 1991.

Hunt, Virginia. "AIAW Championship Results." Report to the Association for Intercollegiate Athletics for Women Executive Board, 1982.

Hutchison, Jill. "Women's Intercollegiate Basketball: AIAW/NCAA." In *A Century of Women's Basketball: From Frailty to Final Four*, edited by Joan S. Hult and Marianna Trekell, 309–334. Reston, VA: American Association for Health, Physical Education, Recreation, and Dance, 1991.

Hyland, Andy. "Finance Officer Counts Down to Retirement." *Lawrence Journal-World*, January 15, 2012. http://www2.ljworld.com/news/2012/jan/15/16 -things-finance-officer-counts-down-retirement/

International Olympic Committee. "Key Dates in the History of Women in the Olympic Movement." Updated 2014. https://www.olympic.org/women-in-sport /background/key-dates

Kansas Association for Intercollegiate Athletics for Women. *KAIAW Communications*. Minutes of the meetings and sport competition results. Kansas Historical Society (Topeka), Janet Nuzman documents, October 1973–May 1980.

"Kansas Board of Regents Allocates Funds for Women's Athletics in Kansas Higher Education Institutions." *KAIAW Communications* 1, no. 4 (May 1973).

"Kansas City Basketball Team Nicknames." *Kansas City Star.* Updated December 9, 2017. http://www.allstarrsports.com/index.php/kansas-city-sports/78-kansas-city-basketball-team-nicknames

Kealing, Jonathan. "Sports Facility Upgrades Expanded." KUsports.com, May 8, 2008. http://www2.kusports.com/news/2008/may/08/sports_facility_upgrades_expanded/

Kessel, John. "History of Volleyball Rules." United States of America Volleyball. Updated 2006. Adapted from "A Summary of Seventy-Five Years of Rules" by William. T. Odeneal. https://www.teamusa.org/USA-Volleyball/About-Us/~/media/8B32C6A5304A4475

Koenig, Fran, and Mary Weston. "Women's Basketball Officiating." In *A Century of Women's Basketball: From Frailty to Final Four,* edited by Joan S. Hult and Marianna Trekell, 261–280. Reston, VA: American Association for Health, Physical Education, Recreation, and Dance, 1991.

"KU Announces Plans for Rock Chalk Park." *Topeka Capital-Journal.* Last modified January 15, 2013. http://www.cjonline.com/sports/2013-01-15/ku-announces-plans-rock-chalk-park

Lhamon, Catherine. "Title IX Resource Guide." US Department of Education, Office for Civil Rights. Updated April 2015. http://www2.ed.gov/about/offices/list/ocr/letters/colleague-201504-title-ix-coordinators.pdf

Limpus, Daryl. "The Archie Whirlwinds: A History of Archie High School Basketball." n.p. 1984.

Lopiano, Donna A. "Affidavit of Donna A. Lopiano: *AIAW v. NCAA.*" October 9, 1981. In the US District Court for the District of Columbia, Washington DC.

Lucas, John A., and Richard A. Smith. *Saga of American Sport.* Philadelphia: Lea and Febiger, 1978.

Mathison, M. Catherine. "A Selective Study of Women's Athletic Administrative Settings Involving AIAW Division I Institutions." Pittsburgh, PA: University of Pittsburgh. Cited in Donna Lopiano, "Affidavit: *AIAW v. NCAA.*" October 9, 1981. In the US District Court for the District of Columbia, Washington DC, 345.

Metz, Christine. "1970: Memories of Violence in City Still Strong." *Lawrence Journal-World,* April 20, 2010. http://www2.ljworld.com/news/2010/apr/20/1970/

Newman, Paul. "Forty Years On, How Billie Jean King Led the Revolution That Propelled Women to Greater Equality." *Independent,* June 18, 2013. https://www.independent.co.uk/sport/tennis/forty-years-on-how-billie-jean-king-led-the-revolution-that-propelled-women-to-greater-equality-8664164.html

Norwood, Arlisha R. "Amelia Bloomer." National Women's History Museum. 2017. https://www.womenshistory.org/education-resources/biographies/amelia-bloomer

Pilon, Nancy Nygaard. "Women's Athletics at the University of Kansas during the Progressive Era, 1890–1920." PhD diss., University of Kansas, May 31, 2008. https://kuscholarsworks.ku.edu/bitstream/handle/1808/19068/umi-ku-2370_1.pdf

Plummer, Bill, and Larry C. Floyd. "A Series of Their Own: The History of the Women's College World Series." Turn Key Communications. December 13, 2011. http://plummersoftball.com

Polsson, Ken. "Chronology of Sport." Last updated May 5, 2017. http://worldtimeline.info/sports

Rosenberg, Jennifer. "Go Back in Time with the 1980s History Timeline." Thought Co. Updated July 12, 2018. https://www.thoughtco.com/1980s-timeline

Schild, Linda. "Student Senate Approves Funds." *Lawrence Daily Journal World*, July 22, 1974. https://lawrencepl.newspaperarchive.com/lawrence-daily-journal-world/1974-07-22/page-11/

Schrag, Myles. "Historic Track Is Torn Up for Football." *Runner's World*, September 3, 2014. https://www.runnersworld.com/advanced/a20811488/historic-track-is-torn-up-for-football/

Schwartz, Jerry, and Hub Meyers. "Three Injured in Bomb Blast on KU Campus." *Lawrence Daily Journal World*, December 12, 1970. http://www.lawrence.com/news/1970/dec/12/three-injured-bomb-blast-ku-camp

Scott, Phebe M. "Food for Thought for the Future." Speech delivered at the Fourth National Institute on Girls and Women's Sports, Indiana University, Bloomington, Indiana, December 9, 1966. Illinois State University Archives.

———. "History of the National Girls' Sports Institutes." Speech delivered at the Statewide Volleyball Workshop, Illinois State University, Normal, Illinois, December 2, 1967. Illinois State University Archives.

———. "Intercollegiate Sports for Women: Present Problems and Future Directions." Speech delivered at the Division for Girls' and Women's Sports National Conference on Sports Programs for College Women, Young Men's Christian Association of the Rockies, Estes Park, Colorado, June 23, 1969. Illinois State University Archives.

———. "Promoting Girls' and Women's Sports." Speech delivered at the First National Institute on Girls and Women's Sports, University of Oklahoma, Norman, Oklahoma, October 1963. Illinois State University Archives.

———. "Reflections on Sports for Women." Speech delivered at the Third National

Institute on Girls and Women's Sports, Salt Lake City, Utah, January 23, 1966. Illinois State University Archives.

———. "What Is DGWS's Responsibility for the Highly Skilled Woman Competitor?" Speech delivered to Division of Girls' and Women's Sports Executive Council, Washington DC, December 28, 1961. Illinois State University Archives.

———. "Women's Programs Should Be Different: Commissioner's Program at AAHPERD." Speech delivered at the Commission on Intercollegiate Athletics for Women session at American Association for Health, Physical Education, Recreation, and Dance Convention, Kiel Auditorium–Convention Hall, St. Louis, Missouri, April 1, 1968. Illinois State University Archives.

———. "Women's Sports in 1980." Speech delivered at the Second National Institute on Girls and Women's Sports, Michigan State University, Lansing, Michigan, September 30, 1965. Illinois State University Archives.

Shepard, Sara. "KU Celebrates 150 Years." *Lawrence Journal-World*, August 23, 2015. http://www2.ljworld.com/news/2015/aug/23/ku-celebrates-150-years

Simpson, Jake. "How Title IX Sneakily Revolutionized Women's Sports." *Atlantic*, June 21, 2012. https://www.theatlantic.com/entertainment/archive/2012/06/how-title-ix-sneakily-revolutionized-womens-sports

Spears, Betty, and Richard Swanson. *History of Sport and Physical Education in the United States*. Dubuque, IA: Brown, 1988.

Starks, Derek. "RCW: Once a Jayhawk, Always a Jayhawk: Cheryl Burnett." *Rock Chalk Weekly*, December 20, 2017. https://kuathletics.com/news/2017/12/20/rock-chalk-weekly-rcw-once-a-jayhawk-always-a-jayhawk-cheryl-burnett.aspx?path=wbball

Sutherland, Brooke. "KU Tennis Tournament Showcases New Courts." KUsports.com, July 18, 2009. http://www2.kusports.com/news/2009/jul/18/ku-tennis-tournament-showcases-new-courts/

Title IX and Gender Equity Specialists. "Three Part Test: Title IX Athletics Q & A." September 2009. http://titleixspecialists.com/wp-content/uploads/2013/09/Q-A-Three-Part-Test.pdf

Treaster, Grant, ed. "Student Athletics to Have New Study Area." *University Daily Kansan*, February 16, 2009. http://www.kansan.com/news/student-athletes-to-have-new-study-area/article_be021744-fb05-5752-8a07-9e207058a153.html

United States of America Track and Field Archives. "USATF Honors 1968 US Olympic Team." April 24, 2018. http://www.usatf.org/News/USATF-honors-1968-U-S-Olympic-team-with-night-of-.aspx

University of Kansas Athletics. "Athletics Facilities: Jayhawk Soccer Complex." *cstv* (blog), Summer 2007. http://grfx.cstv.com/photos/schools/kan/sports/w-soccer /auto_pdf/07-mg-wsoccer-eightb.pdf

———. "Facilities: Allen Fieldhouse—Pay Heed, All Who Enter." Last modified June 27, 2013. https://kuathletics.com/sports/2013/6/27/facilities-allen-fieldhouse -mbb.aspx

———. "Facilities: Anderson Family Football Complex." Last modified June 27, 2013. https://kuathletics.com/sports/2013/6/27/facilities-anderson-family -football-complex.aspx

———. "Facilities: Anderson Strength and Conditioning Center—in Pursuit of Peak Performance." Last modified June 27, 2013. https://kuathletics.com/sports/2013 /6/27/facilities-anderson-strength-center.aspx

———. "Facilities: Anschutz Pavilion—the Inside Track." Last modified June 27, 2013. https://kuathletics.com/sports/2013/6/27/facilities-anschutz-pavilion.aspx

———. "Facilities: Arrocha Ballpark at Rock Chalk Park." Last modified June 26, 2017. https://kuathletics.com/sports/2013/6/27/facilities-arrocha-ballpark.aspx

———. "Facilities: Horejsi Family Athletics Center—a Home Court Advantage." Last modified June 27, 2013. https://kuathletics.com/sports/2013/6/27/facilities -horejsi-family-athletics-center.aspx?id=198

———. "Facilities: Jayhawk Soccer Complex." *cstv* (blog), summer 2007. http://grfx .cstv.com/photos/schools/kan/sports/w-soccer/auto_pdf/07-mg-wsoccer-eightb .pdf

———. "Facilities: Jayhawk Tennis Center—an Exciting Time for Jayhawk Tennis." Last modified January 1, 2018. https://kuathletics.com/sports/2017/1/18 /facilities-jayhawk-tennis-center.aspx

———. "Facilities: Robinson Natatorium—Historic Robinson Natatorium." Last modified June 27, 2013. https://kuathletics.com/sports/2013/6/27/facilities -robinson-natatorium.aspx

———. "Facilities: Rock Chalk Park Track and Field—a Dream Fulfilled." Last modified January 18, 2017. https://kuathletics.com/sports/2014/12/29/facilities -track-and-field-complex.aspx

———. "Facilities: Rowing Boathouse—along the Banks of the Kansas River." Last modified June 27, 2013. https://kuathletics.com/sports/2013/6/27/facilities -rowing-boathouse.aspx

———. "Facilities: Soccer Field at Rock Chalk Park—a Grand Opening." Last modified June 27, 2013. https://kuathletics.com/sports/2017/2/13/facilities -soccer-complex.aspx

———. "Kansas Athletics to Celebrate 50 Years of Women's Sports." August 16, 2017. https://kuathletics.com/news/2017/8/15/cross-country-kansas-athletics-to-celebrate-50-years-of-womens-sports.aspx

———. "KU Golf Nears Completion of New Practice Facility." Last modified January 1, 2018. https://kuathletics.com/news/2018/1/25/mens-golf-ku-golf-training-facility-officially-open.aspx

———. "Personnel History: Administration." 2016.

———. "Personnel History: Women's Sports Head Coaches." 2016.

———. "Walk Down Memory Lane: A Decade at Arrocha Ballpark." Last modified May 11, 2014. https://kuathletics.com/news/2014/5/11/SB_0511145206.aspx

Urlaub, Jeanne. "AKWIS Survey of Sources of Funding for Women's Intercollegiate Sports." Association for Kansas Women's Intercollegiate Sports fall meeting minutes, September 1970. Kansas Historical Society Archives (Topeka), Janet Nuzman documents.

———. "History: The Organization of AKWIS." *KAHPER Journal* 39, no. 1 (October 1970): 7.

US Department of Education, Office for Civil Rights. "A Policy Interpretation: Title IX and Intercollegiate Athletics." *Federal Register* 44, no. 239. Last modified December 11, 1979. https://www2.ed.gov/about/offices/list/ocr/docs/t9interp .html

US Department of Labor. Title IX, Education Amendments of 1972, Section 1681–1688. https://www.dol.gov/oasam/regs/statutes/titleix.htm

Van Dalen, Deobold B., and Bruce L. Bennett. *A World History of Physical Education.* Englewood Cliffs, NJ: Prentice Hall, 1971.

Wardwell, Nancy Weltzheimer. "Rachel E. Bryant: Twenty-One Years of Women's Leadership in Basketball—in Sport." In *A Century of Women's Basketball: From Frailty to Final Four*, edited by Joan S. Hult and Marianna Trekell, 249–260. Reston, VA: American Association for Health, Physical Education, Recreation, and Dance, 1991.

Webb, Bernice L. *The Basketball Man: James Naismith.* Lawrence: University Press of Kansas, 1973.

Wikipedia. "Big Eight Conference." August 13, 2013. https://en.wikipedia.org/wiki /Big_Eight_Conference

———. "History of the Big 12 Conference." September 3, 2016. https://en.wikipedia .org/wiki/History_of_the_Big_12_Conference

———. "United States at the 1984 Summer Olympics." March 28, 2018. https://en .wikipedia.org/wiki/United_States_at_the_1984_Summer_Olympics

Women's Sports Foundation. "Our Athletes: Billie Jean King." July 20, 2016. https:// www.womenssportsfoundation.org/athletes/our-athletes/billie-jean-king/

Woolum, Janet. *Outstanding Women Athletes: Who They Are and How They Influenced Sports in America*. Phoenix, AZ: Oryx, 1998.

World Baseball and Softball Confederation. "The History of Softball." 1991. http://www.wbsc.org/softball/history-of-softball/

Wu, Ying. "Early NCAA Attempts at the Governance of Women's Intercollegiate Athletics, 1968–1973." *Journal of Sport History* 26, no. 3 (April 999): 585–601. http://library.1a84.org/SportsLibrary/JSH/JSH1999/JSH2603/JSH2603i.pdf

INDEX